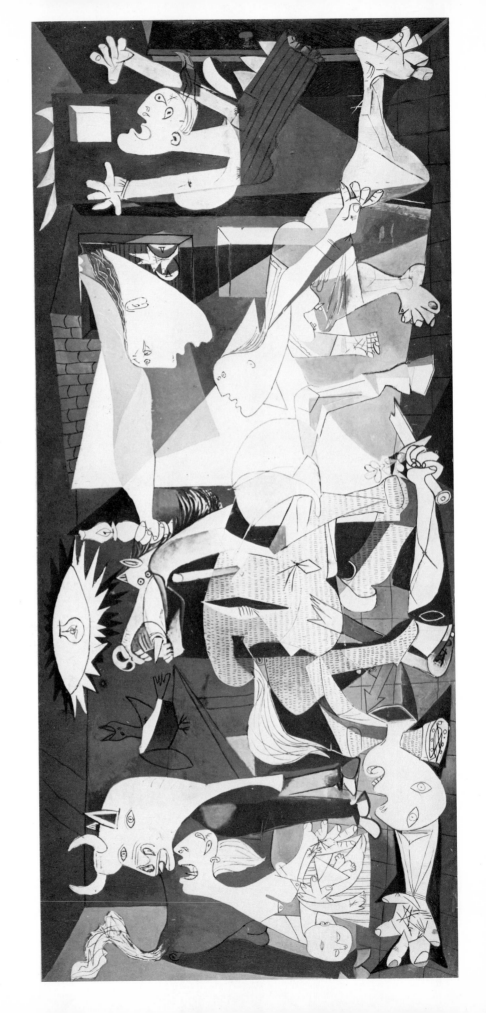

FRANK D. RUSSELL

PICASSO'S

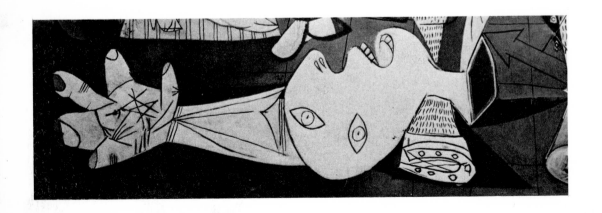

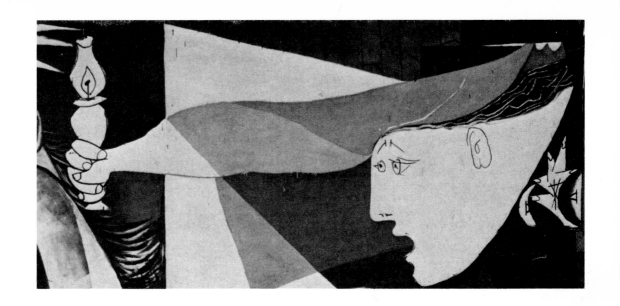

GUERNICA

*The Labyrinth of
Narrative and Vision*

ALLANHELD & SCHRAM • MONTCLAIR

ALLANHELD, OSMUN & CO., PUBLISHERS, INC.
Montclair, New Jersey

ABNER SCHRAM LTD.
Montclair, New Jersey

Published in the United States of America in 1980
by Allanheld, Osmun & Co., 19 Brunswick Road, Montclair, N.J. 07042
and by Abner Schram Ltd., 36 Park Street, Montclair, N.J. 07042
Distribution: Abner Schram Ltd.

Library of Congress Cataloging in Publication Data

Russell, Frank D., 1923–
 Picasso's Guernica.

 Bibliography: p.
 1. Picasso, Pablo, 1881–1973. Guernica. I. Title.
ND553.P5A78 1979 759.4 79-52472
ISBN 0-8390-0243-2

Printed in the United States of America

For my father, Harris Russell

Contents

Part II

THE PICTURE IS DELIVERED

Acknowledgments

In my progress through the Labyrinth of the Guernica, it has been my good luck over the years that many persons have placed strings in my hands. I am indebted in more ways than can be expressed, to the artist and art historian Dr. George Weber of Rutgers, my sometime colleague, for his many-sided illumination of the processes of seeing and communicating, indeed for his part in the forming of my values. I am at a serious loss to express my indebtedness to Dr. William Rubin of the Museum of Modern Art, whose sustained help, more than generously given, has steered this work in innumerable ways and brought it to its scope, certain of its resolutions, and much of its finish. I have the painter José Maorta to thank for a number of unique and original contributions. Throughout, my work as been furthered by the thoughful objections of friends and colleagues: these include Emily Bernstein, Maírín Cotter, Bowdoin Davis, Jr., and Jean McClintock. I am especially indebted to Jean Rubin of the Maryland Institute for her trenchant criticisms and advice. I am indebted always and profoundly to the poet Harris Russell, my father, for the approaches and attitudes and the ways and methods of seeing which he has shared with me from the first. The book could not have prospered without the guidance of John Marion of Philadelphia, and the help of Ursula Russell-Wassermann of Switzerland. The book has been much set on its feet by the creative editorship of Sara H. Held. Finally I am indebted to students at Rutgers and at the Maryland Institute, College of Art, whose stimulus has opened paths and turned up ideas, and indeed brought this work into being in the first place.

It is to be hoped that the expectations of these well-wishers will be justified, and that shortcomings will be laid at my door, not at theirs.

What are the roots that clutch, what branches grow
Out of this stony rubbish?

T. S. Eliot, *The Waste Land*

[2] below, a dismembered swordbearer with arms outspread,

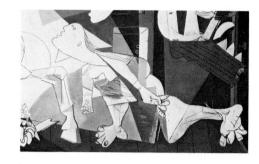

to the right a kneeling or stumbling woman,

overhead a woman leaning from a window with a lamp—no detail in fact which pins the picture to war in particular, and, other than

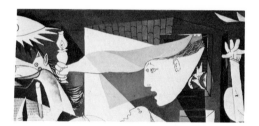

the detail of the electric bulb brooding over the proceedings (itself equally a sun or indifferently an eye), nothing to connect the mural with any particular century. Detonated by sudden entrances and exits,

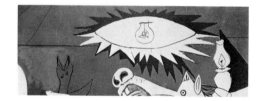

nonetheless the picture in its episodes is timeless, archaic. The timetable of the Spanish Republic is here widened to include all time, and in fact it is in certain Biblical outlines, more than in war or rumors of war, that a large piece of the Guernica iceberg is to be uncovered.

The present work aims in part at tracing such an outline, showing the connection between Picasso's picture and one of the artist's own recurrent themes: a traditional Spanish preoccupation, the crucifixion. In the first Part we begin with the pursuit of this theme and a following of Picasso's preparations for it in his works over many decades.

Other, still more prominent episodes in the picture are discussed later in the first

Part, in relation to another scene of execution, the bullring; and further, the picture's architecture and its transformations of nature.

In the second Part, having arrived at some tentative conclusions about the Guernica based on its years of background, we turn to the artist's final midwifery of the mural, the Guernica Studies, culminating in the final revisions of the mural on the canvas. We finish with a look at the picture's substance in history as we live it now, and as after all we inherit it.

PART ONE

The Picture and Its Background

SCENARIOS:
WHAT THE GUERNICA TELLS

CHAPTER ONE

Calvary

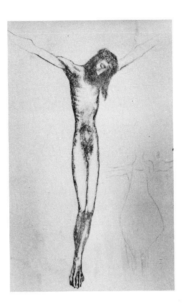

1. Picasso,
1902

The Question

We begin with the Guernica as illustration, because for all the choppy seas of its Cubist surface the Guernica is fitted together in an orderly and ingenious fashion out of recognizable fragments of storytellings. Literally the stories do not include much of Guernica itself, but come across as a counterpoint between the two loosely parallel themes of sacrifice, that of Christ on the cross and that of the picador's horse gored in the bullring: Picasso has stirred these two main themes together into what is surely one of the most explosive and uncanny mixtures in the history of art, leaving us to receive the impact and pick up the pieces as we may. For all the initial shock impact, the full measure of these broken narratives comes through gradually, not like an explosion, but like the gradual unfolding of a somewhat monstrous organism. The forthright Guernica images of the horse and the bull force the bullfight theme into the foreground so that it hits us at first glance. The Calvary theme is no less urgent and no less specific once we peel off the outer layers of the picture and rummage in its depths, and it is this theme which contains within itself the wealth of reference which sets the picture up as a work of dedication to the past and to the future. The transient and somewhat aimless emotions which, for tender observers of the bullfight, cluster around the mute sacrifice of the horse, take on a

larger definition in the emotions which are sharply articulated in the long tradition of the crucifixion. Picasso picked up this tradition long before 1937, reverting to it in sketches and paintings of the theme in most periods of his life. The roots of this

2. 1930

interest were deep, planted in Picasso's religious upbringing in Catholic Spain; their depth is shown most largely by their ultimate flowering in the Guernica.

The crucifixion, the bullfight, and the disasters of war have in common that they center around an innocent victim. They unite in illustrating the breadth of man's talent in dealing death, and (especially in the case of the crucifixion) his need for resurrected life. The Guernica sums up this talent and this need, and has more than once been noticed in various ways as a modern Calvary. [3]

With the words modern Calvary in mind we pick our way across the field of funereal gray, the women burning or bereaved, others watching in distress, animals halted or crippled, the man in fragments, the bird falling. The idea of a Calvary brings us a certain distance, we feel, into the Guernica's steeled passion, its sense of bereavement intimate yet universal, the inexplicable sense of authority. We stand back to catch a perspective of forms lighted awesomely from above, but scored and confused, the photomontage, as it were, of a Calvary crossed with explosions, and it occurs to us that there may lie under our hands a network of more tangible connections, the hard elements of a modern Calvary present in fact.

The Guernica in its breadth and complexity may be a mirror which posterity will consult in order to reconstruct something of our general troubled image; there is of course no great agreement as to what is to be discovered in such a controversial surface. The picture is sometimes felt to be a chaos of emotion, a rubble. We shall [4]
try to find whether it is merely that, or a structure salvaged carefully from the rubble of the past, dedicated to the idea of a resurrection and to a future.

Past and Future

The crucifixion, the isolated episode of Christ hanging on the cross, was illustrated by Picasso in a changing cycle of thirty-nine works sustained across some six decades, from 1902 to 1959. Significantly it is distinguished as the only Biblical moment to crop up in the artist's works within that comprehensive span of years. His drawings of it

[5]

3. 1932

infuse a violent life into the somewhat moribund history of illustrations of this theme, for they are filled with invention, and, in their brutal and twisted way, touched with majesty and compassion.

The crucifixion had undoubtedly a special relevance to Picasso as inventor of tortured images and interpreter of a tortured century. Altogether the theme was an essential one for Picasso. Something of the compassion itself was visible as early as the painter's boyhood,

4. 1932

in studies of beggars and peasants of the earliest Spanish period,

5. 1895

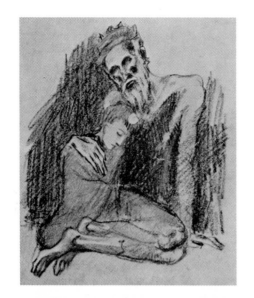

6. 1903

and shortly afterward in the lean and hungry Blue period,

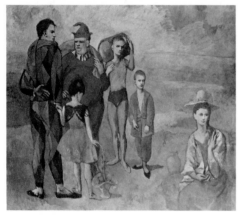

7. 1905

and in the Rose period with its long looks at the color of human separateness. All this

8. 1911

came to a stop before 1910 when Cubism began bursting ahead of the bombs, raining a final destruction on sentiment and on the last remains of traditional form. An anarchist revolt of its own, an armed sortie into the future,

but hardly had the dust settled on it when Picasso veered backward toward

9. 1921

[6] those ultraconservative props hitherto defunct for many generations, the settled Junos and Jupiters of the academy. Now toward the past—now the future, a destruction of the past; grasping first one way, then the other, the painter kept his tread on the vibrant line of the present.

Like Picasso's work, the crucifixion, the Biblical incident, may be said to have faced in two directions, suspended between ages of prophecy and a hoped-for salvation. The tendencies which absorbed Picasso alternately in successive periods, compassion, destruction, tradition, are brought together and reconciled in the crucifixion; a timeless compassion, a destruction and tortured fixing, and the theme of traditional rebirth and ordered continuity. In this way the crucifixion may be said to have worked over the years as an essential theme for Picasso, though he only occasionally dealt with it directly.

In the winter of 1937 the Republican Spanish government, from its wartime capital in Seville, asked the painter in Paris to make a mural. For five months from January to April he hung fire and painted nothing. Like other painters of his generation Picasso had shied away from demonstrations such as history subjects; he could not paint a civil war, even the

[7] Spanish one, until April 26 and the

innocent body of one town systematically gored. The painter was torn from the retreat of his intimate communications and furnished with his moment. He

carried it onto the canvas in a welter of knifelike forms, a reaping of Cubism appropriate enough for destruction, [8]

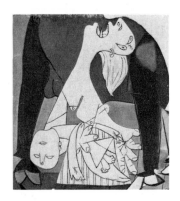

but put a furious compassion there besides, more openly than had been required in the Blue period. Certain cooler elements, too,

were transferred from the storehouse of classic style; [9]

the Guernica was to be a general husbanding and reconciling of the painter's resources, little less than a summary of Picasso; but the promise of renewal was to be [10] more definite than any the classic by itself could make, just as the compassion was to be more pointed than that which could be called up from the Blue period. Triggered by destruction, the picture had little reason for existing except that it carry a

promise of regeneration, and to this end the painter brought to it the most potent signs and forms his life had enabled him to summon. Thirty-five years after his first version of Calvary these signs and forms, reshaped to a new urgency, were [11] presented to the world.

The Voice

In fact the crucifixion theme had supplied Picasso's picture visibly with its sense of utterance, literally with the central image of its mouth.

The Biblical accounts of the crucifixion consist of little besides the utterances of Christ; the incident itself is mentioned but not described, and comes to us simply as voice. "And, when they were come to the place which is called Calvary, there they Crucified him, and the malefactors; one on the right hand, and the other on the left. Then said Jesus, 'Forgive them, Father, for they know not what they do.'"

The Japanese possess a word, "yugen," to suggest the quality of silence which follows our seeing a great work of art. Picasso's picture with its arrangements of the dead not only ends but begins with a silence; nonetheless the Guernica is a picture about voice. Emerging against a silence such as might have followed a roar of collapsing rubble, we see the horse, the focus of the mural, itself focused in its trumpetlike mouth, the image reaching us ahead of its crippled and cancelled legs; as in the case of a crucifixion, voice is the one power left. Across the mural other [12] mouths are stretched open, an all-around insistence of address to our ears. The daggerlike tongues and harsh outlines suggest little of the soft accents we sometimes associate with Christ, but much of the tone of Old Testament prophecy-making, accusing, harshly clipped, and always full of animals, full of parable: "Thy sons have [13] fainted, they lie at the head of the streets as a wild bull in a net." No modern image better than the Guernica horse, can be stood beside the prophetic utterance of the 22nd Psalm: "My God, my God, why hast thou forsaken me? Why art thou so far from me, and from the words of my roaring?"

The sense of audibility in the Guernica is a link with long tradition, a new transcription of the cry of sacrifice and martyrdom which sounds through the art of the middle ages and their aftermath. One of the most subtly penetrating occurrences of that cry takes place four hundred years before Picasso, in

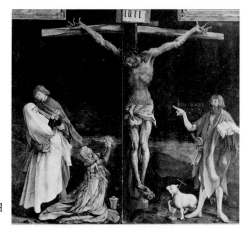

10.
Grünewald

the Isenheim altarpiece of Mathias Grünewald—a picture which had preoccupied Picasso profoundly five years before Guernica. It was this sixteenth-century document which was to bequeath to the Guernica its opened mouth: the voice of the German Renaissance work is focused in

11.
Grünewald

the gaping mouth of the Christ, with its bared teeth and emerging tongue. Picasso in 1932

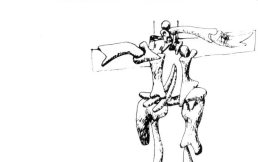

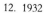

12. 1932

had submitted himself to the electric horror of this work, shifting its emphasis in a series of nightmarish adaptations in which the emotion is focused unreservedly in the gaping mouth which now dominates the cross:

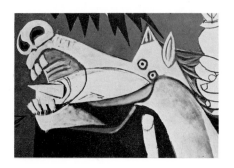

the teeth and visible tongue of the Grünewald Christ, revived together and driven home still more pointedly, as it would seem, in the spiked eloquent gaping of the Guernica horse. [14]

The utterance, low but penetrating in itself, of Grünewald's Christ is sharpened and amplified by the radiating of the crown of thorns. These enormous points, like the teeth and the tongue,

13. Grünewald

may be said to come down to 1937, visible still as spikes, but spikes of light and shadow, lined up point by point like thorns along the contours of the horse and pressing the length of its head. As in the Grünewald and still more directly, these extend the sharpness of the voice which issues from their midst, exact reiterations of the spike of the horse's tongue.

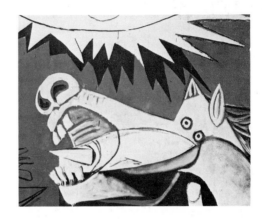

Long before Guernica, Picasso in his own works over the years had made use of both images of martyrdom, Christ and the horse. The incongruous pair shared in each other's development, each taking a deeper or sharper overtone from reflection of the other. The equine mouth crenelated with teeth, the focus of the Guernica,

is foreshadowed in an early study for the crucifixion. Here, pain is expressed not by the head of the Christ, a motif which on this occasion Picasso put down gingerly, the mutest of icons; but by the grinding teeth of the Roman soldier's horse, a growling which jumps forth as the most forthright element in this unpredictable little drawing. This was 1930. In 1932

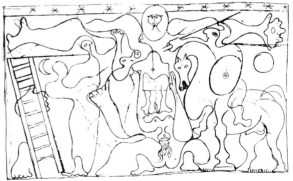

14. 1930–31

15. 1932

the grinding teeth part, and it is the horse, no longer content to express the crucifixion from the sidelines, which raises its elongated jaws onto the cross. The audacious switch takes place within the arid passion of Picasso's Bone period, in which the flesh of the Christ has disappeared and likewise the horse's, only bones surviving, and, issuing from these, the horse's animal howl.

Not only the equine jaws of this Christ but also its pathetically speechless eyes—the artist's adaptation of Grünewald's blind Christ—are bequeathed to the Guernica animal. Little enough, in this Bone period work of 1932, is left for the eyes,

16. 1932

mechanical holes fitted into one of the jaw bones; it is the hinging of these two exaggerated bones with their naked clumps of teeth, which serves by itself as Christ's head. The two vacant circles, shrunken, become in 1937

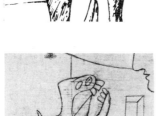

17. 1937

the sightless ragdoll's buttons of the horses in Studies for the Guernica,

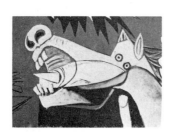

and of the Guernica horse itself: surrounded on every hand by hugely staring personages in the mural, the horse is endowed with the most shrunken sight, and the most greatly magnified eloquence of voice. The purpose and mission of Picasso's horse, no less than of the Christ, is not to see us, but to speak to us.

[15]

The Nail and the Spear

Not only an impression of Christ's voice, but also a likeness of his outstretched arms is to be traced in the Guernica, together with a new enactment of the coup de grâce which despatches him on the cross.

The scriptural details of the coup de grâce, like those of the crucifixion generally, have their relevance to Picasso's picture. Conceived in a rough compassion, the coup de grâce was administered too late, to a Christ already dead. "But when they came to Jesus, and saw that he was dead already, they brake not his legs [the usual method of despatch on the cross]: but one of the soldiers with a spear pierced his side, and forthwith came thereout blood and water."

In recognition of matters such as the miracle of blood and water the soldier is canonized as St. Longinus. But in fact the real significance of the soldier lies not so much within his miracle as within himself, the symbol of every impassioned but belated gesture in the wake of an injustice, the helpless reading of the newspapers after it is already done; the fist brought down impotently on the breakfast table. In particular, the centurion's act may be said to symbolize an aspect of the painter's brush brought down on canvas, his record of life and death after the fact. Illustrators of the crucifixion, Picasso among them, take up where the centurion left off. Picasso's long-term involvement with the image of the centurion, then, may perhaps be seen as an aspect of the painter's self-portrait, a parable of himself.

The Guernica horse impaled and brought down by a spear, is a parable seemingly self-sufficient. To interpret the spear itself as another reminiscence of the crucifixion—of the coup de grâce administered by the Roman soldier at the request of the Jews—is to interpret the symbol in literal terms, and to stray perhaps from any exact truth of 1937. Nonetheless the soldier, remote as he may seem to be from the Spanish Civil War, towers in Picasso's crucifixion scenes. We meet this equivocal personage in every attitude,

he poises his spear,

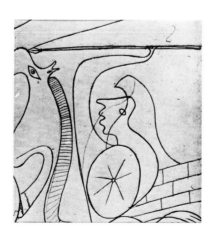

he plunges it,

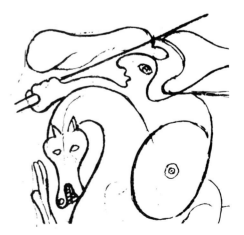

18. 1930 19. 1930–31

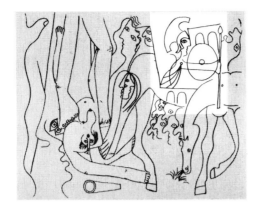

20. 1929

he turns his back, dressed up always with his spear, his helmet, his trappings. He has generally an air of the pathetic, even of the superfluous; slack on certain occasions, on others vacant or puppetlike; on one occasion perhaps, brutal—so the search goes on for his rightful identity. In

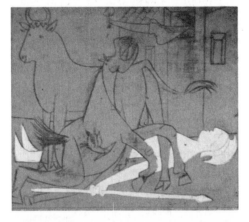

21. 1930

1930 he almost disappears, dominated by his spear: but far from dwindling altogether, he seems destined for reincarnation seven years later

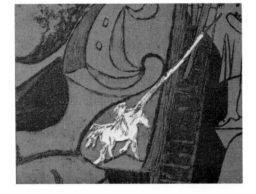

22. 1937

in Studies for the Guernica—on his back, more ineffectual than ever, but complete with his identifying spear and helmet. At last

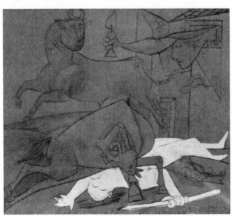

23. 1937

relieved of his archaic headgear, his weapon broken, he is cast as the corpse in a Guernica Study once more. It is this decapitated figure,

arms outspread with the same grasp on the weapon, which emerges in the mural itself, grasping, in place of the broken spear, a piece of a broken sword. Bodiless but jolted into a blinding semblance of life, the warrior may be said to figure as an awakening of the centurions which precede him, an explanation of their veiled and frustrated purpose, a hard illumination of the grandeur and courage which is death.

Of the human beings who participate in the Guernica none has a more checkered, a more seemingly contradictory background than the dismembered sword-bearer. The centurion of the coup de grâce is in fact only one among his array of ancestors, and not necessarily the most conspicuous of them.

In the early States of the mural (successive revisions on the canvas, preserved in [16] photographs), the figure of the warrior was laid out differently, describing a huge defiance with his opened arms and at the same time none at all with his passive and closely joined legs. Few circumstances are likely to result in the nude male figure thus twisted and extended, feet forced downward and overlapping:

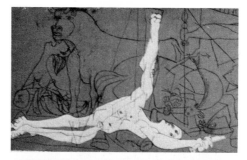

24. 1937

the exaggerated rolling arm muscles are almost those of the crucifixion of 1930:

25. 1930—31

the figure makes at this point the one approach to an outright completed crucifixion to appear in the development of the Guernica, the fist dominating the mural as its central motif. Defiance in the midst of helplessness, a figure crucified but brandishing on one side a sword, on the other a fist: perhaps too theatrical, too romantic a

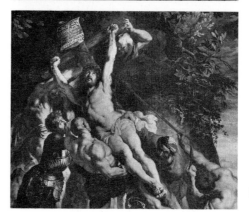

26. Rubens

vision. For whatever reasons, the image was to be cooled somewhat, layed flat; the upraised arm, harsher and still more direct in its outlines, brought down and resolved in its final position anchoring the mural at the lower corner. But the fist is there opened, to reveal a suggestion of the agonized wire-drawn radii and elongated focused wrist-tendons of a nailed and crucified hand, in particular, it appears,

27.
Grünewald

the hand and wrist in Mathias Grünewald's Isenheim altarpiece, the German Renaissance picture from which Picasso's Bone Crucifixions were adapted. At the same time the Guernica warrior's hand reflects [17]

28. 1930–31

the squarish peasant outlines of the nailed hand in Picasso's own Crucifixion of 1930. In the geometry of this earlier Picasso work, the nail itself is located by a circle: in the hand of the Guernica warrior, in the midst of otherwise irregular scorings, is to be seen a mechanical star—the stigmata, so it would seem, of the execution of Guernica, a figure apart, a sign without parallel elsewhere among the irregular hand etchings in the mural at large.

Christ and the centurion—he who dies, and he who deals an appreciation of death—their contrasting yet complementary parts come down in an uneasy counterpoint to 1937, to be fused in a sort of luminous mystery in the single person of the Guernica warrior, the two-sided figure which thrusts on the one hand its weapon, on the other its wound. And not only the two personages, but also

the spear itself finds its mark, completing the elements of the coup de grâce. It is through the flank of the horse that it shows the detail of its head,

picked visibly out of the Crucifixion of 1930,

29. 1930–31

[18] dropped, so to speak, from Calvary to Guernica. The suggestion of Christ is divided between the swordbearer and the horse; in the same way, the centurion's weapon is also dispersed, its remains grasped by the one figure and planted in the other, planted, like the other Biblical elements, in a new, more general symbolism.

The Mark of the Spear

In 1926 when the Crucifixion studies gathered momentum Picasso was forty-five, and exercised a virtuosity tempered by maturity. There is every ingenuity in these sinewy inventions, in the counter-

[19] point of human and animal forms—

and at the same time the straightforward, literal, even humdrum details of the scenery and properties, the Instruments of the Passion. Cheek by jowl with the twisted proportions of men, women, and animals, the inventor of Cubism confronts us again and again

30. 1930–31

31. 1930

with the unmodified angles of the cross,

32. 1929

the obvious illustration of a spear,

33. 1930–31

the uncompromising measurement of the rungs of the ladder by which Christ was taken down from the cross. In 1930

34. 1930

we see quite academically suggested the sponge of vinegar, the last of the torments of Christ before the words, "It is finished." [20]

Why these Instruments of the Passion, so earnest, so undeviating?

In connecting Picasso's work with elements in traditional art one thinks in a general way of the Louvre or the Prado,

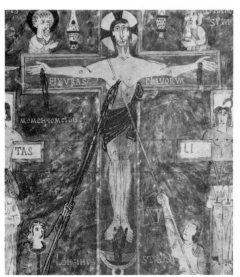

35. Beatus
of Liebana

or medieval manuscripts, or decorations in Romanesque churches which Picasso may indeed have known as a boy in Spain. Such historical elements are there in Picasso's Crucifixions, as in the Guernica, but perhaps it is possible to see something closer to home than antiquity and the Middle Ages. Picasso grew up in the most zealously religious corner of

Europe, with floods of up-to-date church illustration of its own emphasizing the details of Christ's torture, scourge, crown of thorns, nails, sponge, spear, and ladder, painted, carved, embroidered on myriad articles for the church, for the home, for the streets, on banners, bookmarks, cups, candlesticks, altarcloths, pews, and Stations of the Cross, not to mention shrines and hangings for the bedroom, for the living room. It is this art of the nineteenth century, and not twelfth-century Catalonian manuscript illuminations, which the boy Picasso must have known chiefly in his parents' house.

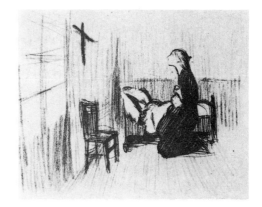

36. 1898

There seems to have been little that was Bohemian in Picasso's background, notwithstanding his father was a drawing [21] master. The Ruis Blascos and Picassos were a long established family and doubtless as conservative as their neighbors, numbering as they did among their ancestors a seventeenth century archbishop, and even a nineteenth century hermit and holy man. Picasso was brought up as the nephew of a professor of theology and canon of the cathedral of Malaga, his father's elder brother and functioning head of the family, across the street from whom the artist's parents lived for ten years after the birth of Pablo, or until 1891. One of

the more elaborate of the boyhood paintings is the "Choir Boy," with its church paraphernalia of the Barcelona of 1896. Spanish religious decoration was never

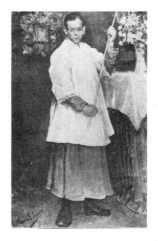

37. 1896

designed to soothe or to be easily forgotten, and Picasso's own boyhood can hardly have passed without its lingering looks not only at the Instruments of the Passion and at graphic Crucifixions, but at such impressments of divine sacrifice as the Stabat Mater with her swords, and the Sacred Heart of Jesus incised, like the Crucifixions, with the almond shaped mark of the coup de grâce.

38.
Commercial

The artist gives us back this almond shape in 1930. In 1937

39. 1930—31

it shows up in the Guernica Studies; from its opening issues the little winged soul of the stricken horse; nearby lies the Roman soldier with his spear.

40. 1937

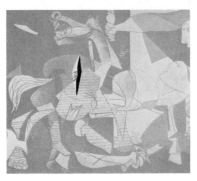

The most brutal appearance of the wound is reserved for the Guernica itself. The suggestion of Christ reverts again from the swordbearer to the horse; in the animal's side we see a shape still more grotesquely enlarged than that in the 1930 Crucifixion. The horse's gash is to be reckoned among the mural's charter details, its outlines put down in the initial impulse in State I and kept to the end untouched, a sort of pilot for the mural at large; in the final State its daggerlike form is followed in the horse's tongue,

the bull's ears,

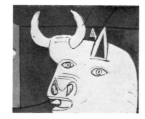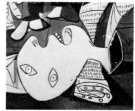

the stump of the warrior's neck,

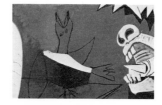

the wings of the falling bird,

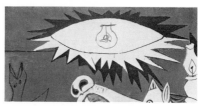

the rays of the sun

and flames of the burning woman,

the lightbearer's fingers at her pointed breast,

and the spearhead, which most nearly duplicates its outline.

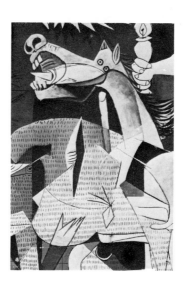

Dwarfing all these at the center of the mural the wound stands out heavily black and white. Despite its emphasis we see in the wound a form without surface logic— next to the spear but unconnected with spear or spearholder, floating, gratuitous. The extinction of the capital of the Basques itself may be said to figure as doubly senseless, in civil war:

"And one shall say unto him, What are these wounds in thine hands? Then He shall answer, Those with which I was wounded in the house of my friends."

The Pietà

The most popular, most venerated image in Malaga, Picasso's birthplace, was a Dolorosa in the Church of the Martyrs—a painted wood sculpture by the baroque master Pedro de Meña (destroyed during the Spanish War). Over and above its conscious charm this work had the Spanish physicality and literalness of suffering and grief, here a question of the tears shed by the grieving Madonna. These were stuck onto her cheeks as crystal drops, their paths charted by lines of paint leading from the corners of the eyes, like maps of voyages. The image was much celebrated on feast days and must have been known to Picasso from early boyhood. The image appears to have been remembered by Picasso in 1937,

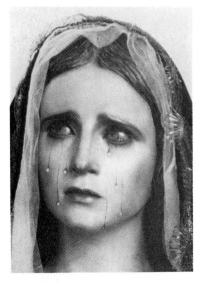

41. Pedro
de Meña

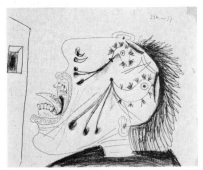

42. 1937

translated then as the Guernica Studies of screaming women: faces, that is, of grieving women whose sharply specified tear-drops stream across their cheeks—the paths charted by lines leading from their eyes. [23]

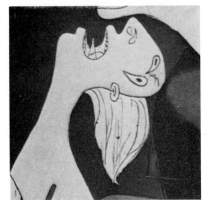

In the screaming women of the mural itself, in particular the mother with the dead child, the tears are dried up; still the identity as Pietà would seem to persist, brought to the threshold of the mural with the force of a childhood remembrance.

A look in an entirely different direction—that is, at Picasso's varied use of ladders—leads us again toward the identity of the Guernica's mother and child as a Pietà.

Of the Instruments of the Passion, the ladder alone was peaceful in its nature. A passage between the human and the divine, the means by which Christ could be brought back to earth, and by means of which man could mount to the height of the cross; and by means of which a Cubist could become a Biblical illustrator (in something of a literal, perhaps, as well as a figurative sense: the Guernica was doubtless executed, like Picasso's other murals, from the steps of a plain wooden [24] ladder). At any rate we see this instrument recur again and again in Picasso's Crucifixions,

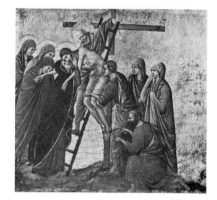

43. Duccio

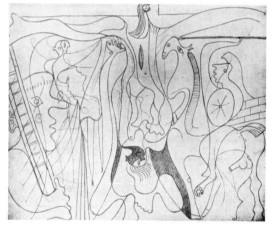

it towers opposite the Roman soldier, carried, or embraced;

44. 1930—31

undulating arms reach upward along its rigid edge. From the first, the instrument has a curious double-sidedness. In the painting of 1930, with its complex double exposures,

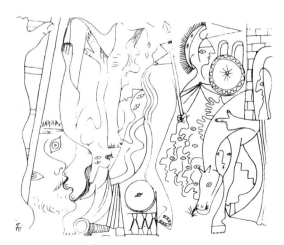

45. 1929

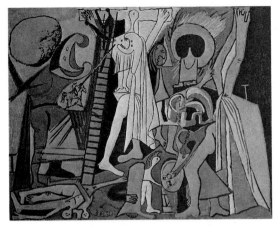

46. 1930

we see the nailing of Christ's hand, alive on the cross, and below, figures of the dead, simultaneously, as it would seem, a dying and a death.

From time to time we shall encounter

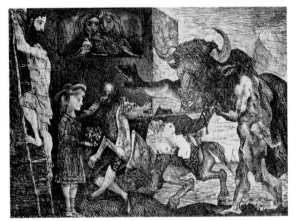

47. 1935

the Minotauromachy, Picasso's etching of 1935, the work which stands in many ways as a rehearsal for the Guernica. In this picture we come upon something very like a Descent from the Cross re-enacted by a living Christ, in his side the [25] mark of the coup de grâce. In this fusing of life and death, time is released from its transient daily sequence much as it is in the Guernica itself, in the living figures there associated with Christ; the horse, the broken warrior each a vibrancy from the grave, a death re-enacted.

The final appearances of the ladder, [26]

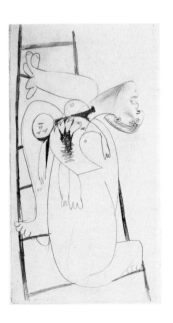

48. 1937

two Studies for the Guernica, give us the descent accomplished by the mother and child. These are the occasions on which Picasso used the ladder for an actual bringing down of the dead, as in the Descent from the Cross. Unlike its appearance in the Minotauromachy the death is a death, and not visibly that of Christ; nonetheless in the linking of death with infancy or birth, time is again wrenched from its ordinary sequence, here rolled inward on itself, a closing together of the ends of a life.

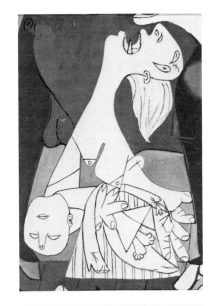

In the Guernica itself

the descent is complete, the mother stands alone and on the ground. The ladder is discarded. Still it has done its work, crossed the path, so to speak, of the mother. The Biblical narrative would seem to persist as an overtone, an explanation of the bereaved mother's separateness, of

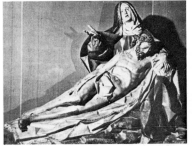

49. Gregorio Fernandez

her quality of permanence, and of the epic and generalized grandeur of her lamentation.

[27]

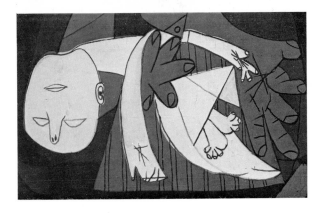

Beyond the ladder and the tears, the identity of the group as a Pietà is seen most literally in the hard compact scorings which cluster at the center of each of the child's hands—a new relocation, evidently, of the stigmata.

Expressive as Picasso's picture is in its own intrinsic terms, the painter has not scrupled to encrust it with external symbols and insignias. Yet here these function not simply as clues to a Biblical identity, but once again as the bringing together of the ends of a life, at once a childhood innocence and the forecast of a sacrifice. Picasso's image of the mother is itself childlike yet mature, timeless in its simplicity. In the breadth of the woman's passion she repeats the essence of the child's tragic range.

The Traces of the Magdalene

One figure above all in Picasso's Crucifixions rises to an intensity of passion, a kind of epic madness, dominating by its intensity each of the scenes in which it appears. This is the kneeling figure of the repentant Mary Magdalene.

In Mathias Grünewald's altarpiece (the Renaissance picture on which, as we have noticed, Picasso based his 1932 Bone Crucifixions),

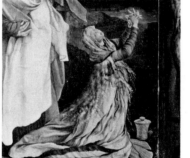

50.
Grünewald

we find the Magdalene at the foot of a gigantic cross, her body half urging upward, half crushed backward:

51. 1929

Picasso in Crucifixion studies of 1929 developed this posture to its uttermost limits, the Magdalene's spine bent completely backward and her head thrown upside down,

a head a face bequeathed, in fact, to the Guernica's one entirely resigned figure, that of the dead child, complete with its uprooted unnatural nose. The pendant nose suggests in 1929 the more than ordinary abasement of the Magdalene, where in 1937 it gives us the death of the child, the death perhaps as it seems to the mother, a more than ordinary death.

Across the mural the figure of the
burning woman

answers that of the shrieking mother—

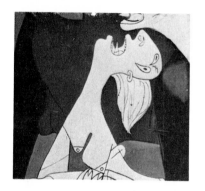

each echoes the other's upward piercing
cry. The answering and echoing of forms
lends to the outcry of these voices the
ritual formality of the entrances of the
voices of a fugue, at once passionate and
rigidly contrived. A pedal note is put in by
the

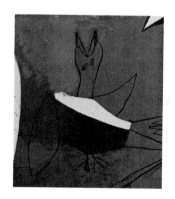

open mouth and upward cry of the broken
warrior;

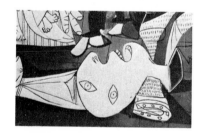

the shadowy upward crying bird in the
background offers its own echo, and
makes for that animal symbolism that is so
much a part of the prophetic and Biblical
tone of the mural. "I reckoned till
morning, that, as a lion, so will he break
all my bones; from day even to night wilt
thou make an end of me. Like a crane, or a
swallow, so did I chatter; I did mourn as a
dove: mine eyes fail with looking up-
[28] ward. . . ."
 The upward path of these voices and
staring eyes is blocked and countered by
what I might call the downward disaster
of Guernica,

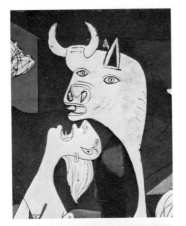

the face of the bereaved mother ground down and forced back by the grotesque proximity of the bull's ugliness,

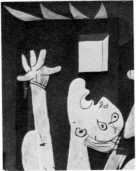

the burning woman's face kept under by the square of the window flatly alight with fire.

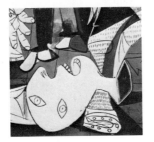

The broken warrior's face is all but trampled by the bull's hooves. Where else

in the work of Picasso, so often the most buoyant and life-loving of painters, does one find this blighting of aspirations, this crushing of upturned faces by intolerable weights?

One finds it in the Crucifixions;

52. 1930–31

it is the Magdalene in each of them, who reaches immensely up, arms flung overhead only to be crushed by the descending feet of the Christ, by a weight of anguish. Reflecting this pattern,

we see not only the burning woman of the Guernica's final State,

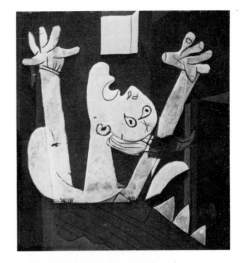

but also this figure's more fluid version in the earlier States of the mural, here translated roughly from

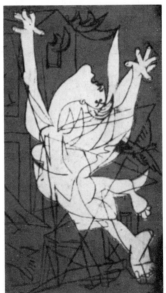

53. 1937

[29] the 1929 Magdalene studies; the inverted faces and sweeping arc of the back and legs, the helpless, wandering line of the arms, the clumsy hillock of an elbow, the stuttering appeal of the fingers.

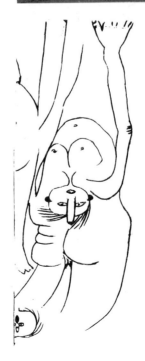

54. 1929

The Magdalene's gestures and features, then, and something of her passion, seem scattered across the finished mural among the two women and the dead child. But it is the kneeling woman, yearning upward yet crushed downward, posed steadily before the agony of the horse, in whom the actual spirit and meaning of the Magdalene seem most nearly reposed. [30]

The Watch

The kneeling woman and the lightbearer make a community of their own, the witnesses or tragic Chorus of the Guernica, their gaze directed into the drama as [31] though from outside it, toward its focus, the horse's head; they assist at the Passion of Guernica

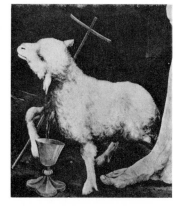

55.
Grünewald

much as the saints or the lamb of God are shown to assist at the crucifixion,

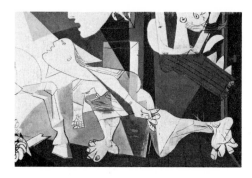

as spectators. With their sympathetic gaze, sweeping arms, and swelling necks the women yearn deliberately forward; so far from shrinking before any physical threat to themselves, they are no part of a topical illustration of general disaster. The kneeling woman drops her knee and plants her foot with a decision, arms outspread as though to call upon us, too, to witness what she witnesses: hers is

the gesture of the bereaved mother, nearly identical in detail but that the kneeling woman, instead of displaying the body of an actual victim, holds, simply, the realization of an agony taking place before her. The mother with her vibrant spreading gesture gives us the death of her child, where the kneeling woman with her gentler and more impersonal opening of arms gives us the ordeal of the horse, as the Magdalene gave us the ordeal of Christ.

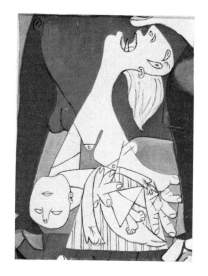

The reaching of the lightbearer is essentially similar. She gives us the whole mural, in a demonstration nothing short of aggressive. One hand is to be seen pressed between her breasts in a sort of despair, or with something of the eloquent passivity of the kneeling woman, but with her other the woman fairly brandishes her lamp, stiff-arms it more firmly than the centurion's spear, displaying it in a passion of affirmation. With her light and her muscular arm she insists on what is before her, demanding our engagement; "For Zion's sake I will not hold my peace. . . until the righteousness thereof go forth as brightness, and the salvation thereof as a lamp, that [32] burneth." Here one may recall

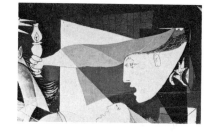

56. 1930–31

the posing of the unflinching forefinger of the John the Baptist in Grünewald's Crucifixion, compelling the panorama, pointing implacably to the agony of Christ.

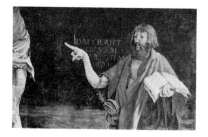

57.
Grünewald

We, too, enter Picasso's mural as spectators, a moving experience because the Guernica *is* that experience, a watching, a meditating. The act of destruction is in the past, its origin in fact is not to be traced, an emotion rather than an event.

The crucifixion and the destruction of Guernica have in common that they are events of the past. If they exist, they exist as a pointing backward, a re-dedicating. Shown as such by a painter, they are made to exist, not in the past, but in the present. Like the Guernica, Picasso's Crucifixions revolve not so much around a moment of happening, as around the acts of dedicating, fierce or sorrowful—the gesture of the centurion, the bringing of the ladder, the witnessing of the Magdalene; acts paralleled or translated in the Guernica's own gestures of witnessing.

Leaves of Grass

Beside the collapsed knee of the Guernica horse grows a flower, the one undismayed witness to the scene.

Sergeant Aristarco Yoldi, a Basque mechanic present at Guernica a few hours after the bombardment, described what he had seen, in an unpublished memoir gathered and quoted by Robert Payne. "Men and women were still digging out the bodies. Around the main square every other building had been bombed, but the façade was still standing. The convent

was destroyed. . . Strangely, the tree of
Guernica, which is a little way behind the
[33] church, was still standing. . .''

Hope, in Picasso's picture, is entrusted
in no small way to the vegetable kingdom,
assuming the form of grasses and grains
clutched convulsively aloft in State II, the
green elevated to a dizzying status as the
principal motif, dominating the whole
drama from within the fist within the
sunburst (displaced finally by the uplifted
head of the horse).

58. 1937

The stubborn Guernica growth was
planted in Picasso's works long before
1937. We find for example

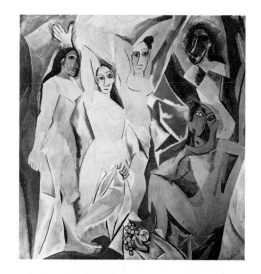

the somewhat alien cluster of fruits,
stubbornly natural and rounded, huddled
beneath the metallic angularities of the
Demoiselles d'Avignon of 1907;

59. 1907

or the flowers of the Minotauromachy,
the girl gazing on the stricken horse and
displaying her incongruous bouquet. As
for the Crucifixions,

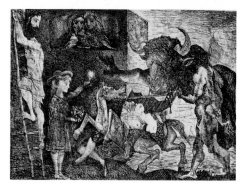

60. 1935

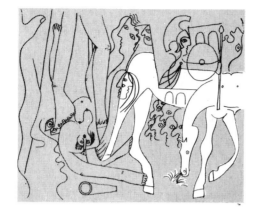

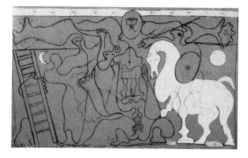

61. 1929

in one early scene crowds mill, tumult heaves, the descending feet of the Christ all but obliterate the raging Magdalene, while to one side stands the horse, the animal personification of gentleness and inviolate peace—munching peacefully at a tuft of grass. In another Crucifixion

we find stars, the sun and moon, and, below, grass coming up still at the feet of the horse. It is this which continues to come up in the mural of 1937, still at the horse's feet, with its token of the enduring.

62. 1930

Sun and Moon

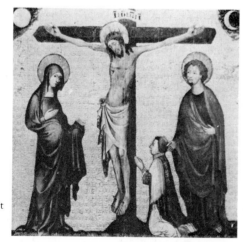

63. Utrecht Master

Not the least enduring of witnesses traditionally present at the crucifixion, are the sun and moon, shining simultaneously on either side of the cross, indicating "the sorrow of all creation at the death of Christ." This early medieval parable, in Spain and elsewhere, is handed down in ivory, tempera, fresco, manuscript illumination across a millennium from the sixth century to the sixteenth:

[34]

to be revived by Picasso in the twentieth, in the Crucifixion drawing of 1930:

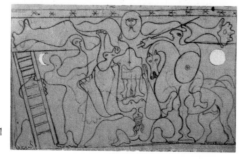

64. 1930–31

and fleetingly at the last in 1937, in the Guernica, the mural State III. Here the sun brings its witness to the center of the field, the moon, so to speak, shouldered to one side. The balance, the ancient logic, is reconstructed only to be torn apart; the moon in subsequent versions of the mural leaves the field to its solitary counterpart, an implacable sun.

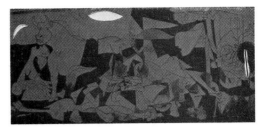

65. 1937

Foundations

It is not only the celestial bodies and grass which, in the drawing of 1930, breathes a sense of universal presence in the midst of disaster. The Christ himself does that. The stupendous

[35] rolling of his arms shelters the scene, measuring a row of stars. It is the roof of this 1930 Crucifixion

66. 1930–31

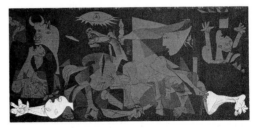

which is carried down, so it would seem, to become the floor of the Guernica;

heroic limbs, magnified beyond the scale of the rest of the mural, branch outward at its lower corners, holding the Guernica up, immovable and invulnerable. One of these pertains to the dead, in the person of the broken warrior—the other, to the living witnesses in the person of the kneeling woman, extending the outline of the crucifixion across the mural in a grand impartiality from personage to personage.

There is about these limbs an unanswerable prophetic vagueness, a breadth and reverberation, a Biblical sureness of stroke:

"And I have covered thee in the shadow of mine hand,
That I may plant the heavens,
And lay the foundations of the earth,
And say unto Zion, Thou art my people.
Awake, awake, stand up, O Jerusalem,
Which hast drunk at the hand of the Lord the cup of his fury;
Thou has drunken of the dregs of the cup of trembling,
And wrung them out."

[36]

* * *

Was Picasso's picture intended as a Crucifixion?

The road to Guernica passed as a matter of course through churches in Spain, and through studios and museums in Paris in a new century. It passed too, as we shall see, through the bullring. Picasso at the time of the mural was fifty-six, his painting the product of a wide background; many themes must have risen to the surface of his mind, still others rested somewhere below that surface. The open mouth of the Christ, his blindness, the crown of thorns, the crucified figure with sword and fist, the swordbearer's mark of the nail, the spear, the horse's wound, the ladder, the tears, the child's stigmata, the features of the Magdalene and her gestures, the grass, the sun and moon, the limbs of the Christ—how much of the meaning and structure of the crucifixion are we meant to derive from all these? This of course we cannot know precisely. It is apparent only that they are there, and that there is a mood of prophecy, accusing, full of animals and of rolling passions.

[37]

It might be said, however, that the Guernica is as religious in its intentions as any other of Picasso's suggestions of the crucifixion. The theme, as we have noticed, had evidently a somewhat special meaning for the artist, spanning the years of his maturity unsupported by any other Biblical moment; the meaning was evidently something new and of Picasso's own time, somewhat independent, it may be, from the Biblical narrative. Just as the Guernica is more than a war picture, it is more than a Biblical illustration. In dividing the crucifixion among a man, a child, and a defiant animal, Picasso has shown us a relevance which extends outward in widening circles. The artist shows us nothing of Guernica in particular, and virtually nothing of modern man in particular—just as he nowhere shows us a recognizable face of Christ. In its outermost circle the relevance extends perhaps not only to Guernica and to an agony of modern man, but to something still more universal, a timeless trial of man in general, an ageless cycle of sacrifice and regeneration.

[38]

CHAPTER TWO

The Bullring

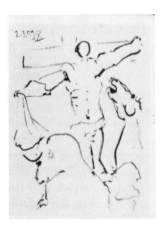

67. 1959

A picador is thrown from his horse (so runs a popular Spanish bullfighter's legend) and lies wounded in the bullring unable to rise. The bull turns to this helpless torero, and lowering his horns, the animal prepares to gore him. At the last minute, as illustrated by Picasso in drawings of 1959, the figure of Christ on the cross appears in the midst of the scene; unwinding his loincloth he extends it as a bullfighter's cape, [39] and so diverts the bull.

In the Guernica as in this legend, the central commanding figure is at once a crucified Christ and a member of the bullfighter's team, in the case of the mural not Christ merged with a torero, of course, but Christ merged with the torero's patient horse. While the Guernica is a crucifixion, then, it is at the same time a bullfight; certain elements in the picture express one saga or the other, while many elements, like the horse, are made to express both simultaneously. Eloquent as it stands by itself, the crucifixion was not enough. In weaving the bullfight through it—literally setting down his cross in the midst of the bullring—Picasso not only picked up Spanish tradition but further released his theme of sacrifice, making it still more generally accessible.

The Guarantee

"The horse," said Picasso in one of his rare moments of explanation, "represents the [40] people." Why should this helpless torero's creature, whether intended as the people or Christ, have been elected as the climax and center of Picasso's picture?

American workhorses who have outlived their ordinary usefulness, sometimes have a further and harder destiny in store. Traditionally they are shipped, for a nominal price, to Spain,

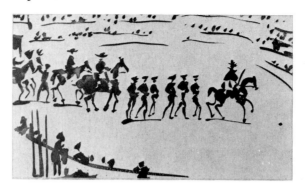

68. 1957

to go blindfolded into the bullring, there to rattle their brittle bones into position under the iron-protected heels of the picadors. Once in place

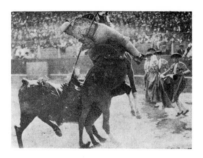

69. Corrida

the confused beasts find themselves lifted like a load of hay on the ends of two horns,

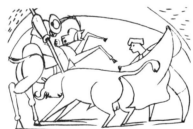

70. 1917

charged and impaled again and again at full speed by an antagonist so furious as hardly to take notice of the picador's pike,

71. 1917

and, of course, usually die of wounds. The incident affects spectators variously as a matter of pathos or indignation or embarrassment, or, in the case of certain aficionados, even amusement. No one, however, with the exception of Picasso, seems to have sensed in this sacrifice a deeper and more challenging significance. This significance resides of course partly in the creature itself and the pain inflicted on it, but further, it would seem, in the framework of the corrida de toros as a whole, the sequences of the bullfight which surrounds it.

The bull, bred and selected for his touchiness, is stirred up first by the mounted picadors with their spear-tipped picas. Overflowing with muscle, the bull is everything the picador's dilapidated mount is not—nonetheless the goring of the horse,

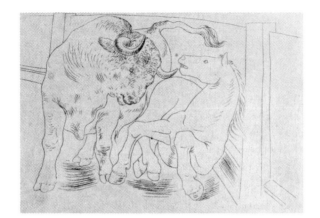

72. 1927

unsporting as it may look, is not simply a regrettable by-product, it is virtually a part of the strategy of the bullfight. The bull demonstrates his power and partially exhausts himself in lifting the hapless scapegoat: in this way it is the horse who takes the edge off his strength, and the bull is sufficiently slowed down to be in properly weakened condition for the banderilleros and the matadors with their footwork. Thanks to the horse's passive and helpless intervention, human beings do not usually die in the bull ring. It is the job of the bullfighters to give the bull the advantages and play as close to his horns as possible, and the men are often wounded—ideally, however, they walk out alive. It is the horse, supremely gentle and unoffending, whose goring and whose death sooner or later, is counted on to guarantee that the picadors with their pikes and the banderilleros with their goads and finally the matador with his sword may survive. Through the horse's death, too, the catharsis of the bull's passion is accomplished, his horns wetted, and his brutality extinguished. Indeed it seems not too much to suggest that there is something Christlike about this arrangement, the one really peaceful creature sacrificed on the behalf of so many warmakers. At all events Picasso evidently felt it this way. Hoisted

[41]

bodily the animal is impaled in a manner humiliating to a degree, and ungraceful— a manner not altogether dissimilar, in fact, to the lifting reserved by the Romans for their thieves and religious agitators. Swaybacked as she is

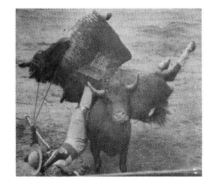

73. Corrida

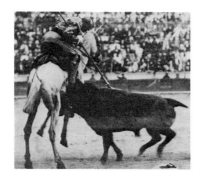

74. Corrida

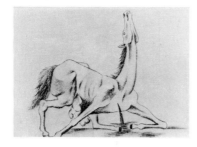

75. 1917

76. 1901

the old nag is often little better than a bag of bones; the Spanish refer to her in an offhand way as "Rocinante;" Hemingway insisted that

the trailing of her guts is irresistibly comic. Despised and rejected indeed! Rather than being a singular anomaly, nothing in fact is more natural than that Picasso in the Guernica should bring his disregarded workhorse to the center of the stage, and there put the beast into a relation with his tokens of the Passion of Christ. [42]

Unlike Christ, the Picador's horse is never in life at the center of her own drama. Early in the game she is retired

to leave it to the men on foot to continue the work of exhausting the bull by running him with their capes. The horse represents only the preliminaries. Tourists and others, as distinct from aficionados, have been so offended by these as to have resulted finally, in 1930, in the armored blanket now required by Spanish law (which, it appears, only means that the creature dies more slowly and agonizingly than before, of inconspicuous wounds which elude the blanket). Picasso, entirely distinct from both tourists *and* aficionados, has made of the bullfight a unique contest between animals, not so much deplorable as engrossing,

sometimes blunt,

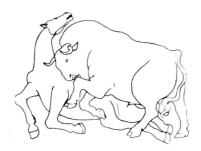

77. 1923

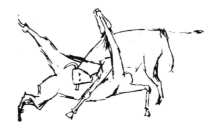

78. 1917

sometimes lacerating,

even, at times, curiously serene. The toreros,

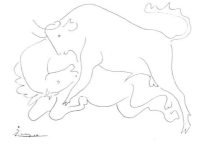

79. 1942

the bullfighers themselves, never aroused the painter's frank intensity—their courage and skill, their honor or lack of it in dealing with the bull, their gilded and embroidered glory are sufficient in themselves without the artist's adding to them, and he generally makes short shrift of his puppetlike sticks of matadors and picadors. Where there is passion and grandeur in Picasso's corridas it is in every case a matter of two beasts, or

[43]

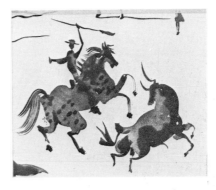

80. 1957

of the one animal by itself, the bullfight narrowed to this last essence.

81. 1923

Picasso has had a way of thinking about animals first and last. David Duncan recounts an incident of his stay with the Picassos and their pigeons, their goat, their boxer, and Lump, the family dachshund. "Jacqueline said she wanted to see Arizona. 'Yes, yes. We'll go!'" Picasso would enthuse. 'In a wagon. With a donkey. With Lump....'" That was 1958. In 1905,

[44]

82. 1905–06

Picasso's horses, young, whole, exquisitely tender and sympathetic creatures led by invisible reins, were stepping forth with an unearthly delicacy in a sort of rose-colored dream Arizona of their own. The painter's veneration for this delicacy at this period and in the years following, was apparently such as to fence and preserve it not only from the bullring, but also from

83. 1912

the peculiar harrowing which was Cubism. It was all very well for such resilient or indifferent beings as men and women and mandolins and newspapers to be ploughed up and played games with: horses, along with vulnerable creatures such as children and birds, were inviolate throughout the major Cubist decade, [45] starting in 1907.

84. ca. 1890

An imaginary sequestering: in the world of men and bulls the real game had been settled from the start. Long before Cubism or the Rose period, the theme is announced in one of Picasso's earliest impressions, a candid little drawing of about 1890 when the artist was nine or ten;

85. 1917

it explodes in force in splinters of 1917— Picasso's only impression of violence to come out of the war years— [46]

86. 1917

[47] and runs its course through tear-filled elegies. Through the years

whether of war or of peace no human conflict, no human emotion of any sort save that of the Crucifixion, is illustrated with such open physical violence; for all its human impetus the Guernica itself is dominated by the anguish of the horse, the final flowering and fulfillment of the theme. But by 1937 the theme was different, larger in its implications.

Already at the time of the Crucifixion studies ten years earlier,

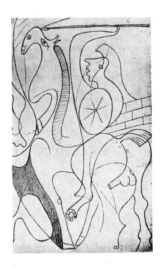

87. 1930—31

a new and ominous note was sounding. The simple equine naturalism of earlier epochs no longer sufficed—in 1926 the immunity to the ravages of Cubism gave way decisively, the horse's outlines as tortured as the event which they accompany. In 1930

the distorted animal bares its teeth,

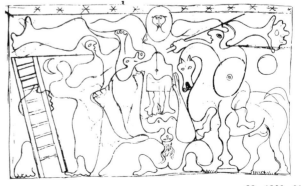

88. 1930—31

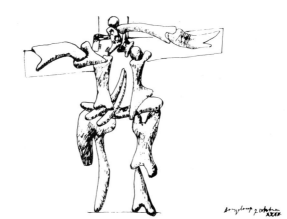

89. 1932

and in 1932, as we have seen, its voice is actually transferred onto the cross. This of course marks an epoch in the sanctity of the horse, and after this the simple equine outline is never to be the same again. The profundity of the animal sacrifice is wrenched free of its merely corporeal image, the same as that of the Christ and the Magdalene.

The profundity is laid bare with a fresh conviction in 1934 when the artist was fifty-three and had taken his theme up to and onto the cross and in and out of the bullring over and over since childhood, pondering it in innumerable variations in pen, pencil, and oil, patiently and passionately winnowing all that was most truthful. We come upon the horse and the bull in

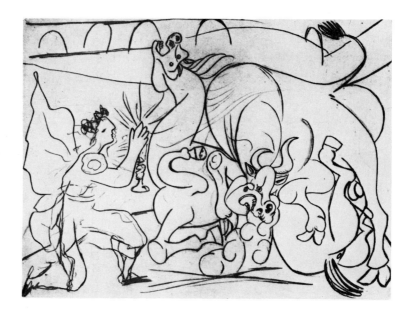

90. 1934

a fury which eclipses that of previous corridas—a snarling and raging hardly to be equalled elsewhere in art or photography. In the background is visible the distant arcade of the bullring, no other topical detail. In the foreground a winged creature

(with the epaulettes and costume of a torero) kneels as before a sacred occurrence, an angelic being tenderly watching the ordeal while not presuming in any way either to interfere or to question its rightness. In an earlier century, a painter would have put into his angel's hand the martyr's crown: the animal had always been saintly and by 1934 had earned Picasso's personal beatification, not, this time, as a parable on the crucifixion, but for its own sake.

Yet the 1934 horse is only a horse, its cry a cry of animal hurt—poignant, but less complex than the rallying which seems to issue in tragedy and in triumph from the trumpetlike mouth of the Guernica horse three years later.

Everything about this animal protagonist of the mural,

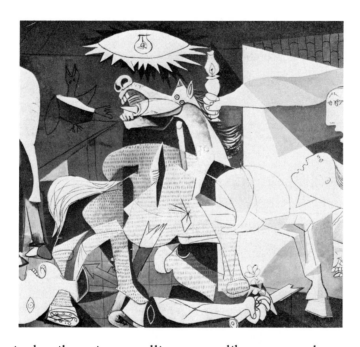

[48] from its upraised tail to its metallic weaponlike tongue, has a passionately affirmative quality not seen earlier. Even the ordered ranks of hair, not seen in previous Picasso horses, imparts decision (unavoidably these rows suggest lines of type—the horse as a public declaration in print, the offshoot of early uses of

[49] newspaper in collage). But if the sense of command is not communicated in print on the animal's hide, it is communicated by the proudly uplifted head and level, upraised line of the body, and by the decision implicit in the solid planting of the forward hoof and hugely swelling breast; and finally by the horse's unchallenged

[50] central position in the picture.

It is this commanding address which suggests in the Guernica horse its broad range of meaning, transcending any usual boundaries between animal, deity, and man. It is this which sets it apart from its gored and crucified ancestors, creatures usually less commanding than pathetic, and it is this which makes the Guernica descendant speak for all of them—makes it the fulfillment which it is.

The Pase Naturale

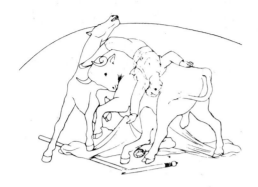

91. 1923

Jolted from his saddle, a picador lands supine on the back of the bull in a curiously trancelike pose, the attitude of a sleeping child—so Picasso gives it in drawings of 1923. Elements of the tableau come back to haunt the painter many years later,

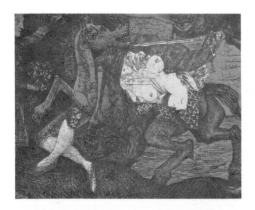

92. 1935

recurring in the Minotauromachy. The animal on which the bullfighter lands is now a horse and the bullfighter is here a woman, but with the original picador's incongruous ease in the midst of mayhem, gracefully thrusting limbs innocent of fear, impervious to danger or death—one arm crooked around her brow like the sleeping child, the other raised lightly to her weapon. The weapon is translated into a matador's sword,

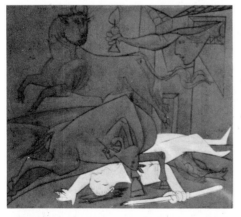

93. 1937

where in the Guernica Studies it reverts to a shaft suggesting the original splintered pica: except that he is now on the ground, this Guernica warrior with his wide-spreading arms and drifting legs is the 1923 picador all over again, the child drifting innocently into death.

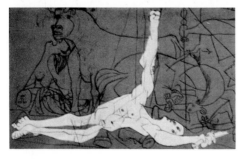

94. 1937

In the mural itself (intial State) the sleep is over—the innocent floating quality is given a new and more positive twist. It is the picador's spreading arms which here stiffen into the gesture of the Crucifixion, the gesture which

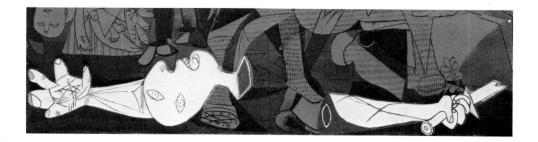

in the final State is stiffened into a still greater suggestion of defiance. The little that is finally left of the figure brandishes his weapon with a fresh convulsiveness, and his outstretched hand complements the brandishing of the sword.

Is this a crucifixion, head downward like that of St. Peter, or is it the centurion with his spear, or the picador with his broken pike? Calvary, in fact, or the plaza de toros? Of course we see all of these, as we see contrasting ancestries merged in any one living being. The Guernica warrior executes in effect one of the world's most superb gestures,

[51]

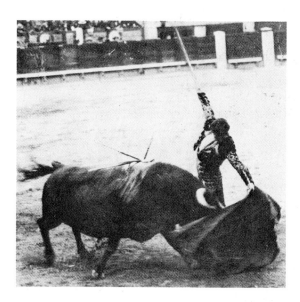

95. Corrida

that of the matador defying death in the *pase naturale*, a gesture which translates the helplessness of the crucifixion into the triumphant control of the bullfight. Nowhere in the Guernica do the two themes coincide with a greater intensity of meaning, than in the swordbearer's reflection of this dazzling moment. Not a picador with a pike, then, but a matador with an espada: and yet at the same time the figure is no longer any of these things, it is what it is—two arms and a piece of a sword, eyes which wheel round to find those of the spectator, and a harsh sound in its mouth. With these it says everything, the equal of the horse, as though at the last to put itself in front of multitudes, and shout them into battle.

The Barrera

96. 1923

And yet multitudes as such were never Picasso's preference. A group of eight or nine was sufficient for his subtle studies of audience reaction to the death throes of the horse (1923), a few perfunctory lines for empty benches sufficing for the remainder of the bull ring. We see, chiefly,

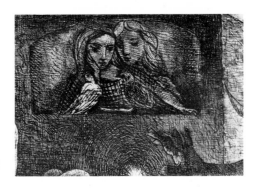

97. 1923

three women leaning on the edge of the barrera, critical, bemused, and sympathetic all at once; women who have watched the uncomfortable spectacle before and know how to accept its terms. In

98. 1935

the Minotauromachy the canopied box, or palco, is translated into a little arched loggia: again the women survey the ordeal of the horse from above, like spectators in a box at the opera, again the woman in front leaning her chin on her hand in seeming negligence. But there is a difference from the aristocratic ease of the senoras of 1923. Two doves, extensions of the young women, face each other on the ledge in front of them: the women are only two, and draw their heads together in a budding sense of tenderness and concern.

In the Guernica and its Studies the women (like the picador) are narrowed to their last essence. The palco has shrunk to an insignificant opening in the wall, and the señoras to a woman with no companion, no dove, no costume and no hair to speak of. The aloofness of the barrera dissolves in the new inferno of the Guernica, the distress of the woman unimpeded. So far from musing abstractedly on the event she stretches forth, and her soul with her. She herself holds the lamp to the ordeal of the horse, taking charge of the mystical illumination which in the Minotauromachy had been entrusted to the girl with candle and flowers: and in the 1934 bullfight to the candle-bearing angel.

[52]

These mysterious spirits stationed within the bullring, too, find their way into the Guernica, the ordeal of the horse observed and sanctified by a sympathetic female presence on ground level directly on the spot. In the Guernica it is the kneeling woman who performs this office. But like the lightbearer overhead, she is different from her own cool predecessors—ethereal beings who show something of the reserve of the señoras of 1923, segregated from human emotion by their spirit nature. No such segregation suffices any longer. Confronting the larger corrida of 1937 we see both women overwhelmed, as Picasso's Magdalenes were overwhelmed by the crucifixion. The barrera, the barrier between actor and audience, affords small protection. Openly the women live the agony of the horse, participants in the catastrophe even while they observe.

Brutality

Unlike his fellow participants the bull stands aside, almost more an observer even while he participates.

What shall be made of this ambiguous but dominant presence?

The first difficulty with the bull is that it is an animal, and the innermost attitudes of animals in a world of men must perhaps always pose a certain mystery. Sergeant Aristarco Yoldi, the Basque mechanic who witnessed the destruction of Guernica, witnessed other destroyed Basque Villages too. "We came to the village of Ceanuni, not far from Barazar. The village had been heavily bombed. The telephone poles lay crazily across the roofs of the houses. There was no one alive in the village, no one at all. It was dusk, and there was only the burned-out village, the emptiness, the desolation. Suddenly we saw something we never dreamed we would see. Slowly, along the bombed road, came two oxen dragging a motor ambulance. The doors of the ambulance were swinging open. Two dead men had been thrown over the roof of the ambulance, but how they got there we never knew. We looked

inside. The ambulance was filled with the dead, and the blood dripped down on the road. The oxen went on in the gathering darkness, and the blood continued to drip down on the road.'' [53]

Much of the challenge of the Guernica is summed up in its own horned brute, the strangeness, the sense of luminous obstacle, almost of oracle. What is the relationship of this creature to the panorama of carnage, its own ambulance of the dead? The meaning was never cut and dried: ''But, this bull is a bull, this horse is a horse. . . .'' said Picasso. ''It is necessary that the public, the spectators, see in the horse, the bull, symbols that they interpret as they understand them. There are

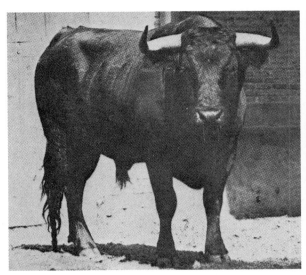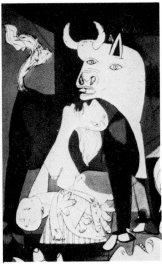

99. Corrida

animals. These are massacred animals. That is all, for me; let the public see what it wants to see.'' [54]

Few of us can successfully resist wanting to see something fairly definite, and even Picasso yields at times to the temptation: ''The horse represents the people,'' as he gave it on a different occasion; and ''The bull is not fascism, but it is brutality and darkness. . . .'' A foolish consistency, as Emerson so conveniently remarked, is the [55] hobgoblin of little minds. The inconsistency here is not after all so great—Picasso's definition is at any rate sufficiently reduced to raise nearly as many questions as his warning against definitions. ''The bull is not fascism'': Why should Picasso in 1937 have stopped short of Fascism for his definition of brutality—what larger or subtler idea seemed to him more pressing? ''Brutality and darkness'': a rudimentary signpost, indicating to us that the bull is symbolic without being the Statue of Liberty. Easy enough to see in the bull the simple picture of push-button war; the animal's power, the seeming vacuous indifference. Suggestive, visible as far as it goes, but this immediately would be to leave out of account that which is no less visible in the animal, its virility, its fine erectness; compare with

100. 1937

the diseased and crumpled monsters of Picasso's etching of earlier in the winter of '37, the Dream and Lie of Franco, in which the bull figures as the hero. The idea of fascism or push-button war leaves out of account the near-sanctity of the bulls in the Spanish bullring: an audience which can give ovations to the body of a dead toro while it ignores the exhausted and wounded matador. And there is in the Guernica after all nothing to implicate the bull in the general disaster, nothing beyond a vague suspiciousness, perhaps, about the animal's scowl, and, it may be, a regrettable desire on our part to place the blame somewhere.

[56]

Very well, shall the bull be seen as a kind of general protector, a sentinel? The keeper of virility?—Benevolent conductor of the ambulance?—The idea is not farfetched, and in a general way has had its adherents. Indeed the animal can scarcely be condemned for its features, its awl-like tongue belonging to the same arsenal of design as the tongues of the horse and the bereaved mother, its dislocated eyes the eyes of the dismembered warrior, its position in the mural, further, loosely mirroring that of the burning woman. But we are warned away from the simplicity of this idea too. Brutality and darkness: visibly the animal has protected nothing, no ambulance is in fact attached to its loosely turned shoulders, and surely we shall not be able to agree on any clear reassurance to be read into its strange and distant glance. Impossible to avoid a disturbing ineffectualness, in fact a sort of monumental vagueness about the bull, unique within the mural. There is no visible connection between the bull's inertia and the decision with which the spear transfixes the horse, or with which the warrior is mutilated, or with which bombs were placed on Guernica—or with which the kneeling woman kneels, or the lightbearer extends her lamp or the swordbearer his sword. Altogether the animal is too contradictory for any direct image either of the perpetration or the redressing of the events of April 26. "These are massacred animals": here finally the bull takes his place among the victims. . . .

Like the other Guernica images, that of the bull did not begin within the Guernica. But the bull's ancestry is almost as contradictory as the bull, and does not immediately seem to light us toward any sense of who or what he is. The toros never had the ready definableness of the picador's suffering mount: "Los toros dan y los toros quitan: the bulls give and the bulls take away; they give you money and they take away your life"—Hemingway's translation of the bullfighter's saying. The

[57]

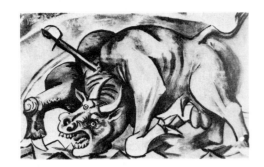

101. 1934

bull stands always in the middle; shall he be called the horse's tormentor or the torero's victim? And "Bulls themselves are varied in temperament: it is true, unfortunately, that not all fighting bulls show fight; too many toros bravos—the term defines a zoological species—are cowardly (mansos)" (the observation is John Marks'). Hemingway gives us the contrary types recognized in the bullring: the bronco, nervous, uncertain, difficult—and by contrast the bull called noble, or frank in its charges, brave, simple, easily deceived. There is the bravacon, a bull who bluffs, not really brave—and the toros bravos, brave savage bulls. And there is

[58]
[59]

102. 1901

the entablada—the bull which hesitates to leave the toril: like the Guernica specimen, an uncertain portent.

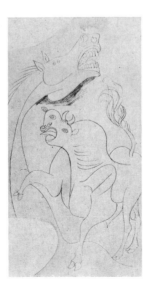

103. 1937

In the Guernica Studies themselves the artist fixes no decisive good or bad upon the animal's wavering personality. Yet at the same time none of Picasso's bulls in the Guernica series, including the final specimen, are given as predators; unlike their cousins in the bullring, not one seeks to wet his horns in the horse's blood. Among the eleven bulls which crop up in the Studies, only one bull in fact is brought into contact with the horse—pawing pettishly, the child seeking attention, demented in front, it may be, but deviating in his hindquarters into a delicate restraint and equine grace.

In the Study dated the first of May the bull
is delightful but idiotic from one end to
the other, a veritable wreathed Ferdin-
and.

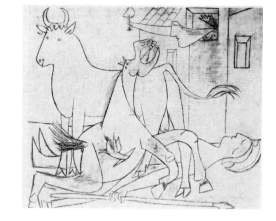

104. 1937

On the second of May he gallops placidly
across the scene, his face elongated into a
prim fastidiousness as though consciously
dissociating himself from the untidiness in
the foreground.

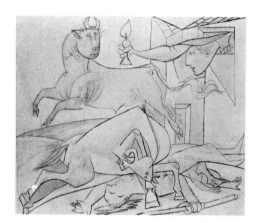

105. 1937

On the eighth of May the bull's power is
stood up as a helpless cypher, too witless
or phlegmatic to pick up his hooves or
lower his horns, while

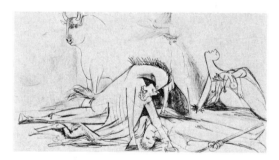

106. 1937

on the ninth the animal is as startled as
anyone else at the general wreckage—
and intelligently concerned (if undecided,
perhaps, as to his next move). On May
eleventh

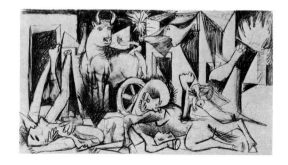

107. 1937

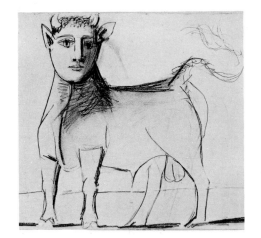

108. 1937

the intelligence is kept up, a classic meditativeness in place of the immediate awareness of disaster; this Minotaur in reverse is more contradictory than ever, and epitomizes the two-sidedness of Picasso's bulls, one general character from the neck up, another from the neck down (ordinary human condition that it is). On May nineteenth

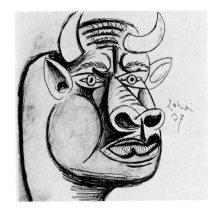

109. 1937

the beast is part livid monster, yet heaves with a just outrage; one comes to find a sensitive consciousness behind these dislocated yet controlled lips and anguished brows—wrong, once again, for a symbol of the murder of Guernica.

The bulls of the Studies are a not unsympathetic lot, ranging from ineffectual to meditative to angrily aware. There is one further and perhaps more negative condition, however, common to this circle of virile creatures with but a single exception, together with the several versions of the bull on the canvas with its States: they stand still. These beasts of the "corrida,"—running of the bulls,—so far from running, are rooted to the spot. Stolidly in their otherwise various moods and attributes these animals reiterate power, but power with no action, no final commitment, no effect.

The bull of the mural is no more decisive than his predecessors but rather less so—a balancing of irresolutions. While the bull stands as the one entirely physical presence in the picture, it is also the one which is not there at all, disturbingly absent, turned away in its corner of the arena. At its most extreme the turning away suggests the moral helplessness of the bombardier, the turning away of brother from brother: yet seems to extend to any absence, even the most sympathetic, any moral disability in the face of need, the capacity of the world at large, perhaps, to stand idle while such things happen. Even, and most poignantly, to the irony and pain of Picasso's own absence, his expatriot residence, continued at the time of the fighting. Studying the confusion in the face of the Guernica bull it occurs to us that it is by no

means surprising that Picasso should have been sensitive to the poignancy of civil war; his own life had been a long foreshadowing, in a sense, of that dilemma, the Spaniard in voluntary division from Spain.

[60]

Picasso himself. The observer, divided from the action, taking his stand behind this revolted and averted mask—the staring taurian bystander—shall it not emerge as the painter, his self-assertion, his self-confession, as convincingly as any other one namable force?

Indeed it would seem that the bull, like other Picasso bulls, may be read as Picasso. At the same time the matter of power withheld, surely it exists below the surface of all life. The divergent forces seen separately in the bulls of the Studies, innocence, indifference, bafflement, the different sides of a passive emotion, all may be said to be forced together and confronted in the single unfocused image of the Guernica animal. It is an image in which many things are suggested, but in which we are shown two things unalterably, that it is strong and that it stands aside.

The other Guernica personalities by contrast, offer a passionately focused involvement, crippled—yet in the action. The arena is underscored by the rallying of a man with no body, commitment stripped of power, the perfect converse of the bull. The arena is presided over by another unconfused fragment, that of the woman with a lamp, an aspiring of truth, or art, or of the artist as artist. Unconfused heads all across the field turn in the general direction of the bull, and in this the picture at large emerges as a heroic dialogue between mind and force; the lightbearer, the horse, the kneeling woman, the swordbearer, and most intimately placed, the bereaved mother, all directing their intelligence toward the personage who represents the thing they lack, physical power.

This one personage stands its ground freighted with the cancellings, the mortal silences which are its only visible offering to the exchange. In this horned and dangerous creature which is planted both in the action and out of it, seeing and not seeing, uttering and not uttering, knowing and not knowing, one sees a strength no less baffled than that of the swordbearer. Its contrary qualities take the shape of a brute, but brutality has its own contradictions—wrenched and abruptly twisted as we see it from black to a lurid white—and must be said, too, to suffer; one has only to study its unfocusing, seeking eyes.

[61]

The bull's power in itself may be said to be neither good nor evil, but simply power. Not without reason the animal has been likened to the life force itself; yet while this ultimate promotion may be said to allow something of the ambiguity of the creature, it would apply perhaps still more aptly to the photograph of a bull in nature, if not to an Assyrian statue, or perhaps to some few of the more indifferent bulls in the Guernica Studies—animals whose presence is let into the picture without hindrance and whose faces and attitudes are innocent of trouble, innocent, certainly, of something like a human dilemma. Hedged aside physically, hindered by its confusion, the Guernica animal is a symbol of the life force, but goes beyond that equilibrium. "The bull is not fascism, but it is brutality and darkness."

This terse signpost of the artist's is never to be sufficiently pondered, for no critic is more thoughtful or articulate than Picasso himself when he chooses to be so. His

thoughtfulness can seldom have been greater than in the matter of the bull of the Guernica, that most hard-won of all the Guernica images with its long path of predecessors probing and laboring from end to end of the Studies and States. "The bull is not fascism, but. . . ." in other words, we are assured, the bull is understandably to be confused with that outright negative; "but it is brutality and darkness"—it carries, that is, a burden of guilt and of blindness; and ". . .these are massacred animals"—so far from a mere abstraction, the bull is a figure of tragedy, as vulnerable as the human beings to which it relates; an answering figure, in the mural's composition, to that of the burning woman. In the bull's tense idleness may be seen a tragedy of much of the human condition; where there is an exaltation, an inward triumph about the other protagonists in the mural, with their gestures of release and of open commitment, the bull alone emerges as baffled, perhaps the one ultimately tragic figure to be encountered. As much as anything the Guernica is the parable of this irresolute creature, the forthrightness of his shadowy body dominated by the huge spreading confusion of his face. Picasso in the Guernica shows us an underlying unity between the bull and that animal's opposite number, the horse. Each gives what he can, not a fullness of power, but, each in his own way, a potential for power checked beyond that giving. "These are massacred animals."

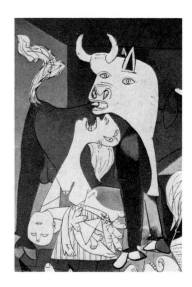

The Labyrinth

Of Bulls, Minotaurs, and Men

A human consciousness runs beneath the power of Picasso's bulls in general, including the Guernica specimen. Half human in essence, the bulls are all, in a sense, Minotaurs.

Like other mythological monstrosities, the Minotaur in some ways comes almost closer to the human condition than human beings themselves, those ill-defined shadows of other creatures. As with humanity but more openly revealed, we see in the ancient monster a creature both animal and human, strong but immobile, force which is aggressive but locked at the heart of a puzzle—like the Guernica bull, power which is closed in and which waits.

The Arraignment

The image of the minotaur was a preoccupation of Picasso's during the several years leading up to the Guernica. Picasso released the Minotaur from his ancient labyrinth and from his ancient sentence of death, and yet at the same time did not so release the poor creature. Again and again

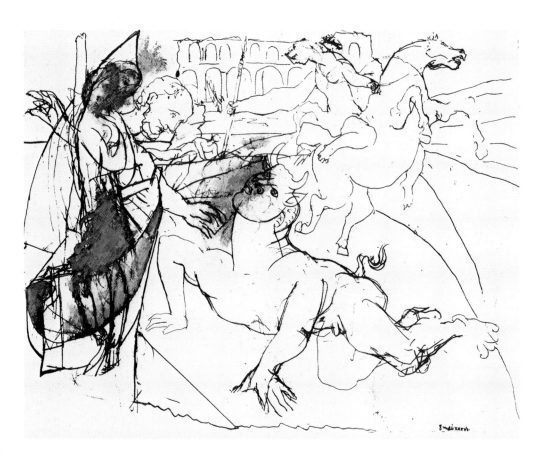

110. 1936

we see the shadowy maze persist as a bewilderment,

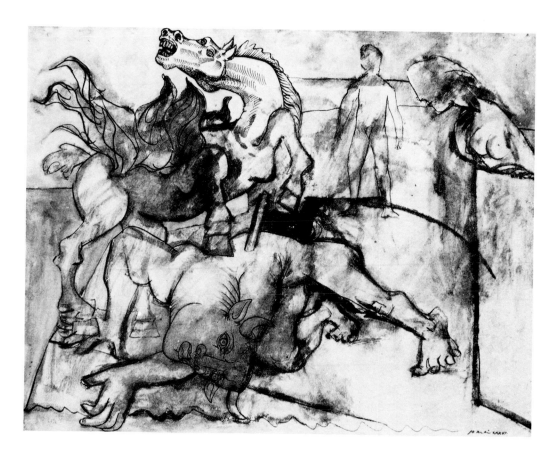

111. 1936

again and again in the bullring we are given to observe the death sentence enacted,

114. 1933

and at the same time the most settled

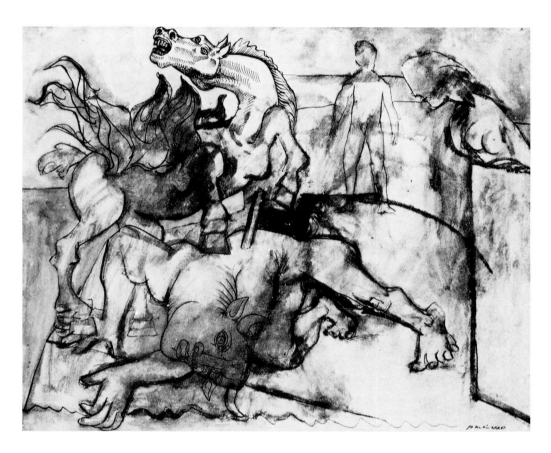

111. 1936

again and again in the bullring we are given to observe the death sentence enacted,

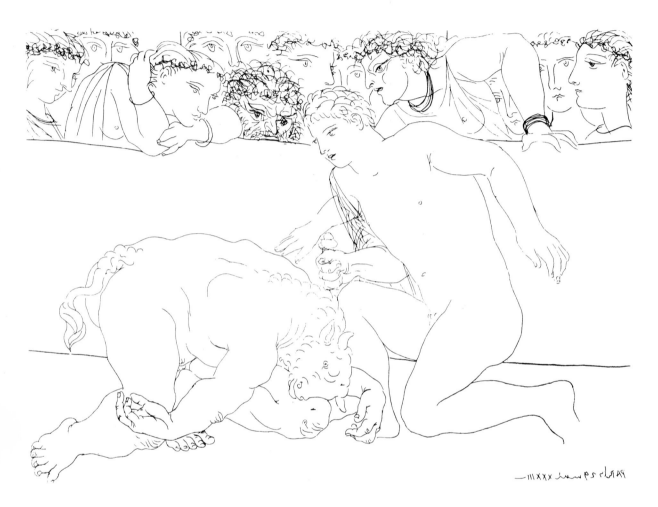

112. 1933

the sentencing of a creature puzzled yet acquiescing in life's terms without resistance. Not altogether differently, the Guernica bull for all its erectness is bewildered and stopped, yet acquiesces.

Like Picasso's bulls, his Minotaurs have many faces. The Minotaur is precisely

113. 1933

one of Picasso's most sentrylike inventions

114. 1933

and at the same time the most settled

115. 1934

and most tragically seeking, a power crossed with blindness. Each of these contradictory essences and more, may be said to feed into the tense disharmony of the Guernica bull. Once again, in the person of the Minotaur

116. 1936

we come upon the bull opposite the gentle and feminine horse, though in a very different sort of role: he guards over the horse's birth

[62]

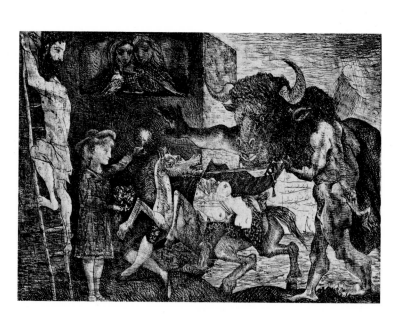

117. 1935

and over her death as though bringing dedication and a rough strength to some sacred ritual. Nothing could be more elegiac than the gesture and manner of the Minotaur as he confronts the dying horse, or

[63]

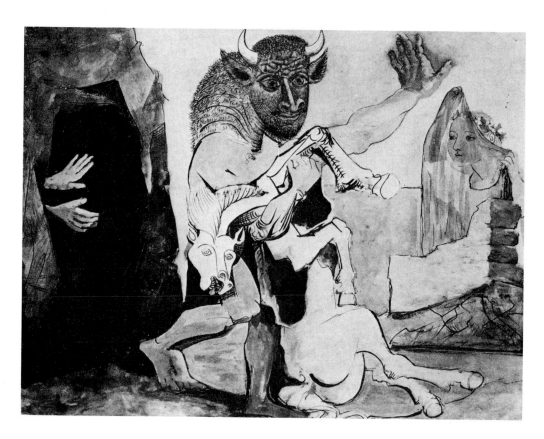

118. 1936

finally, bears her along on his arm, conductor of the ambulance indeed—the horned policeman who holds up a human hand as if to warn away an unnamed threat. But who can say whether it is not the Minotaur himself who has killed the weaker adversary, for all his show of strength and generosity?—As for the toro of the bullring, he is not necessarily simpler than the Minotaur: ". . .a bull that is very noble," said Angus McNab, "may scorn to gore at a man whom he has knocked

down." And in the case of the toro of the Guernica, that animal's position, [64] withdrawn to one side and absolutely still, seemingly idle, is a recognizable re-enactment of the stand assumed by the tired bull of the bullfight—after he has completed his charge.

Yet the Guernica bull stands protectively, encloses with his virility the form of the grieving mother—completes the triptych.

Picasso's bulls outside the Guernica series, are a physical lot, and do little to illuminate the wracklike tension of these opposites. It is not the bulls, but the Minotaurs with their human complexity, subject to every human vulnerability, which thrust upon us the intimation of the Guernica bull's dilemma, a power helpless to determine its ends.

Picasso's own identity shows up of course without disguise in the Minotaurs, and [65] helps in leading us to the remains of that key identity in the Guernica bull. In that most complex creature the artist's identity is there, yet diffused. The identity takes indeed the widest breadth, a mirror in which every puzzled spectator, motionless in front of the picture, is invited to see something of his own puzzlement, his own motionlessness.

There is perhaps no end to the inflections which can be read into the Guernica bull. In the animal's blanched and widened face, for instance, with its unseeing stare and jaw slack as though with horror, we see a creature awakened suddenly to the evidence of an overwhelming self-guilt. As a portrait of the artist it carries as his self-arraignment, and perhaps further his arraignment of all fellow-bystanders as defendents in the incident of Guernica.

As bystanders looking over our shoulder at the Guernica bull, our position is almost as difficult as that of the bull itself. We find ourselves one minute with the prosecution, the next with the defense, and the next we find that we ourselves are in the dock. Shall it never be possible to make these judicial proceedings come to rest? At times we are threatened almost with a touch of nostalgia for a solid American eagle, a Russian bear, a relief from Picasso's salmagundi of bulls and Minotaurs, the bombardier and his victims, the artist, ourselves, the life force. Perhaps there is no experience more relevant to this bewilderment than turning to the long built-up and available tradition of Picasso's earlier art, in fact the early art of Cubism. There we see forms threading their way in a rich confusion from out of their chaos, turning, dividing, returning to their chaos. The Guernica bull, too, for all the flatness of its drawing, is not one surface but a maze; of its nature it must show the crossing of facets which proceed in disharmony from an undirected life force.

No one face, no one moment, is of course finally appropriate. The bulls, the Minotaurs, the bombardier, the Basques, the artist, all claim the surface of this image, the spectator too—observing, all of them, all able-bodied, all unable to stop the disaster—for in its depths the image is, simply, a general tragedy of power unresolved.

Throughout the frozen line-up of bulls in the Guernica Studies and in the frozen Minotaurs which stand in back of them, there is a distant reminiscence

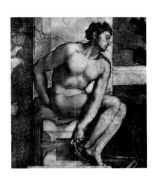

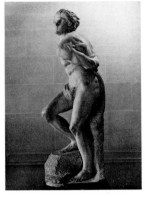

of Michelangelo's bound slaves and other scarcely defined allegories, vitality numbed, enchanted, restlessly twisted, nameless universal symbols of unresolved power. Where shall these vague, troubling images in the Sistine ceiling or in the Medici tomb, or in the labyrinth, or in the Guernica, be pinned down—who are they? There is no one answer; no final arraignment, no final release. "The bull is not fascism, but it is brutality and darkness. . . There are animals, these are massacred animals."

119. Michelangelo

120.
Michelangelo

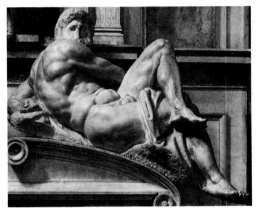

121. Michelangelo

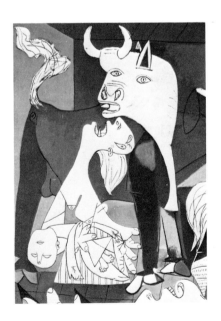

CHAPTER FOUR

The Stage

The Cornada

Not without reservations we have assisted at some scenes of sacrifice, a program linking Calvary with the bullring, the bullring with the labyrinth. Reservations, because we know that Picasso's drama was never acted on location at those places, nor at Guernica, but only in the less clearly posted arena of the mind.

A sword, animals, fire, some generalized persons, the action in Picasso's drama adds up to a scene of destruction somewhere between the bronze age and the future. There is a man with wide-spread arms and a weapon, who seems once to have been a picador with his pike and a matador with his sword and after that a centurion with his spear and after that Christ, everything in fact except the citizen of Guernica, the soldier of the Republic with his rifle. Guernica remains farthest from the surface of the picture: Calvary and the bullring come to us scattered and merged, variously separated from their origins. The wound of the Guernica horse sums up the mural's locale at large, dependent and independent of the past, of

[66]

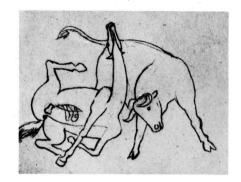

122. 1917

the counterpoint of its two-sided background. The cornada, the flesh opening inflicted by the bull, had always been seen

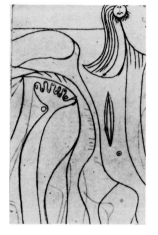
123. 1930–31

as the same gaping incision as the coup de grace administered in compassion. These two opposite themes, countering over the years,

may be said to have been brought together in the sanguinary detail of the Guernica wound like the themes of a fugue resolving

and driven home at the last to one note. What then is the diagnosis of the wound, to which does it point backward, the horn or the centurion's spear? To neither, of course, having at the last its own poignancy. It comes to us as a wound, the animals as massacred animals. [67]

The Guernica is endowed with parentage which extends as far back as we care to

trace it, whose echoes cannot but deepen the picture's chords. Still like any life the picture emerges as itself, and it is for this that we must return to it.

What is to come next in the narrative, what is to become now of the horse with its wound or of the swordbearer, or of the lightbearer? Such questions are of course impossible; if there are no organized excursions into the past there are none into the future—no separation of sacrifice and resurrection. "To me there is no past or [68] future in art," said Picasso. "If a work of art cannot always live in the present, it must not be considered at all." The picture must stand, then, on the richness of its moment. It is on its own stage, in the outlines and substance of its visible scenes, that its drama must take place finally.

STRUCTURE:
FOUR SCENES

CHAPTER FIVE

The Pediment

124. Olympia

Dead Level

The kneeling woman spreads her arms, the horse rears its neck, the swordbearer grips his sword—and the angle enclosing them rises and falls in perfect harmony, the symmetrical slope on either hand does what it can to quiet their emotion; in fact the scene resolves itself as a pediment.

[69]

The triangular tableaux which crowned Greek temples were staged with a quietness and repose which, we cannot help feeling,

are scarcely the theme of Picasso's great triangular seismograph of mayhem. Nonetheless the Guernica is cousin to these antique military formations in more ways than one. War stands in the background if not the foreground of both with their swordbearers, their contests and heroic horses, their victors and their vanquished. War is normal, war is noble, so the pediment remarks. War is hell, so the Guernica cries aloud. Still both tell of arms and the man. The mural tells of an excitability which would have offended the Greeks, but not without its own nobility, even its flash of martial pride.

Nobility in the Guernica we allow. The levelness of the Greeks, is, we say, less conspicuous in the picture. Still for all its excitability, that quality too underlies the picture,

extremities leveled across the bottom as strictly as the hoofs, knees, hands, and feet on the shelf of a Greek cornice,

the bereaved mother and the lighted portion of the burning woman planted to right and left of the triangle as firmly as

125. Delphi

the acroteria on the two ends of a pediment. The geometry [70]

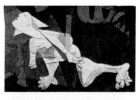

is all the tougher for its abridgement: in the unity of Picasso's compact drama there are no walk-ons, no spearholders. Three personages—the swordbearer, the horse, the kneeling woman—fill out the structure by themselves, a trinity stretched in orthodox pedimental fashion to the structure's height, and further bent under its pedimental slope, and

126. Olympia

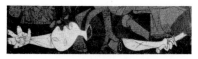

armed and cut down in its pedimental corners precisely à la Grecque; [71]

127. Aegina

brought to the fore (seen from a certain point of view) and flattened to its architectural plane. Taken individually the figures fling this way and that in a fine abandon. Collectively they come to us stilled to a symmetry, an Attic rigor.

Light and Voice

Into the Guernica triangle the light-
bearer intrudes the level of her arm. It is
here that the structure is more disorga-
nized and more human than in the case of
its architectural counterparts: the classic
mold broken, charged with a romantic
infusion. Unashamedly the lightbearer
strains in making her achievement; not
only does her light succeed in entering
and crowning the triangle but

its rays in turn take over much of the
architect's business, the pediment defined
by the streaks of her radiance. With the
lightbearer's reaching the pediment is
brought into a human intercourse with
the frieze of the picture at large, shown to
spring from a source outside itself, the
creature of a vital impulse.

Outward beyond the triangle the horse
in turn pushes its head, breaking the
confines of the pediment from within,
freeing its voice and bringing it into a
more general address. The rupture of the
classic is complete: the animal itself, the
pediment's chief component, breaks the
structure at its apex, gathering up and
releasing its energy, the energy which
was planted, so to speak, by the light-
bearer. A geometry remains, yet the

horse's head and the lightbearer's lamp
work not as statuary, but as the picture's
ventricle and auricle, thrusting and circu-
lating its power, emptying the triangle
and filling it. The timelessness of the
pediment, at a point in time, is brought to
an overflow of vitality, a passion not so
much stilled as achieved and working.

The Mass

With the Greeks Picasso speaks not so much of victories and defeats, Marathon, Guernica, as of timeless renewal. The pediment with its quiet symmetry adds to this timelessness—and if the symmetry is not only Euclidian but a construction of life, then we are permitted to sense not only a plane geometry but a form planted organically, working in depth. Indeed behind the triangle we make out the outlines of a mass, the face of a pyramid.

CHAPTER SIX

The Pyramid

Rubble

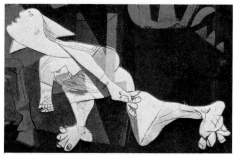

128.
Sakkara

Anchored heavily from side to side

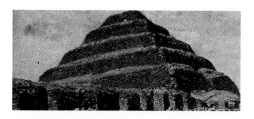

by its row of extremities the pyramid
slopes to a distance, the triangle recedes
[72] to a summit. The cornerstones of hand
and foot loom forward huge in the
perspective of the tiny fist clutching the
lamp at the apex,

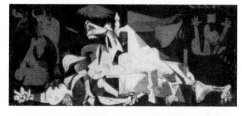

the Atlas-like feet of the kneeling woman
give way to her helpless reduced torso
diminishing upward along the slope. The
horse's

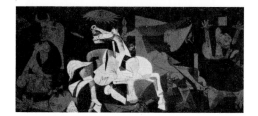

hooves are turned forward along the base,
their undersides forced upward and visi-
ble in the animal's drastic tilting, seen, as
it were, from the angle of vision of the
swordbearer. Rearing backward from its
hooves to its head, the horse is planted as a
[73] pyramid within a pyramid. Spreading this
way and that, the

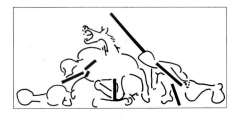

streaks of light define and confirm the structure. The shape of the pyramid, shadowy though it may remain,

makes its suggestion of permanence. Perpetuating some miscellaneous rubble, fragments of a Calvary, the bullring, and Guernica, the pyramid gathers these into an architecture foreign to each. It piles them into a shape more lasting and stable (and more evident) than crosses or the plaza or burning streets.

"No paseran"—They shall not pass, so the slogan ran in Loyalist Madrid. Like the pyramid, the Republic does not want to tip over.

But the steadiness and the proverbial inanimation of the pyramid, has, in the Guernica, a life and a kind of death of its own.

The Buckling

Men have always ended by growing impatient with the inanimate,

129. Erechtheum

grafting the vulnerability of life into stone structures

130. Egyptian

or mounting the most domestic of objects onto paws so that they depend on the support of an animal vitality. Feet lodged

at the corners of pictures, too, have given structure a life of its own, a pyramid with its own two extremities planted apart like those of a colossus. Picasso often uses

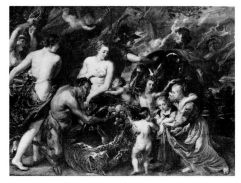

131. Rubens

this classic ruse, as in the Crucifixion of 1930, a pyramid lifted on the extremities at its two corners,

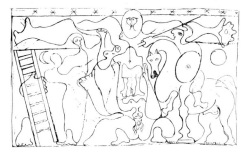

132. 1930–31

and similarly in the Guernica State I. But in a Guernica

133. 1937

Study of mother and child, the pyramid, instead of standing as a pyramid must— stumbles. A *hand* is substituted for one of the critical members.

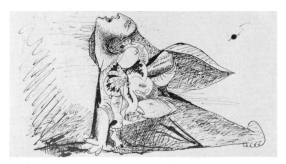

134. 1937

This misadventure is the forerunner of a panoramic buckling in the final version of the mural. Here as in the Study, the pyramid heaves to an apex, with the horse's head in place of the woman's, while the mass drops with the knee of the kneeling woman, again with the knee of the stricken horse; half balanced on its colossal foot at the right, the entire structure catches the ground finally at the left with its colossal hand.

[74] A parable new in art, a cataclysm to rock the pyramids.

Illusion and Disillusion

There is perhaps more than one logic in the fact that Picasso's unwieldy picture stumbles, for it was not only Guernica and the Republic that were under fire in 1937. Subtler and in a sense deeper was the spirit of moral commitment in society, the spirit that sustained the Loyalist cause with an almost religious fervor in Spain and abroad. Active though it was, drawing private citizens, for example, from the democracies to volunteer in Spain, still this spirit could do little but stumble under the pressure of an age which for some generations had looked dubiously at old certainties and which had long ago finished with visions of nobility. In art, accordingly, the age had cancelled all heroics. Small wonder that Picasso's heroic picture, for the Guernica is nothing if it is not heroic, should present itself with a certain uneasiness before the world.

In the generation following the French revolution

135. Delacroix

a warm egalitarian upsurging in pictures had its inevitability, as in Delacroix's Liberty Leading the People. Here we see death, but little stumbling in the exhibitions of suave footwork—still less in the structure sweeping to the limits, the pyramid all but bursting its frame, suffering no confinement. So indeed the structure was to do in Picasso's version of the subject, in which liberty is personified by a heroic horse. Under the screen of Cubism, the shatterings and dry cynicisms of this century, we find ourselves carried in Picasso's mural on the last great surging of the Romantic age—Delacroix's affirmation, the lightbearer's lamp thrust forward as descendent of Liberty's flag: and Delacroix's dead across the base, and his images of smoke and heroism stationed to right and left.

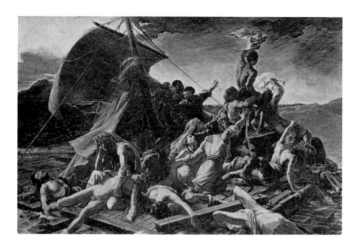

136. Géricault

Or Géricault's heated response to topical disaster, his pyramid of agony piled onto the abandoned raft of the Medusa, again the heroic gesturing at the top, and death stretched across the bottom.

Here the romantic strain in the Guernica ancestry goes underground, and here indeed the long history of heroic painting comes to a halt, for by way of reaction against such ecstasies, the Impressionists and their followers were aloof from smoke and heroism, from Buonapartes and from causes of all sorts. A century of revolutions and their doubtful aftermath left France drained of the moral credulity which sustained David and Delacroix, and when in 1900 Picasso arrived as a young man in Paris, progressive French painters were of course long since done with glory and with gestures and passions. Something had happened to the human spirit, and the moment for such things had gone by. Events in themselves were large, yet painters could no longer rise to them, put up pyramids to them; the Commune of 1870 with its desperate ideals and bloody finish left the surface of French painting unruffled, no painter stepped forward to restore Delacroix's Liberty to her barricades. Anarchists, Dreyfus, rivers of beggars in the streets, Prussian guns, none of these aroused the painters from their perfect constellations of apples and oranges. The private anguish of Van Gogh, the mournful retreat of Picasso's Blue period, the feverish jibes of the Fauves and Expressionists, these defined the isolation of artists and their disillusion. World war found Monet pursuing the level of his water lilies; Picasso, his bits of newspaper, his pencil studies in the style of Ingres. Heroics in an age of disillusion and scepticism fell flat when they were tried; the Futurists cranked up their machines without lasting effect, and Germans and Russians trying to lift heroic art from its tomb in the 1930's only proved how far the world had moved in the hundred years since Delacroix. It remained for Picasso to achieve the impossible, in fact to bring back the dinosaur, to restore the pyramid of fists and swords and trumpeting horses and shafts of light, and to restore it so that we cannot smile when we see it. Certainly the achievement did not flow readily from the artist's brush—witness the forty-five Studies and eight States of the mural stabbing

in every direction—rather it may be said to have been tortured into existence, [75] forced upward like a monster from the ocean floor by an event whose special poignancy could no longer be resisted. No other artist of our time, not even Picasso himself outside the Guernica, has thought to attempt such a massive revival. The picture stands apart, stumbling indeed, hectic, but a testament to the permanence of the romantic spirit no less than to the difficulty of its emergence in a practical age. But of course it is difficult to say what age the Guernica belongs to, and where it emerges from; the lightbearer spreads her light in every direction; Picasso in his picture brought together the opposite ends of a century of the human spirit, turning the cycle of painting both backward and forward, bringing it to its fullest, its tragic themes and grand shapes.

The Triptych

The Dialogue

Nonetheless the romantic impulse, vivid though it may be, is not necessarily the deepest to take its place in the structure of Picasso's picture. Much of the largest art, such as the symphonies of Beethoven, is of course romantic and classic at the same time, if the words must be used at all. There is passion, and, in art, the control of passion. The Guernica contains its unappeasable emotion but it contains also the pediment, a structure of perfect coldness, and in front of all are spread the parts

[76]

of a formation which is medieval in its moral rigidity, the triptych. Its two wings, straight as sentries, answer and challenge one another across the gulf of the mural in a kind of tragic dialogue,

blocks built on two symmetrical limbs, rising in the somber monuments of the bull and of the burning house—

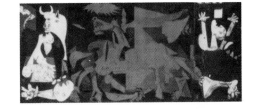

the beast enclosing the bereaved mother like a great clamp while the house frames and ignites the falling woman,

the millstone of the bull's head, the square of the flaming window opposite, grinding the women's faces. At the kernel of

the panels, the bereavement of the mother is equaled to being burned alive, the heads of the women as alike as those on two coins, arms flung out in a symmetrical choreography at equal angles, the burning woman's straight up, the bereaved mother's precisely opposite.

A hinged panel is by its nature a sort of dismemberment, a planned rupture. In the Guernica this aspect of triptychs is brought to the surface in theme as well as in form,

[77]

the one panel hinged at the pinched or choked-off neck of the lightbearer, the other at the shrunken and hacked-off neck of the warrior—neither personage permitted to cut across the boundaries, the painter preferring to lop heads rather than cover over the formal clarity of his plan, part of the plan being of course these acts of mutilation. The bull is submitted to a Procrustean mashing in order to square him to his narrow rectangle—thus the inner helplessness of this aggressor, the last to presume to cut loose from his appointed cage. In the melee of the mural

one figure transcends the panel frontiers, knitting the whole together. This is the kneeling woman, a spectator, a witness, one who exists, in a sense, outside the inner dramatic context.

The panels make

a close counterpoint with the pyramid, both structures anchored at their outer corners by the hand and foot; the warrior's head and the kneeling woman's bulbous knee swollen so as to approach the contours of each. As for the woman's knee, this lumpish and amazing member not only assists in anchoring both panel and pyramid, magnified as one of the

pyramid's foreground foundation blocks, but serves as the crux of an impassioned and monumental kneeling: a rightful mirroring of the dropped head of the warrior. Structure summoned by the dictates of form and sense, passionately contrived and [78] submerged in the meaning which it serves.

The Gulf

Seen from a different angle of vision the no-man's-land of the mural amounts to

an obstacle-course bristling with verticals. Barred, severed, impaled by these, nothing is free to pass from side to side, obstruction everywhere—the boundaries of the leaves of the triptych in particular planted like fortified gates.

Why?

The triptych submerged in a single panel as in the Guernica, suggests the medieval or Renaissance panels divided by their internal pillars. Such pictures center upon

some unapproachable presence, a Queen of Heaven, for example, isolated by columns and rigidly excluded from saints and earthly courtiers, the air she breathes distinct. Thanks to the painted barriers, we take the shuffling of fact and symbol for granted; visualizing the incongruous cast mingled in an open conversational setting,

137. Domenico Veneziano

we have the measure of the painter's problem. The necessary harmony seeps beyond such matters as the heavenly blue of the Madonna's robe, and into the painter's architectural exclusions.

The *Guernica*, too, is in a certain sense a religious painting, its images neither physical nor political realities; "The bull is not fascism, but it is brutality and darkness." The protagonist is played not by a human being, not by any hero or heroine of Guernica, but by a domestic animal, a figurative victim, stricken by a figurative, an archaic weapon. Whereas the horse, the people (or Christ) is virtually *all* symbol, the figures flanking it—the mother, the burning woman—may be taken to suggest the world, Guernica itself, in fact might almost have figured in a newsphoto. Two levels of reality must coexist much as in the Renaissance painting, remotest essence in the middle, flanked by the merely venerable, the physical, on either side. The devising and answering of the leaves of the triptych, is no more significant than their isolation from the gulf between. [79]

[80]

The Façade

Towers and Walls

Was Picasso's visual outcry so studiously plotted and contrived? Indeed we must conclude that it was. Rushing spontaneously at the canvas bursting with impulse, some such frenzy may have played its part in the making of certain of the Guernica Studies. The finished work is tightened into the opposite of such looseness, a passion, but a passion for articulation, balance, functioning. The painter gives us the working of the architect. The resulting structure amounts to a pediment, a pyramid, a triptych, but these together seen in their flat aspect,

a gable flanked by rectangles, conspire to make up the façade of a cathedral—the grandest of the Guernica's internal structures.

Like a cathedral

138.
Canterbury

the structure urges upward, flanked by its own gaunt upward-facing towers and culminating in pinnacles, its horns and flames. The whole is carved into breaks from a gray light to a gray dark, a curtain of stone, colorless as any weathered cathedral front.

139. El Greco

Picasso and El Greco: similar arrays of blade shapes, plunges from light to dark; a gable, and flanking this the towers, loosely, of the facade.

In such pictures as El Greco's and Picasso's

140. Paris

no less than in cathedral fronts, design chases into every corner, the sense of wall built up strong and continuous, structure driven forward at every turn—symbolic meaning is solidified in place, thrusting everywhere at the beholder demanding his engagement.

141.
Poussin

It remains for other, generally more equable artists to acquiesce in distances. The zeal, the

streak of religiosity in either Spanish master seeks the undissolved wall, the latitude for a broader, more aggressive mapping of symbol.

* * *

It is of course a zone of the imperturbable, a zone of the invulnerable which is marked out in these architectural structures, a terrain which never existed under the bombs, and which, like Dutch country held by the dikes, is imposed rather than discovered. Ultimately it is the artist himself, he who imposes, who is shown. The pediment, the pyramid, the triptych, the façade, each erects its separate logic—the archtectures are united chiefly in that all of them alike reflect the workings of an architect. It is structure in the Guernica which constitutes in the deepest sense the artist's stamp, his entirely personal intrusion, rearranging a chaos in the image of an [82] ordered mind. But as against this inward projecting, the Guernica projects of course at the same time its further spectacle—its outward mapping of the objective world.

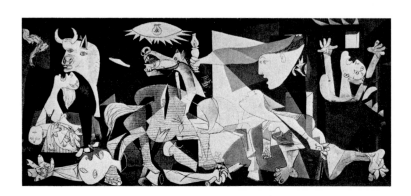

THE TRANSFORMATIONS OF NATURE:

HOW PICASSO SEES

Staging

The Play's the Thing

The remaining action no longer centers around the plots and counterplots or around the abstract sceneries, for these have taken us to the threshold of the visible exchanges of nature, the coinages of flesh and blood, brick and mortar, light and color. How are these ancient unkillable props to be brought on, transfigured? Nature comes to us observed. The play is finally the play of the painter's eye.

Black and White

A young Basque priest, Alberto de Onaindía, was present at Guernica during the bombardment. He described his experience, in his *Guernika* (Bilbao, 1937). Father de Onaindía's experience differed in kind from Picasso's; the two records, the factual and the poetic, sometimes reached close to one another, but on other occasions the artist's poetic reportage is seen to wheel free of probabilities and to establish its own slant, as in the matter of color. "The new bombardment" (as Father de Onaindía gave it) "lasted thirty-five minutes, enough to transform the town into an enormous furnace . . . We heard that the glow of the buildings had been seen from Lequito, two kilometers away. . . . When it grew dark the flames of Guernica were reaching to the sky, and the clouds took on the color of blood, and our faces too shone with the color of blood."

[83] There are no blood-colored clouds to redden our own faces as we stand unconcealed before Picasso's picture, and no blood-colored faces in the picture. The flames instead of reaching to the sky, shrink to the gray metallic teeth we see fastened to the burning house and to the body of the burning woman. And before the eye picks these out it surveys throughout the mural a virtually colorless rubble, a gray funeral waste, the value of so much sackcloth and ashes.

Or so much inward thought, a picture of the mind. The scene is set, not at Guernica in Vizcaya province, neither Picasso nor ourselves have Father de Onaindía's advantage, but on an inward stage. Like any meditative experience or even the most shattering nocturnal dream, its theme cannot be literally interpreted in red or yellow or blue. No deep inward pondering is registered in color, for there is after all no actual color in the mind.

Animals, we know, are generally colorblind outwardly as well as inwardly. They see, as well as dream and think, in grays, yet do animals miss the truth? It would

seem not. Elemental themselves, they are alert to elemental truth, and no doubt this is why men so often prefer them to each other when it comes to embodying the deepest force, the boar of Vishnu, the Lamb of God, the Guernica horse, the Guernica bull and falling bird. In Picasso's picture we see these animals in something of the elemental way animals must see each other, and the picture as a whole as a variation on the way animals would look at Guernica—an arena of black struck through with light, centered in the lightbearer's lamp and scattering left and right in the sun and in the burning house. In this arena we are taken beyond tricks and inventions of the human lens, here is too brutal an objectivity. The contest is laid down in black and white, light by itself is pitted against dark. [84]

Lights

142. 1937

Light makes a simple bid for supremacy in State II of the mural, the sun swelling as though it would burst. "El sol es el mejor torero," the sun is the best bullfighter; while he lives, the torero himself follows the sun in his traje de luz, his suit of light. But

143.
El Greco

the Guernica like the corrida becomes a kind of daytime nocturne, a death in the afternoon. "Towards dusk," said Father [85] de Onaindía, "we could see no more than five hundred meters. Everywhere there were flames and thick black smoke." In [86] the final version of the mural

darkness presses around and in back of every shape, including that of the sun itself. Little is left of the boyish optimism of State II; in place of its flowerlike sunburst a metallic apparatus is congealed, a baleful eye-shape broad enough to project not only light but an icy glare of history, accepting light impassively (as an eye), transmitting it no less impassively (as a lamp); infallible, humanly distant.

Picasso's view of the rape of Guernica, in mockery of the heat and courage of the bullfight, is staged finally at night, under a sun which is very like an electric ceiling fixture.

144.
Van Gogh

Artificial light is doubly unnatural in the bullring. "Wrestling matches, prize fights, the ballet," said John Marks, "and several other shows that make a visual appeal to a large public may be staged, without detriment, under artificial lighting; [87] the bullfight needs sunshine and heat. The sun himself is the best *aficionado*. He seldom frowns on bullfights, which are his favourite sacrifice; when they drag on too long and the arcs are lit . . . the sanded arena becomes a sawdust ring, where [88] tinsel figures of a tawdry circus perform meaningless feats . . ." Aircraft declare the tawdry contest at Guernica, noted by a world which cannot help—which is not there; for all its brilliance the Guernica arc with its mechanical isolation is without [89] heat or human suggestion. But into the meshes of an equivocal light, a different kind of illumination is pushed, and it is here that light again makes its approach to a victory. The lightbearer enters the lists with her seemingly pitiful kerosene lamp, her warm and personal declaration of truth, and visibly it is this light which works.

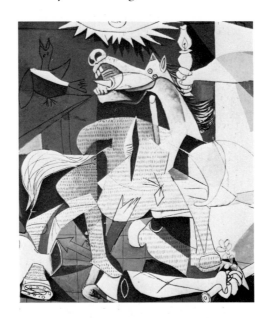

It is this, forming the apex of the pyramid, which alone causes solid effects of light and shadow, cutting a path of light across the horse's back. The horse's wound is lighted where its surface faces the household lamp steadied in the woman's grip, and the warrior's arm shadowed where its stump is turned from this [90] intimate source. These key details, with the horse itself, make up a cone of sculptured light which one might suppose to be

as self-sufficient as that which combatted chaos on the first day of creation: what, then,

145. English,
X Cent.

of the fixture which still broods imperturbably next to the lightbearer's lamp—the fixture itself a sun, a lamp, an eye: is the forthrightness reduced by a certain confusion of image?

Light has often in art been suggested

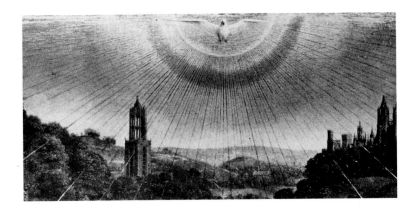

146.
Van Eyck

by more than one source at the same time. The fifteenth century gives us walls and battlements bathed in a rational sunshine, while through this medium, rays stream from the Holy Ghost. The seventeenth century

147. Bernini

confronts us with shafts streaking through the midst of an actual light which plays over sculptured surfaces, the whole revealed simultaneously to the mind and to the eye, again one reality transfixing the other. It is not the unity, but the clash, the conflict which Picasso, like the religious illustrator, precisely wants. Like him, Picasso claps the one reality into the

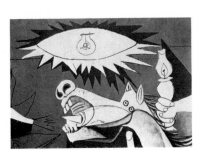

teeth of the other—the warmth of compassion, the cold glare of history—so that there can be no escaping their joint thrust.

The Curtain

Aggressive as is the thrusting of the lightbearer's lamp, the woman's offering extends beyond this conspicuous item of equipment. In one of the Guernica Studies, we first meet with the gentler but hardly less significant phenomenon of the lightbearer's curtain.

This is the ordinary Spanish sun-curtain, a plain rectangle of cloth at the window. Leaning from her window the lightbearer carries the cloth outward like a shawl; it rests along the top of her head, laps over her arm, and then descends in a rigid triangle below her elbow. Fulfilling its function it interrupts an intolerable light, and is seen to cast its triangular shadow below the woman on the front of her house. Curtain and shadow emerge together

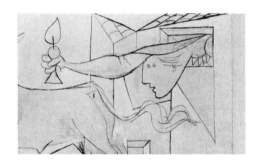

148. 1937

in the mural State I. There they figure among the charter elements, their outlines to be carried intact

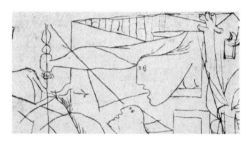

149. 1937

into the final picture.

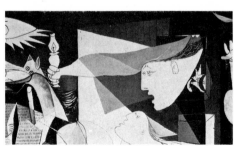

Images of a light shaded before the ordeal of the gored horse, reached back some years in the artist's impulses. In 1934

150. 1934

the act had been accomplished by the holding up, not of a cloth, but of a hand against a candle, a gesture which was echoed in 1935

151. 1935

by the hand of the Minotaur. The mystical and rather grand poetry of the Minotauromachy

152. 1937

yields to a childlike drawing, one of the first of the Guernica Studies, in which the covering of the light is accomplished, simply, by a lampshade; this efficient stage property is taken over eventually in the mural itself, disengaged from the lightbearer and amplified as the dominating lampshade which covers the central light bulb.

At the same time it is the lightbearer's curtain which survives as her personal lampshade or parasol. Her action in extending it against the light seems straightforward enough, yet with her cloth this woman epitomizes her contrary impulses. With one hand she pushes aggressively forward with her lamp; with the other she shrinks passively back between her breasts. With her curtain, she summarizes this two-sidedness, stopping the intolerable flow of her own light.

The light screened by a curtain, seems to have had no precedent in Picasso's pictures: nonetheless the cloth itself may be said to have entered the scene a year before Guernica, with

another vision of the horse's ordeal. Here the female observer holds up a cloth to veil not a light, but her own face. Somewhat similarly, the lightbearer of the mural curtains her profile from the rear; beyond this, she covers her head much as a Catholic woman covers her head in church; in effect she covers not only her head but the scene at large, protecting it under the wide vault of her cloth.

This sheltering rather than light-screening action of the cloth is externalized in a more obvious way in

153. 1936

another of the Guernica Studies, in which the lightbearer reveals both of her arms. From an upstage position with her two arms she reaches outward and forward to embrace and shelter the whole stage, administering a kind of mass papal benediction. (Picasso tried out this somewhat theatrical notion only once.)

154. 1937

Both these ritual gestures, covering the sacrifice with outstretched arms and shading a light before it, are performed in the mural by the carrying of a serenely simple cloth, one which is made to float outward like a protecting hand. The spreading downward of the cloth may be said to answer the growing upward of the flower from underneath. The two enclose the agitated panorama between their quiet tokenings of consolation and survival.

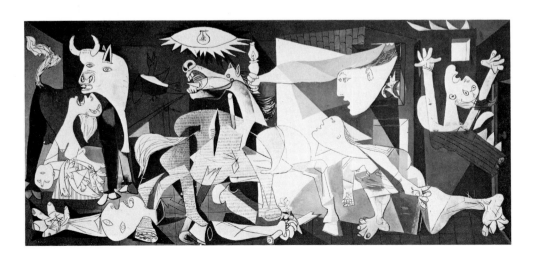

The Hill and the House

A handful of actors, no extras, a few strokes of physical scenery—for all its broad stage and elaborate lighting the Guernica remains an intimate drama, hardly on the scale of super spectacle. "I knew Guernica well. . . . It is a small town of red roofs and whitewashed walls, very clean." (Sergeant Yoldi.) Picasso's setting does nothing to magnify the town: [91]

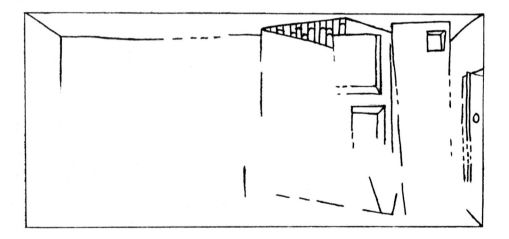

a pair of flats at either end and what amounts to two large doll's houses, these seemingly little more than a convenience, something for the lightbearer to climb up into and the burning woman to fall out of. The stolid dwellings account for a good share of the panorama, their angles are made to flash like axe blades, yet in their relation to the figures a species of birdcage or doll's house they remain, innocent of headroom or of architecture beyond the most rudimentary.

Why should the painter have so insisted on these walls of Guernica, only in this way to reduce them?

The significance of architecture sometimes lies of course in its shrinkage. The

Greeks with their miniature dwellings of
the dead, for example, brought eternity
down to a manageable size. Through the
middle ages

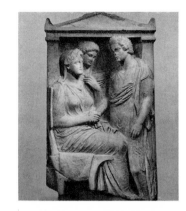

155. V Cent. BC

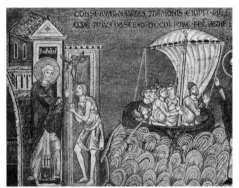

the painter reduced all his architecture to
a rudiment, a cube with an opening here,

156.
Byzantine

another there. The dignity of man lay not
so much within his skyscrapers as within
himself, and in pictures he wore his
architecture much as he wore his clothes,
as the complement to the dignity of his
own stature.

Picasso's own pictures

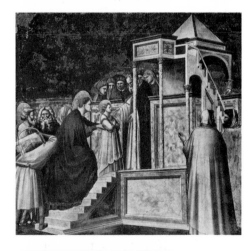

157. Giotto

of houses often show a certain medieval
curtailment, reverting over the years to a
modesty of scale,

158. 1906

159. 1909

a simplicity of type, as though the painter were haunted over the years by the memory of a rural austerity. The proto-type

160. 1895

is a Biblical adobe with its simple en-trance in the background of a boyhood Flight into Egypt of 1895, [92]

161. 1937

re-erected identically forty-two years later as the barren dwelling in the back-ground of a poignant death scene in the Dream and Lie of Franco, 1937. Such [93]

162. 1935

elemental surroundings can only enhance the personages occupying them; a wall, an opening—the fascination of these en-closures is all

163. 1901

in the contemplation of the life which they enclose.

In general, Picasso gives us to contem-plate these humble boxes from outside. But

in a Bathers of 1921 we find ourselves in a new and strange position, outside and yet, almost, not outside at all but inside, the distant horizon raised and straightened so as to join the flanking roof lines in suggesting the contours of a ceiling: an [94] interior stage with a backdrop. In the Guernica

164. 1921

these interior contours are kept, while houses, out of doors, are returned to the [95] center of the stage, an out-of-doors which is enclosed by shadowy wings, a tiled floor, a sky which is a ceiling. They provide the setting for an event which is to reverberate on either side of the threshold, at home and abroad, a space which is [96] universal. And not only space but also time is enlarged, lodged simultaneously in lamplight and sunlight, the hands of the clock standing simultaneously at midnight and at noon.

The confounding of light and space suggests its own Biblical largeness and confusion of image. "Ye are the light of the world, a city that is set on a hill cannot be hid. Neither do men light a candle, and put it under a bushel, but on a candlestick; [97] and it giveth light unto all that are in the house."

In the mural this impartiality of light on the hill and in the house amounts to a confusion general in scope, the universe of the picture from end to end ripped, alternately opened and collapsed. "Throughout the night houses were falling, until the streets were long heaps of red, impenetrable ruins": so reported the New York Times. But what need has the mural of falling houses or incidental flying bricks when the roof of the picture is torn off, the barrier which separates the hours [98] collapsed?

Still despite this remarkable mayhem Picasso's toy houses display a remarkable stability under the bombs. One house is beset with flames, it is true; the other goes so far as to spin, its several aspects shuffling cubistically before our eyes, simultaneously corners and windows; nonetheless the lightbearer's watchtower comes through intact, both houses im-maculate, no corner cracked, no brick [99] charred. The scenery needs neither re-pairs nor extra stature, persisting on a level with the rays of a downward plunging sun—like the Guernica flower, too humble, finally, to be leveled. With the flower, the houses stand as the symbol of a surviving.

The Door

"We came up in lorries, but when we came to Guernica we knew we would have to abandon them. We could not take the lorries through the flames. We jumped out and made our way through the town as well as we could, dodging the flames." (Sergeant Yoldi). [100]

It would seem unrealistic for us to follow suit and come up to Picasso's picture to dodge through it physically. The stage is metaphor, inaccessible to human tread; the people are too large, the houses are too small.

But like the co-existence of lamp and sun, there is here a bringing together of two realities. A door, nearly the height of the two-story houses, a relatively non-metaphorical convenience with headroom and a doorknob, waits half hidden in the shadow off-stage. Offering itself indifferently as an exit or an entrance, it stands unattended, constituting, so it would seem, a cue for anyone intrepid enough to take it. It gives directly onto the flame-lit enactment while it communicates discreetly with the wings—open to the world.

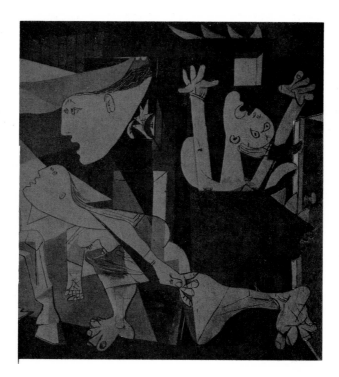

On Stage

Numancia

As for Picasso's imagery of life, it is perhaps as old as it is new—like the pattern of the Spanish war itself, that latest in a series of foreign invasions reaching back as far as the Romans. The definitive and indeed legendary resistance against foreign invasion in Spain, has always been that of Numancia, ancient capital of the Iberian Celts. It is recorded that this provincial city withstood Roman siege for an incredible twenty years, and when in 134 B.C. it was overwhelmed, tradition has it that the Numancians threw themselves from the city walls rather than put themselves into the hands of their captors.

The Spanish civil war revolved throughout its four-year duration around the long defense of Loyalist cities, and one word was to be heard throughout Loyalist Spain in those years uttered like a slogan; the word, ripe with a Spanish sense of tragedy, was Numancia.

Unlike that of Numancia the tragedy of Guernica was momentary, there was no defense strung out across years, indeed there was no defense. Still the Germans' decision to destroy the "sacred town" was made in a last effort to break the spirit and long resistance of the Basques, thereby putting Guernica and the whole Basque country into something of the position of a modern Numancia.

Numancia itself left a legacy of art as well as heroics. The remains are to be seen in the museum in Soria, near the excavations of the ancient city. A pottery fragment gives us

165. II Cent. BC

the image of a horse in typical Celtic contempt for Roman forms, Roman grace and suavity, all metallic bands and raw nerve—a visible token of the spirit its makers were to bring to the defense of their city. Numancian pottery was plowed under, then in modern times dug up, and

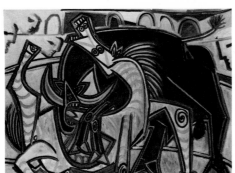

166. 1934

in 1934 Picasso was to bring something not unlike a Numancian horse into the midst of a new conflict, that of the bullring. Three years later when the name of Numancia was in the air,

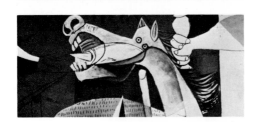

the horse's jagged outlines, its eyes and ears, its jutting mane and cleated jaws, were to be found in another and larger arena, that of the Guernica. [101]

The question whether Picasso was familiar with Numancia and its forms, is not finally to be answered. Still in the Guernica the horse is flanked by a woman falling in flames, a figure which looks certainly more defiant than defensive, arms and body locked not in confusion but as though in a military discipline. The [102]
figure of the burning woman perhaps makes most sense when we think of the Numancians of tradition throwing themselves defiantly from their walls.

Shadow and Substance

"The Milicianos and I followed the flight of airplanes; and we made a crazy journey through the trees, trying to avoid them. Meanwhile women, children and old men were falling in heaps, like flies, and everywhere we saw lakes of blood." (Father de
[103] Onaindía.)

Picasso's picture has no lakes of blood and confronts us with scant human remains, the pieces of a swordbearer, the scrap of a lightbearer, the flattened shell of a kneeling woman, the shadow-puppets of a mother and of a burning woman. Scenery is built up but the cast of characters truncated and eviscerated, their remnants left to hold the stage and required to swell with prophecy and meaning—whether or not falling from Celtic battlements.

For all their economy of form the artist's human remnants carve out a depth, the stage opens backward in shadow deferring to lighted presences, rays from the lamp are interrupted by a substance—an obstinate wholeness persists in these shards and ectoplasms. Sinewy contours make a physical assertion in key details, the hands and feet, the mouth of the horse. Scenery is shrunken and the sun lowered, to give the human and animal presences by contrast that which Father de Onaindia could not have reported, their vastness. Even without the shrinkage of surroundings the figures have a buskined immensity, the kneeling woman's seemingly in-drawn figure measuring a slope of eight feet, the lightbearer's arm by itself reaching seven feet forward, the warrior's outstretched arms spanning fifteen feet across the stage. How should such heroic fragments communicate anything but force, shadowy
[104] though they may remain?

Signatures

Alike in their size the characters diverge in their relation to the drama, giving us both actors and audience, or the medieval with its frenzied acts, and the classic, which detaches itself and watches. Not the least among these classic spectators is a first-hand piece of life, the repeated likeness of the artist.

The artist of course can never be altogether absent, the most hellish catastrophe must be told by someone who can pull himself together and summon the detachment to tell it—the eternal classic. "But tell me all, without distraction tell me, all this calamity . . ." so the Chorus puts it squarely in Aeschylus' tragedy of the ruin of cities, "The Persians." Greek tragedy is surrounded and climaxed by such

undistracted observers outside the action, the ancient bard who hands down the outlines of the saga, the audience itself, and on stage the chorus which, like the kneeling woman, amplifies and enlarges at a distance: then the Messenger who, like Picasso's lightbearer, holds the stage at the climactic moment to reveal a catastrophe which is already a thing of the past. "Of arms and the man I sing"— these words are the signature of the poet himself, as Picasso's lightbearer is the painter's own signature. Picasso himself, through the medium of his lady with the lamp, was his own most eloquent bystander, and faced over the years

with the disasters of war

167. 1937

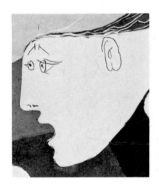

168. Drawing by the author

he has confronted us with the outlines of his own distress—outlines translated and fixed in the lightbearer's face. Like the artist, the lightbearer conveys a clear-seeing, a classic sympathy, and perhaps something larger and more impersonal, art, or truth; a tragic mask no less than a projection of the artist, she narrates the Guernica with an incorruptible grace and serenity of feature which is [105] [106]

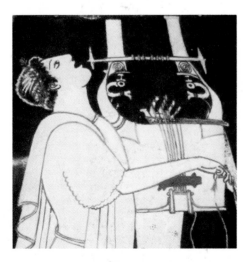

169. Attic amphora

itself a kind of song, detached from the event while suffused with it. Her lamp, so to speak, is her harp, and there she stops; her voice and her

light are all that count, beyond her few
necessary parts she dwindles and tapers to
nothing, leading, if anywhere, upward
and beyond the scope of her house and, in
[107] fact, out of the picture.

Her own delicacy of expression is
confronted by the grotesque shapes of the
events she watches. Her swelling and
rounded arm is translated elsewhere

170. 1933

into the rigid sticks thrust out by the
active members of the cast. These, their
[108] galvanized bodies only too flatly there,
throw off all grace and form, their agony
beyond

posturing of any classical sort. Rather
their

171. Laocoön

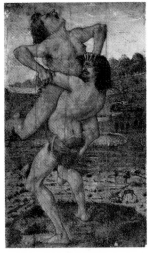

172.
Pollaiuolo

awkward and distended howling is Flor-
entine—of the earth. Their

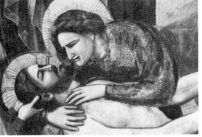

173. Giotto

scored faces and grief-pulled eyes, are, [109]
like those of the Renaissance, rooted at
least in part

in the ages of faith;

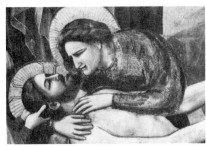

174. Castel Seprio

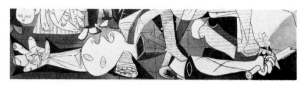

their outlines have a visible ancestry

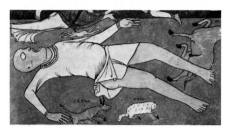

175. Beatus
of Liebana

[110] in the ages in which form followed
passion. At the same time

an incorrigible trace of the classic, in
which passion follows form, is filtered
even through these grotesque and medi-
eval parts of the Guernica,

176. Praxiteles
(copy)

flows, so to speak, from the lightbearer
with her light, a white heat

which tempers and simplifies profiles and
bleaches surfaces to an impersonal blank-
ness. In the finished mural there is little
residue of

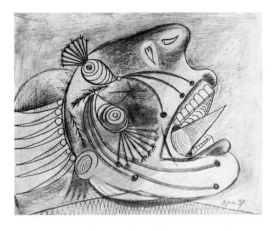

177. 1937

those inward-turning essays which Picasso put down as Studies and exercises, vents, so to speak, for visual excess; passion in the mural itself serves no individual member of the cast so much as [111]

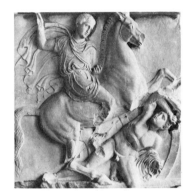

178. Stele
of Dexileos

the generalized epic of which each is a part. Like the Greeks [112]

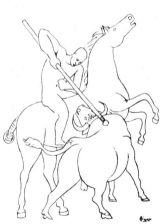

179. 1919

Picasso could freeze and discipline his moments of climax to a ceremony, fitting them for ageless perpetuation. There is some of this iciness about each of the Guernica's disasters and furious passions. Cold restraint reaches its extreme, in fact, in the bald and stony remains of

its most aggressive, in a way its most medieval personality, the broken warrior.

Hot-blooded as this many-sided figure may be in the final effect,

he is in literal fact nothing but a sculptured bust, or more precisely a group of plaster casts, and not a creature of flesh. His hollow-ended stumps derive, beyond his other ancestries, from nothing more animated than a group of casts which [113] show up earlier in a still life of 1925. These in turn

180. 1925

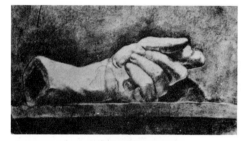

stem from Picasso's earliest academic studies, those of 1893: the hollow cast of the hand closed around the cylinder, fixed in Picasso's imagination and put on the shelf forty-four years before Guernica, when the artist was twelve. Such studio casts derived of course from

181. 1893—94

classical antique originals, such as the Spearholder of Polyclitus, or some other image of arms and the man in utter self-possession. Seen in this light the broken warrior's severed parts are not helpless mutilations, they are finished studio props, the day-to-day perpetuations of [114] classic form, classic command.

182. Polyclitus (copy)

For all his classicism the warrior is as much acting as observing, a microcosm of the picture at large. His glance divided like his ancestry, the many-sided figure stares at us, a torero, a Christ, an ancient Greek, and beyond all these cross-identities, a routine studio project, a moment in the artist's life. Indeed in a deeper

sense the warrior's carefully set and separated scraps give us the outline of Picasso's lifelong work, his salvaging and destroying of the classic; and perhaps still deeper, his old alchemy of bringing life to the surface of hollow masks. Whose life is brought finally to the surface of the broken warrior—what identity brings this jigsaw puzzle together? Should we, indeed, make any final distinction between Picasso's projection of his own agony, and his projection of the hollow man with a broken sword?

We have noticed earlier in the warrior another reflection of antiquity, the outlines of the centurion's hollow thrust, with its parallel in the artist's helpless rage. Greek or Roman, the warrior seems to bring us around to a piece of the same identity. No substance, no legs and no body, almost more an absence than a presence, little enough of those round limbs which were so much a part of the Greeks and Romans and still less of the peasants who were physically present at Guernica; but suggesting with a poignancy the painter, who was not there. A presence barred except as a gesture, stretched under the picture like a signature.

[115]

The signature pretends after all to little in the way of classic flourishes or classic features, but rather

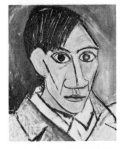

a structure intensely personal, intense as no ideal Greek was intense, and it would seem appropriate enough to sense something of Picasso's own person behind his unguarded revelation of this fragment,

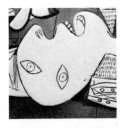

183. The artist at fifteen

the round close-cropped head, in particular, of Picasso's boyhood,

184. 1907

the rigid eye-stamps of certain early self-portraits; eyes wrenched around, in the warrior, to accomplish a stare

[116]

185. The artist in 1905

not less grasping than Picasso's unique devouring stare. The signature seems in some ways more precise than any photograph. The artist here puts himself in arms, as it may seem,

186. Delacroix

not altogether unlike Delacroix before him, in the Liberty Leading the People. But whereas Delacroix showed himself in a single image complete, with his top hat balanced on his head, Picasso's image is subtler, and divided. If it is the artist whose strength is held aside in the completeness of the Guernica bull, then the warrior and the lightbearer severally, it may be, are that strength pushed forward—in fragments.

Still the warrior, like the picture at large, remains allegory no less than intimate confession. Classic and non-classic flow together, not classic but rather something more classic than the classic, still further clarified and reduced—stripped to the bone and hollowed out, a frugality of image which is, finally, Biblical: "For my days are consumed like smoke, and my bones are burned as an hearth . . . By reason of the [117] voice of my groaning, my bones cleave to my skin."

Life or Death

At the core of such frugalities, life itself is the one thing purchased at all costs. Acting or watching, it persists: "My bones are burned . . ." and yet I speak. Of the nine participants, seven are living and speaking (all but the warrior and the child); most, in fact, are in no apparent danger of death: the bull, the mother, the lightbearer, the kneeling woman. Of the few who face death, only the bird and the burning woman suggest any possible pathos, the central figure of the horse triumphant, by contrast, in its sense of command. And of the two dead, only one, the child, is dead truly and in fact—the remains of the warrior exhibiting every vitality, [118] making the most aggressive member of the cast.

Despite all this the sense of death dominates the stage. A pall persists. The cries of the women, the shouting of the warrior, the calling of the bird, the trumpeting of the horse, all come to us in a medium of death-silent paint, and the silence of paint [119] has something in common with certain silences of life. "No one spoke. . . . We could see Guernica burning, and we heard the roaring of the flames, but there was not a [120] single human voice anywhere to be heard." (Sergeant Yoldi.)

Positions

Silent on whichever side of the grave, rigid with death or with life, the tableau of figures does not move. The rigid branching of the abstract architecture holds any local action in suspension, no cycle of action can begin. The horse is brought to its knees, impaled, gashed with the cornada or coup de grace, pressed by the splintered end of a boardlike arrow (symbol of Franco's military junta, the one political [121] element in the mural)—and further stopped within the abstract pediment like a nut in a nutcracker: descendant of Calvary, the animal takes a stasis complete as that of the cross itself. The bereaved mother displays her anguish in a gesture supremely fixed; the lightbearer does no less. The bull is rooted stupidly to the spot. The warrior shows no likely motion; still less the child; even the falling woman is stopped from really seeming to fall, by the dominant horizontal pattern of her shadow, and what little sense of motion she has is involuntary—as for the gesture of her arms, this is locked, frozen. The falling of the bird is arrested by the table shape to the right of the bull. The kneeling woman is brought up short at her unspeakable destination, dropped on her knee like the horse, arms spread downward in a gesture of utter finality. Such, then, is the unflinching agony of the animals and persons in the drama. In back of them the town itself stands miraculously inert, no beams dangle nor walls collapse. Features and component parts of figures may veer crazily: black and white angles explode across the surface of the picture like a curtain of flying shrapnel, still beneath it the figures themselves and their setting are as motionless as the settled symmetry of their plan. [122]

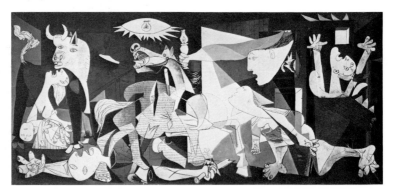

The Wall

"When the bombing was over," said Father de Onaindía, "the people left their shelters: I saw no one crying. . . ." [123]

There are no tears in Picasso's picture, none even on the face of the bereaved mother. It seems not so much that the figures cannot move, cannot cry, as that they will not. The grandeur of death surrounding them is the measure of their force in refusing it,

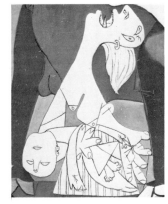

187. Byzantine

the bereaved mother stationed with a kind of Byzantine fixedness, a flat fragment of wall: No paseran—

[124]

188. Olympia

the trunk of the burning woman ruled and stiffened like a pillar,

[125]

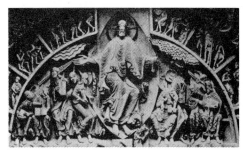

189. Vézeley

not so much bending as locked and flexed, luminous with the rigidity of medieval decision. There is not

[126]

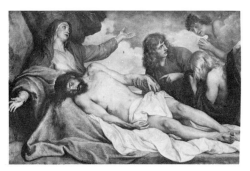

190. Van Dyck

that yielding up and acquiescence which is sometimes a part of the Christian epic,

[127]

nor that gentle complaining which keeps passion within bounds in the classic. Nowhere is to be seen the tear-streaked and florid emotion of the screaming women of the Studies: in the same way no trace is left of the passive drifting of the dead warrior of the Studies, or the helpless fluttering of the burning woman in the mural State I, or the crumpled defeat of the horse throughout the series and up to the mural State IV. Resistance, focus, both finally have matured

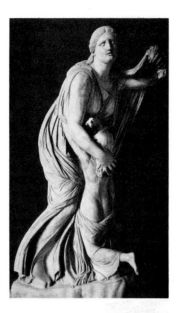

191. Niobe; Roman copy

with a vengeance. An acrid reality is undiluted by

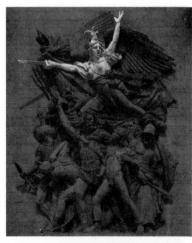

192. Rude

graceful theatrics. The gestures [128]

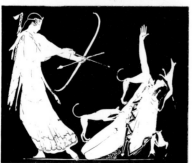

193. Attic
bell krater

are a hard semaphore, the angles

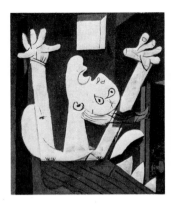
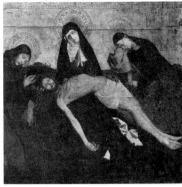

194. Avignon
Pietà

[129] those of the resistance of bodies to the rack, the wheel, and the cross. Is this resistance in the mural effective, finally, or merely deadlocked? A victory, or, at best, a tragic resistance?

The Increase

The Guernica *is* in many ways a kind of deadlock. One by one each actor's face turns up to face an intolerable weight, the mother's directly to the bull's head, the warrior's to its hooves, the burning woman's to her flaming window. The horse's, most brutally pressed of all, is turned squarely to its crown of thorns, the mace of the artificial sun.

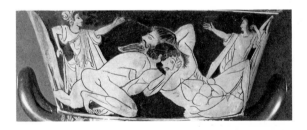

195. Kylix krater

The struggle itself is more clearly announced than its outcome; like the best in any art it is the unfolding of passion within forms which cannot release that passion, forms which must outlast it. A meditation, in a sense, rather than an act, but a sore and angry meditation, a questioning which will not be stopped. Time stands still, it has a generalization and largeness not ordinarily its own, and it is precisely because time and place alike transcend their ordinary limitations that human passion is at
[130] liberty to do the same. The picture stands unnaturally still, and a more than ordinary

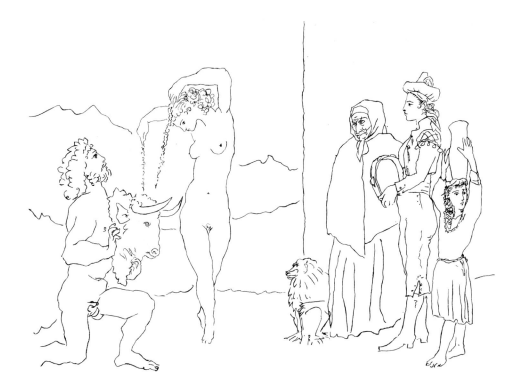

196. 1954

passion courses through this stillness. Like the old woman observing the mystery of youth in Picasso's poignant Dance of the Banderillas of 1954,

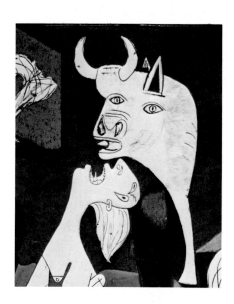

the bereaved mother expresses a universal emotion, a loss which is more than personal—a cry both after the bullfighter and after the bull, a bitter appeal after the truth which lies behind a barbaric surface. [131] Throughout the mural

this appeal takes the shape of an imperative reaching. This reaching is the physical act of Picasso's picture, and in this reaching the intimation of a triumph is to be felt perhaps most nearly. "Around me people were praying," said Father de Onaindía, "and some stretched out their arms in the form of a cross. . . ." [132]

In the picture six pairs of arms are opened
out in variations, broadly speaking, on
this or on the still more ancient appeal
to a higher power,

the orans.
 Picasso early discovers the outlines

197. Hellenistic

of this submissive gesture, in dance studies
of 1919, bequeathing them

198. 1919

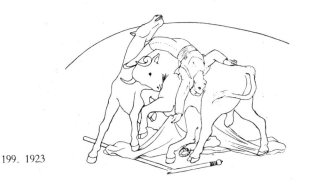

199. 1923

in due course to the fallen picadors. In the Guernica, as we know,

iron is driven into these outlines. But the mechanization of outflung arms in the mural, [133]

200. Millet

is tempered in the extremities of these by an earthiness,

a gutteral urgency, clumps of fingers which stammer across the picture. Arms like cannon, but hands like roots pulled out of the earth, the mutest, simplest human truth, clenched or opened out and distended in an agony of speech. From side to side the mural addresses us in signals of pity and terror, and, no less, in signals of knowledge, resolution, command.

No matter which lens we have held up to Picasso's picture, human gestures have pushed across our vision; first and last, they announce and carry the picture, and, as we shall see, its long escort of Studies. Where the thrust of the horse is focused in its mouth, that of the human figures is focused in

their gestures, their defeat negligible in
the presence of the huge aspiring of their
limbs. If there is a triumph of the human
spirit in the Guernica, it is in its reach, in
its figures extended beyond themselves,

magnified at the moment of truth into
more than that which they were.

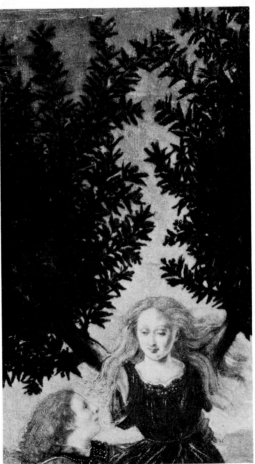

201. *The Transformation of Daphne.* Pollaiuolo.

PART TWO

The Picture Is Delivered

THE STUDIES

Like every picture Picasso's Guernica with its many-sided reach is joined to the decades and centuries. It floats on the surface of the years organically, like a water-flower, stems reaching downward through the artist's life, into his antecedents and into the fertile mud of antiquity. In the Guernica these shadowy stems are complex and visible, and hitherto our sounding of the picture has tended to sink into these depths, into the immemorial themes, the structures reflecting back to the middle ages and beyond, and the modes of vision rooted in history and in the years of the artist's youth. Ultimately of course a picture must be taken as itself, a sounding not of centuries and decades but of a moment, an act of unfolding. For the Guernica, the artist has logged the phases of this final act, logged them and brought them into being, in his relentless probing sequence of the Studies.

Picasso's burst of forty-five Studies for the Guernica, preceding and accompanying the mural, was accomplished within a space of some six weeks: irresistibly within that moment of time these electric drawings bring the mural into port. A week of the artist's inactivity followed the news of the destruction of Guernica, from April 26 to May 1—a long intake of breath: then the Studies go down pell mell onto white and colored paper, onto canvas and gessoed panels in every possible medium, pen, pencil, oil, gouache, collage, and colored crayon, and in every style and even non-style, ranging from explosive to exquisitely finished. Halfway through the Studies (with No. 22, on May 11) the mural itself is commenced; the Studies continue to unfold, tugged this way and that, and, in turn, tugging the mural toward its destination.

Now and then in our reconnoitering of the mural thus far our searchlight has picked up a few of the Studies, only to sweep them into sequences outside their own: we have bundled them in and out of the courtroom as witnesses, permitting them to flash their relevance to the crucifixion and the bullfight, or to aspects of structure and staging in the mural. The accumulated years of Picasso's work up to 1937 constitute the painter's development of these themes, and the Studies have offered themselves merely as links between the picture and those earlier years, not the first but rather the last of the artist's prefigurings of the mural. Eventually of course the artist arrived at the Studies in themselves, shutting everything else out in a long volley of self-confession. Taking our cue we, too, arrive last at the Studies, taking them not as marginal but in the fullness of their suggestion—standing them up not as witnesses but as defendants.

Emotionally uncensored and not a little capricious, the Studies do not consistently seem to take on themselves the chief responsibility of shaping the outer surface of the mural. Some of them, notably the first, essay that sober function, yet many of them suggest a more subtle role, that of sharpening and defining the facets of the artist's state of mind—the inner surface, so to speak, of the mural. It is precisely their free-wheeling and unguarded nature which gives the Studies this unique importance, both as experiences required by the artist at the time, and as sidelights entering at unexpected angles, sharpening at every turn our own perceptions of the final monument which is the mural.

The mural can be seen to stand on its feet as an experience without benefit of the Studies. Can the Studies claim a like independence? They are overshadowed certainly by the larger work, like the corbel-sculptures and gargoyles of a cathedral. Broken from the parent structure and stood on separate exhibition-plinths in a gallery they remain indeed very much alive as works of art in themselves, perhaps more vivid for the isolation. For all their articulating of the mural it is in part for the Studies that we approach the Studies. Never sensational, never virtuose, they remain in their variety a visual chamber music, a fantasia of passion and thought in superb control.

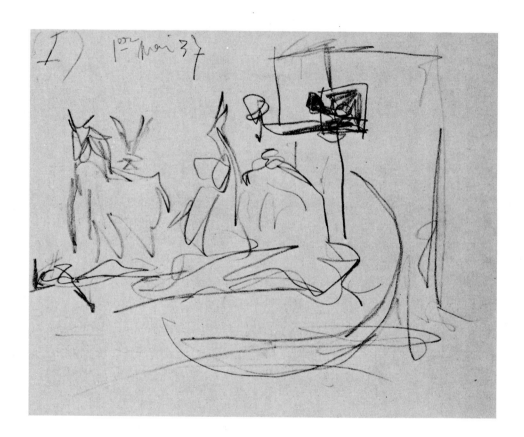

1 *Composition study* Pencil on blue paper. 10⅝″×8¼″. Dated "May 1, 37 (I)."

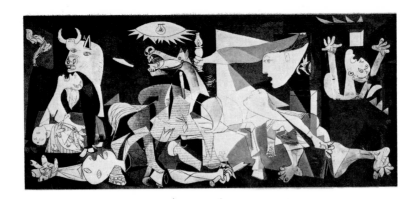

Study 1

More potently than any of the forty-four Studies which follow in its wake, the first sketch was the kernel from which the mural's outlines unfold. It is the one stage-plan whose every element is to reappear in position in the final picture, a childhood pattern, as it were, come home to roost in later behavior. In the mural after many wanderings and diversions among the later Studies we find the original arrangement of lightbearer and horse, the bull turned from the scene, the figure of death stretched predella-like across the bottom. Even a detail such as the lightbearer's window cubistically straddling the angle of her house, nails down at the start its note of disruption for the finished picture.

[134]

The crucifixion, as in many of the Studies, is not directly hinted at. The theme of resurrection is, however, floated tentatively. We see a winged creature poised on the back of the bull, clarified in Study 2 as the Pegasus-like soul of the horse, emerging in place ultimately in the mural as a bird.

[135]

Not only identities and positions, but essential gestures and outlines are laid down; for the lightbearer, her massive stiff-arming of the light, aggression which is pushed intact into the apex of the mural; for the horse, the heavy bulk from which the slender neck rises spoutlike, like the freezing of a cry. As for the bull, already we see his physical power squared to its appointed quarter as though stuffed into a box. Much of the simple force of a childhood experience with its lasting consequences, is planted in the seemingly casual scrawls of this first Study.

A childlike element is drawn to the surface visibly in many of the Studies. A trace of the child's breathlessness is visible in the texture of the first drawing, and lays the foundation for some insistent eruptions of this tendency early and late in the Guernica series. Under this pencil we see little taint of visual sophistication, little of the fast Raphael sketch, and nothing of style or manner, nothing of the formulas of Cubism or Surrealism. We see a grown man's access to native impulse, the visual release of the child. The lightbearer is made to poke her light forward with a gesture devoid of any understanding of muscle or bone, devoid of the implications of marble

or plaster as of flesh and blood—more the outline of a salami or a canoe, the raw vibration of a childhood scrawl or yell. Uncannily no trace either of Cubist discipline or how-to-do animals, underlies the blob of yarn which is the horse, its clawlike jaws (apparently) parted at the apex in an inarticulate yelp of its own. [136]

Such natural yelping was unprecedented in Picasso's work. In 1898 when the artist was seventeen, he was making

202. 1896

rough but richly plastic sketches to rival those of Rembrandt. In 1891

203. ca. 1890

when the artist was ten, he was hawking his precocious bullfight drawings outside the bullring in Malaga. By 1937 he had been elaborating on the bullfight theme for some five decades—always brilliantly; never, even at the first in Malaga, with the ready childlike abandon which is to be found among his Studies for the Guernica.

This abandon was perhaps the most potent contribution of the Guernica Studies, and quite likely the most difficult of achievement. It seems to have come as the result of an evolution which had been going forward underground since the artist's boyhood, an evolution in which after many reversals, the master won through to a piece of his boyhood in his fifty-sixth year.

The normal child lets go with paints or crayons without trouble—nothing inhibits. Picasso never had this easy access to truth. He was burdened in childhood with the ability to pick up adult visual conventions, optical effects and an astonishing command of the academic and illustrational fashions of the '90's. In this

he was furthered of course by his training at the hands of José Ruiz Blasco, his father; he was heavily heaped with praise, for as we know, Don José, a professional painter, in a gesture of submission when the boy was fourteen gave up his craft and relinquished his own brushes, placing them in the hands of the already full-fledged prodigy. This unheard-of ceremony, a reversal of nature in which the father placed himself humbly behind the boy, must have left a subtle wound on both sides, a buried shock which, we may imagine, left Picasso with a lifelong uneasiness with his own academic achievement, erupting understandably over the years and contributing perhaps to the swings of his "periods," those wrenches as violent as the swings of the flagellant's whip.

Uneasily, then, Picasso from time to time over the years may be said to have struggled backward toward an always elusive innocence, a childlike force. Witness the old man we all know in David Duncan's photographs, the boy with his capers and false noses! His approaches to Cubism in the years between 1906 and 1909 were a decisive shrugging off of academic know-how, subjects rendered in a manner which the academy indeed called clumsy. Still in his pictures in those years and the years following there was the fresh skein of sophistication anything but childlike, the glittering web of African masks, Cézanne, color filtered out of the Spanish baroque and out of the bare Spanish hills. Cubism was after all an academy as complex as any he had accepted at the hands of his father.

It was not to be until the master was blasted free of his artistic mastery by the deafening impact of an outside event, that he was able at long last to achieve some full measure of the self-effacement and self-release, the free driving force which are the birthright of ordinarily gifted men from the start. It was the atrocity of Guernica which may be said to have liberated Picasso. It is in certain of the Guernica Studies that we feel that the old master was able at long last to place himself at the
[137] beginning, unencumbered.

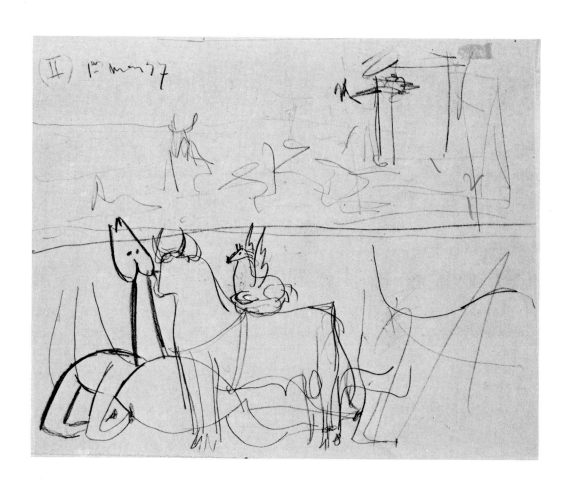

2 *Composition study* Pencil on blue paper. 10⅝″ × 8¼″. Dated "May 1, 37 (II)."

Study 2

The childhood project is muted or laid aside for the moment in favor of something more like an experienced sketching. Two horizontal scrolls are unrolled for us, evidently separate drawings one above the other. Each, this time, roughly forecasts the proportions of the mural. Picasso in his first and most elemental Study had arrived without hesitation at his main dramatic grouping; in his second (upper scene) he drives this pattern home, repeating its main elements and adding the broad proportions which were eventually to permit the entrance of more actors. These two first drawings are like two great hammer-knocks which set up the main outlines of the house at the outset of its construction.

The lightbearer again commands the scene, again put down with a heaviest pencil. This figure stands evidently as Picasso's first impulse in the making of the mural, her light-making instrument advanced stiffly in a gesture of measuring very like the gesture which the artist himself must have used with charcoal or brush in starting his canvas. She, like the artist, shows us the scene, and, as we have suggested earlier, her identity perhaps merges with that of the artist. From first to last the panorama is commanded by her emotion and her powerful arm.

The horse shows here as a crumple of lines with a vertical for the animal's rising neck. The bull, too, goes down in a flash. The creature is here turned squarely to face the center of the action, a tactic never again repeated: the experiment is an [138] isolated deviation from the prophetic plan of Study 1. The final posing of the bull, then, is an amalgam of the two first Studies—the animal first turned away from the action altogether, then turned altogether toward it.

The lower scene gives us the first of the artist's spotlights on isolated details, here the horse and the bull. The two animals, after some try-outs for the horse visible at extreme right and left, are drawn into a close community toward the center, a bond which is emphasized by the tiny Pegasus or winged reincarnation of the sacrificed [139] horse nestled trustingly on the bull's back. Nowhere in the Guernica series is the bull to show the sympathetic side of his nature more openly than in this, his first clear presentment. But at the same time an element of the animal's "brutality and darkness," its tragic idleness, may be said to be latent (as generally in the series) in the animal's stillness, boxed once again into the square of its own outline.

3 *Composition study* Pencil on blue paper. 10⅝″×8¼″. Dated "May 1, 37 (III)."

Study 3

In a first return to the kindergarten, a figure of the lightbearer carries inept rendering to its last extreme. The first two Studies were alike in that their pencil strokes had a full measure of continuity and boldness—here in this figure they do nothing but scratch and fumble, an act of baffled numbness as though the artist had suffered a stroke. The mural itself has its residue of frozen haltingness, visible virtually in its every contour: still as against the astonishing helplessness of the Study the mural figures as a fairly full recovery, a lightbearer's arm whose contour swells knowingly, the woman's hands tangled inward or fanned outward in mudras of tensely explicit emotion. The lightbearer in Study 3 comes through then not so much as a visual proposal for the mural, as an old master's exercise in humility, a ceremonial laying down of worldly goods and cleansing of pride; just as the Pope washes the feet of the choirboy, Picasso here sharpens the pencils of the child, or of the adult who has never before held a pencil.

Four versions of the horse run through metamorphoses in which the animal appears as something like an armored tank, and then again as a spider. His head and neck suggest in turn a phallus, a fish, a skull. Study 3 stands by itself: fantasy of this sort is not met with subsequently in the series, twisted or Cubist-oriented though some of the horse entries may be. In the mural the overall figure of the animal is proportioned almost classically, but for some moderate distensions and a choppy surface pattern. The free childlike invention in Study 3 would seem to stand not as a proposed choreography, but an emotional limbering up.

A few of the elements among the fanciful horses in Study 3 are fairly literal, however, and are handed over more or less intact into the mural. In particular there is the animal's wound, literal in the Study but for its size—the animal's body is nothing but an outline for its cornada, the most monstrous to appear among the works of Picasso. In the mural the gash is still oversized, though minus the spirals of the escaping bowels. And whereas this nightmarish creature in Study 3 is permitted to dance upright like a ballerina, the neighboring version on the extreme right, equally vertical, is labeled "bas," indicating evidently that in its final appearance the horse is to be returned to its horizontal.

4 *Horse* Pencil on blue paper. 10½″×8¼″. Dated "May 1, 37 (IV)."

Study 4

The ultimate and the most nearly authentic nursery project. As with the previous Study, it may have been the artist himself and his desired simplicity of mind which were served, more than any strict blueprinting of the mural.

Perhaps Picasso felt a taint of self-assertion in the extravagances of Study 3 and wanted to bring his childlikeness to a more final humility, a starting point, innocent of invention.

If so he was apparently satisfied with the result, and asserted himself to the extent of putting an "OK" on the drawing in the form of a cocky little stick figure in the corner.

Nevertheless for all its simplicity—or perhaps because of its simplicity—this sketch contributes its coinage to the final image. We see the entrance of the horse's pin-point eyes, outweighed by its nostrils, with a first hint of its protruding tongue. And of the rich parade of horses in the Studies, none forecasts as clearly as this one the final animal's hugely swelling mid-section descending in a V, emphasizing the animal's heroic achievement in lifting its body off the ground: indeed Study 4 constitutes the only occurrence in the Studies of the horse's body elevated. As much as anything in the series, the horse in Study 4 demonstrates the paradox of potency in drawings seemingly infantile, and of humility at the root of a proud achievement.

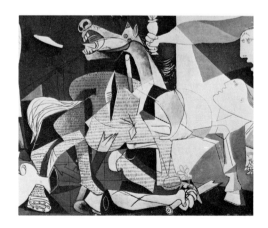

5 *Horse* Pencil on blue paper. 10½″×8¼″. Dated "May 1, 37 (5)."

Study 5

Having achieved what must have been a difficult self-abnegation in his first drawings, Picasso in a characteristically radical swing moves without transition to an extreme of technical sophistication, an almost academically-oriented figure study of the horse. Abruptly the creature is given the most complicated pose, collapses, pushes upward, curls forward, twists its neck, tenses its throat and jaw palpably in its trumpeting. Every inch of contour articulates bone and sinew, while at the same time the artist's line is at one with the animal's writhing and desperate bristling.

If the first four Guernica Studies function variously as blueprints and as a master's self-humbling, Study 5 comes through as an exercise in empathy. The artist enters, we feel, into the horse's physical experience, here clothed in its literal and visible aspect, the specific tensions of its limbs, its quality of trembling. Calculatedly he moulds his experience like a sculptor with a first mass of clay, rearranging parts, visibly lowering the line of the back, shifting the legs and neck. Steadily he gathers together his sense of collapsing and his counter-sense of struggling upward, the latter concentrated in the neck and in the upward-pushing rear leg. His experience goes down with immediate authority, solidifying as an image which sets the type for the final version of the horse.

In the mural a difference is that the animal is reversed right and left, perhaps in order to face toward the bull—like the rest of the cast of characters, to issue its appeal in the direction of that undecided mass. Beyond this the horse of the mural succeeds at last in the all important matter of raising its body off the ground, its act of resurrection which in the Study exists only as an endeavor.

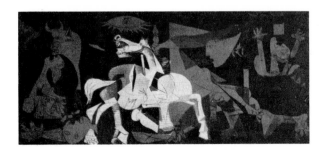

Study 6

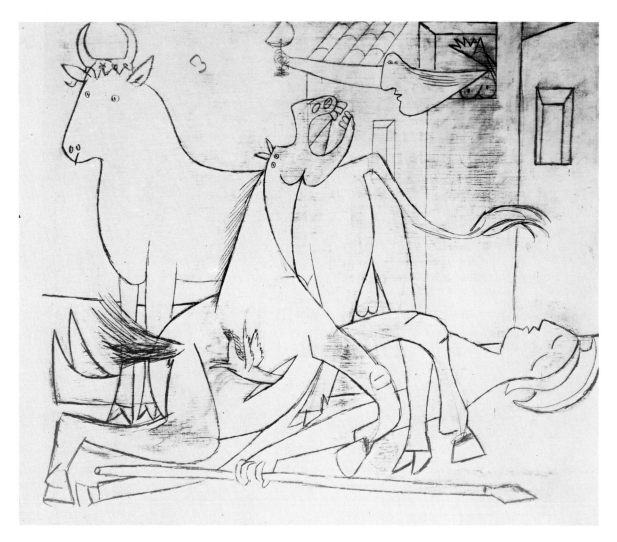

6 *Composition study* Pencil on gesso on wood. 25½″×21⅛″. Dated "May 1, 37."

A first glimpse of the mural's abstract architecture shows up beneath the tangle of this drawing, the first of the elaborated group Studies. As in the mural we see a main central triangle, the horse rising as its mass, with human extremities branching to form its lower corners, and the lightbearer's light dwindling pyramidally to make the apex. The most prominent piece in this masonry is the lifted head of the horse, an assertion which, however, is dislodged throughout the remainder of the Studies; having set up his pediment the artist topples it until State IV of the mural, for it is not until then that the horse's head is at last re-erected, and the scheme of Study 6 fulfilled.

The intimate overlapping of the horse and the bull is held over and developed from Study 2, a close community which is here further congested by the entrance of

the spearholder, a third and equal participant. We are baffled and somewhat excluded by a dense weave of extremities—a closed group. The ample horizontal scope of the mural as proposed in Study 2, is here shrunken, telescoping the actors into a state of congestion which, however, raises the question: Was this congestion intended literally as a proposal for the mural, or as another experience required by the artist, the working out of an emotion? The latter would seem to be persuasive. Study 6, precisely because of its awkward closeness, its hopeless mingling, stands as the most intimate possible bringing together of the members of the Guernica community into a tight-knit family. We feel a warm emotional state of affairs, one which is readily felt to underlie the mural despite its final dispersal of members. The mural with its larger population and broad scope still unrolls before us as a family, one whose members are somewhat dispersed and altogether diverted from their mutuality, but a family nonetheless. It is Study 6 which may be said to figure as the homestead from which this dispersal takes place.

(Indeed in the Study a certain family resemblance runs through the different members, the lightbearer and the two animals each endowed with the same button eyes—ultimately differentiated; the spearholder's eyes, serenely closed in a seeming sleep, do nothing to rupture the sense of harmony among the group.)

One member of the group, the lightbearer, is pushed somewhat into the background—her one such diminished occurrence in the series. She makes up for this by extending her two arms, stretching them forward, as we have noticed earlier, to embrace the scene in a wide sheltering or papal benediction. The idea never recurs. The alternate arm is withdrawn never to reappear; in the mural itself, the *hand* reappears, pressed modestly to the woman's bosom.

The puzzle of the bull gathers momentum in Study 6, offering the opposition between its flower-decked babyishness at one extreme and the prominence of the animal's testicles at the other, a creature at once helpless and virile. The weak-minded power presented here brings out the bull's contradictoriness as clearly as any other image in the series, and surely contributes some of its essence to the final version.

[140] A miniature Pegasus is seen to sail forth from the horse's wound, a lightsome birth-fantasy and reincarnation of the horse. Carrying over from the miniature winged horse of Study 2, there settled on the bull's back, the creature here makes its second and last appearance in the series, a schematic and perhaps somewhat over-prettified symbol of the reincarnation-theme which underlies the mural at large in its iron austerity, the horse ultimately accomplishing its own resurrection. The impulse toward wings is buried until State 1 of the mural, the stage at which the

[141] creature may be said to re-enter the scene as a bird.

A final sense in which Study 6 stands as a rehearsal for the mural is in its quality of drawing, its long barely modulated contours describing simple arcs and angles. As in the mural there is a minimum of shading, and faces bare of any but the most irreducible glyphs for features. Throughout, a generalized and impersonal quality prevents any localizing, whether of time, place, or emotion, and lends the scene its quiet suggestion of the universal, or of the universally accessible. In all of this the drawing reaches as close to the mural as any of the Studies to follow.

7 *Head of horse* Pencil on blue paper. 8¼″×10½″. Dated "May 2, 37 (I)."

8 *Head of horse* Pencil on blue paper. 6″×8½″. Dated "May 2, 37 (II)."

Studies 7 and 8

In a pair of workmanlike proposals the horse's head is plotted close to the final plan. The simultaneous view of the two sides of the animal's lower jaw is presented in full force, as though from below, the two bony arcs codified into a hard Cubist scheme which carries over into the mural. This viewing of the underside of the head, subtly stated though it is in the mural, forces us to see the horse as soaring above us and receding pyramidally, consistent with our view of the undersides of the animal's hooves.

In general the horse's parts are tacked together. The tear-shaped revolving nostrils make their entrance, also the scoring of the palate. The blinded button eyes are sewn in place from Study 6; the spike of the tongue, too, is carried over as a fixed feature, along with the ineffectual bow-knot of the ears. (But these latter are to be much hardened in the mural, the further ear to be mechanized and integrated as a nose-cone for the forehead.)

The teeth are extroverted first in Study 7 as outward-stabbing cleats, spearheading the animal's aggression, a device derived from the bullfights of 1934. This malocclusion is put through several variations in the course of the Studies, but yields in the mural to the inward-clamping teeth which retreat to their normal function as in Study 8. The teeth in this final resolution relinquish the workable initiative of the exterior cleats, but, in so doing, withdraw their competition from the tongue, leaving a more fully concentrated outward force to that organ of eloquence.

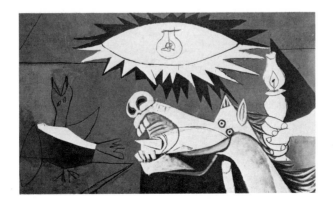

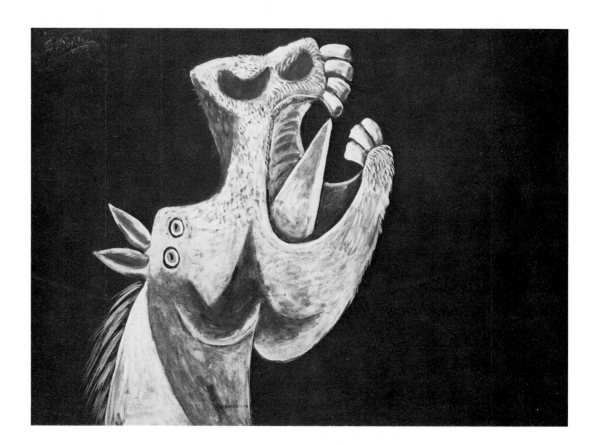

9 *Head of horse* Oil on canvas. 36¼″ × 25½″. Dated "May 2, 37."

Study 9

Translated into oils and clipped awkwardly just below the head, this heavy decapitation has the look of a detail cropped out of a larger scene. This incompleteness has a certain justice and at bottom may have been the artist's intention, since it was conceived, we may take it, as a detail to be *worked into* the larger scene of the mural. Seen, however, in its own terms, the head in Study 9, guillotined as it is by the frame of the picture, may be said to have its own physical relevance to the agony of the horse.

[142]

The upper teeth are again extroverted, this time not on the jaw's top surface or roof, but on its front surface or forward wall. This leaves the upper teeth still aggressively extroverted, yet returns them to an occlusion with the lower teeth—and would seem a workable compromise. But more than ever in this after-all unsatisfactory strategy these teeth muffle the functioning of the tongue, closing heavily over its point.

The under-edges of the lower jaws are picked out with arcs of reflected light, an added emphasis on the hinges which engineer the animal's all-important achievement of voice. The somewhat lurid under-illumination is carried over from the preceding Studies

and finds its place ultimately in the mural.

Texture is tried out, a naturalistic stubble of hair—ultimately much cooled in the regular scorings on the body of the horse in the mural.

The eyes are accented with tiny arcs for pupils. In the mural this dallying with expression is replaced by dots, the peculiar poignant blindness of an uncompromising geometry.

Softer, then, in some ways than the final version in the mural, Study 9 stands nonetheless by itself among the Studies for its sculptural and monumental quality, expressed uniquely in its medium and scale—an oil on canvas three feet in width; a high point in the long preparation for the ultimate horse's rallying, its aggressive outcry, and its superior physical presence.

[143]

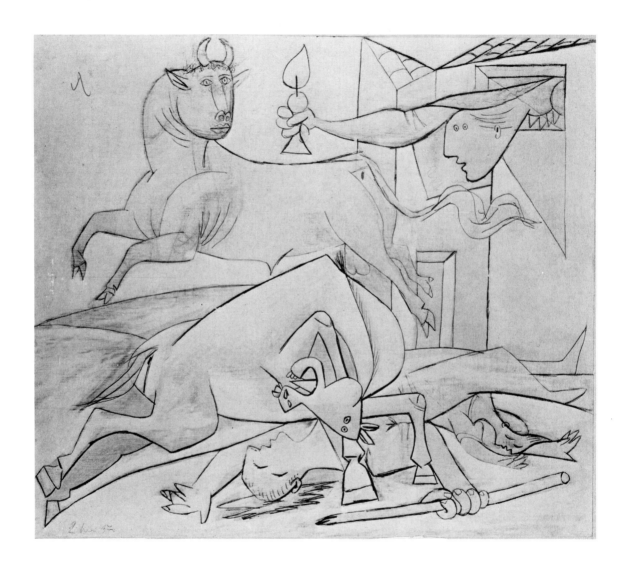

10 *Composition study* Pencil and gouache on gesso on wood. 28¾″ × 23⅝″.
Dated "May 2, 37."

Study 10

The tight family of Study 6 begins to disperse and expand. In this new group-arrangement an additional member is admitted, a recumbent female, the dormant seed, as it were, of the additional female members in the mural. The woman throws her arms over her head, in position to be elevated as the burning woman.

The Gordian knot of criss-crossed extremities in Study 6 is daringly cut in the severing of the spearholder's head, a stroke which starts off the alternating procession of animal and human parts which clumps ultimately across the floor of the mural.

This key device, the sculptural decapitation facing upward and flanked by the outstretched arms, occurs nowhere else in the Studies and is not to re-emerge until the seventh and penultimate State of the mural; once again the discoveries in the Studies flowing underground like childhood experiences, only much later to come into the open.

The horse had reared its head promisingly on May 1. The animal goes into a reversal on May 2 with a head which is wrenched downward, perhaps the better to drag its body along the ground, the rear legs pushing helplessly. The lowering of the animal's neck and agonized head may, however, be read also as a protective sheltering of the head of the fallen spearholder—an embrace of the horse and the dead man, that tender engagement which was seen first in the Dream and Lie of Franco. And for all its bringing down, the overall figure of the horse is still made to add up to a pyramid, its apex sharply modelled out of the animal's rising shoulder.

As for the bull, the animal canters indifferently across the background, his tail floating in a rapture of casualness, his face a study in emotional disengagement. As this is the only occasion on which Picasso's bull breaks loose and really moves, we may take it that the animal even when moved to action can give us no clear relevance to the making or unmaking of Guernica and its plight. A baffling neutrality is all that can be deduced; virility and a clear if somewhat abstract vision—that seems to be the most that can be expected of this active incarnation of the beast. Elsewhere in the series a certain emotional engagement comes through, sometimes poignantly, sometimes implicitly as in the scene in which the winged horse nestles on the stronger animal's back. But in those more sympathetic instances the bull is immobile: his capacity for engagement seems to expend itself either in a static sympathy, or in an active neutrality—we cannot expect, nor do we get, both action *and* sympathy from this observer. Taking the bull's metamorphoses throughout the series as facets of the artist, we see the limitation and the strength of that person. His eyes in Study 10 are keenly open, yet focused where? Somewhere in the distance, just off the mark; as though seeing Guernica, it may be, but seeing it on a screen or in a newspaper as the artist must, after the event.

It is in this drawing that the lightbearer's curtain is introduced, as we have noticed. And as always the woman crowns the scene with her light, her flame here making the finial for the composition's central vertical post—a general architecture which is bequeathed to the developed mural.

Study 11

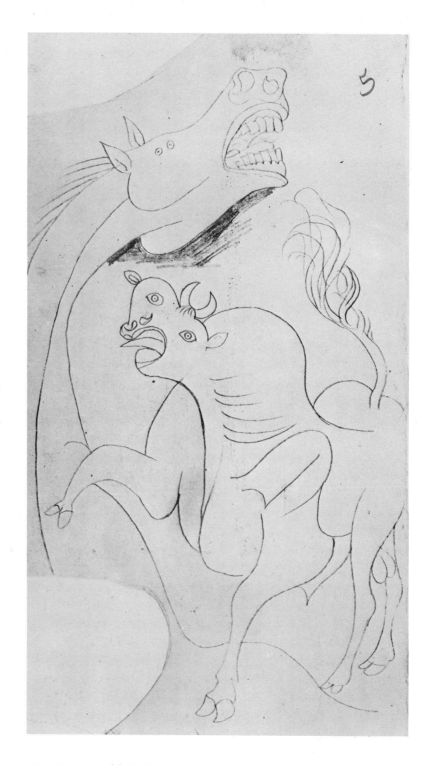

11 *Horse and bull* Pencil on tan paper. 4¾″ × 8⅛″. Not dated.

The bull is brought into contact with the horse, the one such occurrence in the series. The artist permits the bull something like a molestation of the horse, seemingly the animal's most negative moment in the series and perhaps the one apparently mean presentment to occur in all of Picasso's bulls over the years. Yet even here the bull's action cannot easily be called an attack. He might be said to trample the horse, were it not for his diminutive size. Is he, perhaps, resting on the horse? As best he offers a small harassment, a scratch. With three of his legs the bull stands still; with the fourth he irritates the horse's neck, a pettish bid for attention; even, conceivably, he caresses or consoles the horse. His act perhaps partakes of all these overtones, irresolute, senile, childlike. The more we study the animal the less sure we are of any culpability—attempting later to describe the apparently incriminating glimpse in a courtroom, we ask ourselves what exactly it is that we have seen. Must the bull indeed be condemned for having touched the horse? And if not, is he to be sentenced for his ugliness? His horns curl as though to keep out of harm's way; his eyes wander pathetically. His hindquarters wait in a gentle gracefulness, his tail reaches as though appealingly toward the horse's head. Looking again at the bull's body we see that it is not so much malformed as old, settled on its frame.

As for the horse, it offers little testimony to the bull's guilt. Its relaxed contours enclose the bull rather than shying away from it. It seems conceivable that it offers its broad back to the bull in sympathy. As for the horse's mouth, the artist relinquishes his angry devices; in a pale prefiguration of the horse in the final version, the composed trumpeting in Study 11 comes through more as a deliberate rallying than a cry of pain: and perhaps the bull, too, may be allowed something of this distinction, aggressing not with his horns, but with his tongue.

The pointed tongue (hornlike this time) is here awarded to the bull and withdrawn from the horse. This item of community between the animals is ultimately to be shared by both simultaneously, in the mural from State IV.

In the Study the animals are further at one in the wandering of their glance, which has no apparent reference to any attack or defense between the two of them, and is beamed more or less in the direction of the spectator, almost as though engaging his involvement in their common cause.

Yet after all is said, the bull scratches, the horse is not comfortable. Picasso's bull as a changing portrait of the artist is never to be simple or resolved. In the mural itself he comes to no easy balance. Ultimately his disconnected stare takes its cue, in fact, from the bull of Study 11: a carry-over of the mechanical unseeing almond shapes with dotted circles, the one eye dropped and strayed as though still not quite able to piece things together. The bull in Study 11 may be said to stand by itself. Picasso's bulls both in and out of the Guernica series are a generally organized lot, in their faces no less than in their bodies, and even in the saddest and most vulnerable among Picasso's minotaurs is not to be encountered the pitch of dislocation and helplessness which stands as the coinage of Study 11, and its unique bequest to the tragedy in the face of the ultimate Guernica bull.

[144]

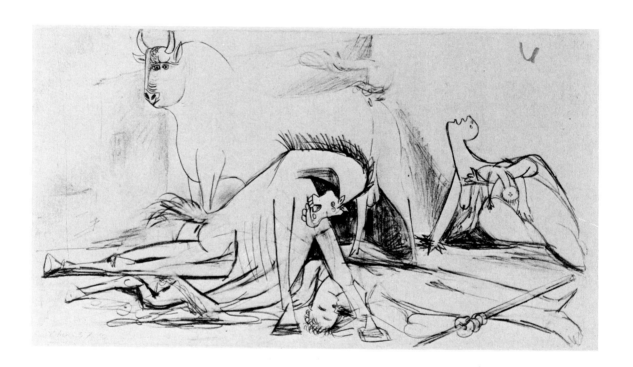

12 *Composition study* Pencil on white paper. 17⅞″×9½″. Dated "May 8, 37 (I)."

Study 12

Sooner or later it may be presumed that Picasso set out to make some developed proposals for the mural, horizontal in scope and monumentally unified in composition. Study 12 is the first of the two which seem to qualify in this line (with Study 15), yet has little air of finality. The lightbearer as central observer is here displaced by the heroic bulk of a new bull, whose still-inconclusive glance fails however to convince us (and doubtless failed to convince the artist) of the animal's eligibility for the role. Eloquence is lodged not so much in the animal's pinched and singularly vacant face as in the creature's serene and powerful body, an animal projection of the great blank wall against which we see it posed.

[145]

Occasionally throughout the Studies we cannot help asking ourselves whether the bull's ineffectualness went down involuntarily under the artist's pencil, or whether it was put there in full wit and deliberation. Of course we can never know the answer to this, and both alternatives perhaps are possible. It seems likely, even apparent, that Picasso used the Guernica Studies as a sanction and encouragement for his deepest and most unguarded impulses—yet at the same time he remains inevitably penetrating and self-governing, and it seems likely that he had a good inkling, at least, of the ironies and devastating complexities which went into his portraits of the bull. Never once does he yield to a vulgar temptation to give us a heroic symbol of unconquerable Spain, nor yet a simple ogreish bestiality at the other end of the symbolic scale. In Study 12 the bull ends as foolish, like a committee chairman who does not know one end of his gavel from the other. And yet . . . he holds his place in the panorama, a great witless hook for a net in which the unfortunate creatures below are suspended.

Within the net, the horse weighs down with the unliftable bulk of an exaggeratedly thick mid-section, spilling blood into a puddle on the ground. He stiffens his forelegs in the futile effort to raise his hulk; unable to raise his hind legs, he stiffens them or writhes them, shows his hard concentration in the sharp triangle

of his neck focused like a nail into the jagged lump of his head, while the points of three hatchetlike triangular shadows complete the assault on the head, converging north, south, and east. His teeth reverse the aggression, aiming outward, a physical pushing which obviates any vocal contribution and leaves his mouth empty of his sometime spike of a tongue. The many-sided effort is needed; the horse has a long way to haul itself before achieving its final upward resolution.

The spearholder's head is protected within another hard triangle, that of the horse's legs; the man's head is decapitated yet not decapitated, an ambiguity which extends to the final swordbearer's head, lopped yet alive. The spearholder of the Study is a picture of resignation, in contrast with the horse; soft flowing parts seem remote from any effort; yet like the lightbearer of the mural his hands express contrary emotions, one an ineffable gentle flowing, the other a hard gripping even in death. This fist is the forerunner of the swordbearer's still harsher grip, and the first seed of the swordbearer's ultimate aggressiveness.

The recumbent woman of Study 10 here evolves into the first entrance of the bereaved mother. Her upper contour is swaybacked in a sharp hammocklike depression as though weighed down with the huge stone of her bereavement and pressed to the ground. The child's head is at one with the woman's womb; elsewhere among the series the child's head repeats the mother's breast. In the mural itself this literal rhyming is not to be seen, assimilated into a pervading unity between the mother and child. [146]

Something of this plastic unity runs through the protagonists generally in the Studies and in the mural. The underlying family thread which we have observed, is exposed among all four of the unfortunates clustering at the bull's feet in Study 12. [147]

In the mural the horse and the man are no longer seen in an embrace: their energies are turned outward in a rallying which goes altogether beyond their mutuality or their physical distress; still they remain linked by the similarity of their spirit and vocal address. Physically, too, they remain somewhat interlocked, and share the same patch of ground.

As for structure, the triangle tried out in Studies 6 and 10 is here supplemented by a first forecasting of the triptych. Its panels are bodied forth in a literal architecture. The center panel is filled up and squarely defined by the bull, a scheme eventually to be moved to the left; the left is obligingly blank; the right is occupied prophetically by an upward-calling woman. Against this still somewhat lopsided layout, an irresolute triangle of horse and spearholder rises part way; as yet a thinnish geometry, yet the full germ of the ultimate plan.

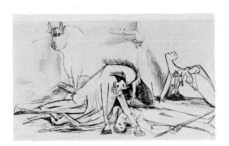

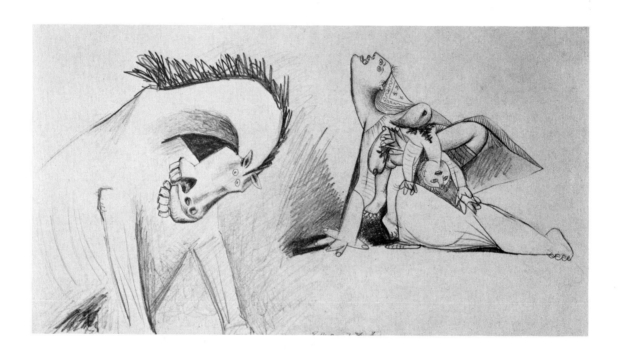

13 *Horse and mother with dead child* Pencil on white paper. 17⅞″×9½″.
Dated "May 8, 37 (II)."

Study 13

The crippled protagonists of Study 12 confront one another in a motionless pas-de-deux, a sort of tragic harmony in which the two principal figures drag themselves symmetrically toward the center of the stage from opposite sides, supported similarly on rigid forward limbs, heads turned respectively straight up and straight down; a forecast of the symmetrical choreography elaborated in the final mural.

Blood flows through many of the Studies, which it does not in the mural with its harder and more disciplined surface. Here it oozes between the mother's fingers and under her breast, but a certain dryness in it fails to dissolve a new static and decorative quality in the drawing generally, a ceremony rather than a direct emotion. Something of the abstract dreamlike quality of Surrealism is felt. The child's features are vacant without pathos; his nose adopts the pendant scheme for the mural but shows in the Study as an ingenuity, where in the mural it comes over in its small way as horror.

The woman is decked as though for a festival or feast-day, in a cloak and embroidered national headdress. This regalia shelters the group something like the lightbearer's curtain introduced in Study 10. Here, however, the stiffly-spreading finery conveys a touch of the symbolic remoteness of a grieving yet crowned and heavily decked Madonna.

The headcloth is to settle significantly in the mural. Faultlessly pinned, it is

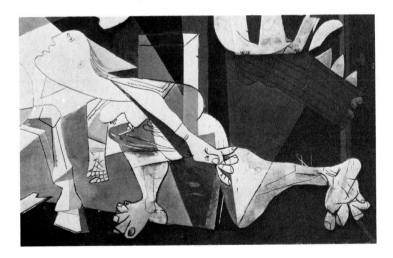

transferred to the kneeling woman; its wings are a charter element, visible from State one. The baby has been transferred across the mural, but the woman herself, empty-handed, remains all heart and emotion and kneels before an image of martyrdom: her head covered like the lightbearer's, she is, in effect, in church. Her arms are spread downward in the wide gesture of receiving which is the Spanish gesture of prayer.

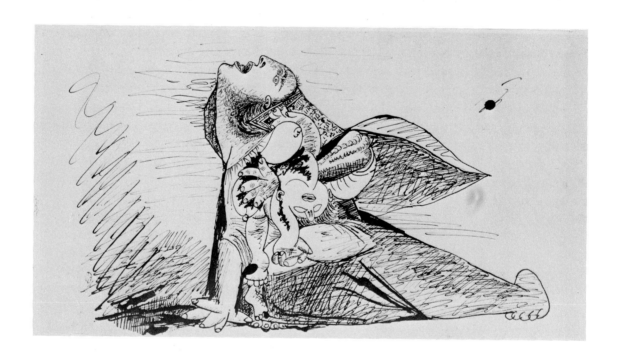

14 *Mother with dead child* Pen and ink on white paper. 17⅞″×9½″. Dated "May 9, 37 (I)."

Study 14

The mother holds the stage by herself. Again her emotion is more symbolic than immediate. A certain thick proteinous self-sufficiency pervades the group despite its nominal distress; the straight slope of the woman's leg on the right makes a [148] powerful supporting gable; the vertical contour on the left buttresses the group like a wall supported on a pillar. The woman's face has the healthy near-imperviousness of a wooden doll. Not only she, but also the child burst with a rough peasant vitality. The overall triangle is a cornucopia packed and overflowing with well-nourished animal parts and with embroideries.

Blood flows through the veins of this robust sculpture. It collects in a fan which asserts the unity between the full curve of the child's throat and the mother's opposite breast.

Perhaps the artist set out in his Studies to line up every possible kind of strength, even the strength of a physicality, every possible offering and encouragement for his final image. A number of elements rough or hard, are grafted from Study 14 into the mural. In the Study the jewel-like ear, perhaps an earring, is the pattern for the cold geometric ring which is hooked to the bereaved mother's head, indifferently flesh or metal. The powerful straight boundaries of the woman in the Study make their larger contribution, suggesting the boards which are the arms of the falling woman in the mural. The stuffed fingers in the Study evolve visibly into the mural's vibrant earthy gestures, those clumps of eloquent roots pulled quivering from the ground.

Study 15

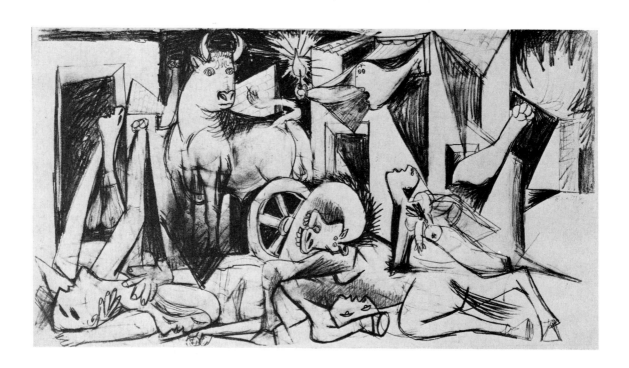

15 *Composition study* Pencil. 9½″ × 17⅞″. Dated "May 9, 37."

Executed two days before the canvas State 1, this is the most comprehensive of the Studies and generally the closest to the finished picture. Uniquely among the Studies it seems geared to the time-table of the mural and comes across as something of a dress-rehearsal. The animals are on stage, the lightbearer takes her position, a woman drops to her knee at the right. As in the mural another woman addresses the sky and holds her dead at the left, a baby hangs lifeless across its mother's arm, and death is distributed across the bottom of the scene. The houses huddle together in

place, flames rise in one corner, light and dark are put down and divided into splinters. There is so much in common between the Study and the mural that one wonders that they are in fact so unlike, cut out of different bolts of cloth.

The mural in general is the less tangible of the two, the Study the more physically accessible. The Study, that is, is a street scene, while the stage of the Guernica is set both in the street and in the house, situated ultimately not so much in space as in the mind.

The street scene of the Study

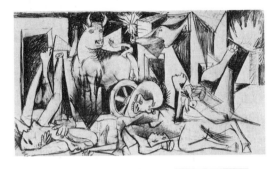

is framed by its entrances or exits. On the left is a square of wall which exists simply as the contour of an enormous door, ominously dark: a motif

204. 1903

drawn from the artist's early store of impressions, previewed in a grim landscape of Barcelona of 1903. Framing the Study on the right

is an empty avenue leading to a house which is itself little more than the setting for another door. Huddled between these passages the action of the picture seems destined to arrive and depart, an incident passing across a foreground, and the fragment of a cosmos larger than itself.

In the mural by contrast virtually no background exists; no street creates a distance, and the houses are brought down to the footlights to become, in effect, a part of the action. An electric foreground draws the space to itself from end to end, like the action on a Greek pediment. The mural does not occupy a cosmos, rather it is a cosmos.

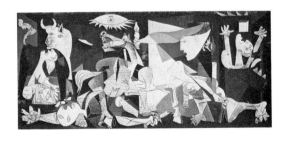

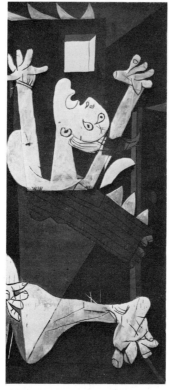

There remains, however, a narrow pass connecting the mural with the space beyond itself, a shadowy residue, in fact, of the wide passages and doors in Study 15. This is the secretive half-open door framing the Guernica on the right, at once inviting and threatening. As with the open door at the left in the Study, only darkness is visible through it. In the mural, the door itself with its implication of transiency is pushed into the dark, leaving the lights and the action to their fixedness on stage.

Light and shadow are brought into action in Study 15 as nowhere else among the Studies. The triangular shadow

cast by the lightbearer across the front of her house, outlined reticently in Study 10,

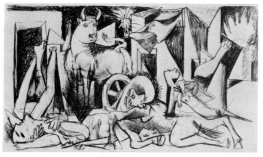

is here harshly blackened; throughout, architectures are stood in space as though with slabs of such light and shadow. These wedge-shaped slabs transcend the architectures they define, dominating the picture as its most aggressive element—variously doors, roofs, assorted cast shadows, the sky, and a central cluster of black wedges between the spokes of the wheel. Some of these dark angles are introduced for their own sake with no apparent surface logic at all, as in the semi-transparent (and very Analytical Cubist) angle balanced like a sheet of black glass across the forefeet of the bull. Logical or otherwise these black wedges dominate

the picture from side to side, overwhelming the delicate unshaded calligraphy of the figures; as shadows they dwindle rapidly downward to a point, as though cast by a source of light much closer than the sun, and more menacing. At right and left, figures turn squarely upward to face this source; fists at right and left are shaken at it; a fire, so to speak, is ignited by it; and the shadows descend in unison like the blades of axes, points pressing precisely on the contours of heads and limbs. Nowhere among the various tangibilities of the Guernica series, is there any approach to a literal suggestion of aerial onslaught, as is achieved in Study 15 with light and shadow.

[149]

In the finished picture this downward aggression is much dispersed, persisting most pointedly in the richly ambiguous image of the sun, with its white and black triangles trained like machine-gun fire over the scene. The mural has little inheritance of the specific light patterns of Study 15, other than

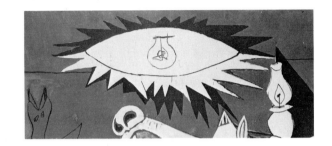

the details of the lightbearer's triangular shadow across her house,

transmitted intact but subdued by surrounding grays. Shadows in the mural tend to be scattered so that solids are dissolved even though their contours re-

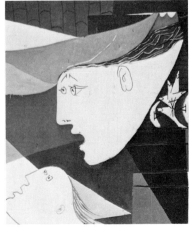

main whole, and among such shades of persons and houses there can be little sense of physical impact from whatever direction. Light sifts consistently downward from the lightbearer's lamp, but only as a beneficence. Again the mural comes before us as something less tangible than the Study; not so much the event, as a balancing of the event in reflection.

Study 15 with its orchestration of light and shadow, is the only occasion prior to the mural in which there is a question of night and day, the lamp and sun of the mural. Night is suggested in the Study by its blackened sky, and by the lightbearer's lamp; and at the same time something like daylight is reflected in the general spreading of light and casting of shadows. But for all their spreading, the lights have no more suggestion of the warmth of day, than the icy solar eye which takes their place in the Guernica; warmth in either picture, is a property reserved for the lightbearer's lamp—the image of night.

Light and shadow in the Study no less than in the mural, then, has its functioning outside the localities of time. As for day and night, they are dammed up and

205. 1930—31

stopped in their progress. They are present simultaneously, like the traditional sun and moon which are simultaneously present at the crucifixion: and present also, as we have noticed earlier, in the Guernica State III.

There is perhaps more deliberating of space composition in Study 15 than elsewhere among the Studies, but far less than in the mural. The one comes to us as an impromptu, the other as a finished fugue.

In the Study the mural's overall triangular tableau is roughly set up, but with a solid overlapping and receding of plastic forms which gives the arrangement a heavier pyramidal suggestion than that to be found in the mural. The flattened aspect of the structure, the pediment, is virtually absent prior to the canvas itself; this lighter and more subtle form, with its artificial separateness and balancing of parts, is prepared for in the Study only in the regular lining up of elements along the bottom edge. Again the Study comes through as the solider, the mural as the more intangible structure.

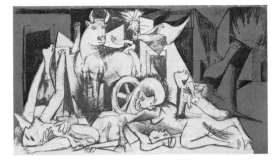

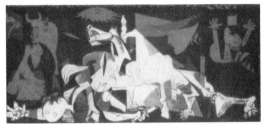

The triptych, like the triangle, is roughly foreshadowed. The wings at left and right in the Study are formed by pierced flats. The left is dominated by an open door. The right presents another void, a special Cubist (or Surrealist) ambiguity of space, seemingly an overall rectangular block (intact across the top) which is at the same time a receding vista of flames and a distant house. Both panels, then, consist of framed openings, invitations to animal or human passage. In the mural this invitation is accepted, the panels are filled and defined by members of the cast. Paradoxically enough, the personages of the Study, while more flexible and somewhat solider than their papery descendants in the mural, are less confident in their positions, and do not assume the architectural responsibilities assigned to them only in the developed mural.

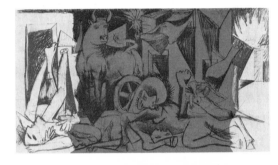

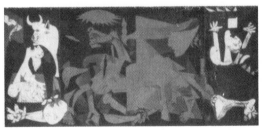

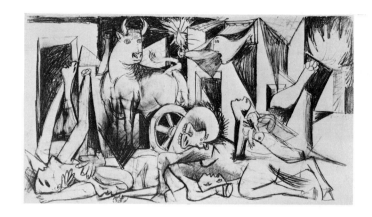

Of the tangible differences between the Study and the mural, perhaps the most arresting is the spoked wheel at the center of the Study, rustic or antique in character like everything in the Guernica series. Solidly set in black and white, it draws the eye to itself, somewhat eclipsing the more lightly drawn forms around it. Somewhat enigmatically it is rolled heavily into place by itself, attached to nothing, and a fugitive, it would seem, from the Minotaur's cart of 1936 (The Minotaur Moves His House, shown above in Chapter Three). In this work of the year previous we see the horned creature supervising the drama of life and death, an image perhaps not altogether irrelevant to the role of the bull in Study 15; compassionately but inexorably the Minotaur moves the mare along her bumpy road despite the on-going delivery of her foal; the cart, supporting the mare, supported by the Minotaur, serves as a link between them, a vehicle for the Minotaur's power, the mare's agony, and the birthing of new life. The linking of ambiguous power, of agony, and of resurrected life, may be seen as of the essence of the Guernica and its Studies; and it is this tumultuous essence which perhaps pivots around the symbol of the wheel.

[150]

Fifteen years later the drama is enacted with a different series of masks. Wheels, not unlike those we have seen in the examples of 1936 and 1937, support the war chariot

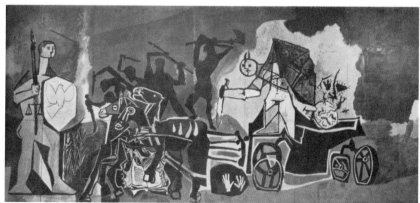

206. 1952

in Picasso's War mural of 1952, the later anti-war declaration in which war horses trample books, and the wheels convey a figure with death-germs and dagger.

The War focuses where the Guernica does not, on the person of the war-maker. Here a somewhat unpredictable turn is taken. Surely Picasso, veteran of innumerable raging bulls, could most readily have given us a convincing predator; yet the title role of the piece is played by one of the master's more appealing fauns, while three somewhat pathetic drays clop patiently ahead of their great haying machine. The tragedy of war, the picture seems to say, is precisely that it proceeds from God's helpless creatures, not from monsters. A two-sidedness, a rueful ambiguity, lies at the heart of the picture—and extends evidently to its various details such as the wheels.

All four of these are illustrated in detail, and perhaps confirm (at a distance of fifteen years) a martial importance of the motif in Study 15. As in the Guernica Study, a prominent section of the picture is given over to this mechanical display: but surely it is ridicule, as much as horror, which these tricycle-sized attachments are meant to communicate, bumping painfully along on their flat bottoms—the war-engine as an obscene toy.

There is, of course, no such obvious engine in the Guernica Study: the wheel seems associated there (if it is associated with anything) with the figure of the bull.

We are presented, it may be, with the vague suggestion of the bull as a kind of war-engine personified, a sort of Trojan horse: again the wheeled toy, monumental, it is true, less obscene than that of the War, but no less frustrated in its motion. Indeed a level line, not unlike that of a wheeled platform, is visible under the animal's forefeet, while the wheel's upper spoke is in exact position to function as surrogate hind leg for the animal; certainly no other rendering of the leg is visible, in a figure whose every other part is richly complete. (Could a toy in the Picasso household, have given the painter his idea for this image, with its overtone of pathos and inutility?)

A chariot—perhaps. At any rate we hesitate to put the bull down as a chariot of war, or, for that matter, any other image of aggression. Like the War faun, the bull throughout the Guernica series declines to be cast as the god Mars. If the animal in Study 15 is to be a chariot, let it as readily be a chariot of peace; an ox-cart; or sergeant Yoldi's oxen dragging a motor-ambulance—that tragic toy. Altogether the bull of the Study, like those of the mural and of the series generally, seems no less ambiguous than the more gently horned creature of 1952; and as for the wheel itself, it epitomizes this ambiguity, its power accessible indifferently to good or evil. (Nevertheless the heaviness of the wheel's rendering, with its position atop the bank of crushed bodies along the bottom of the picture, gives the object ineradicably a brutal overtone—lends it its overtone of juggernaut, an overtone which still perhaps clings to the Guernica bull.)

Whatever its iconography, however broad or narrow its ambiguity, there is one sense in which the wheel comes across as alien to the spirit of the developed mural. Inevitably the wheel had to be abandoned, for wheels must move, and describe a progress in space and in time. Little such progress is suggested in the choked or flattened wheels of the Study and the War, and it is this form of progress which is cauterized altogether in the Guernica with its consummated motionlessness, its timelessness, and its transcending of place.

The bull of Study 15, like the wheel, is a highly physical presence—perhaps the most richly plastic form to appear in the Guernica series. For all its immobility, it swells with muscle, bone, and sinew. A Cubist triangle of shadow settles on its back, but Picasso has modelled the beast elsewhere in sensitive light and shadow and a commanding naturalistic contour.

The bull of the Guernica itself derives its main outline, reversed in mirror-image, from the bull of Study 15 (together with that of Study 22). In the mural the animal is flattened and generalized, and further has relinquished the central position it enjoyed in the Study. It has lost much of its large relative scale, too, dwarfed by the immensities of the light-bearer, the horse, and the swordbearer. Nevertheless the Guernica bull, cooled down and pushed aside though it may be, shares with the bull of Study 15 its pose and much the same underlying physical alertness and virility.

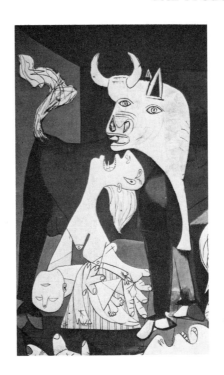

Not the least significant aspect of these animals is of course their virility. The body of the animal in the Study and in the mural both, is curved in a manner not unfamiliar in Picasso's bulls, so that both ends of the creature are twisted around to confront us at the same time, presenting with equal frankness and a kind of insistence its face and its sexual organs. Picasso's bulls over the years go through every contortion in order to achieve this double exposure, and, in Study 15, the all-important testicles are displayed at almost the exact center of the composition, a hub for the picture more central than that of the wheel. They form also a point on the central vertical axis together with the lightbearer's flame, whose shape they repeat. In the Guernica itself, this central emphasis is abandoned, the testicles figuring more discreetly within the circle of the bull, the mother, and the dead child.

[151]

As for the Guernica bull's head, while it derives from Study 15 in its position, it is allied to other, more "abstract" Studies in its details—a complete swing from the literalism of Study 15. The bull of the mural stands in fact by itself; nowhere among the Studies (not even in Study 11) is the animal's head wrenched so radically this way and that from its vertical axis, making a flattened rectangle with the brow pulled independently to the left as though distended with its unnatural pressure of thought or emotion, and the opposite eye wandering grotesquely from the zone of the face as though on its own desperate errand of seeking. This is of course a measure of the achievement made possible by the artist's experiments in the Studies: a final expressiveness which by its tortured nature is furthest from the extreme of physical normalcy set down heavily like an anchor in Study 15.

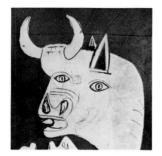

The panorama of the Study is dominated by the bull's brilliantly perceiving eyes. More pointedly than elsewhere in the series we sense in this animal Picasso's portrait of himself, the bull in his capacity of observer. The Study represents the high point in the bull's clarity and aggressiveness of seeing, and the anchor, so to speak, by which this function in the animal is most definitely established; the sense not only of vision, but of the concern behind the vision, the body itself fairly bristling with perceptiveness. For all its aggressiveness there seems a burning sympathy about this wide stare and gentle contracted mouth; when indeed have Picasso's own eyes looked anything but similarly intense, raking in the world around them with their glance. [152]

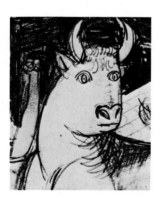

If the bull of this drawing comes across as the observer,

the rest of the cast functions as the observed, whose own eyes do not matter—their eyes nullified as smudges or pathetic buttons. Nowhere else in the Guernica series are the other figures dominated in this way by the vision of the bull: least of all in the mural itself, once again a complete swing from the surface pattern of Study 15.

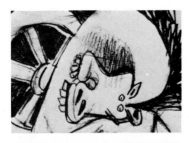

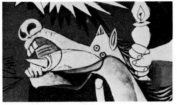

Button eyes survive in the Guernica only in the special case of the horse, whose energy is focused not in its vision but in its voice;

elsewhere in the mural, especially in the case of the lightbearer, the more active members of the cast rival and even surpass the bull in their intensity of focus.

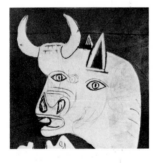

In the same way that the bull is moved to one side, his eyes are settled finally in their quality of absence, their more subtle and more tragic state of achieving the act of seeing are against odds, against distances.

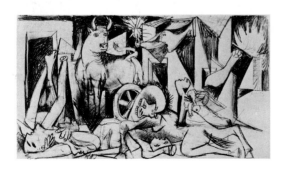

Vision is not the only element giving the bull its dominant role in Study 15. The bull's roundness and natural fullness of presence, is intensified by its contrast with the other members of the cast with their mechanical or melted parts: altogether a drawing divided against itself, in something of the tradition of Cubist collage with its literal objects intruded amongst abstract shards. Little of this

kind of division persists into the mural with its greater consistency of style and its dispersal of emphasis. In the mural the bull's eyes, ears, nostrils, tongue, all are adopted variously by other members of the cast; even a measure of its physical invulnerability is shared by two other personages, the lightbearer and the kneeling woman. Nothing about the Guernica bull is larger or more powerful than the lightbearer's arm; nothing could be more final than the kneeling woman's lowered knee. In the mural the bull ends, then, among personages which bid to match his physical presence: the defeated bodies which stretch across the bottom of Study 15, are metamorphosed entirely in the mural.

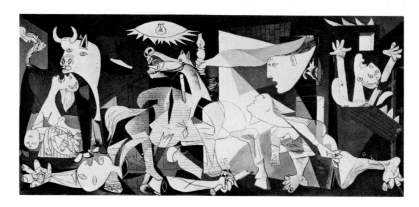

In particular there is the final emergence of the triumphant figure of the horse in the Guernica. This emergence was in a sense inevitable, given the dogged persistence of crippled creatures which lead up to it in the Studies. None of these are allowed

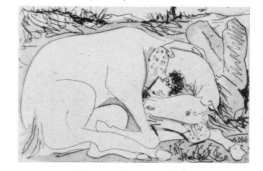

207. 1937

the gentle passivity seen outside the Guernica series, as in the Dream and Lie of Franco;

consistently in the Studies we find an anguished (though not yet precisely a defiant) raising up of the head, or a head lowered not in resignation but in

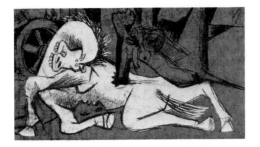

an angry effort at dragging a crippled body along the ground or raising it to its feet, as in Study 15. Furiously this creature of the bristling mane and downward-twisted neck drags itself through six of the Studies, contracting its neck the better to grind its jaws; with the States,

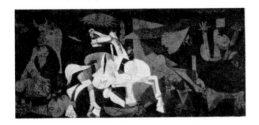

sheer determination brings the animal to its destiny, which is that of raising its body at last—and finding its voice.

Study 15 falls midway in this long road to Calvary and culminates the curious aggression which was built up in the preceding Studies: *all* the horse's teeth thrust outward and foreward, suggesting, with the jaws, a pair of spiked clubs or brass knuckles. Deprived of its teeth, the useless mouth-opening retreats to the interior of the profile, shrunken like the eyes; the head as a whole, shaped like the head of a mallet, relinquishes any function except that of ramming.

The symmetrical mallet shape is foreshadowed outside the Guernica series, in the centurion's horse in the Crucifixion drawing of 1930. Here the toothed aggression is intensified not by an advancing of the teeth, but by their grinding. The aggression both here and in the Study is, however, achieved at the expense of the animal's clarity of voice: teeth alternately stop up the mouth and, in Study 15, seal it over. Neither muzzling device appealed to Picasso except in passing, or as steps toward the solution achieved finally in the Guernica horse.

208. 1930—31

Here, somewhat impossibly, the open
voice and the closed physical thrust are
conjoined. The mallet shape is made to
persist in the square ending of the mouth,
at once cavernous and solid, presenting its
long straight exterior line from the nostril
to the chin. Through this front the horse
leads, not with its teeth, but with the
spike of its metallic tongue, sharpening
the physical thrust no less than the already
resonant voice.

The human members of the cast in
Study 15 are permitted no such special
advantages as teeth or tongues or mallet
shapes, and indeed their gaping faces
border on muteness. They are entirely
bodiless, except for the nullified sack of a
body pertaining to the stumbling woman.
Expression is concentrated in the gestures
of hands and arms.

The lightbearer's gesture as always
takes precedence of place, surveying and
protecting the scene from overhead. As in
Study 10 she shelters the scene, not only
with her arm, but with her extended
curtain. In line with the heavy space
chopping of Study 15 with its descending
triangles, the curtain here plunges in a
steep hard overall rectangle: its banner-
like sweep projects the voice of the
woman more aggressively than her facial
features, with their somewhat ineffectual
note of revulsion and restless anxiety, the
button eyes askance. In

the mural the lightbearer's cloth reverts
to a feminine softness of outline, and with
it the expression of the face. Not so the
continuing defiance of the woman's arm.

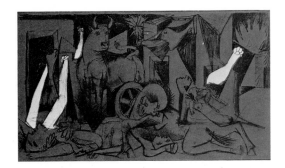

Gesturing in the Study reaches its climax, however, in its unique array of bodiless arms and fists. More openly [153] aggressive perhaps than anything else in the Guernica series, vengeful even, these are trained upward like the anti-aircraft which the town of Guernica did not possess, amplifying the lightbearer's gesture and carrying it into a vertical key. As we have noticed earlier, these rising arms are foreshadowed in

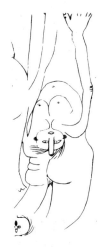

the Magdalene's loosely waving limbs of 1929

209. 1929

and in her clasped hands of 1930: the [154] aggression

210. 1930

of this sequence culminating, as it would seem, in the closed fists of 1937. Two of the arms shoot up rocket-like from among the inert forms at the left. Swollen with rage, two others push from windows scarcely big enough to emit them. The tiny pill-boxes of houses left and right, are too small to accommodate any actual owners of these limbs; the human being is extinguished or rather diverted entirely into its arm, all furious gesture.

As against this display of extended fists is to be seen the sludge of crippled forms which continues to drag across the bottom of the scene. Gestures count for little in this zone of the picture with its two defeated women. The woman with the [155] dead baby at right supports her weight with a downward push which is without alternative for the woman, and essentially passive; rather startlingly, a maximum of misplaced aggression is packed into it; scored more heavily than any other gesture in the picture, it pushes directly into the belly of the horse, suggesting, almost, a renewed goring or rape of this already much put-upon animal. This unsatisfying undertone emphasizes the ultimate insanity of the scene, horror breeding horror like light in a house of mirrors.

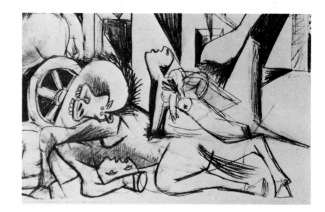

Where the one gesture is tragically pointless, its counterpart on the left is merely passive. The gesture of the bereaved woman there expresses consolation rather than fury, the inward-closing bud of the wide gesture in the mural.

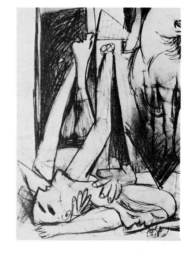

The voices of the women are as ineffectual as their arms. The two figures yearn upward at left and right, their upturned faces and stretched throats mirroring one another's physical helplessness, the pattern of this two-part invention in the mural: but here the women are seen to mew or grunt at the heavens rather than to shriek and yell.

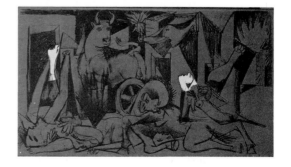

Outside of the two women, the situation in the lower depths of Study 15 worsens: physical cancellation is pushed to its last extreme in a French Revolution of decapitated heads. These assert nothing at all, entirely dormant seeds of the swordbearer's defiance in the mural. Two of these bulbous vacuities, at the lower left, are attached to the same neck, a monstrosity of physical functionlessness. A third head

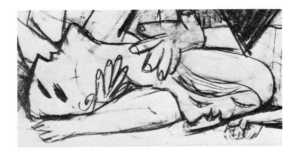

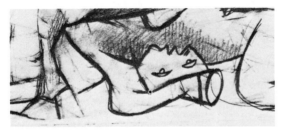

has no parent body other than its enclosing by the leg of the horse, a new variation, it would seem, on

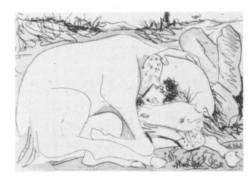

the tender but passive embrace in the Dream and Lie of Franco. As for

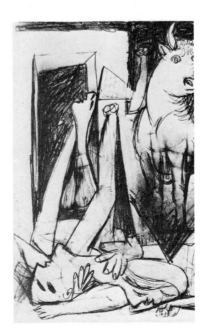

211. 1937

the horse itself, outside of this protective gesture, the animal's own emotion is expended in the as yet futile effort to rise to its feet or haul its belly along the ground.

Coherent aggression in the drawing remains a function of the upraised arms, some isolated at their tower outposts, but others planted with a certain insane intimacy into the midst of the defeated group on the left. Here these arms bring into the closest juxtaposition the apparently irreconcilable opposites of the scene at large, separate to the last: defiance and defeat throughout the picture, no matter how closely they may be drawn together, still remain precipitated into separate layers, the one tending to rise, the other to settle along the bottom.

In the Study there is one presence standing altogether outside this duality:

the figure of the bull. He stands balanced and independent, defeated perhaps in his immobility, yet defiant in his vision and physical presence. Ultimately in the mural this fusing of opposites is achieved not only in the bull, but throughout the cast of characters, so that no image of pure defiance or pure defeat persists (except in the dead baby). The

floating arms of Study 15 are

brought down to the bottom of the scene, where they are attached to the service of their antithesis, the floating heads; or are

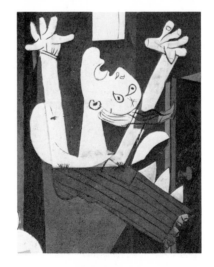

united with the body of the burning woman, a figure, precisely, which falls. As with the action of light and shadow, there is no dominant rising or settling. The keynote is the horse's wound, which points both up and down. Sky and earth, so to speak, are addressed impartially,

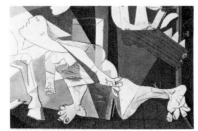

faces addressed upward while hands with an equal forthrightness are addressed downward. As in so many ways, the quality of balance in the finished picture is the product of the separate intensities which are given their head among the Studies.

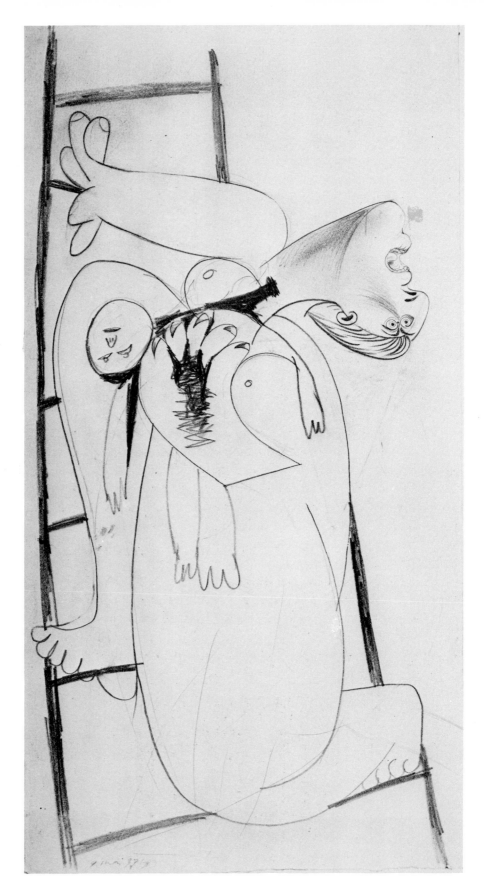

16 *Mother with dead child on ladder* Pencil on white paper. 9½″×17⅞″.
Dated "May 9, 37 (III)."

Study 16

The artist's impulse toward broad orchestration in the Studies, was consummated and finished in Study 15. Work on the canvas was to take over two days later, coincident with Study 22. With the present drawing the chamber music of variations on isolated themes is resumed; the image of the mother escaping down a ladder, would seem to be an independent fantasy, never worked into a group Study, and was perhaps judged too intrinsically sluggish to be considered for the mural.

A soft sluggishness is virtually the drawing's theme, altogether a descent, the woman's body and leg melted into a great descending pillow, her limbs boneless, the child a rag doll. A sense of hardness is seldom imparted by Picasso to his pictures of women, except when they are exiled cleanly from the human race to begin with as sometimes in early Cubism. The ultimate rigidity of the women at right and left in the Guernica must have been somewhat difficult for Picasso to arrive at—their brittleness essential, as it turned out, to his theme of a diamond-hard resistance. Study 16 is a gesture in Picasso's usual direction, a divided vision in which the soft passivity of the woman is put into conflict with a hard disaster. Her resistance and anger are expressed in the isolated detail of her head, and there her femininity is relinquished in favor of features heavy and mannish. For the rest she identifies passively with her means of escape, her shin rhyming with the direction of the ladder's lower rung, her escaping blood paralleling the upper rungs.

Nonetheless her image is not without its direct potency. The top of her head descends too, flung completely backward, the introduction of

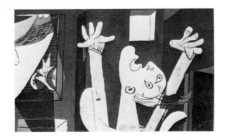

the falling woman's unnatural inversion in the mural, nature forced upside down.

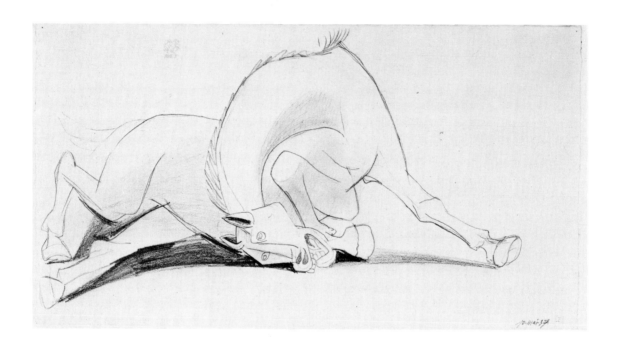

17 *Horse* Pencil on white paper. 17⅞″×9½″. Dated "May 10, 37 (I)."

Study 17

The spotlight turns again on the throes of the horse. The animal's neck would appear to be broken, and describes a curved trajectory of the descent of the head, which hits the ground almost audibly. Still the creature resumes its struggle, pushing the ground horizontally with its rear hooves, pushing and writhing helplessly with its forelegs, its ears pricked and teeth gnashing.

The horse in its pose and triangular silhouette is a revival of the animal as it appeared in Study 10, the shoulder accomplishing the apex which is eventually to be crowned by the raising of the animal's head. Humbled by its bringing down to the hoof, the animal's head is ultimately in the mural to be replaced by the head of the swordbearer, culminating the mutuality and exchange between these two person-ages.

[157]

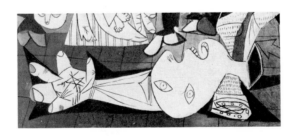

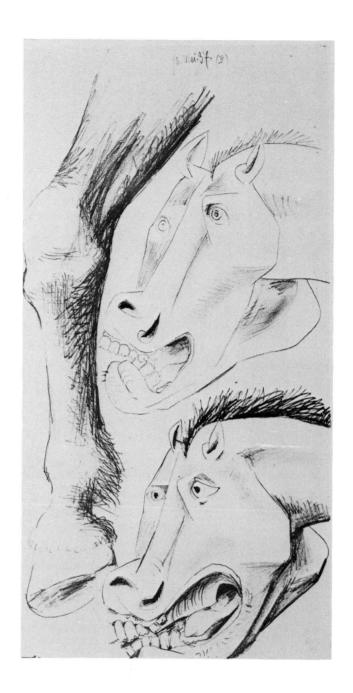

18 *Leg and head of horse* Pencil on white paper. 9½″ × 17⅞″. Dated "May 10, 37 (II)."

Study 18

Here we are invited to execute a traditional Cubist hat dance around the horse's head; seeing its parts in rapid succession from different vantage-points; from below, for the two jaw-bones, once again present (here quite naturalistic in themselves); from the further side, in the case of the further eye which is shown as though in full face; from the three-quarter rear, in the case of the closer eye, whose front corner disappears from view (lower drawing); from the inside of the mouth, in the case of the palate grinding into view with its exposed ridges.

This kind of Cubist agitation is generally cooled in the mural. Conflicting facets there are reconciled within a flat planar unity, in the faces of the human beings. Throughout, the further eyes without any forcing are brought into the flat scheme, so that there is no need for us either to dance or to walk, but only to stand still.

The horse's head in the Guernica, makes the strongest exception to this screenlike unity. Carrying the voice of the mural, it is allowed a strong tangible sculpture. As in Study 18, the mass has its sculptural contradictions; in its own agony of disjointed parts, it forces on us a kind of agony of disjointed perception.

[158]

Study 18 offers also an entirely academic horse's leg. This literal limb relates to the mural in its own way; it forms the raw material of

the forward leg of the Guernica horse; reversed right and left, we see that angular extremity in all its essentials, but for an ironing-out and simplifying which is imposed on it. As we have observed, the Guernica horse in its main outlines is proportioned almost classically—in line with its classic heroism.

19 *Head of bull* Pencil on white paper. 9½″ × 17⅞″. Dated "May 10, 37 (III)."

Study 19

Executed the day before Picasso began work on the canvas, this first of several close interviews with the bull (or the Minotaur) gives us in sharp focus that creature's first function, his vision. Advancing nakedly into the open, the irises of the eyes overlap the contours of the eyelids. (The lids themselves drift off indifferently, their corners uncompleted.) Luminously the irises come at us like doctors' head-mirrors, reflecting without comment.

The mouth adds little comment of its own. It cannot offer comment; these lips, composed but inwardly smiling, are precisely the lips of the draughtsman successfully immersed in work.

Yet, is it only the artist who is shown? We all have eyes, and frequently use them without comment. Perhaps Picasso's creature reflects a moral withdrawal of artists, people, creatures generally. In this protean creature something of the range of the two sexes seems to confront us—relatively feminine in the mouth, masculine elsewhere. The animal features, the nose, ears, and horns, relate the creature to nature in general.

Vision, vision abstracted, seems to be the burden of this version of the bull. Symmetry and youth are present, but range themselves behind the working of two irises.

For all its serenity, or at any rate its equanimity, this image foreshadows something of the tragic figure of the Guernica bull—that more complex creature's uncommitted power, its lips parted in an attempt at speech, the mirrors of its irises [159] reflecting helplessly.

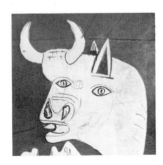

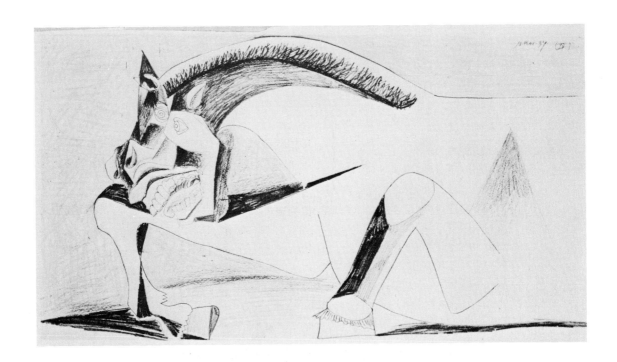

20 *Horse* Pencil and color crayon on white paper. 17⅞″×9½″. Dated
 "May 10, 37 (IV)."

Study 20

The horse resumes its irregular ascent. Its hind legs count for nothing and are excluded. Its body (the last appearance of its body in the Studies) is here a huge cylindrical mass, grotesquely beyond lifting; a distant prefiguring, nonetheless, of the enormous horizontal rotundity of the final horse's body.

Thin shadow-daggers stab in contrary directions, indicating the presence of hard lights both right and left; fires, for example, or bombs exploding?

The figure alternates between bland abstract flatness (the body) and chiseled sculptural mass (the head), a separate precipitation of the abstract and the concrete, isolating the two levels of the Guernica itself with its oscillations between these poles.

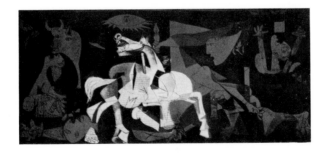

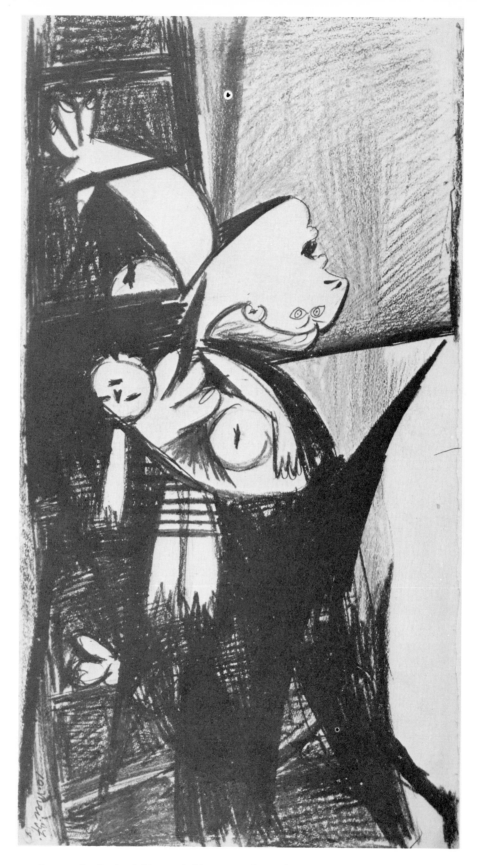

21 *Mother with dead child on ladder* Pencil and color crayon on white paper. 9½″×17⅞″. Dated "May 10, 37 (V)."

Study 21

Sabre-like flames engulf the mother as she makes a second and last descent on the ladder. The flames are repeated in miniature in a dagger-like shadow which covers the *upper* surface of her upturned throat, cast apparently by the flames below—if such literal plotting is indeed part of the scheme. There is at all events a theatrical luridness about the shadow above, the light below; more or less in keeping with the melodramatic event and its staging in raw children's crayon.

The woman's downward acceleration is broken by a curious fixing of her hand and one of her breasts *behind* the ladder. And a far broader stopping of time is achieved in the close equating of the mother's breast and the child's head; a merging of the generations, and of life and death.

A hard black edge, perhaps a horizon, cuts across the background and jabs into the woman on the right. It reinforces the horizontal of the rungs, and so assists again in breaking the woman's descent. It offers the pattern for the sharp dominant horizontal which divides the figure of the falling woman in the mural. It is this division in the mural which assists structurally in the stopping of time, permitting the descending form of the woman its measure of fixedness.

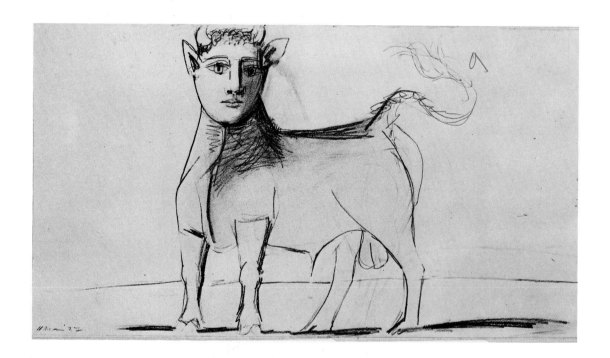

22 *Bull* Pencil on white paper. 17⅞″×9½″. Dated "May 11, 37."

Study 22

On May 11, the day work is commenced on the canvas, it is the bull who takes his turn in a fresh disguise in the Studies. The drawing is his only full solo appearance anywhere in the series. Despite the isolating of the body the eyes compel us first. The animal's vision cuts through to us in the isolating of the irises, again set slightly forward of the eyelids, as much observing as observed.

This human-headed reverse Minotaur is sharply pricked out in the thin shadow-dagger resting on its back, like that of the mother's throat in the previous drawing. The hard triangle is repeated in one of the ears, a piece of unnatural metalwork which is moved intact to the final version of the bull. The contrast between the hard ear and the soft, in the Study, sums up the two-sidedness of the creature, brutal yet sensitive.

Not only the ear, but the overall figure makes (together with the bull of Study 15) the closest pattern to occur in the Studies, of

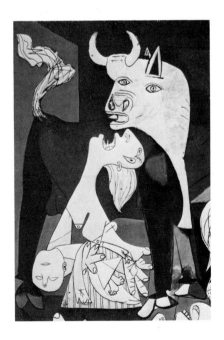

the body of the final bull, again reversed right and left: the specific rectangle of the body, the simple arcs and angles, the alert masculine set, tail afloat, and head and hindquarters turned to the observer. But in the Study the masculinity of the body, so insisted upon in the testicles, undergoes an abrupt aboutface in the soft feminine oval of the head. The mouth (as in Study 19) suggests that of a sensitive woman; and similarly the exquisite enlarged eyes. Male and female no less than animal and

human, the totality is a cross-section of life. In its teeming vitality it hardly needs to move, its action is within itself; it stands self-sufficient, watching.

The sufficiency of this image is based partly, it would seem, on Picasso's habit of populating his fantasies with the likeness of the current woman in his life, at this period Dora Maar. Looking at Picasso's portraits of Mlle. Maar of the year previous,

[160]

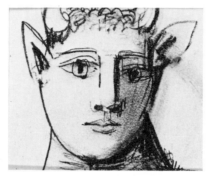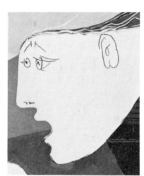

212. 1936

we are no doubt right in seeing in Study 22 the oval of that watchful face with its hint always of sadness, the same delicate composed lips and long nose, the tilted serious eyes and long straight line of the brows. We are confronted, it would seem, with a kind of total or dual autobiographical presence, the artist's physicality and pride planted staunchly as a pedestal for his mistress's face and delicate consciousness. The feminine face is made to take its strange post in the most natural way without a trace of self-consciousness or owlish humor, a fantasy plumbed to a depth where only truth is to be encountered.

This bold entente and sexual crossing is not met with elsewhere in the Guernica series or for that matter in the works of Picasso, if indeed in art (unless in sculptures of the god Shiva merged with the goddess Parvati). A trace of the same dark beauty is, however, perhaps transmitted in turn to the face of the lightbearer of the mural, and the picture surveyed and climaxed by the same tilted luminous eyes. In the personage of the lightbearer we have already noticed a signature of the artist, the thrust of his artist's gesture and of Picasso's peculiar distressed glance: and it would seem that the vehicle for this glance is the face forecast in Study 22, the guarded countenance of Mlle. Maar broken up finally in Picasso's own anguish, the set lips opened in horror and compassion.

The sadness and compassion is surely the main current of this progression. The universality or bringing together of opposites in the creature of Study 22 might be said to parallel the double exposure of sun and moon at the crucifixion, a "sorrow of all creation." For its glance is exquisitely compassionate—rather than serene. Beyond its surface impassivity we make out the distant elegiac sadness. And it is this sadness, without the lyricism and inward composure, which contributes its current

to the baffled glance of the Guernica bull; another distribution of the artist's presence, this time sexually unified.

Yet male and female, a bull's body with the face of a human, these are only the beginning of the creature's confusions in the Study, for we notice that the face, profound though it is, does not belong to the body physically, but is added as a mask. Its oval is separate, cutting in front as artificially as a mask of papier-mache.

Real and false. Who, then, is behind the mask? The bull, the artist, his mistress, or that other observer, the spectator? Or any life which observes. . . . Looking again at the final Guernica bull we see that it, too, is fronted by a mask, a head divided from the body by a sword stroke of white on black. Life itself when it is deeply realized, is a mask—has some other life ranged behind it.

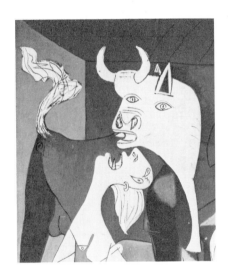

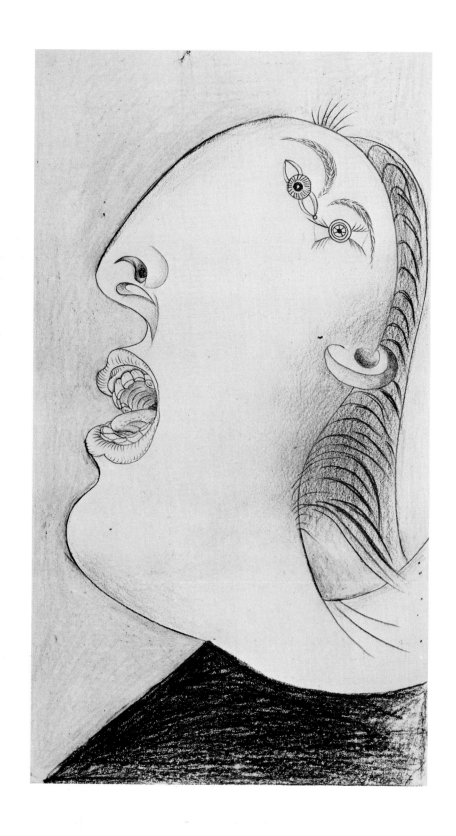

23 *Head of woman* Pencil and color crayon on white paper. 9½″ × 17⅞″.
Dated "May 13, 37 (I)."

Study 23

The extroverting of irises is picked up as a formula, released to other protagonists—the lead motif of this first close-up of the screaming woman. Intense vision is not the exclusive property of the bull; in the mural this key faculty is shared by virtually all the participants, with the exception of the baby and the horse—everywhere eyes searching, beseeching, accusing, commanding. In the hard discipline of the mural the externalized irises as such, however, are mostly tucked back into place. They do survive, subtly and luminously, in the eyes of the lightbearer.

A score of picky details are planted like pins into Study 23; the radiating of the irises, the eyelashes, tear ducts, hairs of the eyebrows, taste buds, and so forth. The drawing seems to offer a neat list of what the artist did not want; like many of the Studies, its function is negative—it clears the ground, a kind of trash basket. The object seems to have been to see how much could be siphoned into this receptacle; that is, how clean and essential the surface of the mural could be left.

At the same time, the accumulation in Study 23 is restricted to the eyes and mouth. Elsewhere in a kind of compensation everything possible is swept aside, an opposite extreme: and it is Study 23 which ends by providing the first pattern for the bald head-contours of the mural—the hair swept strictly away, outside the skull's silhouette.

This sweeping of hair is an aspect of the taut flatness achieved in the mural, in which the normal sheltering and overlapping of parts may without warning be repealed. The resulting bared irreducible skulls go far toward isolating the picture's hard sense of life and death.

Study 24

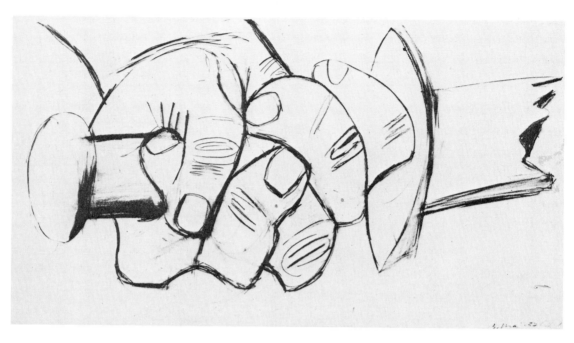

24 *Hand of warrior with broken sword* Pencil on white paper. 17⅞″×9½″.
Dated "May 13, 37 (II)."

Picasso here clenches an alternate fist for the swordbearer, in a visual proposal put
down two days after the fist was established in the mural State I.

The fist of State I is not precisely the fist of the finished mural. It goes unchanged
until the eleventh hour:

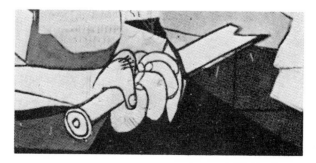

in State VII the fist is given a new twist, or rather swelling. This occurs in the heel of
the hand, visibly scratched out in State VII and enlarged, and supplemented, too, by
a new lump at top center between the heel and little finger. The result of this plastic

surgery is a rounder, more apple-like clump of fingers, which no longer has any room within it or passage through it. It clenches like a fist—on itself: not on the sword. The hilt is seen to enter it, but the blade does not exit from it. The blade ends up with small status, not only broken off at the one end, but rejected at the other. The overall image is one of flesh and blood first, armament second.

Study 24 seems to seek in the direction of this priority. Three thumbs and three fingers struggle for possession of a hilt which they end by squeezing out of existence, as though they never really wanted it. The fingers nearest the guard close inward to invade the hilt's territory, demonstrating that like the blade itself, the hilt is not really there at all.

The image is subject to various interpretation. The village of Guernica although it possessed a small-arms factory on its outskirts, was undefended—had no big guns or anti-aircraft; the swordbearer's non-sword could be taken to symbolize this defenselessness. But the more immediate interpretation would seem to be the artist's feeling about armament in general, expressed in a habitual avoidance of martial themes except, on rare occasions, ridicule. In his

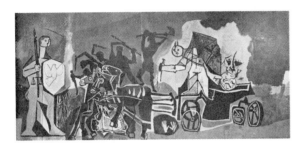

213. 1952

War mural of 1952, the figure of peace grasps his weapon securely enough—a giant pen. The artist's centurions with their real weapons, are figures of gentle ridicule. His armed toreros are generally puppets, or asleep. Even in the Guernica—or especially in the Guernica—Picasso never made a full reconciliation between arms and the man.

Study 25

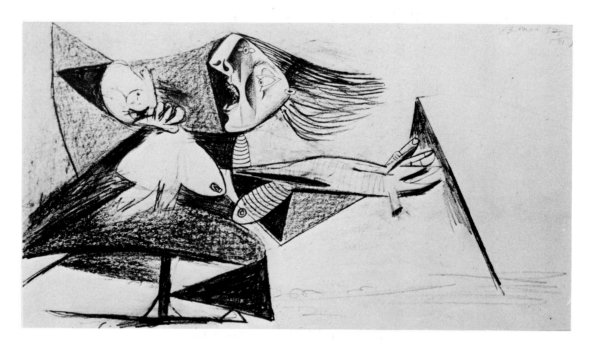

25 *Mother with dead child* Pencil and color crayon on white paper. 17⅞″×9½″.
Dated "May 13, 37 (III)."

The mother and child are set up as a charter element in the mural State I. Two days
after this finality, Picasso turns to a fresh fantasy on the theme. Colored crayons juice
up a clash between shadow and substance, a clash, that is, in which flat patches vie
with a hectically illuminated sculpture. Clash takes over on every level—the dry
eloquence of the mural seems suddenly inaudible under a Wagnerian tumult.
Simultaneously we are directed here, there, everywhere; the mother pushes ahead
(the gesture of the Minotaur in the Minotauromachy), while, turning in an opposite
direction, she utters the brazen yell of a heroic Victory. Her mismatched eyes glare
in two directions, her hair sweeps in the wind and she herself whirls like a
weathervane on a stick. The child looms into view like a wisp of ectoplasm; it stares
outward with a ghostly reflectiveness which begins by calming the picture but ends
by underscoring its general agitation.

This lurid little vignette has a large potency for the mural. The mother's battle
yell makes a somewhat theatrical forecast of the rallying of the Guernica's horse and
swordbearer, both still mute at the time of the Study. Nowhere else among the
Studies is this key vocal exercise performed with such force and clarity.

As for the Minotauromachy, the key work in the background of the Guernica, that elaborate piece of stagecraft is much dominated

by one motif, the outstretched arm of the Minotaur. One looks logically to see this gesture carry into the Guernica, and in fact Study 25 would seem to stand as its reflection in the series. The aroused mother, inheriting the Minotaur's commanding gesture and putting it into something like a martial context, acts perhaps as a channel by which this choreography is

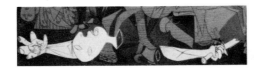

transmitted in turn into the mural, where the gesture appears to contribute the impulse of its extended palm to the outstretched hand of the swordbearer. The aroused mother's vocal rallying and gesture both, have some reflection visibly in that most complex protagonist of the mural, whose wide-spreading genealogy seems always ready to accept one more branch.

In a broader key, the drawing's jigsaw puzzle of flat angles stabbing in all directions, provides the model for the main texture and surface of the canvas at large. No other Study, not even number 15, forecasts the mural's panorama of flying glass as vividly as this one. But where in the drawing the angles are executed in a raw technicolor, in the mural they are simmered down to a cold arsenal of grays; similarly, in the mural the clash between shadow and substance is simmered down in favor of a general withdrawal of substance, a shadowy flattening of faces and gestures. The clash of broken angles, the dominant effect in Picasso's mural, emerges in its overwhelming force for these ultimate restraints.

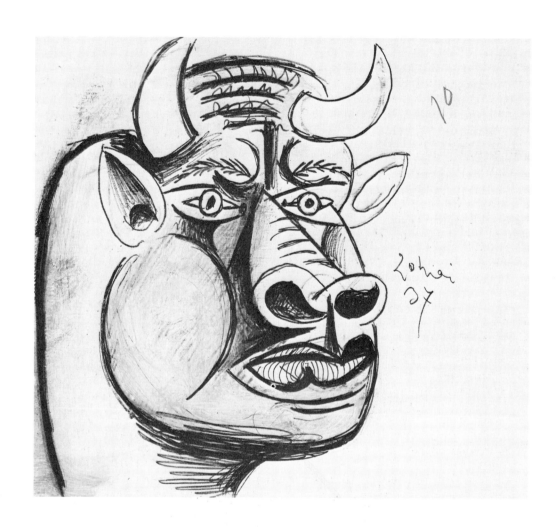

26 *Head of bull* Pencil and gray gouache on white paper. 11½″×9¼″. Dated "May 20, 37."

Study 26

Irises once again punch forward in this fresh encounter with the bull. This incarnation is apt to hit us at first glance as brutish; on second look the creature comes through as one of the most overtly sympathetic in the series, ranking alongside the animal which presides over Study 15. We are startled at first by a turmoil among heavy features; but once safely behind a fence and observing patiently, we study the congestion of the animal's brows, anxious marks of an engagement with some outside event which is focused in the steady reflecting of the irises. The cheeks swell and nostrils dilate as in a huge sense of wrong, human lips compress with a thoughtful indignation. The engagement is a matter of thought and emotion, not of the animal's horns; these lightly drawn items of gear are hung up out of the way, dangling irrelevantly in a crisis which goes beyond their use.

[161]

Coming out from behind our fence we notice that the beast is not a bull but a Minotaur, his head set on a slender human neck and squashed passively into the square of the page on which he is drawn. Hedged in, he makes one of the most fully conscious and intelligent of the relations of the hedged bulk of the Guernica creature, that other animal swollen with something like a human anguish.

It is not logged by the artist whether the Study came before or after State III of the mural, in which the bull takes his final form. It is evident, anyhow, that the images link, most tangibly in the expressive horizontal scorings of the face: the anxiety raked between the horns, and, most heavily marked in the mural, the revulsion raked above the nostrils.

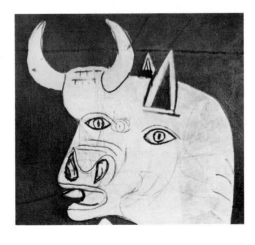

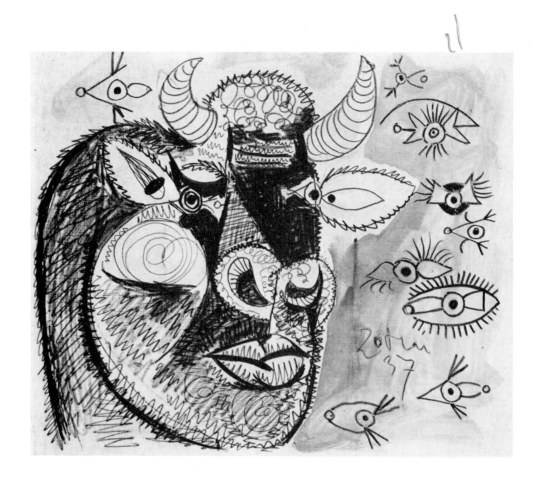

27 *Head of bull with studies of eyes* Pencil and gray gouache on white paper. 11½″×9¼″. Dated "May 20, 37."

In a last confrontation with the bulls of the Studies, a rich congestion is unrolled for us, a great square giftbox full of seemingly useless gadgets. Eyes are unwrapped like snowflakes, insects, propellers. Yet the artist's seemingly wayward invention in these contraptions, revolves around an obstinately ordinary core: the iris with its pupil, a dot centering a circle, which runs through the nine floating eyes as common denominator. Invention is fenced off from this central preserve, licensed only in the peripheral kaleidoscope of lids, lashes, and tear ducts. Like the ultranaturalistic details in Study 23, these anti-natural extras are put in apparently only to be sloughed off, got out of the way. In the head of the bull itself in Study 26, the irises come through nearly unencumbered.

Wall-eyed, slightly lost, the animal has something of the unfocused seeking quality of the bull of the mural. In the mural the eyes of the bull are circled dots in an almond shape, still the broad denominator of everyday usage. Deflected momentarily by invention, the artist returned in the end refreshed in his commitment to his timeless uninventive image, a rough plan for any eye in nature.

Yet his experimenting in Study 27 took root in its own way. The harvest includes a strange crop of ears. The eyes of the bull are after all not so innocent, but have ears attached to them, enlargements of the irises with propellor-shaped whites attached to them in the floating inventions (upper left). And within each ear is inscribed an almond-shaped iris or inner eye, with a pupil of its own; the ear as an amplification of a normal vision which is visibly faltering.

The bull's ears throughout the series are emphatic and often something special, large, pricked up, richly naturalistic or forcefully geometric. The culminating ear of

the final Guernica bull is the most emphatic item in the procession; not the eye, but the ear ends as the largest and by far the boldest of the animal's features, with its rigid triangle of black. Indeed the animal dominates with this feature. No longer an eye, the ear is promoted as a dagger. Like the artist, the bull cannot see Guernica, nor enter it; still he can hear of it; and in this his ear becomes his weapon.

Life is always spelling out some other life in Picasso; metamorphosis spells out the common life-force which flows through all superficially separate forms. Men and bulls impersonate one another, the sexes merge, death impersonates life. In Study 27, ears pose as eyes, ultimately as daggers. Similarly in the Study, nostrils pose as horns: the bull's striated horns are repeated in miniature within the hollow of the nostrils, leasing their solid aggression to these two enormous cavities. These, with the cavity of the ear, dominate the Guernica bull itself, outdistancing the hesitant solid of the animal's tongue.

Ears and nostrils make an aggressive passivity. In their hollow armor they hint almost at the *Hsu*, the void, which is the strength in Chinese painting.

Breathing and listening, the Guernica animal stands and waits. Its vitality is manifest, yet inward, a receiving station only. For all its urgency the animal is powerless to release its power, or to undo the brutality and darkness of its frozen body and tragic disconnected glance.

A baffled power runs through the eleven bulls of the Studies as common denominator. But what of the differences? We ask whether the bull of the mural has more of

the simple alertness of the first sketch in Study 1,

the sentrylike sureness seen in Study 2,

the innocent strength found in Study 6,

the useless power of moving of Study 10,

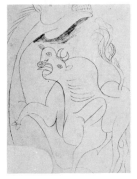

the pettish dependency of Study 11,

the blank muscularity of Study 12;

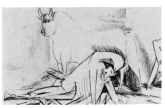

or yet again the intelligent arrest of Study 15,

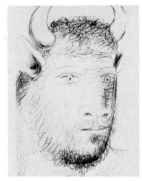

the bold indifferent vision of Study 19,

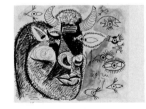

the distant sadness of Study 22,

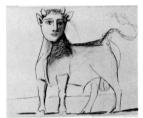

the rough indignation of Study 26,

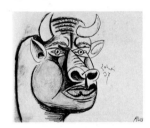

the baffled stare and potent listening of Study 27. The creature of the mural

emerges as protean, it lights up and gathers meaning with the substance of whichever of the artist's preparations or reflections are placed behind it. Much as the artist himself built his meaning piece by piece, like a bridge which was finally joined across the middle, we fill out the elements of his final result in retracing the stages of his progress.

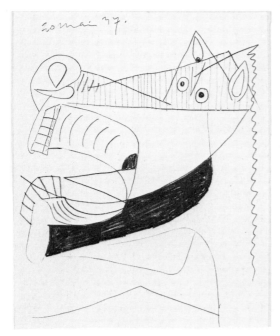

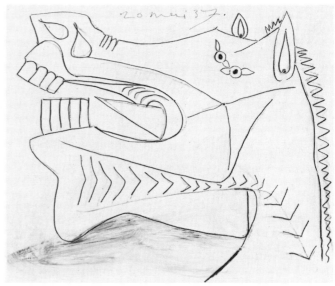

28 *Head of horse* Pencil and gray gouache on white paper. 9¼″×11½″. Dated "May 20, 37."

29 *Head of horse* Pencil and gray gouache on white paper. 11½″×9¼″. Dated "May 20, 37."

Studies 28 and 29

The horse enters the mural with its head brought upside down; even in this position the head is much the same as in these final versions in the Studies, the boxy form and wiry line, and similar hardware in the way of eyes, ears, two visible jaws, scored palate, revolving nostrils, and tongue blocked by teeth. Inventions such as eyes with propellors and ears with pupils, are, however, sheared off in the austerity of the mural from the first.

These Studies followed nine days after the fixing of the head on the canvas, and it seems possible that Picasso meant them not exactly as postscripts for State I, but as tryouts for the erecting of the head in State IV. What did the artist set out to achieve with his alternate squarings of the animal's head, one horizontal, the other vertical?

It is to be observed that the horizontal component is the easier and more obvious element in the final horse's head of the mural, with its leveled nose: but the vertical component has its essential role to play in articulating the animal's overall upward aspiration. This more problematic vertical trick is approached cautiously in Study 29 with the slight vertical peak of the animal's brow. In No. 28 (the sequence of the two is unrecorded) the vertical trick is turned decisively with the abrupt volcanic rising up of this triangular gable, a huge accordian pleat produced by the general compression of the head. The peak is still partly cancelled and concealed by a long slope which crosses it; in State IV of the mural, which sets the final head, this crossing is cleared away and the peak fully exposed, the apex of the animal and the

miniature of its overall triangular presence.

The general horizontal of the head as a whole is restored, culminating in the level spike of the tongue; but at the same time the vertical axis, rising directly in the impaled spear, culminates in the peak, gearing into the spikes of the overhead ceiling fixture.

As in the Study the peak enclosed the animal's ear. This natural geometry repeats and redistributes the force of the triangular tongue. Across the mural, it makes an answer to the still more aggressive culminating ear of the bull.

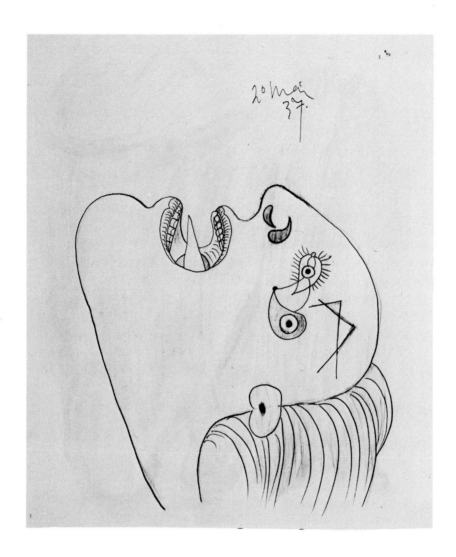

30 *Head of woman* Pencil and gray gouache on white paper. 9¼″ × 11½″.
Dated "May 20, 37."

Study 30

[163]

Entering the lists nine days after the mother's first appearance in State I of the mural, this repetition of the woman's head retains the essential outline of a building block, set down squarely like the horse's heads in the preceding Study.

As with the preceding pair of Studies, this workmanlike plan seems to set up details for the final version in State IV: the incrustations of teeth, tongue, nostrils, brow-scorings. All, however, are further simplified in the mural and loosened up, the dry geometry of the Study vivified as an organic roughness.

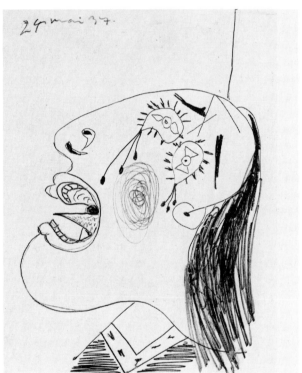 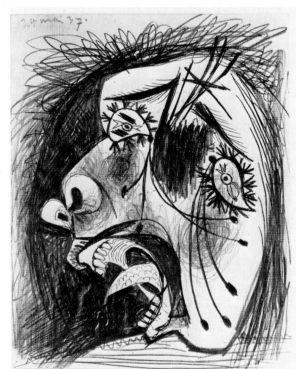

31 *Head of weeping woman* Pencil and gray gouache on white paper. 9¼″×11½″. Dated "May 24, 37."

32 *Head of weeping woman* Pencil and gray gouache on white paper. 9¼″×11½″. Dated "May 24, 37."

Studies 31 and 32

A string of fantasias on the theme of the screaming woman's head is launched with these two Studies; the series of eight resumes with No. 34 and again with No. 38. Each bloodless decapitation revolves around a set framework, peas in the same ghastly pod, the artist coming down again and again on the same set of nerves with the tedium of a torture machine, the revolving tear-shaped eyes centered by the dull button of iris and pupil, the same tear paths wandering crazily from the corners of the eyes like flails, again and again the eyelash clusters harrassing the eyes like circles of arrowheads, and the scorings clustered compactly in the brow, seeming relocations of the stigmata (these last retained in the mother and burning woman of the mural). There is the usual Picasso swing from fullface to profile; in these examples the beholder is wrenched from the tear-shaped fantasy of the eyes to a surgically literal reportage in the mouth—and back again at the last minute to the spikelike tongue, a fantasy rooted in the jaws of naturalism.

[164]

Seven out of eight of these horrorgraphs mark a return to the nursery, in the scribbles which are the cheeks. Over and over again these inarticulate bunches of yarn assert the link with childhood, an access to the elementary fear of the child in a dark room. The child-impulse, carefully built up as an artist's exercise and surfacing intermittently throughout the forty-five Studies, comes into its own in the mural, where it glows through every sophistication, trembling under the surface of potato fingers and sticklike arms. Surely its meaning in the picture is nothing esoteric, and transcends the personal or biographical necessities of the artist. It stands as a visual equivalent of the irreducible infant "Mamma mia, mamma mia" of Hemingway's freshly mutilated soldier in *A Farewell to Arms*. Invention is tethered to one framework apparently because all eight are working elaborations of the mural: close incrustations of the twin heads of the mother and the burning woman. The drawings function evidently as vents to keep those particular images clear of excess demonstrativeness—preserve their hard discipline. At the same time, they give an unbridled emotion its moment, with all the noises and juices possible, played out, as it were, in private. They give definition to what the artist wanted *behind* the discipline of the Guernica—emotion not to be drained finally from the mural nor yet released there, but to be contained there, through the orchestral interplay of the whole with its clarified parts in eloquent interrelation.

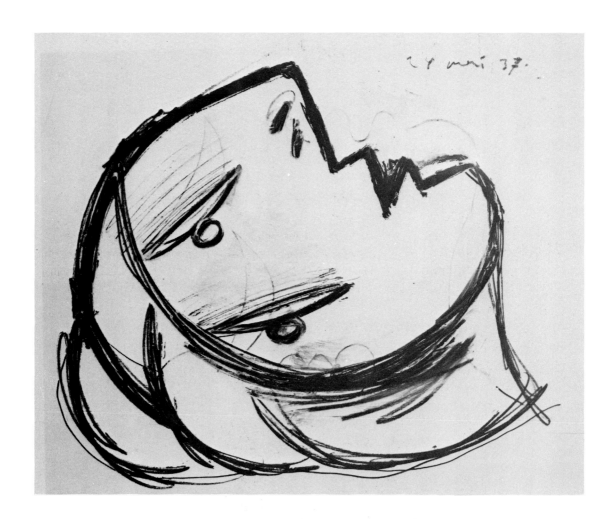

33 *Head of warrior* Pencil and gray gouache on white paper. 11½″×9¼″.
Dated "May 24, 37."

Study 33

In the first of several close-up decapitations of the swordbearer, the eyes are the bow-and-circle devices of the recumbent figure in Study 15—here a total resignation, irises not so much extroverted as sunken below; the device is carried into the swordbearer's eyes of the mural State III, far from their luminous emergence at the end in State VII.

Round arcs of a soft jawline and piles of hair suggest a female presence (the matador of the Minotauromachy?).

Yet soft as they are in their direction, the contours are brutal in their rendering, heavier than any in the mural, with its thinner more incisive clarity. Study 33 is an independent meditation, soft yet brutalized. Its roundness survives in the Guernica as the round stone of the swordbearer's dropped head.

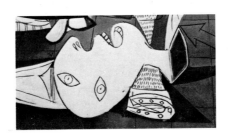

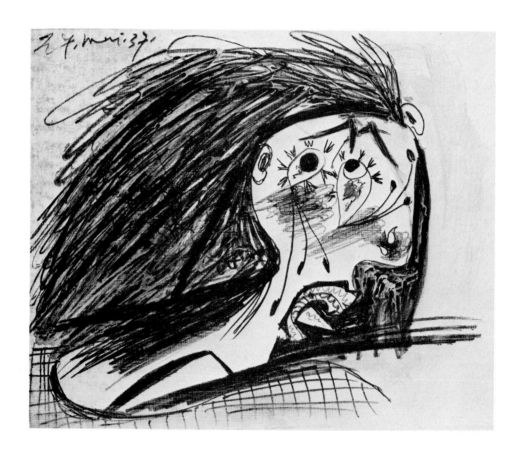

34 *Head of weeping woman* Pencil and gray gouache on white paper. 11½″×9¼″. Dated "May 27, 37."

Study 34

The eight heads of the screaming women are resumed, scribble-cheeks and all. Throughout the series and into the mural the eyes revolve erratically, chasing each other this way and that like tadpoles; here the two confront one another fairly symmetrically, but placed on end, like seahorses; the *irises* wander off on separate tacks, like the eye-buttons in a plastic novelty. Like the useless button-eyes of the horse in contrast with the horse's monumentally articulate mouth, the eyes of the screaming women of the Studies, and of the mother and falling woman in the mural, may be seen as non-functioning—wandering, crazed—in contrast with the organized and vocally concentrated mouths. Blinded but vocal, the women would seem to reflect an aspect of the crucifixion pattern which we have traced earlier, like the Christ and its descendant the Guernica horse, their function is not to see, but to speak.

In Study 34 the characteristic dispersal of vision is accelerated by the paths of the tears, wandering in opposite directions independent of gravity. Conversely, the concentration of the mouth is reinforced by teeth in concentric ranks, like the keys of an organ, confirming the set orientation of this monumental cavity.

A mass of hair is scalped as always, leaving the bare fact of the skull.

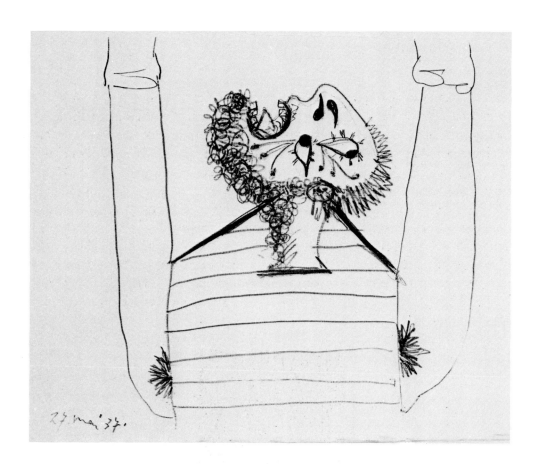

35 *Falling man* Pencil and gray gouache on white paper. 11½″×9¼″. Dated "May 27, 37."

Study 35

The screaming head is here transferred to a man. For once we meet with naturalistic hair: the scraped-off hair elsewhere in the series and confirmed in the mural, takes an added likelihood from the irrelevancy of this experiment, with its effect of softening and diverting. Few heads in life or art are so powerfully bone stark as those in the Guernica, the more so for their stripped hair.

[165] The oneness or axial symmetry in Study 35 is more marked than anywhere else in the series, arm, neck, eye all vertical. In the burning woman of the mural, the counterpart of Study 38, this axial rigidity is upset by powerful slopings, dynamics which pull the figure's verticality into play with the horizontal mural at large. The levelness of the head in the Study, yields to a dynamic tilt in the burning woman's head. There the stabilizing horizontal persists only in the remains of the woman's hair; this floats on a level but is sponged out of prominence by an erratic patch of dark.

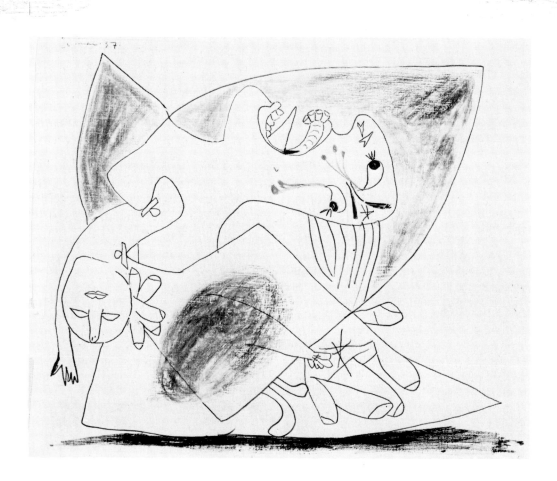

36 *Mother with dead child* Pencil, color crayon, and gray gouache on white paper.
11½″×9¼″. Dated "May 28, 37."

Study 36

Mother and child again take the spotlight. As in their last appearance (Study 25) they direct us everywhere at once; nipples, eyes, nostrils, gestures—all possible pairs face in opposite directions. The group makes an overall cross whose lower points are the corners of the woman's dress, and whose upper points—again directed opposite—are evidently the flying corners of the woman's cloak, seen last in Study 14.

The counterbalance to this prevailing dispersal is the usual concerted attack of the mouth. Here we see a new variation, the mouth of the woman accommodating the craggy teeth of the horse. The metamorphosis spells out the underlying oneness between these two protagonists; in the mural the teeth are differentiated, but not the pointed tongues.

Another oneness is a new unity between the mother and the child: this is in the laying of the child's hand within the mother's, the one gesture melting into the other, the larger amplifying the smaller. This scheme is fixed identically as a charter element in the mural State I. In the Study further, both of the two hands, the mother's and the child's alike, are seemingly crossed with the stigmata, as though the two were the opposite hands of one being, a Pietà with no final distinction between the dead and the surviving. These stigmata, too,

take their place in the mural, the mother's nailed in place in State IV.

The scribble-patch of the screaming women's heads here shifts its ground: a patch of blue wax crayon marks the abdomen or genital area of the child, and, behind the child, that of the mother, once again a unity between the two figures.

(Emphasis on the genital area of the dead child functions as a visual bringing together of the child's life and of his death. This, and the child's specific sex, is brought out in a variation on the theme which Picasso made after the Guernica series; here the child's penis is shown, erected like that of a hanged man.)

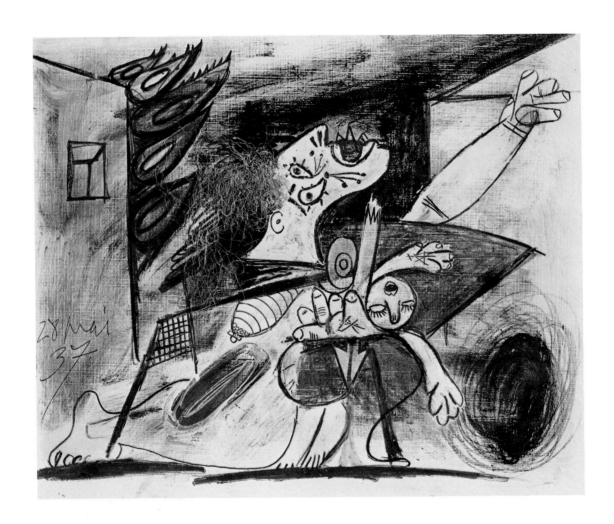

37 *Mother with dead child* Pencil, color crayon, gray gouache, and hair on white paper. 11½″×9¼″. Dated "May 28, 37."

Study 37

Scribble-patches roll like tumbleweed across the floor of this last appearance of the mother and child. A long blue oval patch stiffens the diagonal axis of the picture, which is also the axis of the woman, the line from her foot to her opposite hand. At lower right by contrast a whirling black patch has no kind of integration with anything and seems to disengage life altogether from the group; a dispersal which is perhaps picked up in a different key in the answering blob of the woman's hair, a collage which disengages the actual from the pictorial.

Imposing a unity upon this chaos, the triptych plan of the mural here comes into the open as nowhere else in the Studies, complete with framing architecture and diagonals overhead. The side-panels are impersonal walls; they enclose an aperture into a world beyond the disaster enacted at the center, a new counterpart of the mural's half-open door.

And within this comprehensive physical framework, the enactment itself has a unique breadth. In its ungainly choppiness it manages to add up to a one-figure pantomime of the mural at large, for it comprehends within one figure the attitude of the kneeling woman, the clean decapitation of the swordbearer, the spear and jutting teeth of the horse, the blocked or stopped up voice of the bull, and not least the bereavement of the mother. The woman's extended arm merges the upward gesture of the burning woman with the forward gesture of the lightbearer. Finally this one figure wraps up the mural at large with its opposite corners of the composition filled out by a stretched hand and a monumental foot. The gathering of witnesses to the scene, is hinted at in the background, by flames designed as enormous eyes. Chiefly the artist seems to have been at pains, as nowhere else in the series, to carry his dramatic unity to the last possible point of condensation. The result comes over as something of a monstrosity, like a frozen concentrate; the figures in the mural are grace and harmony by comparison; but the indigestible image clinches the flow of common life which, in the mural, extends a unity from one separate form to another.

[167]

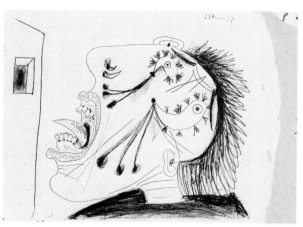

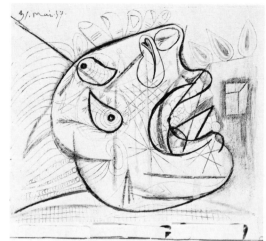

38 *Head of weeping woman* Pencil, color crayon, and gray gouache on white paper. 11½″×9¼″. Dated May 28, 37.''

39 *Head of weeping woman* Pencil, color crayon, and gray gouache on white paper. 11½″×9¼″. Dated May 31, 37.''

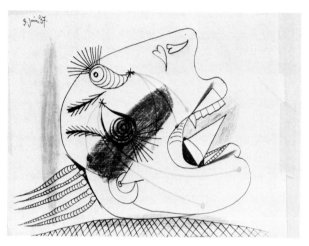

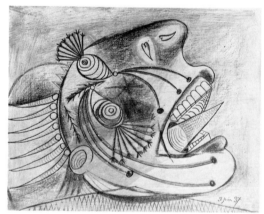

40 *Head of weeping woman* Pencil, color crayon, and gray gouache on white paper. 11½″×9¼″. Dated June 3, 37.''

41 *Head of weeping woman* Pencil, color crayon, and gray gouache on white paper. 11½″×9¼″. Dated June 3, 37.''

42 *Head of weeping woman* Pencil, color crayon, and gray gouache on white paper. 11½″×9¼″. Dated June 3, 37.''

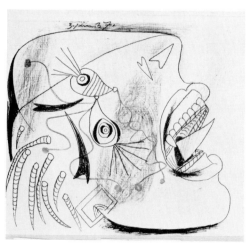

Studies 38-42

Five more heads are tumbled from the guillotine to complete the roll call of screaming women. Hard cranial outlines keep their own integrity but enclose encephalograms of motor disruption, monstrous nerves confusing their function with that of hairs, or wrapping themselves around eyeballs. Each seemingly chaotic event keeps close to its appointed place, the stripping of scalps, the baby-smudges, the assorted tears and tadpoles. On May 31

the tongue is displaced cautiously to the rear plane beyond the mouth-cavity, like an astronaut venturing outside a space capsule;

on June 3 it is restored, and keeps its position and concerted attack to the end. Ultimately

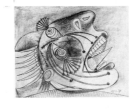

the head itself is ruptured and its contents appear to spill; all previously tense formations of tears and hairs shrivel and scatter in a last paroxysm. Still the mouth retains all its disciplined architecture, holding as a link with the general hard clarity of the mural.

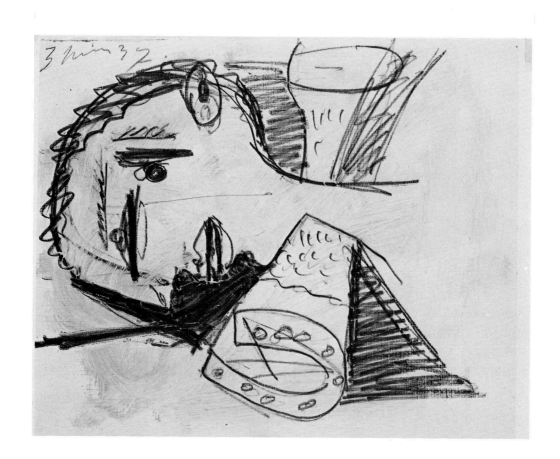

43 *Head of warrior and horse's hoof* Pencil and gray gouache on white paper. 11½″×9¼″. Dated "June 3, 37."

Study 43

The artist here gives us the swordbearer's head as it bites the dust in the mural States III-VI. In a near-strangulation which is retained in the final version, the shrunken neck makes a sort of Maltese cross with the horse's leg and hoof. Yet, is the head strangled or embraced? The animal and human forms are fitted with common boundaries in a sort of mutual cradling, like organs of the same body, reinforcing the bond which certainly exists between horse and swordbearer, a carry-over of the man's head enclosed by the horse's legs in Studies 12 and 15.

The head whether embraced or cancelled, or an anguished irony which includes something of both, is loosely and even laxly drawn, invested with a slack pathos—the piteous tilt of the eyes and eyebrows, lips parted in a passive smile of their own anguish (maintained in the mural through State VI), cheek laid to the ground.

As against this vague and somewhat teary tendency, a new revival of hard shadow-triangles accumulates outside the head: and within the head, the eyebrows are roughly laid down like straight bits of macadam roads, leading respectively straight up and straight across. This is a hardening of the eye-axes established with the usual tear-shaped eyes in Study 35 (the bearded man); verticals and horizontals now to be followed through into the next Study, and into the eyes of the swordbearer in the final version.

[169]

Embraced and cancelled, slack and rigid, the head in Study 43 is a skein of tensions between tears and defiance. This is carried out in the positioning at the horse's feet: a descent, perhaps a humiliation. Yet while this is true, it is only half the truth. In the mural itself, the positive side comes out more clearly. There the rich line-up of the head and the other monumental extremities both animal and human, which is planted across the Guernica floor together with sword and flower, functions as a row of foundation blocks and a suggestion of earth and grass, at least as much as a humiliation of coming down. In the mural the swordbearer's head finally faces upward (only at the last in State VII) like an iris bulb rooted in the ground, which has at last sent up its shoots.

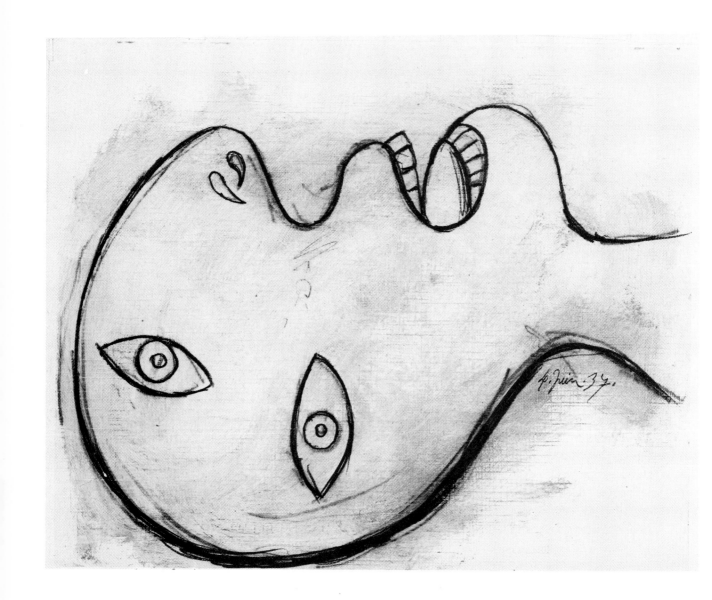

44 *Head of warrior* Pencil and gray gouache on white paper. 11½″ × 9¼″. Dated "June 4, 37."

Study 44

[170] After its various cauterizations earlier in the Studies, the swordbearer's head arrives at a total cleansing. Hair and tongue are stripped. An economy and a hard regularity are achieved.

The vertical and horizontal of the eyes, relates the head to the space in which it is ultimately to situate. In the mural,

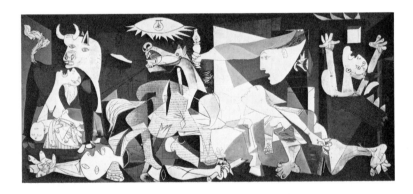

the horizontal eye carries the direction of the Guernica floor; the vertical eye sets the right-hand boundary of the triptych leaf, pulling the ruglike horizontality of the swordbearer into play with the mural at large.

Beyond serving this somewhat frigid geometry, the wheeling eyes make a dynamic appeal, transcending the disadvantage of the supine position. The swordbearer of the mural is like a great opera singer forced to deliver a climactic aria lying on his back. Nowhere among the heads of screaming women is the dislocation of the eyes so radical as in the swordbearer with his eyes in altogether separate zones, one seeming to orbit around the other, catching at the beholder as though by the casting of a net.

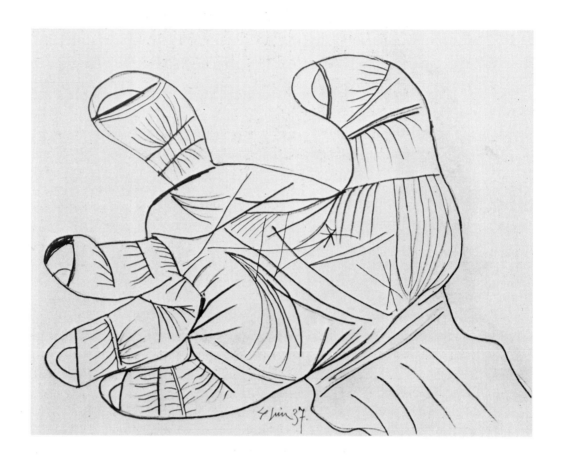

45 *Hand of warrior* Pencil and gray gouache on white paper. 11½″×9¼″.
Dated "June 4, 37."

Study 45

The Studies are brought to a farewell in the crippled contours of a swordbearer's salute, irregular in silhouette and vacillating in its intervals; not quite a pointing, not yet a grasping. It is a hand unused to speech, a hand which cannot ever have held a pencil, visibly only just pried from the handle of a plow or hoe. (Guernica in fact was bombed, probably deliberately, on a Monday, or market day, so that its streets were full of peasants from the surrounding farms.)

[171]

From State V onward,

the hand in the mural takes over with its increasing eloquence and militancy, though not without its permanent residue of peasant earthiness. The more-than-normal build-up of power is implicit in the little finger stronger than the thumb, and the fourth finger—ordinarily the weakest in the hand, as every piano-student knows—brought up as the strongest of the lot. In line with this strengthening, the redundancy of the crease-markings in the Study is strengthened in the mural to a hard economy centering in the star of the stigmata, the most forthright or geometric such to appear in the mural (nailed in place at the last in State VII)—the mark of the nail merged into that of the plow. And the wrist-tendons in the Study, laid out passively like shirts in a drawer, are focused in the final version so as to drive into the hand, the reflection of the form in Grünewald's Isenheim altarpiece.

For all its stiffness, the final hand is not precisely static. Fingernails in the mural are originally two in number (State V), implying that the hand is seen partly from the front, partly from the back; in the final version, as in the Study, the sense of martial regularity is furthered by the full complement of nails, giving a hand which is all front (the palm) and simultaneously all back (fingernails). The thumb is on the wrong side, again as though the back of the hand were presented, making altogether for a vibrancy in the hand, a sort of Cubist flickering. Addressing the space around it both fore and aft, the hand, like the mural at large with its indoors-and-out, makes its microcosm of general space. And fusing its time-sequence of alternate poses, it makes a generality of time, like the midnight and noon of the mural, the lamp and sun. It is no doubt this breadth of space and time which makes it natural that we should encounter in the hand its broad arc of identity—a Christ's hand on the cross, a matador's salute, a Minotaur's warning, and a peasant's hand taken from a plow, stretched in its mute appeal: and the heroic rallying of a man with two arms and a piece of a sword.

[172]

THE STATES

In keeping with their bridging of old and new, the Guernica and its Studies with their twentieth-century splinterings were chopped into place under the mellow beams of a seventeenth-century Paris house—a studio of sufficient size for the picture, discovered by Picasso's mistress Dora Maar. There Mlle. Maar photographed the canvas itself seven times prior to its completion, freezing the passage of the artist's brush and bequeathing this record to posterity.

The eight revisions on the canvas are the final long raising of the curtain. For all its elaborate rehearsal in the Studies the operation is not always smooth, with its frequent whiskings and jerkings of the material. Reversals and reactions follow to the last; none of the Studies is followed verbatim, neither those which precede the mural nor those which cluster around it, and elements make their appearance which have no forecast at all among that long prelude of exercises. And indeed it may be felt that in this independence of the mural, this shrugging off of its many plans and scorn of being plotted in miniature, we have a clue to the grandeur of its essence. Studies 1, 2, 6, 10, 12 and 15, the overall composition Studies, early made their bid for adoption on the canvas but none of the six were adopted except in selected aspects; in the inexorable self-sufficiency of its development, we trace a dimension of the vitality of the finished and accomplished picture, which comes before us tensed and scarred and all but panting from the interior upheavals which brought it legitimately to its final locked balance.

As we have remarked, the Guernica was an openly heroic vision born into a world of skepticism and normality. Understandably its delivery on the canvas was to be a blind and hazardous adventure.

State I

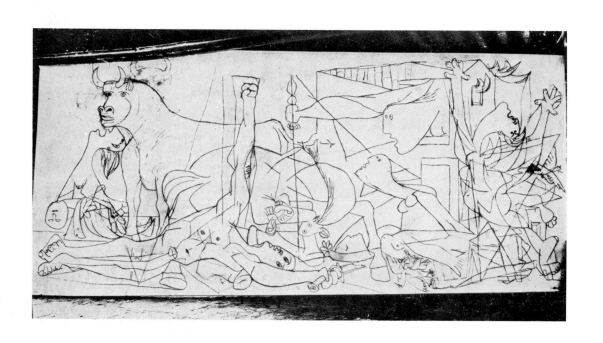

The picture was arrested by the camera six times in its hectic passage between a fully composed premise in State I, and a changed resolution in State VIII. It was finished at the end and at the beginning.

In general the beginning is more consistent than the end. Breaking down ultimately as a torture chamber of wrenching contradictions—the lightbearer's fluidity vs. the burning woman's angularity—the canvas starts with fluid, plastically suggestive outlines in general, just as Picasso's lifework in general began with such naturalism and only gradually hardened into mechanizations and contradictions. Nonetheless in State I the germ of the geometry-to-be is planted stiffly in details such as the bereaved mother's hublike nipples and ringlike ear. And more broadly the final geometry is forecast in a web of vast angles strung scrimlike across the stage. These assist in a blueprinting of major structures such as

the pyramid, filled out from the first by the horse and swordbearer—

and triptych, panels populated from the first by upward-facing women at right and left. Some of these angles, such as the light ray diagonally slicing the lightbearer's arm,

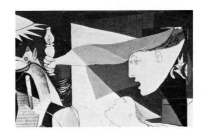

survive intact in the final mural, while

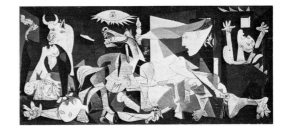

the original vertical dividing the picture explicitly in halves, survives in fragments, visible along the horse's crumpled leg, invisible as the axis of the lightbearer's lamp. Locally,

an isolated triangle descending below the bull's feet,

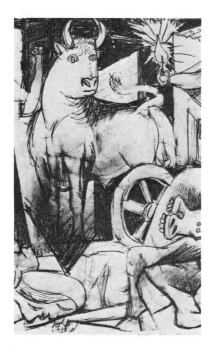

carried through from its same position among the downward-hacking triangles in Study 15,

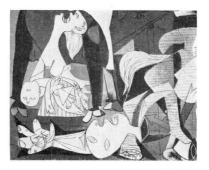

is to be absorbed in State III in the swordbearer's downward-pressing nose, and submerged ultimately in that person's dropped head. The answering figure

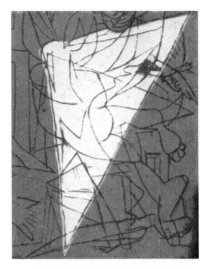

in State I is a triangle descending at lower right, originally a disconnected geometry,

integrated in the end as an angle uniting the burning woman's torso and the kneeling woman's knee—piercing and articulating the descent of that boulderlike member.

Despite its talent for survival, the loose web of wires reaching from proscenium to floor tends ultimately to sink into obscurity, like country houses engulfed in an urban development. The architectures and angularities, originally independent themes, pass into the texture of the figures themselves.

Not only the abstract geometry but also the figures themselves go down initially as hard outlines, wires unobscured by any shading or mass. This edgewise incisiveness is a carry-through from Study 6 and other Studies (a switch, that is, from many of the drawings with their rough crayon or brush); thus the consistent cutting edge of the finished mural, goes down as the premise of the picture in State I, and not merely as its acquired surface.

The forms of the figures and properties themselves tend to survive as charter elements. This roster includes the bereaved mother entire but for the detail of the child's nose; and the lightbearer, but for her forthcoming brilliant eyes and pointed hands and breasts; and important bits and pieces such as the lightbearer's house and curtain; the warrior's hand and sword (later somewhat modified, as we have noticed); the kneeling woman's head and headdress; the flower. As for the horse,

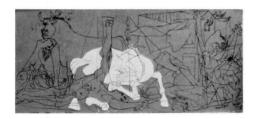

it is in State I that it achieves without further hesitation the all-important raising and leveling of its body. The animal requires little further change throughout the States but for the key raising of its neck and head, yet to be accomplished, and, beyond that, the straightening of the one leg which in State I lies (with a touch of sentiment yet to be outgrown) as a kind of pillow under the swordbearer's back and shoulder.

The crucifixion theme is richly established in State I. In particular

the horse's wound is carved out to stay unchanged—complete with the horizontal wrinkles,

which seem to have belonged originally, in an earlier statement never photographed, to the swordbearer's elbow. The central vertical line dividing the wound, evidently began as a piece of the outer contour of the swordbearer's arm and elbow, and State I apparently offers a montage of arm and wound, the remainder of the arm outside this fragment

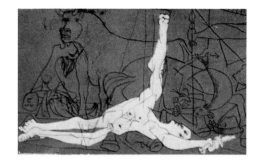

eventually to be sloughed off. Thus the wound originates as the perpetuation of a gesture of defiance, and certainly in its brittleness keeps its air of defiance to the end—a glimpse of the warrior's uplifted (and crucified) arm embedded permanently in its outline as though visible [173] through a window.

The swordbearer himself in State I constitutes, as we have noticed earlier, the most open visual statement of the crucifixion to appear in the Guernica series, the feet overlapped as though nailed and arms outspread complete as though in the elevation of the cross. A branch of the cross itself, appears to be outlined as a rectangle framing the upraised arm. This angular framing is transferred seemingly

as a series of black angles framing the arm and outstretched hand in the final version at lower left, a pattern which is reflected nowhere else in the mural except around the rear hoof of the horse.

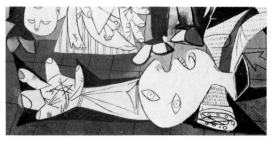

The horse itself stands of course as an alternate suggestion of Christ with its wound, tongue, spear, and crown of thorns, as discussed earlier. The rear hoof, whether or not framed by a piece of cross, is first marked on its underside not by a horseshoe (this incidental property waits until State III to be tacked in place) but by

a criss-cross suggesting yet another distribution of the stigmata in State II;

an answering asterisk is slashed in place on the underside of the adjacent hoof as a charter detail in State I. In these marks a likeness of the stigmata is carried to its last available outposts, the nails of the cross, it would seem, preceding those of the horseshoe; the crucifixion-identity of the animal is suggested by wounds not only on its flank, but on its extremities.

The suggestion of Christ-identity, relayed from swordbearer to horse, is relayed at the same time to the dead child, whose hands are brought into the picture punctured in State I. The dispersal of three personages more or less crucified—the child, the swordbearer, the horse—marks the mural, as we have seen, not as an image of the crucifixion of Christ, but as the broad image of Guernica and of modern man crucified.

The winged horses which float their note of resurrection into the Studies, are followed through in State I as birds. One bird

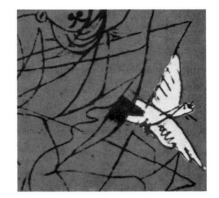

escapes from the scene at extreme right near the burning woman's elbow, blazing a passage into the outer world which is ultimately to be regulated as the half-open door. The second bird

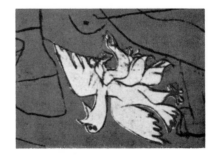

falls head downward below the kneeling woman, defeated—but for widespread wings, a wide-open beak, and open circular eyes. In its way the creature adds up as one of the most wideawake and vocal members of the cast in State I—the tiny forecast of the swordbearer's ultimate aggressive grounding.

The liveliness of this bird contrasts with the inert head which is enclosed between the forelegs of the horse much as in Studies 12 and 15, an enclosing which persists through State IV. There the horse in its final austerity is at last denied such warm and equal contact, other than the less intimate twining of its hind leg with the head of the swordbearer.

Adrift and inert but for an involuntary falling, the burning woman makes initially the most submissive form to appear in the States of the canvas, a carry-through from the pillowlike descent of the mother on the ladder in Study 16. Her evolution from soft to hard is to take place step by step through the first four States; she enters as anything but a charter element. But soft as she is, she begins in State I with a unique monumentality of height, stretched from top to bottom of the canvas; this reach is gradually denied her, the kneeling woman taking over her foot at the corner of the scene in State II, and the higher of her upraised hands lowered in State IV to leave a supremacy to the lightbearer's lamp. Truncated and trimmed as she is in the final version, the woman's ultimate rigid strength is a kind of boiling down of the huge sweep of her fluttering figure in State I.

Much as the bird at right faces outward beyond the stage,

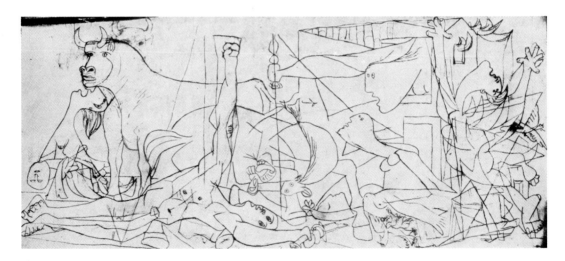

the bull faces outward at his end of the proceedings. Must the bull be seen simply as turning his back on the disastrous goings-on around him? On the contrary, throughout the first three States and indeed to the end the bull may be said to stand guard however ineffectually at the wings, communicating not with the protagonists

but with observers or persons yet to arrive. His sympathetic essence, built up through his appearances in the Studies and tending to vary there from innocence to a classic meditativeness to indignation, is hardened into the image of a sentry who seems to ask and demand that we pass—"This is what has happened—see for yourself"; so at least he may be read in one of his overtones. Maintaining communications with the world, holding a kind of beach-head, the bull makes his own foreshadowing of the half-open door, threatening and inviting, a widening of the picture's access and direct address.

Alert and unified in his staunchly raised bulk and focused in his vivid glance, the animal shows at first little of the tragic confusion of the final version, the frustrated vision. His address beyond the stage was apparently still more direct in the state of the canvas which preceded State I (that earlier state implied by the swordbearer's arm under the horse's wound). In this original layer of excavation, the bull's head faced us directly across the footlights, like the startled animal of Study 15; the fragment of a smouldering and very human glance survives in State I, visible above the withers of the profile animal (and effaced reluctantly step by step, faintly visible through State III). Vacillating thus from the first, the bull pushes into the States of the canvas unrelieved of the load of alternatives which drove him restlessly through the Studies, still the most difficult corner of the picture, a hard reconciling of the artist's immobility with the world of action.

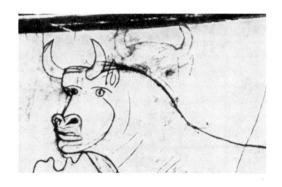

State II

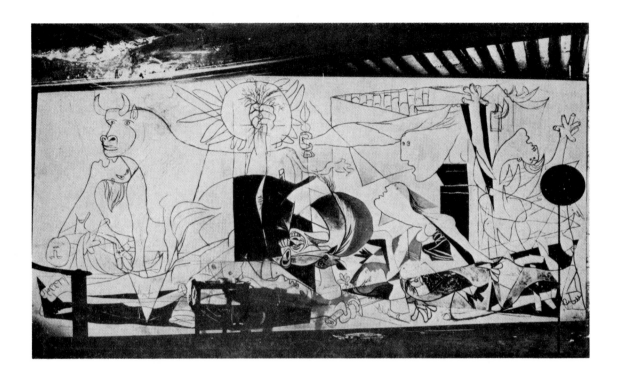

Light criss-crosses the stage in State II as nowhere else in the series, streaking from the lightbearer's lamp, bursting from the flowerlike sun, descending in radiance-lines from a still higher source above and outside the picture as in State I, and stabbing from the continuing hornlike flames of the house and burning woman. Altogether State II is the high point in the literal sourcing of light, gradually to be abstracted as rays are broken up, the sun shrunken, and light in general scattered like fragments of debris in an explosion.

[174] Rehearsed nowhere in the Studies, the sun here makes its debut directly on the canvas. It makes up for its tardiness with the hugeness of its burst of innocence. Its rays accommodate themselves in their petal-like softness to the contour of the bull's back. This irrelevant mildness, vetoed in the next version, is transformed eventually as the harsh stabbing of pointed rays accommodated to the contour of the horse's head (from State IV), the sun shrinking and hardening from a flower to a crown of thorns.

Abstract thorns in the form of hard black triangles make their entrance without delay, a carry-through from Study 15. A huge triangle enters horizontally like a battering ram at lower right, its point bringing up at the horse's crumpled knee.

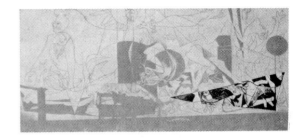

This form dwindles from one state to the next until its point alone remains in State IV, so to persist into the final version, the remnant of a unified aggression which has largely vanished in favor of the general chopping and shrapnel-like dispersal. Another triangle in State II, destined this time for a fuller permanence, cuts downward across the corner of the lightbearer's window and frames the burning woman's higher arm, a thin descending icicle which persists, somewhat faded, into the finished picture after the arm itself is moved aside.

A smaller but equally permanent triangle is restored as the horse's tongue, confirming the tradition of the Studies and displacing the rounded lobe which made its momentary move toward naturalism in State I; again a move from soft to hard.

A system of monumental black rectangles, squarely settled and balanced, is tried out in State II visible on the horse's body and under the lightbearer's window. These blocks with their sense of stability are to be vetoed in State III, dynamited as diagonals. Still the impulse toward a monumentality had its vital place in the mural. The impulse was to be carried through eventually not in local patches, but in the strengthening of symmetries in the overall underlying architectures.

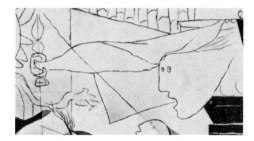

An impulse in sharp contrast with architectural wires, blocks, and blackened angles, is betrayed uniquely in the tender shading of the lightbearer's curtain, a most delicate manipulation of brush and paint which has no parallel elsewhere in the series, if indeed in Picasso's work. It seems to mark the artist's special regard for the compassionate sheltering performed by the lightbearer with this cloth, a motif apart from the rest of the picture. As though in a penance for this seeming lapse into a visual sentimentality, the cloth is flattened in the next version in hard uncompromising plates of gray, and keeps this hardness to the end.

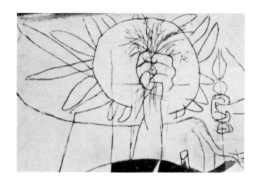

In State II the lightbearer's sheltering, like her brandishing of the lamp, is only secondary to the swordbearer's steeple-like brandishing of grass and grain. This uninhibited gesture marks the high point of simple affirmation in the series; in its scale and aggressiveness it ranks above the affirmation of winged horses in the Studies and the small affirmative properties which survive to the end, the curtain, the modest flower, the equivocal sword. The fist and grass emerge to form the nucleus and perhaps the motive for the sun-splendor which encircles them; fist, grass, and sun-splendor collapse together in State III; a nucleus to the sun is not to be restored until State VII, there in the form of a light bulb, a motif which leaves all eloquence to the forms which it illuminates.

As for the grass itself, this is put forward—or rather upward—as the heart of the matter, the nucleus within the nucleus. The barren version of the fist in State I, is now enlarged to enclose and celebrate this green deciduous matter. It is moot whether the fist exists as a vehicle for the grass, or the grass as an excuse for the fist;

both together emerge as one, the grass withdrawing the element of militarism from what would otherwise be a merely threatening or pugilistic gesture. In this way the brandished fists of Study 15 and their hard small descendant in State I are led to a huge if somewhat irrelevant fulfillment, like a giant hothouse chrysanthemum. Instead of a narrow caging within the branch of the cross as in State I, the enormous fist now has a benevolent sun to foster it, and the lightbearer's gripping of her lamp to rhyme with it.

Altogether the affirmation extinguishes the tragedy, and compels the eye to itself to the detriment of the rest of the scene. But perhaps more than any other occurrence in the series it betrays the artist's enthusiasm and personal passion; that he should have allowed himself to rush even momentarily into the arms of this somewhat posterish display, gives us a glimpse into the man beneath the artist, a reservoir of undischarged emotion which must still have been green and untried, [175] and in the event easily toppled.

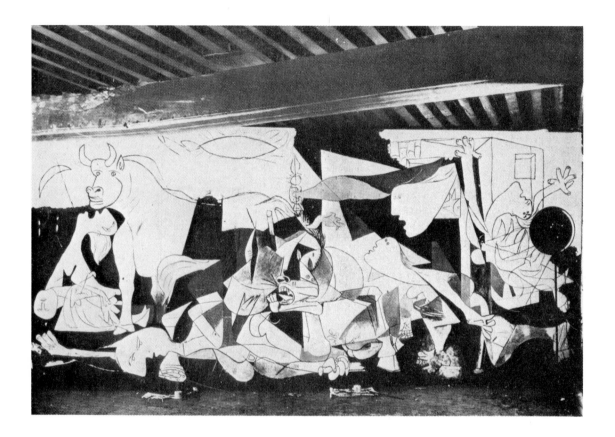

State III

The reaction, then, against the inflated condition of the sun, sets in without delay and results in the collapsed almond-shape which persists to the end; a few of the petal rays cling but are cleared away in State IV. Meanwhile in a new effort at celestial participation the crescent moon makes its brief appearance at the left, also, however, to be extinguished promptly. If indeed the medieval reference to sun and moon flanking the crucifixion, lay in back of this motif, as seems possible in view of Picasso's Crucifixion drawing of 1930 (discussed earlier) it does so nonetheless with a hesitancy and lack of conviction, a moon which is parked on the side like a suitcase waiting to be carried away. There was perhaps too much balance in the medieval idea to suit Picasso's mood at the time; and even when thrown off balance a moon can only be unperturbed.

With the collapse of the sun, the swordbearer's fist is vetoed altogether. So are the mighty fallen. But the raised arm itself and its framing within the window of the horse's wound, here takes its final definition, an independent assertion pushing its apex just *above* the contour of the horse's back as it continues to do in the final version.

The horse's upside-down head undergoes a curious upheaval. Its main outlines remain almost unchanged from the previous States—

except for a revolt of the eyes, ears, and hugely breathing nostrils: these three spearhead the elevating of the head by rising independently, the nostrils appearing, in effect, as though perched on the chin, and the eyes embedded in what had been the throat. The ears sprout from the dome of a newly located forehead (they attach to a lingering diagonal which had formerly been the inside contour of the neck). Thus while the mass of the head is still upside-down, its details are all right-side-up. This apotheosis of Cubism in which the head is both up and down, results certainly in the most eye-bending of the horse's parade of contortions and double images.

The huge new dome of the animal's forehead, accented by ears which push upward like new spring bulbs, is harshly outlined by the adjoining zone, a compact shape which detaches itself as a sort of streamlined bowknot of black. When the precarious balance of the up-down head gives way in the next State to the final uprighting of head and neck, the domelike forehead itself is swept away but the adjoining black bowknot is left undissolved to the last; it persists as a permanent relic of the moment of turmoil in which the horse prepared for its final upward spring.

In a more stable resolution in State III, the lightbearer's pointed hand takes it final position between her breasts. And the kneeling woman's outlines take their final shape (having appropriated the burning woman's foot in State II).

The swordbearer's new head, passive but for its hatchetlike nose, hacks with that member into the ground in place of the original triangle below the bull's feet, as we have noted. In another and upward aggression the splintered board makes its intrusion into the picture, pressing into the horse's belly.

Beyond these local turnings and assorted entrances and exits, State III marks the beginning of the disappearance of the cast of characters under an overlay of black angles and shards. Throughout the States the outlines of forms remain intact, faultlessly epidermal, but in State III begin to be overbalanced and obscured by the axe-strokes of black and white which press and slice across them.

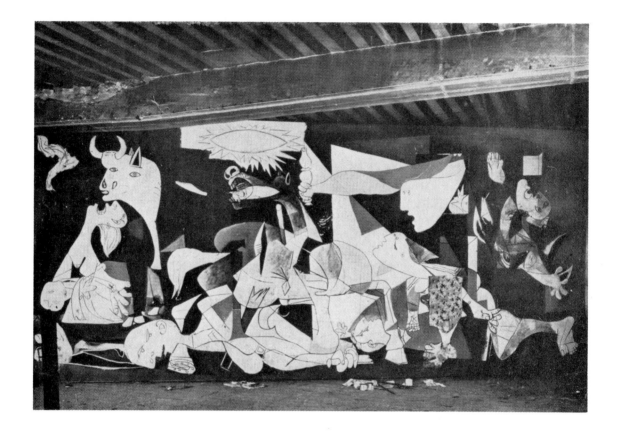

State IV

By State IV the artist has required us to enter his blizzard of angles on faith, virtually to piece together by a kind of braille what we can of the forms and indeed architectures which wait under our hands. The curtain of flying shrapnel over steadily anchored forms achieves its take-over in State IV.

At the same time that forms generally are obscured under this Cubist camouflage, the horse's head in a daring swing from bottom to top is raised into its martial prominence. Uniquely within the mural the animal's head is treated to its sculptural filling and hardening, and the animal projected toward its apotheosis.

Nonetheless the picture is softened in some few details, the temporary passive smile of the swordbearer (from Study 43), tears streaking from the eyes of the kneeling woman (a leakage from the screaming women of the Studies which persists through State VII), and, permanently, the descent of the child's nose. At the same time the burning woman's body is compacted, her head hardened to its final geometry, and the lightbearer's convulsively tangled grip tightened around her lamp. The sun's rays are mechanized and driven at the horse's head, while the spearhead is driven through the horse's flank. The spearhead pushing through the skin gives point to a spray of wrinkles which appear somehow to have waited for this moment, present as a charter element from State I; the shaft of the weapon entering the scene in State II, lengthening in State III, and finishing its business in State IV—a completion which is countered in the abrupt raising of the horse's head.

The raised horse's head creates a zone from which the other participants all keep back—other than the hand of the lightbearer. In a discreet vacating of this zone, the bull's body is swung around completely: relinquishing the center of the stage, it yet takes its final position clamping or protecting the bereaved mother within the broad arc which was forecast in Studies 15 and 22. Despite the new shortening of the bull's body, the artist bestows on the animal a new cosmic flourish: he gathers up

the crescent of the preceding moon,

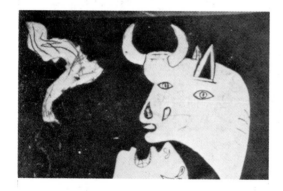

and shapes it into the strong initial curve of the bull's tail. In ancient mythologies, earthly creatures were translated into stars: Picasso's mythology, characteristically, works in reverse.

The bull's profile remains largely unchanged from its first statement—the nose, jutting brow, and horns. Against this constant, the bull's body is swung to the left while the eyes are strung out toward the right, the animal reaching as far as possible both out of the scene and into it, its vacillation and seeking epitomized in this new rack-like tension. In their reaching toward the heart of the mural these eyes take their final shape as satellites or smaller editions of the new sun.

Another and larger such sun-satellite,

again a long pointed almond shape, is embedded in the horse's head. The upper arc of this shape

(it persists within the head to the last)

is in fact a piece of the upper contour of what had been the hind-quarter of the bull, in his previous existence. And another piece of what had been the upper contour of that bull's body,

a fragment of its shoulder,

is seen in State IV to float in mid-air as the odd white diagonal linking the horse's head and the bull's; this hard uncompromising little floater

is finally to be knit into the body of the falling bird, yet retaining its insistent integrity to the end. Like the sword-bearer's arm visible through the wound, these relics of the bull's first posture are to survive revision after revision each time more carefully preserved and polished, embedded respectively in the trumpeting of the horse and in the calling of the bird.

[176]

The bull's original position which is traced in this constellation of relics, is the animal's martial posting at the entrance of the picture. It is this posting which had been the artist's impulse not only in the first of the States, but in the first of the Studies.

State V

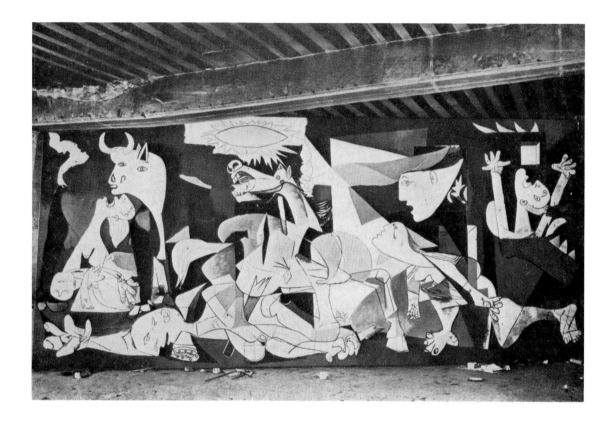

The swordbearer's eclipsed hand is now restored—to displace his nailed feet, achieving the basic take-over of arms and suggestion of crucifixion across the floor of the picture. The floating head between the horse's front legs is relinquished, as though in recognition of the swordbearer's new unity and self-sufficiency of presence.

[177]

The burning woman's body is realized finally at a clip, an about-face from the billowings and flutterings of all previous versions in Studies and States. Her body, neck, and arms come through as the most mechanical and armament-like of all flesh elements in the arsenal of the Guernica (other than accents such as nipples or tongues).

The assortment of mechanical devices for eyes which serves throughout the mural, is abruptly countered in the luminous and eloquently natural eyes which are now accorded to the lightbearer, a carry-through and intensifying of the exquisite sorrowing eyes of the bull's female face in Study 22, and, more distantly, from the casual grace of classic Greek vase painting. These eyes in their central commanding position and their stark contrast with everything else, assume a focal intensity within the mural, its human vision separate and physically immune from the broad mechanical disaster which they overlook.

Attentiveness as a central theme of the Guernica, is expressed not only in eyes and stretched throats and kneeling gestures, but sometimes still more forthrightly in ears, as in those of the bull and horse, discussed earlier. The swordbearer in State IV had been added to the roster of major ear-bearers; the temporary appendage, visible through State VII, tends to outweigh the temporary passivity of his other features. And in State V a permanent addition to this range of listeners is made on behalf of the lightbearer. Her hair, swept aside from the first, has left the field clear for an ear which now makes its appearance and which can only be referred to as large, yet not ungraceful. Like her eyes, it figures as the mural's only example of its kind to come through as softly natural—the antithesis of the ears of the bull and horse, and yet their equal.

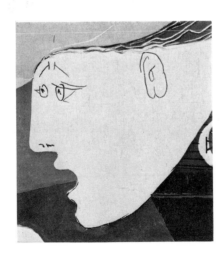

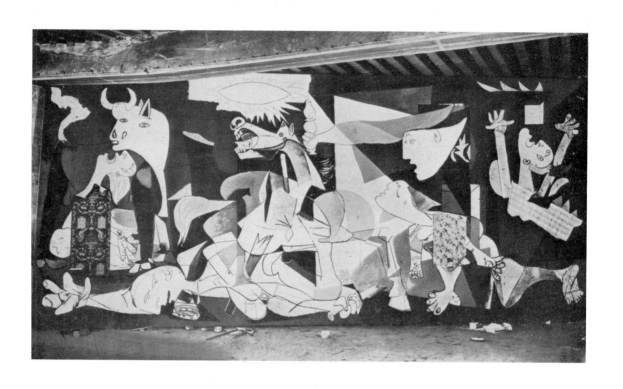

States VI and VII

When José Blazco, Picasso's father, wished to try out a change in one of his compositions he would cover over the questionable segment with a piece of wallpaper, and make his revision tentatively on that removable surface. This procedure he passed on to his son, who perhaps adapted it into the evolution of collage. The curious interlude of State VI of the Guernica, seems to consist of a new variation on Don José's old experiment, with the intrusion of four shaped sections of wallpaper each of a contrasting figure. The papers seem to add up to so many arbitrary distractions, perhaps introduced in order to disrupt the lifeline of the picture and so force new strengths. The old distractions which are here covered over, are the three female figures, and a wing of the kneeling woman's headdress. In the case of the kneeling woman's body the covering impulse had already been acted out once with the same piece of flowered paper in State IV. The new strengths which follow in State VII, however, are difficult to trace to this insistent maneuver, and the most we can be sure of is that the master wanted in some way to keep the general pot boiling rather than let it cool down. The female figures themselves and the kneeling woman's headdress re-emerge in State VII without change. Elsewhere with the release of the wallpaper the swordbearer at last faces upward, emphasis shifts from his ear to his eyes, his voice is released, his decapitation is accomplished, and in fact he takes his final form. The star-shaped stigmata is punched into his hand. And in the gap left by the chopping of the swordbearer's opposite arm, the horse's fourth leg is filled in, built as a strong supporting column to complete the sense of upright power in that animal as a whole. The animal's hoof, obscured since State II by a weaving of the swordbearer's figure, is brought back complete with its significant scoring on the visible underside. And the horse is now complete.

In the mural's one seeming approach to a political note, the splintered board pressing the horse's belly is angled in back of the horse's leg (apparently) to re-emerge as an arrow, a likeness of the symbol of Franco's military Falange.

In another quarter the bird is elevated into final position. Winged creatures were associated both with the bull and the horse in the earlier Studies, as we have seen— emerging from the one animal and perched on the other. Now, appropriately, the bird finds itself balanced midway between these two erstwhile patrons, where indeed it completes its relevance to the other larger protagonists by making a miniature reiteration of the swordbearer and the women at right and left; stricken, that is, and calling upward. Beneath the bird is introduced a table; this simple furniture functions—perhaps—as a kind of sacrificial altar on which the bird's body is deposited.

[178]

Together with the final opening of the bird's beak, the bull's own tragic attempt at vocalization is articulated, his mouth widened somewhat to face the spectator; and the bull's vacillations are brought to their final stop.

As for the sun, a rectangle of white had persisted tenaciously around this tortured object from State IV. This at last is relinquished and darkness flooded in back of the sun altogether. The relinquishing of the white rectangle seems to be the only move which suggests any possible rhyming with the simultaneous peeling away of the wallpaper pieces.

[179] At the same time that it is asked to stand by itself against the dark, the sun is heaped all at once with its trunkful of alternate roles, a sun, a pupiled eye, a shaded lamp, a crown of thorns. Insofar as the resulting form suggests the glaring of a suspended eye, an almond shape with pupil and eyelashes, it plays its compelling new part without precedent, for the legendary modernistic picture "with an eye in one corner" was never a part of Cubism or any other ism, but blows up at the last minute in the Guernica's State VII as a monstrous sport.

Insofar as the bulb defines the shape at the same time as something suggesting a shaded newspaper-office ceiling light, it moves perhaps in rhythm with the newsprint added simultaneously to the body of the horse, the legitimate inheritance from newspaper collage in Picasso's early Cubism. The lampshade overtone is itself not without precedent, for it was forecast, as we have noticed, by the shaded light raised above the horse's distress by the lightbearer in Study IV. The bulb takes further courage no doubt from its immediate rhyming with the bulbous chimney of the lightbearer's kerosene lamp in the canvas; in fact the core of the light bulb, its filament, is brought into focus simultaneously with the interior flame and wick of that sister globe.

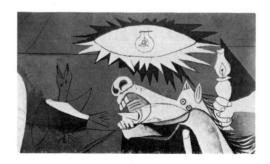

State VIII

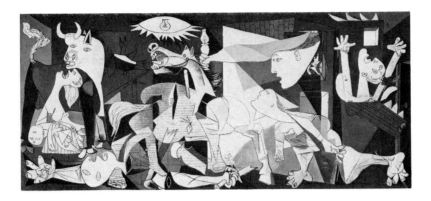

Little remains to be accomplished beyond State VII, beside some last scorings of the swordbearer's hand in its rich completion. One form, however, remains significantly uncompleted to the end—the bull's face, with its underground network of leftover brush-passages and obsolete eye still visible from an earlier incarnation. These restless swirls and wandering eye come into the open nowhere in the photographed States, and apparently had their moment intermediate between State III and the final fixing of the bull's head in State IV. Where innumerable such revisions elsewhere are tidied up and scrubbed out of sight (as in the hand with the sword, changed as we have seen from State VII to the final version, the stitches of the operation neatly removed), the bull alone with his pentimenti keeps his transparencies leading backward in time down the maze of his attempts to reconcile himself to his age-old labyrinth. To the last his body turns both ways at once, like a heraldic animal with two bodies, while his seeking eyes reach both backward in time and to the left and to the right. Of all the protagonists he remains to the last the most powerful and at the same time the most tragically unresolved and most unresolvable. For all his boxing into the balanced wing of the triptych, we suspect almost that in the future, if we consult the Guernica the right moment, the bull will be seen to have struggled through to some still undreamed-of solution to his eternal dilemma. And yet this is not likely, for it is at once the tragedy and the resolution of this creature that its wildness is forever locked and enlisted in a scheme whose grandeur is spread before us in its fullness and in its stillness.

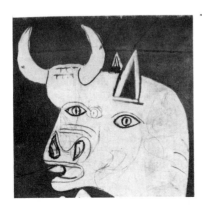

215.
Catalan,
XII Cent

A Recasting: The Old Peasant

Gathering our impressions of a picture we look first to see something of the artist's first and inevitable subject, himself. It is this subject which we have guessed to be stamped across the face of the Guernica like so many Chinese seals, halted in the bull, seizing in the swordbearer and again in the lightbearer. The lightbearer's lamp, the meagre light-maker whose rays are painted nonetheless undiminished into the teeth of a hard daylight—and similarly the scrap which succeeds somehow as a sword, a nothing gripped and extended to shake the world—these may be seen as disguises of that insubstantial weapon of the artist, his brush. Surely it is Picasso who pushes through to us, seen from a certain angle of vision.

The Guernica is of course more than a posting of the artist's likeness. We have sifted rubbles, the remains of histories—we have dug along the outlines of architectures. Yet histories and architectures recede behind some still closer meaning, for the mural clamors through as something more insistent than a clay tablet, or an outline of walls and towers.

A headline, an outcry against blood-letting, undoubtedly the picture's orchestration includes that. Yet little is insisted on literally in the way of death, nor is there any death-dealing to be seen; no image of an outward adversary, none to be seen or named.

We see the general image of life in contest with death. Life holds its own; and the agony in the picture, so conspicuous on the surface, goes to force the link between past and future; throughout the mural in its theme of resurrection and in its close fugal organization we see a harmony and a hard logic in the last extremity, and in its gestures, a signaling and handing over of life. And in all of this the Guernica shows us things which we ourselves possess, or hope that we possess. Even the Guernica bull, its brutality and darkness, not fascism but a tragic idleness—an inward adversary—this, too, we can recognize and own. More than a painter's signature, more than an architect's outlines, and more than the catastrophes of the archives, we find a resonance of strengths and contests within ourselves. Here then as in all art

which holds and tests our imagination, we see the artist's last and most lasting subject, a portrait of ourselves, made from some difficult interior angle.

"I saw an old peasant standing alone in a field: a machine gun bullet killed him." (Father de Onaindìa.)

Who was it, after all, that Father de Onaindìa saw?

But the poet has reminded us not to ask for whom the bell tolls. No distance can divide us finally from an occurrence such as Guernica, or from the artist's relocations of the old peasant who stands while he can. In each of Picasso's protagonists we see a separateness, each figure "alone is a field," a likeness, if you will, of the human state. Life goes on, but contends with our isolations and our self-destruction. Over and above the sense of external catastrophe we see in the Guernica the tragic exchanges common to all life, the tragedy of mind which is not brought into focus with physical force, and, in the bull, the tragedy of force which is not governed in the mind. How much, then, of all life is tragically summarized in Picasso's picture! In its re-growth out of the mangled roots of histories, in its taking up of scraps and pressing into service of human fragments, surely in this mountain of improvising we discover something of the texture of our own lives, no less than in the architectures which must lend a predestined shape to that texture.

The artist has given us a picture which transcends incident and time, a work whose relevance lies within issues of peace at least as much as within those of war. "If a work of art cannot live always in the present, it must not be considered at all."

Like much challenging art, like life, the Guernica is not apt to stay one thing steadily. We see a piece of ourselves, ourselves stood up roughly and blistered with light—and now all at once something unfamiliar, something merely heroic, distant. All at once no part of our known experience seems any match for it; craning upward, we calculate the authority of the horse, the passion of the bereaved mother, the reach of the warrior's arms. Our own hands remain full of life and of dealings with the middle of it, theirs, with the extremities of life, and with death. A crag towers over us, and yet as with other tragedies and with all intense life, at its most extreme the crag comes down and is again ourselves, newly seen and named, enlarged.

An Epilogue

How enduring a work, then, do we feel Picasso's clifflike monument to be?

Hitherto our attitude toward the picture, like that of the majority of its observers, has been what might be called telescopic: scanning towering heights. The Guernica is a towering height, but is telescopic awe the only useful approach to a height?

The future will not lose sight of the Guernica, we are convinced. We look to it to take its place in the mountain ranges of the past. But despite the picture's huge authority, its timeliness, its timelessness, its eloquence and mystery, its relevance to ourselves—despite the things that it is, at occasional intervals there intrudes for many of us an uneasiness, an uncomfortable rattling as of stray pebbles slipping from the summit. Why, for instance, must the picture be eternally argued, searched? Why is there not, we ask when all is said, that unquestioned, that unquestionable quality we find in some earlier tragic expressions, expressions addressed, like the Guernica, in grand programmatic terms to a general public— Bach Passions, Giotto?

This way and that we may argue this point, according to the urging of the moment. It is natural, for example, for the Guernica to pose problems, because our taste has gone beyond Picasso; or has not yet arrived at him; and no art has ever been entirely self-sufficient within itself, all art is dependent on life, which is to say on history. . . . still the Guernica will not simply be dismissed, taken for granted. Some irritant, it may be, excites us, or, just at the height of our response, chills us, slightly. When the mural's eloquence does not seem needlessly obscure, it may present itself now and then as slightly forced. Some maverick piece of us at an awkward moment strays to the sidelines and declines to be awed by the mural's elaborate structure—a dissatisfaction we never experience in relation to Giotto or to Bach. We seem to sense when all is said, a volatile heat, an emotion thrown off perhaps too close to the moment of its causing. We ask ourselves—not while under the direct spell of the

picture, but in retrospect—whether we have experienced the full catharsis which comes of an emotion wholly subdued in life and in wisdom.

Do we sense these negative things: do we ask such questions—or do we not? We return to the picture. We are not sure.

But Picasso was the illustrator of an unsure age. One of his difficulties in particular, was of course that the present age is not one in which artists are born to illustration, especially illustration of passion and of large occurrence. Picasso rushed in where other painters since at least as early as the 1930's, warned by many casualties, fear to tread. Illustration in our century, if it ventures into the open, has learned to protect itself behind a slightly sarcastic warmth, or else a suspicious coldness. "Love and death," as Virginia Woolf said of the works of a clever modern writer, "like damp fireworks, refuse to flare up. . . ." It is of course the discouraging atmosphere of the times, the general rubble of iconographies and faiths; all credit to Picasso, who almost alone among artists of his time has seized both love and death clothed in their visible flesh, and compelled them (outside the Guernica) if not always to climb to a heroic height, at least to rise to an authentic level. Where does this leave our scanning of the special heights attempted in the Guernica uniquely? Has the painter tried, this time, for something more Himalayan than the century can allow—has he kept his footing to the end of his hazardous ascent? Do we find him slightly out of breath?

Picasso rushed in: the press of time was precisely one of the difficulties. Picasso was of course too close to the event which aroused him, to treat it with serenity. Classical illustrators such as Giotto and Bach, along with those of Elephanta, Athens, and Chartres, took for their heroic themes the collective memories of centuries, where Picasso's May project was triggered by an occurrence in late April. No contemporary artist, plucked at by newspapers, has at his command those broad distances which tended to enlarge the artists of earlier times, and which, giving them their authority in relation to the past, gave them their authority in relation to the future. Both in theme and in ways of seeing, they steered securely within tradition, for tradition was everything; a lesser artist could polish its brass and scrub its decks, while a strong artist could turn it in some new direction, a ship which needed guidance but which supported, and which contributed a deep impulse of its own. The new ships, those afloat, leave it to the artist to steer his course in any direction at all; he is invited to tear the decks apart under his feet; the old ships are, of course, dried hulks which the artist is at liberty to pick at as he pleases, joining or scattering the pieces as he chooses. Such freedom is of course intolerable to humankind, and we see some artists, among them the most advanced, clinging to one another in formations as closely knit as ever they were in the middle ages—others, like Picasso, circling around the old hulks, wresting planks. Picasso, like the others, has had to be shipwright, crew, and pilot. It is precisely a part of the buoyancy of Picasso's ship—we might well argue—that its borrowed planks of tradition are not self-sufficient, do not stick out superficially for us to count and to name, but must be searched, flashlighted below its surface where they have taken their place among its

innermost workings. The ship stays afloat. The Guernica with its obstacles to casual understanding, its origins invisible below decks, its improvisations, its metamorphoses unlikely and unpredictable, its traditions chopped up and scattered, begged and borrowed—all this is good sound living material, it is after all none of it of Picasso's making, it is ourselves. If the ship proceeds uneasily, rears up, strains, surely it is the uneasiness of the times, the unsteadiness of the winds. Picasso has done what can be done, he has given us in full measure what one man can. No ship, we feel, could get across these waters between the past and the future with greater sureness than his.

Figure List

Illustrations of the Guernica in its finished State, including details and explanatory diagrams, occur throughout the text without being numbered or included in the following list. For Part II, devoted to the Guernica Studies and States, illustrations of the Studies and States are similarly unnumbered and, accordingly, do not appear in the following list.

1. Picasso. *Crucifixion,* 1902. Pencil, 14½″ × 10½″. Estate of the artist.
2. Picasso. *Crucifixion,* 1930. Oil on wood panel, 20″ × 26″. Estate of the artist.
3. Picasso. *Crucifixion,* 1932. Chinese ink, 13½″ × 19¾″. Estate of the artist.
4. Picasso. *Crucifixion,* 1932. Chinese ink, 13½″ × 19¾″. Estate of the artist.
5. Picasso. *Man with a Cap,* 1895. Oil, 29½″ × 20″. Estate of the artist.
6. Picasso. *Old Man and Child,* 1903. Colored pencils, 13¾″ × 10¼″. Private collection, Switzerland.
7. Picasso. *The Family of Saltimbanques,* 1905. Oil, 83¾″ × 90⅜″. National Gallery of Art, Washington, D.C., Chester Dale Collection. Photo: National Gallery of Art.
8. Picasso. *Accordianist,* 1911. Oil, 51¼″ × 35¼″. The Solomon R. Guggenheim Museum. Photo: The Solomon R. Guggenheim Museum.
9. Picasso. *Four Bathers,* 1921. Tempera on wood, 4″ × 6″. Detail. Private collection.
10. Grünewald. *Isenheim altarpiece,* Crucifixion panel: approx. 8′10″ × 10′1″. Musée d'Unterlinden, Colmar. Photo: Giraudon.
11. Grünewald. *Isenheim altarpiece:* same work as No. 10 above. Detail.
12. Picasso. *Crucifixion,* 1932. Chinese ink, 13½″ × 19¾″. Estate of the artist.
13. Grünewald. *Isenheim altarpiece:* same work as No. 10 above. Detail.
14. Picasso. *Crucifixion,* 1930–31. Pencil. Estate of the artist.
15. Picasso. *Crucifixion:* same work as No. 12 above.
16. Picasso. *Crucifixion:* same work as No. 12 above. Detail.
17. Picasso. *Guernica,* Study 6: Composition study. Pencil on gesso on wood, 25½″ × 21⅛″. Detail. Estate of the artist, on extended loan to the Museum of Modern Art, New York.
18. Picasso. *Crucifixion,* 1930–31. Pencil. Estate of the artist.
19. Picasso. *Crucifixion:* same work as No. 14 above.
20. Picasso. *Crucifixion,* 1929. Pencil. Estate of the artist.
21. Picasso. *Crucifixion,* 1930. Oil on wood panel. Same work as No. 2 above.
22. Picasso. *Guernica,* Study 6: same work as No. 17 above. Detail.
23. Picasso. *Guernica,* Study 10: Composition study. Pencil and gouache on gesso and wood, 28¼″ × 23⅝″. Detail. Estate of the artist, on extended loan to the Museum of Modern Art, New York.

24. Picasso. *Guernica,* the mural State I. Detail.

25. Picasso. *Crucifixion:* same work as No. 14 above. Detail.

26. Rubens. *Elevation of the Cross,* 1610–11. Oil on wood panel, 18¾″ × 134¼″. Detail. Cathedral, Antwerp. Photo: A.C.L.

27. Grünewald. *Isenheim altarpiece:* same work as No. 10 above. Detail.

28. Picasso. *Crucifixion:* same work as No. 14 above. Detail.

29. Picasso. *Crucifixion:* same work as No. 18 above. Detail.

30. Picasso. *Crucifixion:* same work as No. 18 above. Detail.

31. Picasso. *Crucifixion:* same work as No. 21 above. Detail.

32. Picasso. *Crucifixion:* same work as No. 20 above. Detail.

33. Picasso. *Crucifixion:* same work as No. 14 above. Detail.

34. Picasso. *Crucifixion:* same work as No. 21 above. Detail.

35. Beatus of Liebana. Crucifixion from the Commentary of the Apocalypse, ca. 875 A.D. Treasury of the Cathedral of Gerona. Photo: Hirmer.

36. Picasso. *Woman Praying,* 1898. Conté crayon, 9″ × 13¼″.

37. Picasso. *The Altar Boy,* 1896. Oil. Collection, Ricardo Heulen, Malaga.

38. Drawing by the author, adapted from a commercial image of the Sacred Heart.

39. Picasso. *Crucifixion:* same work as No. 18 above. Detail.

40. Picasso. *Guernica,* Study 6: same work as No. 17 above. Detail.

41. Pedro de Meña. *Mater Dolorosa,* 1673. Polychromed wood. Church of the Martyrs, Malaga (destroyed by fire in 1936). Photo: Mas.

42. Picasso. *Guernica,* Study 38: Head of weeping woman. Pencil, color crayon, and gray gouache on paper, 11½″ × 9¼″. Estate of the artist, on extended loan to the Museum of Modern Art, New York.

43. Duccio. *Deposition,* back panel from the Majestà, 1308–11. Cathedral Museum, Siena. Photo: Alinari.

44. Picasso. *Crucifixion:* same work as No. 18 above. Detail.

45. Picasso. *Crucifixion,* 1929. Pencil. Estate of the artist.

46. Picasso. *Crucifixion:* same work as No. 21 above. Detail.

47. Picasso. *Minotauromachy,* 1935. Etching, 19½″ × 27½″. Collection, the Museum of Modern Art, New York. Photo: MOMA.

48. Picasso. *Guernica,* Study 16: Mother with dead child on ladder. Pencil, 9½″ × 17⅞″. Estate of the artist, on extended loan to the Museum of Modern Art, New York.

49. Gregorio Fernández. *Pietà,* 1616. Polychromed wood. National Museum of Sculpture, Valladolid.

50. Grünewald. *Isenheim altarpiece:* same work as No. 10 above. Detail.

51. Picasso. Crucifixion study, 1929. Pencil. Detail. Estate of the artist.

52. Picasso. *Crucifixion:* same work as No. 14 above. Detail.

53. Picasso. *Guernica,* the mural State I.

54. Picasso. *Crucifixion study:* same work as No. 51 above. Detail.

55. Grünewald. *Isenheim altarpiece:* same work as No. 10 above. Detail.

56. Picasso. *Crucifixion:* same work as No. 14 above. Detail.

57. Grünewald. *Isenheim altarpiece:* same work as No. 10 above. Detail.

58. Picasso. *Guernica,* the mural State II. Detail.

59. Picasso. *Les Demoiselles d'Avignon,* 1907. Oil, 8′ × 7′8″. Collection, the Museum of Modern Art, New York. Acquired through the Lillie P. Bliss Bequest. Photo: MOMA.

60. Picasso. *Minotauromachy:* same work as No. 47 above.

61. Picasso. *Crucifixion:* same work as No. 20 above.
62. Picasso. *Crucifixion:* same work as No. 14 above.
63. Ultrecht Master of 1363. *Calvary* of Hendrik van Rijn. Tempera on wood panel. Musée Royal des Beaux-Arts, Antwerp.
64. Picasso. *Crucifixion:* same work as No. 14 above.
65. Picasso. *Guernica,* the mural State III.
66. Picasso. *Crucifixion:* same work as No. 14 above.
67. Picasso. *Bullfight* (Christ appearing in the bullring), 1959. Chinese ink, 14½″ × 10½″. Estate of the artist.
68. Picasso. *Entrance of the Bullfighters,* 1957. Aquatint, 7¾″ × 11¾″. Estate of the artist.
69. Photographic view of the bullfight. Photo: Rodero.
70. Picasso. *Bullfight,* 1917. Pencil, 6″ × 9″. Estate of the artist.
71. Picasso. *Bullfight,* 1917. Pencil, 6″ × 9″. Estate of the artist.
72. Picasso. *Bull and Horse,* 1927. Etching, 7½″ × 10″. From *Le Chef-d'Oeuvre Inconnu* of Balzac, published 1931, p. 394.
73. Photographic view of the bullfight. Photo: Santos Yubero, Madrid.
74. Photographic view of the bullfight. Photo: Vandel.
75. Picasso. *Wounded Horse,* 1917. Conté crayon. Estate of the artist.
76. Picasso. *Bullfight,* 1901. Oil on cardboard, 19¼″ × 25¼″. Collection, Stavros S. Niarchos.
77. Picasso. *Bullfight,* 1923. Pencil, 10″ × 9¼″. Estate of the artist.
78. Picasso. *Bullfight,* 1917. Pencil, 6″ × 9″. Estate of the artist.
79. Picasso. *Bull and Horse,* 1942. Pen, 11¾″ × 15″. Estate of the artist.
80. Picasso. *Bullfight,* 1957. Aquatint, 7¾″ × 11¾″. Estate of the artist.
81. Picasso. *Wounded Horse,* 1923. Oil, 7½″ × 9½″. Private collection.
82. Picasso. *Boy Leading a Horse,* 1905–06. Oil, 76¾″ × 38¼″. Collection, William S. Paley, Manhasset, New York.
83. Picasso. *Man's Head,* 1912. Conté crayon, 24⅝″ × 18½″. Estate of the artist.
84. Picasso. *Bullfight,* ca. 1890. Pencil and gouache, 5″ × 8″. Detail. Collection of the artist.
85. Picasso. *Bullfight,* 1917. Pencil, 6″ × 9″. Estate of the artist.
86. Picasso. *Wounded Horse,* 1917. Conté crayon, 4″ × 5¾″. Estate of the artist.
87. Picasso. *Crucifixion:* same work as No. 18 above. Detail.
88. Picasso. *Crucifixion:* same work as No. 14 above. Detail.
89. Picasso. *Crucifixion:* same work as No. 12 above.
90. Picasso. *Bullfight,* 1934. Pencil, 10″ × 13½″. Estate of the artist.
91. Picasso. *Bullfight,* 1923. 18¾″ × 24½″. Estate of the artist.
92. Picasso. *Minotauromachy:* same work as No. 47 above. Detail.
93. Picasso. *Guernica,* Study 10: same work as No. 23 above. Detail.
94. Picasso. *Guernica,* the mural State I.
95. Photographic view of the bullfight. Photo: Rodero.
96. Picasso. *Bullfight,* 1923. Pencil, 13½″ × 9¾″. Estate of the artist.
97. Picasso. *Bullfight,* 1923. Oil, 10½″ × 8½″. Estate of the artist.
98. Picasso. *Minotauromachy:* same work as No. 47 above. Detail.
99. Photograph of a bull in the bullring: Photo: Santos Yubero, Madrid.
100. Picasso. *The Dream and Lie of Franco,* 1937. Etching and aquatint, 12¼″ × 16¼″. Detail. Estate of the artist, on extended loan to the Museum of Modern Art, New York. Photo: MOMA.
101. Picasso. *Bullfight,* 1934. Oil, 5¼″ × 8½″. Private collection.

102. Picasso. *Bullfight,* 1901. Pastel and gouache on canvas, 17¾″ × 26¾″. Collection, Mrs. Henry J. Heinz, II.
103. Picasso. *Guernica,* Study 11: Horse and bull. Pencil, 4¾″ × 8⅞″. Estate of the artist, on extended loan to the Museum of Modern Art, New York.
104. Picasso. *Guernica,* Study 6: same work as No. 17 above.
105. Picasso. *Guernica,* Study 10: same work as No. 23 above.
106. Picasso. *Guernica,* Study 12: Composition study. Pencil, 17⅞″ × 9½″. Estate of the artist, on extended loan to the Museum of Modern Art, New York.
107. Picasso. *Guernica,* Study 15: Composition study. Pencil, 9½″ × 17⅞″. Estate of the artist, on extended loan to the Museum of Modern Art, New York.
108. Picasso. *Guernica,* Study 22: Bull. Pencil, 17⅞″ × 9½″. Estate of the artist, on extended loan to the Museum of Modern Art, New York.
109. Picasso. *Guernica,* Study 26: Head of bull. Pencil and gouache on paper, 11½″ × 9¼″. Estate of the artist, on extended loan to the Museum of Modern Art, New York.
110. Picasso. *Composition,* 1936. Chinese ink and gouache, 19½″ × 25¼″. Estate of the artist.
111. Picasso. *Composition,* 1936. Chinese ink and gouache, 19½″ × 25¼″. Estate of the artist.
112. Picasso. *Minotaur Defeated by a Youth in the Arena,* 1933. Etching, 7⅝″ × 10⅝″.
113. Picasso. *Minotaur Seated with a Dagger,* 1933. Etching, 10⅝″ × 7⅝″.
114. Picasso. *Minotaur with a Young Woman,* 1933. Etching, 7⅝″ × 10⅝″.
115. Picasso. *The Blind Minotaur,* 1934. Etching, 9 5/16″ × 13⅝″. Detail.
116. Picasso. *The Minotaur Moving His House,* 1936. Chinese ink, 19½″ × 25¼″. Estate of the artist.
117. Picasso. *Minotauromachy:* same work as No. 47 above.
118. Picasso. *Minotaur Carrying a Dead Horse,* 1936. Gouache and india ink, 14¾″ × 25¾″. Estate of the artist.
119. Michelangelo. *Bound Slave,* for the tomb of Julius II, 1513. Marble. Louvre. Photo: Réunion de Musées Nationaux.
120. Michelangelo. *Athlete,* from the Sistine ceiling, 1508–12. Sistine Chapel, Rome. Photo: Alinari.
121. Michelangelo. *Day,* from the tomb of Giuliano de Medici, 1520–34. Marble. New Sacristy, San Lorenzo, Florence. Photo: Alinari.
122. Picasso. *Bullfight,* 1917. Pencil, 6″ × 9″. Estate of the artist.
123. Picasso. *Crucifixion:* same work as No. 39 above. Detail.
124. Temple of Zeus at Olympia: East Pediment (reconstruction), 468–460 B.C.
125. Siphnian Treasury (reconstruction), ca. 525 B.C. Delphi Museum. Photo: Alinari.
126. Temple of Zeus at Olympia: West Pediment (reconstruction). Kneeling figure. Ca. 490 B.C.
127. Temple of Aphaia at Aegina, East Pediment (reconstruction). Dying warrior. Ca. 490 B.C.
128. Stepped Pyramid at Sakkara, III Dynasty Egypt.
129. Erechtheum, the Caryatid Porch. Acropolis, Athens. 420–409 B.C.
130. Egyptian chair, wood. Louvre. Photo: Réunion des Musées Nationaux.
131. Rubens. *Allegory of War and Peace,* 1626–30. Oil on wood panel, 78″ × 117″. The National Gallery, London. Photo: Reproduced by courtesy of the Trustees of the National Gallery, London.
132. Picasso. *Crucifixion:* same as No. 14 above.
133. Picasso. *Guernica,* the mural State I. Detail.

134. Picasso. *Guernica*, Study 14: Mother with dead child. Pen and ink, 17⅞″ × 9½″. Estate of the artist, on extended loan to the Museum of Modern Art, New York.

135. Delacroix. *Liberty on the Barricade*, 1830. Oil, 10′8″ × 8′6″. Louvre. Photo: Réunion des Musées Nationaux.

136. Géricault. *The Raft of the Medusa*, 1818–19. Oil, 16′1″ × 23′6″. Louvre. Photo: Réunion des Musées Nationaux.

137. Domenico Veneziano. *Madonna Enthroned*, ca. 1445. Tempera on wood panel, 6′7½″ × 6′11⅞″. Uffizi.

138. West facade, Canterbury cathedral, begun 1175 A.D.

139. El Greco. *The Virgin with St. Ines and St. Tecla*, 1597–99. Oil, 76⅛″ × 40½″. National Gallery, Washington, D.C., Widener collection. Photo: National Gallery of Art.

140. West facade, Cathedral of Notre Dame, Paris, 1163-ca. 1250. Photo: National Gallery of Art, Washington, D.C., Clarence Ward Medieval Archive.

141. Poussin. *Holy Family*, ca. 1650–51. Oil, 38½″ × 51″. Fogg Art Museum, Cambridge. Photo: Fogg Art Museum.

142. Picasso. *Guernica*, the mural State II.

143. El Greco. *View of Toledo*, ca. 1604–14. Oil, 47¾″ × 42¾″. Detail. Metropolitan Museum of Art, bequest of Mrs. H. O. Havemeyer, 1929. The H. O. Havemeyer Collection. Photo: Metropolitan Museum of Art.

144. Van Gogh. *The Night Café*, 1888. Oil, 28½″ × 36½″. Yale University Art Gallery, bequest of Stephen Carlton Clark, B.A., 1903. Photo: Yale University Art Gallery.

145. English manuscript painting, second half of the tenth century. Caedman's Poems: The First Day of Creation. MS Junius II, folio 6. Bodleian Library, Oxford. Photo: Bodleian Library.

146. Van Eyck. *Adoration of the Lamb*, from the Ghent altarpiece, 1432; detail of the Holy Ghost. S. Bavon, Ghent. Photo: A.C.L.

147. Bernini. *The Ecstasy of St. Teresa*, 1645–52. Marble. Sta. Maria della Vittoria, Rome. Photo: Alinari.

148. Picasso. *Guernica*, Study 10: same work as No. 23 above. Detail.

149. Picasso. *Guernica*, State I. Detail.

150. Picasso. *Bullfight:* same work as No. 90 above.

151. Picasso. *Minotauromachy:* same work as No. 47 above. Detail.

152. Picasso. *Guernica*, Study 3: Composition study. Pencil, 10⅝″ × 8½″. Estate of the artist, on extended loan to the Museum of Modern Art, New York.

153. Picasso. *Minotaur Carrying a Dead Horse:* same work as No. 118 above. Detail.

154. Picasso. *Guernica*, Study 6: same work as No. 17 above. Detail.

155. Greek, *Stele of Lysistrate,* Ca. 420–410 B.C. Marble. The Metropolitan Museum of Art, Rogers Fund, 1906. Photo: Metropolitan Museum of Art.

156. Byzantine: *St. Castrensis freeing the possessed from a devil.* Mosaic, twelfth century A.D. Monreale cathedral. Photo: Alinari.

157. Giotto. *Presentation of the Virgin at the Temple*, ca. 1305. Fresco. The Arena Chapel, Padua. Photo: Alinari.

158. Picasso. *Houses of Gosol*, 1906. Oil, 21¼″ × 14½″. Statens Museum for Kunst, Copenhagen. Photo: Statens Museum for Kunst.

159. Picasso. *Houses*, 1909. Pen and ink, 7¼″ × 4¼″. Estate of the artist.

160. Picasso. *Flight into Egypt*, 1895. Oil, 19¾″ × 14¼″. Detail. Estate of the artist.

161. Picasso. *The Dream and Lie of Franco:* same work as No. 100 above. Detail.

162. Picasso. *Minotauromachy:* same work as No. 47 above. Estate of the artist.

163. Picasso. *Bullfight:* same work as No. 102 above.

164. Picasso. *Four Bathers:* same work as No. 9 above.

165. Iberian black pottery of Numancia, detail of a vase. Second century B.C. or earlier. Museo Numantino, Soria.

166. Picasso. *Bullfight,* 1934. Oil, 38″ × 51″. Collection, Harry Anderson. Photo: E. V. Thaw and Co.

167. Picasso. *The Dream and Lie of Franco:* Same work as No. 100 above. Detail.

168. Drawing by the author, adapted from a photograph by David Douglas Duncan; published in Duncan, *The Private World of Pablo Picasso,* New York, 1958.

169. Berlin painter, Attic red-figured amphora, early fifth century B.C. Detail of a youth playing a lyre. The Metropolitan Museum of Art, Fletcher Fund, 1956.

170. Picasso. From series *The Sculptor's Studio,* 1933. Etching, 10½″ × 7⅝″.

171. Agesander, Athenodorus and Polydorus of Rhodes, *The Laocoön Group,* late second century B.C. Marble. Vatican. Photo: Vatican Museums.

172. Pollaiuolo. *Hercules and Antaeus,* ca. 1460. Tempera, 6¼″ × 3¾″. Uffizi. Photo: Uffizi.

173. Giotto. *The Lamentation,* ca. 1305. Fresco. The Arena Chapel, Padua. Photo: Alinari.

174. Medieval Italian. *The Lamentation,* ca. eleventh century A.D. Fresco. Castel Seprio.

175. Beatus of Liebana. Same manuscript as listed above in No. 35. Detail, figure from The Flood.

176. Praxiteles (Roman copy after). *Aphrodite of Cnidus,* original ca. 330 B.C. Marble. Vatican. Photo: Vatican Museums.

177. Picasso. *Guernica,* Study 41: Head of weeping woman. Pencil, colored crayon, and gray gouache on paper, 11½″ × 9¼″. Estate of the artist, on extended loan to the Museum of Modern Art.

178. Stele of Dexileos, ca. 394 B.C. Marble. Kerameikos Museum, Athens. Photo: TAP.

179. Picasso. Scenery-study for the ballet "Le Tricorne," 1919. Pencil, 11¾″ × 9″. Estate of the artist.

180. Picasso. *Studio with Plaster Head,* 1925. Oil, 38⅝″ × 51⅝″. Museum of Modern Art, New York. Photo: MOMA.

181. Picasso. Study of a hand, from a plaster cast, 1893–94. Conté crayon, 9″ × 13¼″. Estate of the artist.

182. Polyclitus (Roman copy after). Doryphorus, original ca. 450–440 B.C. Museo Nazionale, Naples. Photo: Alinari.

183. Photograph of Picasso at age fifteen.

184. Picasso. Self Portrait, 1907. Oil, 22″ × 18½″. National Gallery, Prague. Photo: National Gallery, Prague.

185. Photograph of Picasso. 1905.

186. Delacroix. *Liberty on the Barricade:* same work as No. 135 above.

187. Byzantine. *Virgin and Child,* eleventh century A.D. Ivory. The Metropolitan Museum of Art, gift of J. Pierpont Morgan, 1917. Photo: Metropolitan Museum of Art.

188. Doric column. Temple of Hera, Olympia, ca. 600 B.C.

189. Church of Ste. Madeleine, Vézeley, 1132–40 A.D. Tympanum of the narthex, representing the Mission of the Apostles. Photo: J. E. Bulloz.

190. Van Dyck. *Pietà,* 1634. Oil, 39″ × 78″. Musée Royal, Antwerp. Photo: Musée Royal.

191. Greek, Roman copy after, ca. 450–440 B.C. *Niobe and Her Youngest Daughter.* Uffizi. Photo: Uffizi.
192. Rude. *La Marseillaise,* from the Arc du Triomphe, Paris, 1833–36. Photo: Bulloz.
193. Pan Painter. Attic red-figured bell krater, fifth century B.C. Detail showing the death of Actaeon. Museum of Fine Arts, Boston; James Fund and by Special Contribution. Photo: Courtesy Museum of Fine Arts, Boston.
194. Southern French master. *Avignon Pietà,* ca. 1470 A.D. Tempera on wood panel, 64″ × 86″. Detail. Louvre. Photo: Réunion des Musées Nationaux.
195. Euphronius. Red-figured kylix krater, fifth century B.C. Detail showing Herakles and Antaeus. Louvre. Photo: Réunion des Musées Nationaux.
196. Picasso. *The Danse of the Banderillos,* 1954. Lithograph, 17¼″ × 25″.
197. Greek Hellenistic. *Praying boy.* Bronze. Staatliche Museen, Berlin. Photo: Staatliche Museen, Berlin.
198. Picasso. *Dancer,* 1919. Pencil, 12″ × 9¼″. Estate of the artist.
199. Picasso. *Bullfight:* same work as No. 91 above.
200. Millet. Sketch for *The Gleaners,* 1856. Charcoal, 11¾″ × 17¾″. Detail. Musée Grobet-Labadie, Marseille. Photo: Musée Grobet-Labadie.
201. Pollaiuolo. *Apollo and Daphne,* undated, detail. Tempera, 11⅝″ × 7⅞″. The National Gallery, London. Photo: Reproduced by courtesy of the Trustees of the National Gallery, London.
202. Picasso. *Drawing,* 1896. Conté crayon. Estate of the artist.
203. Picasso. *Bullfight,* ca. 1890. Pencil and gouache, 5″ × 8″. Detail. Estate of the artist.
204. Picasso. *Landscape of Barcelona,* 1903. Oil, 27″ × 42¾″. Estate of the artist.
205. Picasso. *Crucifixion:* same work as No. 14 above.
206. Picasso. *War,* 1952. Oil, 185″ × 403″. Temple of Peace, Vallauris.
207. Picasso. *The Dream and Lie of Franco:* same work as No. 100 above. Detail.
208. Picasso. *Crucifixion:* same work as No. 14 above. Detail.
209. Picasso. *Crucifixion study:* same work as No. 51 above. Detail.
210. Picasso. *Crucifixion:* same work as No. 21 above. Detail.
211. Picasso. *The Dream and Lie of Franco:* same work as No. 100 above. Detail.
212. Picasso. *Portrait of Dora Maar,* 1936. Ink and pencil, 16″ × 12½″. Estate of the artist.
213. Picasso. *War:* same work as No. 206 above.
214. Picasso. *Minotauromachy:* same work as No. 47 above.
215. Catalan painting. *Lamb of the Apocalypse,* 1123 A.D. Fresco. From San Clement in Tahull. Museum of Catalan Art, Barcelona.

Bibliography

1. Rudolf Arnheim, *Picasso's Guernica.* Berkeley and Los Angeles, 1962.
2. Dore Ashton, *Picasso on Art: A Selection of Views.* New York, 1972.
3. José Camón Aznar, *Las artes y los peublos de la España primitiva.* Madrid, 1954.
4. Aznar, *Picasso y el Cubism.* Madrid, ND.
5. Alfred Barr, *Picasso, Fifty Years of His Art.* New York, 1946.
6. John Berger, *Success and Failure of Picasso.* Penguin, 1955.
7. René Berger, *Découverte de la Peinture.* Paris, 1958 (and English edition, *Discovery of Painting,* New York, 1958).
8. Anthony Blunt, *Picasso's Guernica.* New York and Toronto, 1969.
9. Wilhelm Boeck and Jaíme Sabartés, *Picasso.* New York, 1955.
10. Gyula H. Brassai, *Picasso and Company.* New York, 1966.
11. Otto Brendel, "Classic and Non-Classic Elements in Picasso's Guernica," in *From Sophocles to Picasso* (Whitney Oates, ed.; p. 121 ff.). Indiana University Press, 1955.
12. John Canaday, *Mainstreams of Modern Art.* New York, 1965.
13. Eugene B. Cantelupe, "Picasso's Guernica." *Art Journal,* Fall, 1971.
14. Jean Cassou, *Picasso.* New York, 1940.
15. Herschel B. Chipp, "Guernica: Love, War and the Bullfight," *Art Journal,* v. 33, No. 2, winter 1973–74, pp. 110–115.
16. Vernon Clark, "Guernica Mural—Picasso and Social Protest," in *Science and Society,* v. 5, No. 1, winter 1941, p. 72 ff.
17. Pierre Daix and Georges Boudaille, *Picasso: The Blue and Rose Periods.* London, 1967.
18. David Duncan, *Picasso's Picassos.* New York, ND.
19. David Duncan, *The Private World of Pablo Picasso.* New York, 1958.
20. Frank Elgar and Robert Maillard, *Picasso.* New York, 1960.
21. Albert Elsen, *Purposes of Art.* New York, ND.
22. George Ferguson, *Signs and Symbols in Christian Art.* New York, 1961.
23. Robert Fisher, edited by Theodore Reff, *Picasso.* New York, 1967.
24. Manuel Gasser, "Picasso Tauromaco." *Du* (Zurich), August, 1958, pp. 11–24.
25. Francoise Gilot and Carlton Lake, *Life with Picasso.* New York/Toronto/London, 1964.
26. Clement Greenberg, *Art and Culture.* Boston, 1961.
27. Timothy Hilton, *Picasso.* New York and Toronto, 1975.
28. Harriet and Sidney Janis, *Picasso—The Recent Years.* New York, 1946.
29. Ruth Kaufmann, "Picasso's Crucifixion of 1930." *Burlington Magazine,* Sept. 1969.

30. Juan Larrea, *Guernica, Pablo Picasso.* New York, 1947.

31. Allen Leepa, *The Challenge of Modern Art.* New York, 1949.

32. *Life,* December 27, 1960.

33. José Lopez-Rey, "Picasso's Guernica," in *Critique,* v. 1, No. 2, Nov. 1946, p. 3 ff.

34. Vincente Marrero, *Picasso and the Bull.* Chicago, 1956.

35. Museum of Modern Art, New York, Symposium on "guernica," Nov. 25, 1947. Typescript in the library of the Museum of Modern Art, New York.

36. Bernard Myers, *Modern Art in the Making.* New York/London/Toronto, 1959.

37. New York Graphic Society and UNESCO, *Spain—Romanesque Paintings,* Introduction by Walter W. S. Cook. Paris and Greenwich, Conn., 1957.

38. Robert Payne, *The Civil War in Spain, 1936-1939.* New York, 1958.

39. Roland Penrose, *Picasso: His Life and Work.* New York, 1958.

40. Pablo Picasso, *2 Statements,* New York and Los Angeles, 1936. Originally in "Picasso Speaks," *The Arts,* May 1923.

41. Edward Quinn, *Picasso at Work.* New York, 1964.

42. Maurice Raynal, *The History of Modern Painting from Picasso to Surrealism.* Geneva, 1950.

43. Max Raphael, *The Demands of Art.* New York, 1968.

44. Herbert Read, "Guernica," in his *A Coat of Many Colors.* London, 1945, p. 317 ff. (reprinted from *London Bulletin,* No. 6, Oct., 1938).

45. Herbert Read, "The Dynamics of Art," in *Franos Jahrbuch,* vol. 21, 1953, p. 272 ff.

46. Martin Ries, "Picasso and the Myth of the Minotaur." *Art Journal,* v. 32, No. 2, winter 1972–73, pp. 143–45.

47. Robert Rosenblum, *Cubism and Twentieth Century Art.* New York, 1960.

48. William Rubin, *Dada and Surrealist Art.* New York, ND.

49. William Rubin, *Picasso in the Collection of the Museum of Modern Art.* New York, 1972.

50. Franco Russoli, *Pablo Picasso.* Milan, 1953.

51. Jaíme Sabartés, *Picasso—Documents Iconographiques.* Geneva, 1954.

52. Willem Sandberg, "Picasso's Guernica." *Daedalus,* v. 89, No. 1, winter 1960, p. 245 ff.

53. Daniel Schneider, "The Painting of Pablo Picasso: a Psychoanalytic Study," in his *The Psychoanalist and the Artist.* New York, 1950, p. 164 ff.

54. Lucien Schwob, *Réalité de l'Art.* Lausanne, 1954.

55. John Sedgwick, *Discovering Modern Art.* N.Y., 1966.

56. Jacques Senecal, "Picasso: His Impact," in *American Dialogue,* Feb.-Mar., 1965.

57. Gertrude Stein, *Picasso.* Boston, 1960.

58. Gordon Thomas and Max Morgan Witts, *Guernica, the Crucible of World War II.* New York, 1975.

59. Hugh Thomas, *The Spanish Civil War.* New York, 1961.

60. Paul Tillich, *Theology of Culture.* N.Y., 1959.

61. Antonina Vallentin, *Pablo Picasso.* Paris, 1957.

62. Christian Zervos, *Pablo Picasso.* Editions Cahiers d'Art, Paris.

63. Christian Zervos, untitled article in *Cahiers d'Art,* v. 12, No. 4–5, Paris, 1937, special Picasso issue: on the Guernica, p. 105 ff.

On the bullfight:

64. Ernest Hemingway, *Death in the Afternoon.* New York, 1932.

65. John Marks, *To the Bullfight.* New York, 1953.

66. Angus McNab, *Fighting Bulls.* New York, 1959.

Notes

Full references to books and articles are provided in the bibliography, which is limited to works discussed in the notes.

1. A documented account of the bombardment of Guernica is to be found in Hugh Thomas's *The Spanish Civil War* (*59*, p. 419 ff.); and in the comprehensive study by Gordon Thomas and Max Morgan Witts, *Guernica, the Crucible of World War II* (*58*).

2. I am indebted to Rudolf Arnheim for the term "swordbearer," as also for the term "lightbearer" (*1, passim.*).

3. The presence of the crucifixion theme in the Guernica has been suggested by a number of observers. It is Herbert Read who has referred to the mural broadly as "a modern Calvary" (*44*, p. 200). Various elements in the mural may be said to suggest the crucifixion in a generalized way, as in the matter of the triad formed by the mother, the horse, and the burning woman: "We can think almost of a Crucifixion, where the cross stands between two thieves and the light of the sky forms a luminous triangle falling from the height. Rembrandt, perhaps?" (Marrero, *34*, p. 77). The connection between the Guernica and Picasso's Crucifixions has been touched on; "Many of the motifs in the *Guernica* appear in his previous work. . . . the *Crucifixion* of 1930 is comparable in its iconographic complexity and certain of its details" (Alfred Barr, *5*, p. 200). More detailed contributions of other observers concerning the connection between the mural and Picasso's Crucifixions, are discussed below, in Notes 14, 18, 30, 39, 73, 135, 141, 179.

4. The mural has been called a visual chaos. "The artist has used none of the artistic tricks but has thought only of expressing as tellingly as possible a supreme moment of human pain and revolt in all its disorder" (Raynal, *42*, p. 140).

5. Picasso's Crucifixions (all in the Estate of the artist):
 1. Pencil drawing, 1902. Zervos, *62*, v. 6, No. 390, p. 48 (discussed in Note 35 below).
 2. Pencil drawing, 1915, *Ibid.* No. 1331, p. 158. Naturalistic drawing.
 3. Pencil drawing, 1926–27. Zervos v. 7, No. 29, p. 14 (similar in dramatic arrangement to listing No. 11 below).
 4. Pencil drawing, 1929. *Ibid.* No. 279, p. 114.
 5. Pencil drawing, 1929. *Ibid.* No. 280, p. 114 (Studies of the Magdalene; similar to the preceding).
 6. Pencil drawing, 1929. *Ibid.* No. 281, p. 115 (similar to listing No. 8 below).
 7. Pencil drawing, 1929. *Ibid.* No. 282, p. 115 (cognate with the preceding).
 8. Pencil drawing, 1929. *Ibid.* No. 283, p. 116.
 9. Painting, oil on wood, 1930. *Ibid.* No. 287, p. 117 (and Barr, *3*, No. 233, p. 149; in color in Rubin, *48*, Pl. XXXIV, p. 293.
 10. Pencil drawing, 1930–31. *Ibid.* No. 315, p. 130.
 11. Pencil drawing, 1930–31. *Ibid.* No. 316, p. 130.

12. Chinese ink on paper, 1932. Zervos v. 8, No. 49, p. 22. (Adapted from the Isenheim altarpiece of Grünewald).
13. Chinese ink on paper, 1932. *Ibid.* No. 50, p. 22 (similar to the preceding).
14. Chinese ink on paper, 1932. *Ibid.* No. 51, p. 23 (very abstract).
15. Chinese ink on paper, 1932. *Ibid.* No. 52, p. 23 (very abstract).
16. Chinese ink on paper, 1932. *Ibid.* No. 53, p. 24 (Bone style Crucifixion).
17. Chinese ink on paper, 1932. *Ibid.* No. 54, p. 24 (related to the preceding).
18. Chinese ink on paper, 1932. *Ibid.* No. 55, p. 24 (related to the preceding, but very abstract).
19. Chinese ink on paper, 1932. *Ibid.* No. 56, p. 25 (abstract).
20. Chinese ink on paper, 1938. Zervos v. 9, No. 193, p. 92 (discussed in Note 111 below).
21. Finally, a group of nineteen drawings in various media, of 1959, showing aspects of the crucifixion in the bullring (discussed above in the Bullfight chapter). Zervos v. 18, Nos. 333–4, 339, 342–345, 347–350, 352–359.

6. Picasso employed the shapes of the past at least as candidly as any other painter of his generation, and at times suggested certain outlines of the future, yet he never makes us feel that he is gazing in either direction. A deep-going carelessness of his two prizes, ends by giving the painter his unique possession of their spirit and immediacy. "The several manners I have used in my art must not be considered an evolution, or as steps toward an unknown ideal of painting. All I have ever made was for the present. I have never taken into consideration the spirit of research. When I have found something to express, I have done it without thinking of the past or the future...." (Picasso in 1923; *40*, pp. 13–14; also quoted in Barr, *5*, pp. 270–271).

7. Rudolf Arnheim notes (*1*, Note, p. 138) that most authors are incorrect in giving April 28 as the date of the bombing of Guernica. The account in the New York Times of April 28, refers to the occurrence of "last evening," and would appear to describe the reporter's visit to the town at 2:00 A.M. of the 28th; this would indicate the 27th as the date of the bombing. Other eye-witness accounts state more clearly, however, that the event took place on the 26th (as quoted by Robert Payne, *38*, p. 195 ff), and, with Rudolf Arnheim, I adopt April 26 as the date.

8. Cubism may be said to have been destructive, slicing up physical form and finishing off some traditional ideas of artistic behavior; but as against this one recognizes of course that it made full reparations, creating where it destroyed, restoring to the artist certain ancient liberties and opening new horizons for the mind. Analytical Cubism in particular, the somewhat illegible style which began to flourish around 1910, with its disguised forms can hardly be called a simple matter of explosives. If it suggests the detonating of the anarchist bomb, it suggests the secretiveness of the anarchist plot. In fact its extreme reserve might be said to border on the aristocratic rather than the anarchic; traditional in subject-matter,—guitarists à la Watteau; strict and mannered in designing; discreet in color; suspicious, often, of romantic plunges of light or volume; fragmented, but finely (as a rule), and, of course, bloodlessly. Cubism foretells the Guernica only as the dry riverbed foretells the flood. In the mural "The insistent angularities, patternings, and fragmentations recall cubist collage but here they serve to suggest the confusion, and augment the explosive emotion of the scene (Barr, *5*, p. 201). And "the Cubist language of fragmentation is directed to new and expressive ends—the grim documentation of the bombing of a Spanish town, whose holocaust of splintered and shattered human lives and moral values wrenches Cubism from the sensuous and intellectual confines of the artist's world to the agonizing actualities of Europe on the eve of the Second World War." (Rosenblum, *47*, p. 296.)

Cubism takes sufficiently physical shape in the mural. The abstract form which intersects knifelike with the horse's hindquarters, suggests Analytical Cubism, defunct for some twenty years at the time of the mural: another such suggestion is in the transparency of the kneeling woman, through whose body can be seen the continuing form of the window behind her; and similar slicings with light. But whereas in developed Analytical Cubism contours were broken and playfully multiplied, each figure and element in the Guernica has a complete, consistent outline—an uncompromising definiteness of statement. "The predominant formal means are the flat elements of Synthetic Cubism of the 1920's...." (Boeck and Sabartés, *9*, p. 226.) Even in the case of the specifically dismembered figure of

the swordbearer, the "insistent ... fragmentations" and "Cubist language of fragmentation" in the Guernica are in fact an illusion, a play of choppy lights and shadows across forms as resolutely finished as those on any Greek vase painting. Indeed it may be observed that Cubism was employed cautiously in the evolution of the Guernica, and only as a late addition to a classical foundation—a sequence which is not always seen; "Naturally as breathing, Picasso drew in the first intimations of shallow Cubist space and then tried to float over them the spread-out, precise, sculptured manner of the great Davidian battle scenes" (Timothy Hilton, *27*, p. 246). On the contrary, Cubism plays only a marginal part among the early Studies, and in the States is laid down as a sort of arbitrary grid over the already-completed sculptural forms in State I (on this see also Note 82, and the discussion of State I). Aggressive as it may be, Cubism entered the contest last; in the mural's struggle between sculptural completeness and Cubist destruction, neither side may be said to yield an inch. (It might be observed parenthetically that there is nothing necessarily shallow about the ambiguities of Cubist space, as in Analytic Cubist paintings of 1910 backgrounded with the suggestion of roof-scapes of Spanish villages, and Synthetic Cubist paintings with their occasional cloud-scapes verging into a hint of the blue wastes of Surrealism; see for example Fig. 180 above.)

9. The classicism of the lightbearer, and other elements, is discussed in the final chapter (see also Note 107).

10. Perhaps more than any other one picture, the Guernica stands almost as a kind of encyclopedia of Picasso. The present work contains references to most of the major phases of Picasso's work through 1937; early Spanish periods; Blue, Rose, African, and Bone periods; Analytical and Synthetic Cubism; circus, ballet, crucifixion, and bullfight series; etc.

11. The mural was begun on May 11, and finished somewhere in mid-June. For accounts of the chronology of the mural and of the preliminary Studies, see Arnheim, *1*, chapter III; also Boeck and Sabartés, *9*, pp. 226 ff.; and Sandberg, *52*, pp. 247 ff.).

12. Discussing certain Guernica Studies, Arnheim points out, somewhat hyperbolically: "Horse or woman, the vehicle is still of secondary importance. The true actor is the mouth, presented with an almost obsessive attention to the realistic details. . . ." (*1*, p. 72)
 Except in the case of the dead baby, mouths in the Guernica are presented in profile, indenting the shape of the head (even when the head itself is seen full front, in the case of the bull): "cette position assurant à l'expression du cri sa plus grande intensité (contour accidenté du visage, orifice de la bouche à l'agonie)" (René Berger, *7*, p. 355).

13. Isaiah 5:20.

14. I am indebted to William Rubin's observations concerning the Crucifixion in the Isenheim altarpiece that "from the Grünewald itself, where Christ's tongue is beginning to emerge from his mouth (Meyer Schapiro has noted the horror suggested by this 'externalization of the body'), Picasso got his idea for the protruding tongue of the horse in *Guernica*." (*48*, p. 294.) The mouth itself in the Grünewald is only moderately open, but such openness as it has was pitched on by Picasso in his adaptations of 1932 (on these see Note 17 below), and it is evidently these which transmit the mouth and the tongue together into the mural. And reaching still further afield within Picasso's crucifixion-oriented works, it is observed that "The screaming, wounded horse in the centre of the *Guernica* bears a visual and conceptual resemblance to the wounded Christ and screaming woman in the centre of the *Crucifixion* [the panel of 1930]" (Ruth Kaufmann, *29*, p. 558).

15. The Guernica horse blind with pain, is suggested in the protagonist of the drawing, The Blind Minotaur (reproduced above in chapter two)—a creature magnificent in its tragic extremity, like the Guernica animal eloquently calling toward the heavens. The heroic Minotaur strides by the sea, preceded by a watchful young girl and sympathetically observed by a chorus of Mediterranean folk: one hand grasps his wanderer's staff, the other is stretched forth in a blind man's gesture: the Minotaur, one cannot help guessing, cast as the blinded Oedipus led into exile by his daughter.
 One might suppose that Picasso's occasional preoccupation with blindness, as in the Blue period,

would connote sympathy, and that the suggestion of Oedipus would connote a sense of grandeur, as it does in Picasso's drawing and in Sophocles' play. But "One remembers from [the author's discussion of] Oedipus Rex that blindness (as in [Picasso's] blind beggars) is castrative self-punishment. . . ." (Daniel Schneider, *53*, p. 165; with related comments.) However this may be, the blindness of the Guernica horse has a closer possible connection than the blindness of Oedipus—and that is the actual condition of the Picador's mount, led blindfolded into the bullring.

16. The canvas itself, as distinct from its preliminary Studies on paper, was photographed in eight successive States of revision. These are published in full in Zervos, v. 9, Nos. 58–65; also in Arnheim, *1*, p. 121 ff.; and discussed in detail in the present work, Part II—The States.

17. The 1932 Crucifixion studies "are based on the Isenheim altarpiece of Matthias Grünewald. . . ." (Barr, *5*, p. 167; and identified as such in *Minotaur*, No. 1, 1933, pp. 30–32.)

18. The connection between the Guernica horse's spear and the spear of Longinus, is brought out by William Rubin (*48*, p. 294), paralleling in part the present writer's observations.

19. The sinuosities of the Crucifixion studies through 1930 have little reflection in the sternly self-contained shapes of the Guernica, or in the angularities of Cubism. The manner seems to grow in part from the continuous looping contours in circus drawings of 1920 (Zervos, v. 3, Nos. 1476, 1477, p. 176.)

20. The object which is usually read as the sponge of vinegar in Picasso's Crucifixion panel of 1930, has an alternate suggested reading, derived by Ruth Kaufmann from a page of the same *Apocalypse of Saint-Sever* which contained the prototype of the Guernica's swordbearer (see Note 110). "This page includes [a picture of] the stone which detached itself from a mountain, the idol made of precious metals which it hit, and the mountain the stone became when it had destroyed the idol. The object in Picasso's painting bears a certain resemblance to the stone which became the mountain and filled the earth. It is one of the few images in the *Crucifixion* which is rendered three-dimensionally. This gives it a weightiness which suggests something falling or hurtling downward, about to hit the bird, the divided figure [the two thieves], or both." (*29*, p. 358.) But visually the object in Picasso's picture might well be taken to lean toward the lopsidedness of a sponge, rather than toward the stylized symmetry of the stone in the *Apocalypse* (reproduced in Ms. Kaufmann's article, and, as she explains, quite likely seen by Picasso). Iconographically, too, it is easier to understand as the sponge (see in particular, Rubin, *48*, p. 292). In the absence of additional Picasso stones or sponges to compare the object to, the point would seem impossible to settle definitely.

21. Picasso's surname, according to traditional Spanish option, was derived from his mother's family; his father's name was Ruiz Blasco. Biographies of Picasso are contained in Roland Penrose, *39*; Jaíme Sabartés, *51*; Franco Russoli, *50*; and a biographical summary in Boeck and Sabartés, *9*, pp. 511 ff; and more comprehensive, Patrick O'Brian, *Picasso—A Biography*, New York, 1976.

22. Zachariah 13:6.

23. For the important information about the Dolorosa of Pedro de Meña, and its visual connection with the Guernica Studies, I am indebted to José Maorta (in conversation).

24. For a photograph of Picasso at work standing on a long plain wooden ladder, see Quinn, *41* (pages unnumbered).

25. The figure at the left in the Minotauromachy has been mentioned as Christ by Herbert Read (*45*, pp. 272 ff.). With his naturalistic anatomy, his traditional loincloth, beard, and wound suggesting that of the coup de grâce, and his gentle compassionate demeanor, the figure would seem to constitute the most orthodox image of Christ to appear in Picasso's works since the Crucifixion drawing of 1915, and a sharp departure from the abstractions of the 1920's and later. The figure's otherwise unexplained relation to a ladder would seem if anything to reinforce the likelihood of a Christ-identity, but with an unresolvable ambiguity: is the figure climbing the ladder or descending?

One observer remarks upon "the bearded man, symbol of the artist himself, escaping from the scene by climbing a ladder" (Anthony Blunt, *8*, p. 24); or similarly, "a bearded man in a loincloth climbs a ladder to safety, looking over his shoulder at the monster" (William Rubin, *49*, p. 148); but these interpretations, while not without a definite logic, seem to lack a clear visual necessity. The man gives no hint of agitation or of fear or revulsion either in his meditative glance, analagous to that of the candle-bearing girl, or in his altogether relaxed hands. The hands rest side by side at the top of the ladder, indicating that the man has halted for a moment's reflection either at the end of his ascent or at the beginning of his descent. On the whole by a narrow margin a descent seems to the writer the more likely, an entering into the scene in visible harmony with the air of sympathetic involvement of the three female participants. The sharply descending angle of the man's feet, moreover, give an impression of flowing downward, again in marked relaxation. The rhyming of the ladder with the theme of the Descent from the Cross, as already suggested, perhaps lends a certain reinforcement to this interpretation. But in any case a certain ambiguity seems the one thing definitely to be recognized; nor is it unlikely that the ambiguity is at least partly the point. A man has paused on a ladder; beyond that we can only speculate. As Dr. Rubin says, "As a kind of private allegory the *Minotauromachy* tempts the interpreter. But explanation, whether poetic or pseudo-psychoanalytical, would necessarily be subjective." (*49*, p. 148.)

26. The ladder motif does not figure only in the Crucifixions and other works cited. A circus scene of 1917 (Zervos, v. 2, Pt. 2, No. 949, Pl. 387) contains several elements perhaps distantly germinal for the Minotauromachy: a gentle horse stands amid a great deal of hubbub, and, on its back, a female rider turns—to assist a monkey who stands on a ladder. After a number of such early designs for ballet curtains and settings (*Ibid.,* No. 950, Pl. 398; and No. 951, Pl. 399; both 1917), the ladder appears in still a different context in a large pastel of 1935 (Boeck and Sabartés, *9*, No. 285, p. 223): here a woman mounted on a ladder, tenderly carries a bird down from (or up to?) a hayloft. Further, the ladder appears in an otherwise non-objective Surrealist drawing of 1927 (Zervos, v. 7, No. 113); and it figures among the furniture being carted away, in the enigmatic painting "The Minotaur Moves his House" (1936; see Duncan, *18*, p. 86). Thematically, however, none of these stray occurrences would seem as relevant to the Guernica as the series of ladders in the Crucifixions, especially given the critical suggestion of that theme in the Minotauromachy.

(Visually, the ambiguity as to climbing the ladder or descending it may be said to extend to the Guernica Studies of the mother and child. Here, however, the programme fairly demands an interpretation of descending, as it is difficult to suppose the mother with her child climbing a ladder into a burning house at Guernica.)

27. The theme of the mother and dead child is variously treated by Picasso over the years. In particular, the theme is found in drawings of 1932 entitled Sauvetages—rescuings. The Guernica mother shrieking over the body of her child, is an image transplanted recognizably from these earlier works (the series, closely cognate, is to be seen in Zervos, v. 8, Pls. 63–66: pp. 27–29; and *ibid.*, Pls. 71–75: p. 32). These, however, express the horror of the event in a kind of physical debasement of the mother (or at best a pathos, as in the Dream and Lie of Franco): by contrast with the monumental grandeur which, whether or not it is to be felt as Biblical, characterizes the attitude of the mother in the Guernica and, to a lesser extent, the Guernica Studies, Picasso's final statement of the theme.

28. Isaiah 38:14.

29. The arms of the 1929 Magdalenes, are related by Barr to the bodiless arms at the right in the 1930 Crucifix painting (*5*, p. 167). Angular and almost vertical, the latter reappear at the left in a Guernica Study of May 9 (Study No. 15). Arnheim, whose discussion of the background of the Guernica is largely restricted to its relation to the Studies themselves, does not note the origin of these limbs: "the idea for which they stand is apparently not rooted in the central concept of the work. They are fillers seeking full status. . . ." (*1*, p. 57).

It is to be noted that the "Magdalene" studies of 1929 (as I refer to them) are not designated as such by the artist, but simply as Studies for a Crucifixion. The identity of the backflung figures with waving arms, as Magdalenes, seems unquestionable in view of Picasso's representations of the

Magdalene in Crucifixion scenes of the '20's and early '30's. In particular it is to be presumed that the figure is a derivation from Grünewald's Isenheim Altarpiece, the source of the Crucifixion drawings of 1932.

30. Outside of any general suggestion of a Magdalene, it has been suggested that the kneeling woman of the Guernica reflects the dice-throwing figure in the Crucifixion panel of 1930, both figures inclining toward something of the same "bent posture and bared buttocks" (Ruth Kaufmann, 29, p. 558). The kneeling woman and the dice-thrower, then, perhaps reinforce one another's significance in a distant way, in that both may be said to figure as witnesses to a crucifixion. (But the kneeling woman's buttocks are not strictly bared, for the woman is plainly skirted; indeed it is fortunate that such things as medical and military reports are not cut out of the same bolt of cloth as so many visual descriptions of the Guernica.)

31. It is frequently observed that the lightbearer "takes the part of the Chorus in a Greek tragedy, who can by the same token be described as an onlooker" (Otto Brendel, 11, p. 137).

32. Isaiah 62:1.

33. Quoted, in English, by Robert Payne: 38, p. 198.

34. Ferguson, 22, p. 60. The presence of sun and crescent moon flanking the cross in Picasso's Crucifixion drawing of 1930, like the enthronement of the Christ in the same work, is a borrowing from medieval pictures, possibly Spanish. The sun and moon appear as early as the sixth century, in the Crucifixion page of the Rabula Gospels. A Spanish Romanesque example occurs in a fresco in the eleventh century Collegiate Church of S. Isidore at Leon (see N.Y. Graphic Society and UNESCO, 37, Plate on page 17; and text, p. 21). The latest-occurring example I have come across is a 16th century Italian *verre eglomisé* (glass panel with picture etched into black paint on the reverse) in the Walters Gallery in Baltimore.

35. The exaggerated arm muscles of this 1930 Crucifixion are foreshadowed as early as 1902, in Picasso's first Crucifixion drawing (Zervos, v. 6, No. 390, p. 48). We see an attenuated but conservatively naturalistic figure, closely shaded and modeled—and, in the background, like a pale shadow of things to come, a faint linedrawing of a figure similarly posed with arms outspread—and abrupt bulging unnatural biceps (Figure 1 in the present work).

36. Isaiah 51: 16–17.

37. Was the crucifixion theme intentional? The conclusion would seem difficult to avoid that it was at least partly so, yet on the question of the painter's intentions it would seem best to hazard as little as may be. A great artist cannot fully intend nor fully analyze. Intentions mean as little in art as elsewhere, and even when a painter tries to tell us his, we are not always enlightened. Leonardo, who in paintings visualizes poetry and mystery, writes largely of optical effects. Joshua Reynolds, who shows us something of the reticence of the English national character, speaks to us about the spirit of Greece. Cézanne, dry and subtle poet of ambiguous moods, writes of cones and spheres (it is George Weber, in conversation, who has pointed out this anomaly). And Picasso: "In the panel on which I am working and which I shall call Guernica, and in all my recent works of art, I clearly express my abhorrence of the military caste which has sunk all Spain in an ocean of pain and death...." (in Barr, 5, p. 202)—thus the painter's much-quoted declaration, made in answer to a question concerning his politics, not his picture; the general sentiment would be as fitting for a Goya, or, indifferently, a newspaper cartoon. Such detached explanations have a biographical or historical interest, but are we the richer for them when we stand in front of the Gioconda or the portrait of Mrs. Somebody or of Mme. Cézanne, or Picasso's mural? On the contrary, if we cannot stop the painter's limited explanations from buzzing in our ear we are the poorer. Picasso himself has summed this up: "Often the picture expresses much more than the artist wished to translate" (Picasso, 40, p. 39). And "Among the several sins that I have been accused of committing, none is more false than the one that I have, as the principal objective in my work, the spirit of research. When I paint my object is to show

what I have found and not what I am looking for. . . . What one does is what counts and not what one had the intention of doing." (*Ibid.*, pp. 4–5; also quoted in Barr, *5*, p. 271.)

Further, Rudolf Arnheim: "Our enquiry cannot be limited to discovering by indirection what the painter had on his conscious mind and therefor could have told us himself if he cared to and if he remembered. From what I said earlier it will be evident that deliberate conscious reasoning and decision constitute only small fragments of the total process, and that therefor any psychological investigation is bound to describe happenings of which the person himself was unaware. The assertion that the 'artist never thought of this' has no bearing on the validity of the interpretation, since the artist, like any other person, does not know what he thought below the level of awareness. We cannot even expect the interpretation necessarily to be plausible to him when he is confronted with it, although a sense of 'recognition' may often be his response to the findings." (*1*, p. 17.) And, more vividly: "in the creative process conscious behavior and unconscious behavior are no more different from each other than the flowing of a river in full daylight is different from its flowing in the darkness of night" (*ibid.*, p. 6).

For all this it remains difficult if not impossible to suppose that the crucifixion was absent entirely from Picasso's mind. The theme had not appeared in the artist's work for five years at the time of the Guernica, but was to reappear in the light of day only a year later: Picasso resumed his series in a Crucifixion dated August, 1938 (this drawing is discussed below in Note 111). (On Picasso's religious orientation see also Note 79.)

38. I am indebted to William Rubin (in conversation) for his reference to Picasso's Crucifixions in general, as an "agony of modern man." (On this quotation see further Note 79).

39. The general connection between the Guernica and Picasso's 1959 drawings of Christ as torero, is mentioned also by Anthony Blunt (*8*, pp. 57–58), though without noting the important link between Picasso's imagery and Spanish bullfight lore: "Described in words, the idea may sound blasphemous and slightly ridiculous, but in the actual drawings it is otherwise. . . ." That such a Picassoesque fantasy should belong not to Picasso but to national legend, shows the Spanish, rather than merely individual and capricious, nature of the artist's thinking in his mixing of crucifixion and bullfight themes in the mural at large. William Rubin draws attention to "the traditional, historical association of Christianity with the bullfight and the many indications of Picasso's awareness of it. For centuries, the bullfight has been part of Spanish popular Christianity, its imagery permeates the *villancicos*, traditional nonliturgical church songs"; with other references (*48*, pp. 294–5).

Prose seems inappropriate all around for expressing the relationship between the corrida and Calvary. The Calvary theme forces itself into the endless and sometimes florid nomenclature of the bullfight—but with a Picassoesque absence of ordinary logic. One of the passes with the cape is called Veronica, another, Dolorosa: thus the slaughterer of the bull identifies himself first with the woman who comforted Christ, and second, with the bereaved Virgin.

40. Quoted by Barr, *5*, p. 202.

41. Paralleling in part the present writer, William Rubin makes the connection between Christ and Picasso's bullring horses in and out of the Guernica: the horse as "suffering innocent." (*48*, p. 290.)

42. Ernest Hemingway, *64*, p. 185.

43. There is a seeming deliberate perfunctoriness in Picasso's torero studies, a lack both of visual technique and of abstract grandeur or inventiveness: see for example the drawing of 1901, Zervos v. 1, Nos. 89, 90, p. 44—in a period of powerful figure representations; or the idiotic picador in the drawing of 1939, *ibid.*, v. 9, No. 379. Indeed in the whole vast range of Picasso's bullfight series over the years, the only bullfighters who are clearly invested with dignity are the dead or recumbent ones, particularly the dream-toreros depicted as recumbent females, as in the Minotauromachy (see also Zervos, v. 8, No. 214, 286).

44. David Duncan, *19*, p. 122.

45. There is in fact an isolated occurrence of a bird in Picasso's early Cubism, though not apparently in that style's classic phase of 1910–12: a Cubist pencil-drawing of a bird occurs in 1914 (Zervos v. 2, No. 855). The tendency to spare animals the Cubist treatment in this period is underscored in two pencil drawings of 1916, in each of which an animal is shown naturalistically, held by a human being who is rendered Cubistically (Zervos v. 2, No. 899, a woman with a dog; *ibid.* No. 900, a woman with a cat).

46. "In Picasso's art prior to 1936 one cannot find any direct reflection of the political happenings of his time—not even of the world war of 1914–1918 which he spent in France" (José Lopez-Rey, *33*, p. 3).

47. The origin of the Guernica horse in Picasso's corridas, has been noted also by Barr; "The bullfight series of 1933–35 provides the shrieking horse. . . ." (*5*, p. 200). Beyond this, the image is to be traced back to the drawings of 1917–1923, and indeed to a drawing of ca. 1890 (on this drawing see Note 136).

48. The horse's conical tongue, like the emphasis on the opened mouth, is foreshadowed in the Bone period (e.g., the painting, "Head," 1930, Zervos v. 6, No. 313, p. 128: in which the tongue is a simple acute triangle).

49. The newsprint-like hair of the horse seems foreshadowed in objects cut out of newspaper, in collages of 1912–13.

 Newspapers in Cubist pictures were occasionally represented in paint—the print symbolized by short brush strokes somewhat similar to the Guernica horse's hair (Rosenblum, *47*, No. 46, p. 81; No. 66, p. 92). In some Circus and Synthetic Cubist pictures the short strokes represent hair, and not newsprint (e.g., the hair of the monkey descending the ladder in a 1917 circus scene—Zervos v. 2, No. 951, p. 399). The Guernica horse's hair seems to descend, then, from early observations of newspapers *and* from early observations of hair.

 In a different key, the Guernica horse's hair may be seen as "numerous little strokes which, far from alluding to the texture of its coat, are so many virtual wounds and incisions. . . ." (René Berger, *7*, p. 356). In line with this idea, one might recall the sores which cover the body of the crucified Christ in Grünewald's Isenheim altarpiece. This work was of course the source of Picasso's Crucifixions of 1932 (see Note 17), and one way and another its influence appears to seep into the mural of 1937.

50. Many observers have seen the horse not as Picasso painted it, but rather as its type in the bullring—"The [Guernica] horse, the passive victim of the bullfights, suitably embodies laceration and pain" (Arnheim, *1*, p. 29); "The symbol of innocent suffering" (Boeck and Sabartés, *9*, p. 230); "A horse which collapses in agony. . . ." (René Berger, *7*, p. 345). The thing wanting is any balancing comment on the horse's superiority to these lacerations, sufferings, and so on.

 An aberrant but generally discredited notion is that the horse constitutes the symbol of Nationalist Spain, the painter "calling down on Franco's Fascism a spasm of agony and its final doom, just as shown in the picture" (Juan Larrea, *30*, p. 34). (Again the limited reading: "agony . . . final doom".) This view is picked up by Max Raphael, who suggests a causal connection between the horse's wound and the swordbearer's sword: "In this case the warrior would stand for a soldier of Republican Spain and the horse would stand for Franco or Fascist Spain. . . ." (*43*, p. 154). One original observer, drawing the horse together with the bull in a union of the negative, states arbitrarily that "Neither the horse nor the bull symbolize the aggressors, but simply stand for the common brutality of man's inhumanity to man. The simplicity of this painting, together with its timeliness, made it the masterpiece that the world knows it to be." (Robert Fisher, edited by Theodore Reff, *23*, p. 23.)

51. A link between the crucifixion and corrida themes in Piccaso's work has been suggested by one observer. On a Crucifixion drawing of 1929 (Figure 20 above), "Both the spectators in an arena and the centurion's spear which pierces the flank of the horse, in the manner of a picador, suggest the bullfight and therefor similarities of the crucifixion to that ritualistic event as well" (Ruth

Kaufmann, *29*, p. 554). The spectators may be said to form a link not only between these themes but between these and the Guernica (on the fusing of themes see also Notes 39 and 95). However, Dr. Kaufmann is mistaken in relating the spear to the body of the horse: visually the shaft of the weapon overlaps the breast of the animal but its head is raised in the air, and the animal visibly undisturbed; in a companion drawing reproduced by Dr. Kaufmann, the spear comes nowhere near the animal, which is again shown serenely grazing.

In the Guernica itself I have myself side-stepped a possible reading of the spear as a picador's instrument, since it does not scratch (pique) in the manner of a hilted pica, but passes through the horse's flesh in the manner of a mortal weapon—a centurion's spear; further, the picador's pica relates logically not to the horse, but to the bulls. It is late in the game, of course, to bring logic into the discussion. Nonetheless in the mural the bullfight parallel seems most safely implicit in the horse's wound, adjacent to the spear (discussed above in Chapters One and Two). This motif, the wound with its implications, has gone generally unnoticed (see Notes 141, 176).

52. "... the Minotauromachy anticipates the *Guernica* in the important relationship between the bull and the woman holding the lamp over the dying horse—though in the etching of 1935 the symbols perhaps concern personal rather than public experience" (Barr, *5*, p. 200). This division between personal and public experience in the two pictures is justly observed in the sense that the candle-holding girl in the Minotauromachy, with her slightly maddening equanimity, is difficult to explain—enigmatic; while the lightbearer of the Guernica is a symbol in some ways sufficiently transparent (discussed in the chapter "On Stage"), at once personal and public.

Still this difference between the Minotauromachy and the Guernica is not in every way clear cut. Both pictures are concerned in part with public experience (the bullfight); beyond this, the Guernica has virtually no visible connection with any other public experience save the crucifixion (on the generalization of theme in the Guernica, see also Note 66). The public experience of the Guernica would seem to be a matter not so much of its symbols, as of the general intensity of its dramatic impact; its size; and the event which called it into being.

53. Quoted by Robert Payne (*38*, p. 202).

54. Quoted by Alfred Barr; in Allen Leepa, *31*, p. 235.

55. Quoted by Barr, *5*, p. 202.

56. In ancient civilizations it was of course the bull, not the horse, which figured as an object of sacrifice. "Rites connected with the sacrifice of bulls go back to the Minoan and Mycenean roots of civilization. Generally, the animal was sacrificed, his meat eaten and his blood drunk as a totemistic way of procuring the strength and virility of the animal." (William Rubin, *48*, p. 290). In medieval iconography the bull as the symbol of the Evangelist Matthew, is meant to reflect the sacrificial mission of Christ, an analogue of the sacrificial bulls of the Old Testament. These traditions perhaps lie distantly in back of the corrida, and, in turn, in back of Picasso's bracketing of the bull and the horse in the Guernica—"These are massacred animals."

57. Ernest Hemingway, *64* (Glossary, under "toto").

58. John Marks, *65*, pp. 11–12.

59. Hemingway, *64*, Glossary.

60. Picasso's self-exile in France is perhaps imaged or expressed, in a simple and touching way, in the Saltimbanques, the Rose period picture with its close-knit family of French vagrant players occupying the main sector, and then entirely isolated in a corner of the composition, the Spanish representative, the woman from Majorca. Though not in any physical sense, it may be felt that a piece of Picasso is contained in this lonely figure. (The dramatis personae of the picture is discussed by Daix and Boudaille, *14*, pp. 74–75.) Interpreted in this light, the Saltimbanques might be said to

figure as a distant precursor of the Guernica with its imagery of exile in the segregated and autobiographical figure of the bull.

The suggestion of Picasso's visible self-imagery in the Guernica bull, has been touched on by one observer, who notes that "the head of the bull in the final painting cannot be taken simply as the head of a bull, for it has many human characteristics, among them the upright posture of the head and its hairless skin. Most human of all are the wide-open staring eyes that are not unrelated to Picasso's own images of himself." (Herschel Chipp, *15*, pp. 111–112; Dr. Chipp juxtaposes the bull's head with a self-portrait of 1906, shown in the present work as Figure 184.) And "Further, what is usually seen as the protective attitude of the bull over the mother and child in the painting has a possible prototype in the several paternalistic and obviously autobiographical Minotaurs of 1936" (*ibid.*, p. 113).

61. Numerous observers have made of the bull a wholly sympathetic image: "the bull is . . . a sacred symbol, not a representative of 'darkness and brutality'" (Boeck and Sabartés, *9*, p. 231). The animal is made to be "the imperturbable . . . the indomitable image of Spain . . . the bull's perfectly fashioned, steady eyes are what remains of that classical, serene image of the bull appearing in the sketches . . ." (Arnheim, *1*, p. 24): still further, the bull becomes not only the Spanish but the universal symbol of "permanence, de force impérissable . . . La sérénité de son regard nous convainc . . . qu'on le retrouvera toujours parmi les ruines . . ." (Zervos, *63*, pp. 106–107).

There are also the witnesses for the prosecution—the bull "stands surveying the scene in apparent triumph" (Barr, *5*, p. 200); it "triumphs over the work of desolation and chaos" (Marrero, *34*, p. 76), "symbol of triumphant violence" (Canaday, *12*, p. 486), "symbol of the oppressor" (Myers, *36*, p. 321). One observer, referring apparently to the relationship between the bull and the warrior, speaks of "bodies trampled by the beast with beetling brows" (Elgar and Maillard, *20*, p. 170): and still more extreme, "the eviscerated horse, the writhing bodies of men and women, betray the passage of the infuriated bull, who turns triumphantly in the background, tense with lust and stupid power . . ." (Herbert Read, *44*, p. 319).

Must the bull be taken as an obvious summary of good or bad? A more subtle and less arbitrary approach is expressed by Marrero, with reference to the bull in Picasso's works generally: "But, after all, what is the significance of the bull in Picasso? It is a vision, so that the artist does not limit himself to saying I have seen it this way, or that, or I was moved or illuminated. The vision itself determines the manner and mode of what happens" (*34*, p. 68).

A few observers have touched on the ambiguity of the Guernica specimen itself. In particular I am indebted to William Rubin (in conversation) for his isolating of the idea of the bull as an embodiment of power, accessible indifferently to good or evil. This idea is perhaps somewhat over-extended by Eugene Cantelupe: "all human impulses and potentialities—destructive and constructive—cohere in the bull. He is a symbol of the life force itself" (*13*, p. 21). A more cautious but carefully balanced estimate is presented by John Sedgewick: "Note how the many traditional associations of the bull—as symbol, emblem and actor, as hero and antagonist, as noble and destructive—are all intertwined" (*55*, p. 132). And of the bull of the Studies, Timothy Hilton observes that "At no point does he seem frankly vicious. If we take him to be aggressive, there is yet no overt sign that he is responsible for the other animal's [the horse's] suffering. Indeed, the evidence of the preparatory material points in the other direction. Some drawings . . . present him with a serene and godlike expression, A Grecian and beatific bull [Study 19]. But this is quite at variance with what Picasso himself said about the role of the animal in the painting. . . . Picasso delivered himself of a plodding symbolic interpretation: 'The bull is not Fascism, but it is brutality and darkness. . . .' There are no neat resolutions of this contradiction." (*27*, pp. 240–41). (But it is difficult to see how Picasso's elegant statement about the bull could seem plodding.)

Again confronting the variety of imagery in the Studies, one observer has said of Study 1, "In his initial visualization of *Guernica* Picasso chose the moment in the *corrida* just after the bull has achieved the supreme satisfaction of driving his horns into a living body. . . ." (Chipp, *15*, p. 103), a somewhat arbitrary assumption which is perhaps suggested by the internal evidence of the drawing but not by its context in the Guernica series, and refers mainly to the ferocious bulls in earlier corrida fantasies; elsewhere, however, the same observer notes the ambiguity of the Minotaur element in the Studies

(*ibid.*, p. 111; see also Note 63) and some elements of the artist's self-portrayal in the Guernica bull (see Note 60). Dr. Chipp observes in general terms that "the concept of the Minotaur, like the bull and the horse, is in a constant state of metamorphosis in both form and meaning. At one pole are the hero types, the artist, king, and classical youth, and at the other is the beast who dies a miserable death as the fighting bull in the arena" (*ibid.*, p. 112; on this quotation see also Note 63.)

The perception of ambiguity in the Guernica bull is sometimes carried into realms of political fantasy. One observer, a voice from the '40's when idea so often waited on ideology, gives us a dizzying vacillation in Picasso's bull which would have opened the eyes of the vacillating creature still wider than they are: of this animal, "The suggestion is that of new life succeeding destruction. The bull as a metaphor of male strength is so ancient in human history that the image may be regarded as part of our cultural heritage. It may denote here the sexual energy of the Spanish people or simply that of life in general. . . . The weakness of Picasso's artistic imagination is disclosed by the fact that he does not choose to make a sacrifice of the bull in order to enlist its magic powers; instead of sacrifice, which is a ceremonial social action, he merely invokes the pure force of nature. . . . In other words the bull, the only creature spared by the bombing, no longer plays the part society assigns it. . . . Picasso responds to a historical and political fact in naturalistic biological terms. . . . The same principle underlies the Nazi theory of racial superiority and the thousand-year *Reich*; the only difference between the Nazi beliefs and a belief in the sexual power of the Spanish people is one of degree. . . . We have deliberately stressed this unfair analogy to lay bare the ideological absurdity of Picasso's allegory. It might be objected that in *Guernica* the biological factor is completely overshadowed by the significance of the bull as symbol or totem of the Spanish people. As totem animal it assures the survival of the tribe. . . . But what even more fundamentally separates Picasso from the Nazis is the presence of a second allegory: the appeal to reason, totally lacking in Nazi ideology. However, Reason, Enlightenment, and Truth are bourgeois abstractions without specific content; they parallel the famous trinity of *Liberté, Egalité, Fraternité*, whose capital letters served to camouflage the fact that they were positive values only for the upper classes but empty promises for the lower classes. . . ." (Max Raphael, *43*, pp. 154–59). But let us lay this well-remembered side of the '30'and '40's to a much-needed rest, that Byzantine era in which biology was politically incorrect, except when it was a totem.

Another elaborate discussion ventures into its own risky waters: "Clearly, the bull is not one of the victims; rather it seems to have wandered in upon the scene from outdoors and stands rooted to the spot, gazing out of the picture with an expression—is it cold triumph? Is it wide-eyed bewilderment? Or is it an indignation so deep that it cannot bear to look at the calamity? The animal is the embodiment of sheer power—the flare of his tail alone, like smoke from a volcano, conveys the latent energy within. But what sort of energy? And what are the cries addressed to it? Are they screams of accusation and reproach, or appeals for aid and comfort? Is the bull good, or is it evil? . . . Perhaps, like so much else in *Guernica*, the bull itself may have two meanings, mutually contradictory but equally valid, resonating in the painting like an unresolved chord. Picasso himself is on record as stating, years ago, that the bull is not fascism; 'brutality and darkness, yes, but not fascism.' Yet his preliminary sketches show that he wavered between an evil bull and a noble one. . ." (Tom Kern, *32*, p. 93). Yet how delicate must be this business of approaching so subtle an organism as Picasso's bull. Looking at the phases of Mr. Kern's approach, "Clearly the bull is not one of the victims"; nothing indeed seems less clear, taking into account the baffled stare and hedged-in body of the animal, and allowing a due credit to Picasso's testimony, "these are massacred animals." Then "rather it seems to have wandered in upon the scene from outdoors"—or wandered out upon the scene from indoors, as the bull wanders into the bullring from the toril. In any case it would seem equally suggested by the bull's static pose and fixed place within the triptych, that a transiency has been denied it, any wandering precluded; indeed a survey of the artist's impulses throughout the Studies and States, including the first of each, shows us a bull planted integrally within the scene, looking out (except in Study 10). Then, the bull "now stands rooted to the spot, gazing out of the picture with an expression—is it cold triumph?" Again: only once in his permutations among the Studies does the bull gaze apparently coldly (Study 10), and never clearly in triumph; for all the final bull's ambiguities and acceptances of contrary meanings, surely that animal's disconnected and

vulnerable stare cannot convincingly be called triumphant. "Is it wide-eyed bewilderment?"—The animal's expression would include that. "Or is it an indignation so deep that it cannot bear to look at the calamity?" But in a long life-time of painting, Picasso's own indignation has never been this deep. It is the business of the artist and his surrogates to look, as the lightbearer looks; surely the bull's wild and seeking glance is dominated by some other meaning than that it cannot bear to look. "The animal is the embodiment of sheer power—" Power, yes: "sheer" power, no, as discussed in the bullfight chapter above. Sheer power is an electric socket, a two-headed eagle, perhaps some impersonal emblem such as a stone lingam—not a confused creature backed into a corner of a composition. It is true that "the flare of his tail alone, like smoke from a volcano, conveys the latent energy within." The bull's hindquarters as a smoking volcano, makes an apt figure; yet the power thus suggested, is kept in balance by an equally significant sense of aimlessness in the tail's drifting, wandering yet static, a kind of counterpart of the animal's face. Finally, Picasso's "preliminary sketches show that he wavers between an evil bull and a noble one." None of the bulls of the Studies, even those which hit us first as the roughest, sustain a sense of evil, unless it be an evil latent in foolishness or indecision. "Brutality and darkness," yet visibly nothing so sinister as evil.

62. A painting of this subject, with the same outlines as the drawing, was identified verbally by Picasso as showing the mare in the act of giving birth, the head of the foal (upside down) visible emerging from her womb (see David Duncan, *18*, p. 86).

63. The quiet authority of the Minotaur's gesture in the Minotauromachy, with its sensitive stillness and the half-relaxed openness of the hand, devoid of the nervousness of any clutching or clenching, is a most elegant if somewhat ambiguous dance-gesture, a mudra with which Picasso was much taken in the mid-thirties. In the Minotauromachy itself the gesture is apparently to be read at least in part as a gesture of finality (not without its element of sympathy) raised over the expiring horse; and still more immediately as a countering of the light of the girl's candle. In other Minotaurs of the period (reproduced above in the Labyrinth chapter) the gesture becomes variously one of a blind man's groping (discussed also in Note 15) and the warning away of a threat, the gesture of a sort of Olympian traffic-policeman. In these gestures a directness, an indefinable poetry, and an assured and relaxed authority are the common denominators.

Circumstantial evidence has misled certain judges of the Minotauromachy—exhibits such as the Minotaur's bulk, his aggressive role in ancient Crete, and the horse's plight. "The monstrous bull gores the horse" (Schneider, *53*, p. 171); "a girl-child with burning taper prevents a hideous Minotaur from attacking a half-naked girl on the back of a gored horse" (Cantelupe, *13*, p. 20); "the Minotaur is not a menacing figure, but is shown reaching for the light held by the young girl" (Elsen, *21*, p. 387) (this last would suffice, if by "reaching for" were meant "blocking": "his right hand extended before him to block the light from a candle held by a young girl"—Rubin, *49*, p. 296). One observer, in offering some pertinent speculations, yet couches them in generalities which have more to do with literary reference than with observation of Picasso's picture: "Monsters are expressions of time out of joint, they are the antithesis of the hero whose weapons are positive powers. Thus the Torera (Europa? Pasiphae? Ariadne?) in *Minotauromachia* surrenders her sword to the Minotaur in a suicidal gesture. . . . the Minotaur . . . devouring youths in his pentagon-labyrinth is the perversion of god and man." (Martin Ries, *46*, p. 144.) It must be observed that whatever the creature's meaning in mythology, the Minotaur as "monster" and "perversion" is hardly relevant to Picasso's recurrent Minotaurs as images of nobility and sensitive consciousness, whether in the Minotauromachy or elsewhere.

One observer has noted that "Although the Minotaur image itself does not appear in *Guernica*, the conception of the bull-man or man-bull underlies all the studies and the final image of the bull. . . . the concept of the Minotaur, like the bull and the horse, is in a constant state of metamorphosis in both form and meaning. At one pole are the hero types, the artist, the king, and classical youth, and at the other is the beast who dies a miserable death as the fighting bull in the arena" (Chipp, *15*, pp. 111–112). And somewhere between or to one side of the fighting bulls, it should be added, is Picasso's noble and peaceful Minotaur who is nonetheless slaughtered in the arena (Figs. 110, 111, 112 above).

The miserable death of the bull itself in the bullring, is in fact rarely illustrated by Picasso (see Fig. 101 above for an exceptional instance of this).

64. Angus McNab, *66*, p. 11.

65. There is a profound and discoverable logic, it would seem, in Picasso's long-term election of the Minotaur as the vehicle for his self-portraits, his visual self-explorations. This logic is suggested partly within the legend of the Minotaur itself, and partly, it may be, in the special status of that legend among Picasso's contemporaries. William Rubin explains that in the '20's and '30's, when Picasso moved among the Surrealists, the figure of the Minotaur stood as a link between myth, Surrealism, and psychoanalysis. "The labyrinth—the recesses of the mind—contains at its center the Minotaur, symbol of irrational impulses. Theseus, slayer of the beast, thus symbolizes the conscious mind threading its way into its unknown regions and emerging again by virtue of intelligence, that is, self-knowledge—a paradigmatic schema for the Surrealist drama, as indeed for the process of psychoanalysis." (*48*, p. 295.)

66. The Guernica is not the Spanish war in particular. "The canvas, today more than ever, is no longer an illustration of one specific bombardment, but the picture of all bombed cities" (Marrero, *34*, p. 77): but for that matter, why necessarily bombardment? "Brutality and darkness"—Picasso himself has rejected all but the most general terms in describing his picture. The "warrior's" sword has no literal or modern existence except it be interpreted as the matador's espada (or the rejon of the Portuguese mounted torero: "the thing used . . . has a blade about the same as a Roman legionary's sword"—Angus McNab, *66*, p. 102). The spear, which has descended directly from overhead, might possibly be taken to symbolize a bomb, but this is outside the visual terms of the picture, and one may readily sense the picador or Centurion, spearholders, more vividly than the bombardier. As more than one observer points out, the Guernica is not necessarily a war scene at all: "En effet, s'il est assuré que Guernica échappe à toute reference historique, on voit qu'il se defend aussi bien de tout rapprochement avec une scene de guerre. Impossible de mettre une date ou d'identifier la scene . . ." (René Berger, *7*, p. 350).

67. In addition to their other origins, the horse's wound and that of Christ, in Picasso's pictures, have also an obvious sexual symbolism which Picasso himself was at no pains to conceal, for example in the rape scene of the 1934 bullfight drawing (see Figure 90 above). In a study of 1935 (Figure 77 above) the relations between the bull and the horse are equally explicit—in this case without the element of violence!

On Picasso's 1917 studies of the bull in the act of goring the horse, one observer has explained that these fierce drawings were made during the artist's active courtship of Olga Koklova and engagement to that lady, and that this circumstance "may help to explain the persistence with which the bull explores the horse's body. The combat is now seen as a highly personal assault by the bull with the goring action of his horns the central theme" (Chipp, *15*, p. 103; for these drawings, see Figs. 78, 85 above.) And further, "the horse's wounds seem to have changing meanings. They are erotic in the series of bull-horse encounters of 1917, repulsive in the disembowelments of the summer of 1934, and repulsive as well as symbolic in the *Dream and Lie of Franco*." (*Ibid.*, p. 112.)

It might be observed that while the 1917 drawings may well be interpreted as erotic from a psychoanalytical point of view, they are in fact perfectly straightforward reportage of the bullring (minus the toreros), and might be shifted to Dr. Chipp's category of "repulsive," or some other. It is impossible to avoid the frequent implications of sexual violence in Picasso's bullfights and Crucifixions—but whether this implication resides in the events themselves or in the artist's record of them is moot. A too facile interpretation is to be deprecated. "There can be little doubt about the meaning of this print [the Minotauromachy]. The *two doves* on the sill above the little girl, the *female matador and human male-portions* of the minotaur, the *ripped horse and minotaur-head* are all simply *reduplication symbols* portraying varying aspects of the sexual act as it might be conceived by a child . . .

In Picasso's imagery (cf. *The Dream and Lie of France*) the horse is a female symbol, a tortured, agonized, screaming animal—as in *Guernica*. The rip in the horse's belly can be nothing else than a sadistic birth-fantasy and a rape-wound. The monstrous bull gores the horse. And the sea suggests the Rape of Europa fable." (Daniel Schneider, *53*, p. 171; author's emphases in the quotation.) Dr. Schneider does not comment on the many peaceful horses in the Rose period and in the Crucifixion series, or on those Picasso horses whose genitals identify them as stallions, as in several of the Crucifixion drawings of the 1920's. Dr. Schneider's interpretation of the Minotaur in the Minotauromachy is especially open to question; see Note 63.

68. Picasso, *40*, pp. 11–12; also in Barr, *5*, p. 171.

69. Inevitably the Guernica structure is generally observed as "a central compositional triangle" (Arnheim, *1*, p. 106), a form suggesting "the pedimental composition of a Greek temple" (Barr, *5*, p. 200). Further, "While the ancient form of the pediment is suggested, it is not carried through; this shows even more clearly in the first version of the painting, where a standing rectangle with the raised arm of the dead warrior prevents the meeting of the sides and breaks the triangle apart in a wide gap. Again, a traditional form has been suggested, only to be destroyed by a rebellious spirit" (Raphael, *43*, p. 139).

Such conservatism as the pedimental mural possesses, has been used as a pivotal point in a sweeping condemnation of the picture, by a newer and sterner generation of revolutionaries than Picasso's: "The American artists—Pollack above all—well understood that *Guernica* was not, in itself, a progressive painting, that it had the stasis—how unlike the *Demoiselles d'Avignon*—of official deliberation. With this, by the American argument, was the fact of its fallacious construction, in that the picture, for all its grand intentions, is not able to reconcile its motives with the facts of its making. Much of this has to do with *Guernica's* epic and neo-classical heritage. Clement Greenberg, uniquely qualified to understand the American response to Picasso, was precise and damning about the picture. His criticism is eloquent of the way that, as far as the new art was concerned, *Guernica* was felt to be irrelevant and even reactionary: 'Bulging and buckling as it does, this huge painting reminds one of a battle scene from a pediment that has been flattened under a defective steam-roller. It is as if it had been conceived within an illusion of space deeper than that in which it was actually executed' *Guernica* is the opposite of a breakthrough. . . ." (Timothy Hilton, *27*, p. 246). Mr. Hilton, writing from his English vantage point, has given the American judgment a curiously unified definition, and perhaps it is true that the cadre to which he refers looms larger across the ocean than it does at home, or did in the '50's. It is probably true in any case that the tighter and more patriotic the group ("the American artists . . . the American argument . . . the American response") the looser the argument and more suspicious of deviation ("fallacious . . . irrelevant . . . reactionary"). Perhaps it points toward an eventual conservative outcome of this sector of the barricades, that Mr. Greenberg's bit of text (*26*, p. 65; source not given in Hilton) is hardly to be distinguished from the deposing of some indignant doctor of the Academy confronted with Cubism; seldom has the wheel of the revolution slipped its brake more abruptly. (For more of Mr. Hilton's brief against the Guernica see Note 122).

70. I am indebted to José Maorta (in conversation) for the ingenious comparison between the Guernica and the Treasury of the Syphnians at Delphi.

71. I am indebted to William Rubin (in conversation) for a discussion of the close parallel between the dramatis personae of the Guernica and that of the Greek pediment.

72. Paralleling the present writer, the pyramidal suggestion has been noted at least once: "Ces formes s'appuient sur les bords jusqu'à disloquer le *triangle*, jusqu'à faire éclater l'accumulation des volumes suggérés, suggérant une *pyramide*." (Schwob, *54*, p. 154.)

73. William Rubin observes of the Bone period Crucifixion reproduced above in Chapter One, that it makes "an open 'bone' formation which widens gradually from top to bottom, providing a striking prototype for the pattern of the dying horse in *Guernica*—the center of its composition, as Christ is of

that of the *Crucifixion.*" (*48*, p. 294.) Some of the pyramidal or monumental character, then, of the Guernica horse was nascent as early as the drawings of 1932.

74. I use the word "parable" for want of a word which to my knowledge, does not exist. Picasso himself was reduced to this inadequate kind of definition: "I make references to objects that belong to everybody . . . they're my parables" (quoted in Gilot and Lake, *20*, p. 74; on this quotation see also Note 96 below). Of course Picasso's objects are not parables in a strict sense; nor does "allegory" help much. "The *Guernica* mural is symbolic . . . allegoric. That's the reason I used the horse, bull, and so on. . . ." (quoted in Barr, *5*, p. 202). "Allegory" has proved an irresistible temptation to numerous observers of the Guernica, no less than to its painter, but has a cold, settled sense which is at odds with the ambiguous, dreamlike mood of the mural, and, further, with the subtleties of individual personality in its various participants, less appropriate to allegory than to life (on this see also Note 112).

 Arnheim makes an interesting attempt to put the Guernica once and for all on a non-allegorical footing: the picture is neither allegory nor life, but a third state in which actual (women) and ideated (bull) coexist without any difference in "level of reality" (*1*, p. 72). But while this is true of the bull (in his equal relation to the human beings), it is at the same time less true of the horse, whose special ideated level is marked by a special formal position and isolation in the picture (discussed above in the chapter on the Triptych). Nonetheless allegory in a strict sense, like parable, must remain at least partly in the realm of personal and tenuous response, rather than that of clear visual substance.

75. I am indebted to William Rubin (in conversation) for a discussion of the Guernica as brought into existence forcibly against the tenor of its own era.

76. Under the romantic upsurge of the dramatic action, lies the calculated symmetry of the plan—no David more ruthlessly classic. "*Guernica*, despite its apparent jumble of lines and planes, its confined space in which insane destructiveness and indignation and the demand for justice are all brought together, is none the less a work that was profoundly willed, thought over, calculated in its every detail. Discipline restrains excess, logic governs disorder, intelligence directs passion. That is why it can be said that here, for the first and perhaps the last time, Picasso imposed a style on his expressionism: thus he solved what seemed an unanswerable problem, how to give classical form to a work which overflows the classical bounds through the violence of its effusiveness and forms" (Elgar and Maillard, *20*, p. 173).

 No one style-sense: "Mieux que dans toute autre de ses peintures nous assisterons ici aux oscillations de l'artiste . . . Il est à la fois romantique et classique . . ." (Zervos, *63*, p. 109).

77. Arnheim notes further that the "torch of the bull's tail on the left will correspond to the . . . mechanically shaped flames on the right" (*1*, p. 106). A possible suggestion, even though the tail has a languidness only equivocally suggesting fire (perhaps smoke?), and unrelated to the "mechanically shaped flames" of the house. (See also the end of Note 61, in which the bull's tail is discussed as smoke.)

78. The relation between form and sense is nowhere heavily underlined in the Guernica, but it is so deeply assimilated into the texture of the picture as to go easily unnoticed: ". . . the subject matter is only loosely related to the formal patterns . . ." (Arnheim, *1*, p. 119). The Guernica has, however, been noted as a triptych, paralleling the present writer in a general way: "it is like a triptych, with the horse, half of the warrior, the apparition [lightbearer] and half of the advancing woman in the centre panel; the bull, the grieving mother and half of the warrior in the left wing; the falling woman and half of the advancing woman in the right wing. This is an aspect which stresses the ternary arrangement of the painting, but one should note how Picasso securely fastens the wings to the center by means of the half figures, which act like hinges. In this way the masses are evenly distributed, and—with the help of a traditional scheme of design—the composition is made 'easier to read'" (René Berger, *7*, p. 357). (And more briefly, John Canaday, *12*, p. 486).

 The triptych form is foreshadowed in numerous Picasso works. A clear-cut example, in which

moreover is loosely suggested the overall compositional triangle, is the painting, Girl Sketching, 1935 (Zervos, v. 8, No. 203, p. 121).

79. The word "religious" is difficult to use without qualification. Some have used it in a sense so strict as to be difficult to understand: "This fantastic Calvary [Picasso's Crucifixion painting of 1930] seems entirely devoid of religious significance . . ." (Barr, 5, p. 167). Others, like myself, prefer to admit the word in a broader sense: the Guernica "is a religious picture, painted, not with the same kind, but with the same degree of fervour that inspired Grünewald and the Master of the Avignon Pietà . . ." (Read, 44, p. 231). Certain writers feel impelled to use the word "sacred" with reference to the Guernica: "the bull is . . . a sacred symbol" (Boeck and Sabartés, 9, p. 231); or, in one case, to refer to the Guernica stage as an altar: "l'autel de sacrifice et de la purification . . ." (Zervos, v. 9, Introduction pp. IX–X).

Were Picasso's intentions specifically religious? This of course we cannot know. The apparent presence of the crucifixion theme would in itself add but little weight to the argument. Picasso's orientation to the Church of Rome is perhaps of little more relevance than his orientation to the Communists; David Duncan tells us (in 1958) that Picasso "is a generous contributor to the Catholic Church" (19, p. 7), while Francoise Gilot tells us that Picasso disliked being omitted in his wife's relatives' prayers, but was "an atheist—in principle" (25, p. 231). Whether or not these seemingly scattered loyalties go to explain the scattered iconographies of the Guernica, I cannot say. The idea would seem to be suggestive, but religious loyalties of course are as scattered and plowed under in the twentieth century at large, as they are in Picasso's personal life; the Guernica would seem to be as much an expression of its time, as of its painter. (See also Note 37.)

Wisely ignoring the question of the painter's intentions, the theologian Paul Tillich discusses the Guernica as a religious painting, which of course on one level or another it remains. Dr. Tillich sees the picture as an expression of "the paradox . . . that it is man in anxiety, guilt, and despair who is the object of God's unconditional acceptance. If we consider Picasso's *Guernica* as an example—perhaps *the* outstanding one—of an artistic expression of the human predicament in our period, its negative-Protestant character is obvious. The question of man in a world of guilt, anxiety, despair is put before us with tremendous power . . . He who can bear and express meaninglessness shows that he experiences meaning within the desert of his meaninglessness." (60, pp. 68 ff.) But the reasonings from which these brief quotations are drawn, have the usual failure to look closely enough at the picture. "Guilt, anxiety, despair . . . meaninglessness . . ." Some seriousness of thought is offered by the theologian, and a summary of the German philosopher Dilthey, but little observation of the passionately affirmative element which dominates every detail of Picasso's picture, in which guilt may be supposed and anxiety taken for granted, but in which despair and meaninglessness are excluded. With the failure to examine the picture (indeed in Dr. Tillich's chapter there is not a word of description, nothing below the level of philosophical abstraction), it follows inevitably that further speculations about the picture will be thrown off course. Dr. Tillich's assertion that "Picasso's *Guernica* is a great Protestant painting," defining Protestantism simply as "the doctrine of a reunion with God in which God alone acts and man only receives," is based on the same judgment of the mural as that of Max Raphael, that it "portrays passive submission" (43, p. 149; on this quotation see also Note 90), a judgment which loses its force when we have noticed the indomitable and aggressive gestures and structures which occur in the mural; these are discussed above in the chapters on Structure and on Staging. The Protestant idea perhaps loses its relevance too when we have charted the build-up of symbols in Picasso's picture, intermediaries, if you will, between man and God—the thicket of wounds, thorns, astral bodies, animal surrogates. These, with the array of baroque gesturings, would seem to place the picture—if indeed a denominationalism were appropriate—if anything within the Catholic camp from which of course the artist sprang. On its surface—or just below its surface—the picture would seem in some ways as Catholic as so many Stations of the Cross.

Yet still the reverse point might be argued, that in his submerging of these symbols and forms, the artist brings them within reach on a purely emotional rather than a sacramental level, and retaining his intermediaries, yet makes his own Reformation.

One would of course have to distort the spirit and content of Picasso's *magnum opus* out of recognition to avoid the conclusion that it is a religious picture, even if religious in a highly personal sense, "un mythe. . . . Qui exprime totalement l'homme moderne comme la Crucifixion exprimait totalement le chrétien autrefois" (Vallentin, *61*, p. 35). Perhaps the Crucifixion lies under the surface not only of the Middle Ages, but of much of modern Western life, the Guernica included, and indeed when we are taken off guard or shocked to the quick it is the name of Jesus which usually escapes us, rather than that of Shiva, Einstein, Freud, or some other—an inheritance which has transcended several generations of its rejection by the intellect. The presence of this name within the Guernica, buried, is perhaps one of the marks of the picture's authentic imagery of its time, and perhaps goes in part toward explaining the picture's continuing fascination to friend and foe (the detractors of the painting usually make it the centerpiece of their books). Yet William Rubin's observation on Picasso's Crucifixions generally, would seem a necessary brake on this recognition: "Picasso in his Crucifixions was concerned not so much with the Bible and the image of Christ in the sacramental sense, as with an image of the artist's own agony and the agony of modern man." (In conversation.)

80. One observer has held that the triptych scheme of the mural "would be even more like that of a medieval altarpiece than it is had Picasso not placed a triangular form in the center, leaving empty areas between it and the rectangular areas at the sides. Thus, what we have is more a kind of revolt against the medieval form than a revival" (Raphael, *43*, p. 139). The revolt-idea would no doubt have pleased Picasso in the abstract; the substance of Raphael's observation is, however, somewhat vaporous, when we consider the number of altarpieces which may be seen as triangles isolated between their side-panels. The Guernica in any case is of course a counterpoint of structures, no one of which is fulfilled in any finality; for example, a strongly dominant vertical is presented by the angle of the lightbearer's house, which divides light from shadow and makes a diptych of the picture, in counterpoint with the triptych plan (see also Note 90; and Barr, *5*, p. 201; and the present writer's discussions of Guernica Studies 10 and 15, in which the mural's diptych plan is anticipated.)

81. The contrast between the Guernica's disciplined architecture and its unfettered emotion, has led many observers to see only the latter, and not the former. "*Guernica* no longer displays a reflective search for form; here Picasso completely surrenders to his emotion" (Maurice Raynal, quoted in Boeck and Sabartés, *9*, p. 230). Or: "*Guernica* has enough of the style of twentieth-century art [sic] to prevent us from interpreting its structure by means of those sweeping trajectories which are used by teachers of art appreciation to guide their students through a Poussin or Rubens. But the presence of the triangular pediment, which fills half of the painting's surface, is sufficient to prove that even in this work certain over-all groupings and directions organize the assembly of shapes" (Arnheim, *1*, p. 27). Dr. Arnheim is capable of relenting in his distrust of trajectories; further down on the same page, "the glance starts its path in the lower left corner with the hand of the statue, which marks the beginning like a star in a diagram, and from there stumbles upward over the debris of organic shapes, runs into the open mouth of the horse, and reaches the ambiguously marked apex laboriously and uncertain of its goal, only to glide downward much more smoothly until the foot of the running woman designates the end"; and interesting formal comments elsewhere, as on the position and shape of the horse's head (*ibid.*, p. 82).

82. I am indebted to William Rubin (in conversation) for the idea of structure in the Guernica as a kind of self-image of the artist. Delacroix in his Liberty Leading the People was able to introduce his actual self-portrait, wearing his top hat and holding a musket: "Delacroix," Dr. Rubin has said, "is a part of the triangle in this picture, participating in the heroic scene, a part of the romantic notion of the artist as culture-hero. Picasso in the Guernica doesn't simply make a part of the triangle: he *is* the triangle. The artist who pushes and pulls and welds the material of the picture, imposing structure on every part of it, forces, in effect, his presence into the very fabric of the picture. Delacroix painted in a time when a certain sense of order could be postulated in society, and when the artist could find order ready-made, so to speak, in society and in the traditions of art: hence the clear, isolated triangle in his picture, in which the artist is able to take his place. Picasso inherits a world in which order no

longer exists: hence the triangle of the Guernica had to be imposed on a chaotic mass of material, made actually to cut across the forms of the people in the picture, created forcibly by an act of will. It is the artist who emerges throughout—the artist as giver of order."

One observer has entered an objection on the score of the artist's entrance into the picture. "This scheme of a group of angles [in State I] is not related either to the structural lines of the picture surface or to the main lines of orientation, determined by the body structure of the observer; it has been imposed on the picture and the viewer by the artist himself.... This raises the question whether so absolute an individualism can create more than a formalistic scheme...." (Max Raphael, *43*, pp. 139–140). Mr. Raphael's argument is not well supported by the looseness of his language. "Individualism" is as shapeless as any other ism; under its erratically fluttering banner, guilt is to be fixed upon the head of an artist who puts a triangle into his picture. "Absolute" is hyperbole, no better than a voice raised. "Formalism" is another antique ism, pointing accusingly at lack of "content," as though the one could exist without the other.

83. Quoted, in English, by Robert Payne (*31*, p. 197).

84. Beyond my own interpretations of the Guernica gray, it might be said with Dr. Arnheim that the funereal monochrome preserves a sense of continuity in a scene compounded otherwise of incongruities and interruptions: "the uniform black and white stresses the unity of everything contained in the picture. Whether dead or alive, human or animal, assaulted or unassailable, all the figures belong to the same clan, to Spain, to afflicted but immortal life. At this level the sufferers and the bull are complementary aspects of one and the same subject. (*1*, p. 26.) And in still broader terms, Max Raphael in his essay on the Guernica holds that black and white "express pure conscious-being as the one and general ultimate principle...." (*43*, p. 148).

Further (somewhat hyperbolically) "When carried to its extremes of intensity, colour reaches the two poles from which it originated—white and black—and therefore also reaches its extremes of contrast. That is why *Guernica* has such dramatic power ... Under the explosive pressure of black and white the forms disintegrate, and the whole picture-space becomes a kind of inferno" (René Berger, *7*, p. 357). This observation has its poetic validity. Disintegration of form, however, is less a solid fact than an intangible effect in the mural. Forms are whole in the mural: disintegrated in Analytical Cubism (see Note 8). As for the "explosive pressure of black and white,"—there is of course little actual black and white in the picture. Most of its area is composed of grays; and these could be translated into the most violent color without altering their existing moderate values of light and dark. "When carried to its extremes of intensity, colour reaches the two poles from which it originated—white and black": it might be argued scientifically that color does originate in white (not in black), but hardly that it returns to that origin at its intensest; maximum violence of color in a painting tends to be reached neither in a light nor in a dark, but, other things being equal, in a median value; maximum violence of contrast between two colors tends to be reached by colors of a common median value. It seems arguable that if the grays of the Guernica were repainted red and orange, their "dramatic power" would be not reduced,—but altered; in fact that there would be a loss not so much of explosive pressure, as of meditative or sepulchral quietness.

The quietness of monochrome in the Guernica (like that of its antecedent in Analytical Cubism; see Note 8) is disturbed by some slight color. It is generally observed that the mural, while grayish, is not purely colorless, but, as Lopez-Rey points out, consists of "whites, blacks, and grays, through some of which filters a very tenuous bluish coloration" (*33*, p. 3). Those light areas achieved with overlays of white paint appear slightly bluish by contrast with those achieved by the naked ocherish sizing of the canvas. A certain illogic, in keeping with the painting generally and its subject, pervades these temperature fluctuations; the flesh tones are generally bluish, and "curiously enough, the flames around the burning woman at the right are also in cold tones" (Boeck and Sabartés, *9*, p. 226). Logical or otherwise there remains in the mural a shifting of temperature, like the stirring of breath in a body which is not quite dead. (These very slight tonalities should not be confused with the mawkish nursery-colors imposed on the Guernica in various published color "reproductions." Color photography of the oversized picture with its ultra-subtle range, has never as yet been successfully published.)

The takeover of gray in the Guernica is deeply rooted in Picasso's early work. It may be seen as the outgrowth not only of monochrome in early Cubism, but of Picasso's early color conservatism in general. His boyhood paintings, those of the '90's (in Duncan's *Picasso's Picassos*), show not the slightest boyish exuberance of color, but rather the restrained palette of the mature Goya. Shortly thereafter, a brief color flare-up subsides into the Blue period, which, in color, may be said to keep to the rear of the avant garde, not so much a putting forth of blue as a holding back of yellow and red, reduced in color not infrequently to a sort of bluish grisaille. The cautious color of the Rose period in turn, making do with the tonal range of a clavichord, has little to do with any part of the avant garde or with this century; its ravishing subtleties, maintained in the teeth of the Fauves, amount to a restoration of Guardi and Watteau. The build-up and consummation of early Cubism following through on the heels of the Rose period in 1906, carry the color-conservatism of that period yet another century backward in time into some closed cell of the Escorial. This retreat to the guarded greys and browns of Velasquez, kept up in the face of Fauves, Futurists, and Expressionists and maintained virtually without relief for six years, provided the pressure, as it may be, which popped the cork off in the mid-'20's and turned Picasso to the flat saturated colors of Cubism in that era. It may perhaps be felt—has, perhaps, been felt by some observers—that his frankness of color then was somewhat forced; that it lacked the spiritual point of stained glass, as it lacked the structural logic of Mondrian; and that Picasso's real leanings were in the direction of monochrome, just as many of his best expressions have always been in graphics. In the Guernica, "The use of blacks, grays, and whites . . . eliminated certain color problems . . . " (Elsen, *21*, p. 389). Yet here an important distinction needs to be made. Picasso's "problems" centered not around any technical inability with color, but around a recurrent monastic streak in the man which, when it came to color, repeatedly drew him in the direction of a sort of poverty, chastity, and obedience. When he used color sparingly, the menu of the Franciscan monk, as in the early periods, we see the relaxed authority and poetry of the best Venetian and post-Renaissance masters of gray. The '20's, then, were certainly a period of conflict—the old aristocrat stamping up to the winter palace with the Bolsheviks. At the height of his revolutionary color-activity the old aristocrat acts as a kind of double agent, reverting from time to time to a monotone derived, this time, from the classic (discussed in Note 125). The conflict comes to a head in a most pivotal picture, the 1930 Crucifixion panel (see in color in Rubin, *48*, Pl. XXXIV, p. 293). Dr. Rubin in his analysis of this picture has exposed its extreme, even unique immediacy, remote from the dreamlike retreat of Surrealism as from the impersonal mathematics of Cubism (*ibid.*, 292): the painter's recently-found license with color is a foremost part of this immediacy—yet precisely at the heart of this display, the old monastic censorship re-asserts itself. It is noted astutely by Ruth Kaufmann that "the black and white of the central portion of the *Crucifixion* becomes the colour scheme of the entire *Guernica* "(*29*, p. 561). In the Crucifixion panel a patch of mind, in other words—a piece cut out of the texture of thought—was planted at the center of that arena of otherwise visceral experience; indeed this patch comprises the figure of Christ, or in Dr. Rubin's terms the artist, the mind at the center of the experience: "in a general sense the assumptions of the picture can be understood if the artist is held to have abandoned his traditional position as observer and put himself in the place of the protagonist . . . " (*48*, p. 292). It was this experience, this color vacuum at the center of screaming color, which was to germinate in the artist's mind until in 1937 it was ready to displace visceral experience and color together, covering the whole surface of the mural with a renewed and uncompromising meditation in gray. In this the Guernica is to be seen once again as a summary, indeed as a culmination of Picasso's early years. It stands as his last and strongest assertion within a long tradition of seeing life at a remove, shading its immediacy as with the candle-shading gesture of the Minotaur in the Minotauromachy, reducing it—in color—to the personal profundity of a dream.

Another and more overt clapping together or double-exposure of dreamlike introspection and raw experience, as in the Crucifixion panel, is seen earlier in an enormous production of Ingres, the Dream of Ossian (see in R. Rosenblum, *Ingres*, N.Y. 1967). Here however the scheme of Picasso's Crucifixion panel is reversed, i.e., the monochrome is identified not with the color of the dreamer, but with the color of the dream. The painter gives us the poet Ossian curled up asleep and rendered in full color, while Ossian's dream (a tableau of heroic Boadicea-like figures, whose grand gesturings,

incidentally, are not unlike those in Picasso's mural) floats overhead in a separate cloud—in grisaille. With impeccable logic the dream equals gray: here the painter has described and catalogued the dream with the coolest objectivity, whereas in Picasso's Crucifixion the painter has communicated the dream's inward effect, transmitted its hot experience. It is this appeal to direct sensation, no less than Ingres' simple reportage, which Picasso in the Guernica rejects and transcends, merging the dreamer (the lightbearer, let us say) and the dream itself in a common limbo of gray and timeless introspection.

One wonders whether the Guernica's staying power is not in part a product of its color restraint, its affinity with the mind rather than with the senses. Picasso's pictures made during World War II are perhaps less absorbing than the Guernica for all their direct color. "There is no respite from the attack upon the emotions and the senses in any of these pictures. The dying horse of *Guernica* which had seemed frighteningly intense at the time, seems considerably milder by comparison" (Janis, *28*, p. 15): a generation after these words were published (in 1946) it is again the Guernica horse with its gray of introspection, which comes through as the more intense.

In this discussion "dream" is meant to be interchangeable with introspection, memory, imagination. For a full discussion of Picasso's connection—and lack of connection—with dream images as such and with the Surrealists, see Rubin, *48*, pp. 279 ff.

85. Lightened forms throughout the Guernica (including the sun itself, a form which evidently distributes no light, irrelevant to the illumination in the picture) are posed against a dark background. The lurid illogic of this scheme (without the anomaly of the sun) is perhaps derived, along with the other derivations discussed above in Chapter One, from the Crucifixion panel in Grünewald's Isenheim altarpiece, similarly a scene of sacrifice harshly lit against a nocturnal distance.

86. Quoted by Robert Payne (*38*, p. 197).

87. The dominating and definitive role of the sun in relation to the bullfight, is brought out in a very simple way in Picasso's several overall distant views of the bullring, compositions consisting chiefly of the brutal contrast between the shadowed half and the sunlit half of the amphitheater (e.g. Zervos, v. 1, No. 88, Pl. 44, oil; 1901). The seating in Spanish bullrings is defined not by its relation to the toril and to the entrance of the bull, but by its relation to the sun: seats which are all sun, those which are all shade, and those which pass from one to the other, "sol y sombre."

88. John Marks, *65*, pp. 9–10.

89. For all its functioning as an eye, it is difficult to feel in the Guernica "sun" any suggestion of human presence. "This sun is nothing but a lamp," said Rudolf Arnheim, "the pupil of this eye nothing but a bulb; there is the coldness of an inefficient power. . . . a symbol of detached 'awareness,' of a world informed but not engaged." (*1*, p. 20.)

90. The lamp vs. the sun-fixture is discussed in Arnheim (*1*, p. 20), paralleling in part my own discussion. Dr. Arnheim points out further that the lightbearer's "modest oil lamp is also a beacon on the top of an almost invisible but nevertheless powerful central column—a potential support— which is all but hidden by the chaos of destruction" (p. 20).

Some observers have been led (or misled) to see the sun-fixture as the chief light in the picture— the lightbearer constrained to "challenge the blinding electric light with nothing but a futile, old-fashioned lamp" (Elgar and Maillard, *20*, p. 169). The only thing wrong in this statement, is the word "futile"; it is true that the seemingly ironic image of the electric sun dominates the scene physically "like some cyclopean eye" (Berger, *7*, p. 345): if inefficient, it is certainly blinding, to the spectator and perhaps to the Guernica horse, and its potency cannot be altogether deprecated. Certainly the efficiency of the lightbearer's lamp (described above in Chapter Nine) is less immediately apparent than the glaring shape of the sun-fixture, and is sometimes overlooked: Otto Brendel calls it "useless" (*11*, p. 187): and more sweeping, "Apart from the . . . jagged aureole [of the sun-fixture],

neither light produces the least radiance. . . ." (René Berger, 7, p. 356). One observer, enlarging on this inadequacy, remarks that "Truth with her night lamp brings too little light. Authentic tragedy is absent because there can be no question of pity and terror unless fate is *within* us as well as exterior to us, so that an individual's resistance to it is actually possible. Picasso, however, portrays passive submission. Accordingly, there is no catharsis. . . ." (Max Raphael, *43*, p. 149). In other words, Raphael has neither seen the effects of the lightbearer's lamp, nor taken into account the massive and determined gesture with which she thrusts it forward (discussed in the Crucifixion chapter above); this is anomalous, as he observes elsewhere that the lightbearer's "arm is strong, her grasp firm, and her profile incisive; she suggests something positive, the power of reason and enlightenment" (*ibid.*, p. 155); Raphael in still another context, however, disposes of Reason and Enlightenment in the summary fashion of a field court-martial—"Reason, Enlightenment, and Truth are bourgeois abstractions. . . ." (p. 159; on this quotation see further Note 61). Like some other observers with a strong religious or political conviction (John Berger, Paul Tillich; see Notes 79, 129), Raphael has tended to celebrate his conviction at the expense of the picture (to say nothing of poor old Reason).

91. Quoted by Robert Payne (*38*, p. 198).

92. Like the religious and classical images in Picasso's art, the adobe had perhaps a somewhat literary origin (an illustration in the family Bible?). "Having spent many years in the Middle East as a foreign correspondent, I asked Picasso where he had seen such simple adobe homes as that in the background of the canvas [the Flight Into Egypt of 1895], for nothing like it exists in Spain. He only shrugged. . . ." (David Duncan, *18*, p. 40). Remembered across forty-two years, kept in reserve, so to speak, for the poignant events of the Spanish war, the adobe itself must have had first and last a special poignancy. Like the shrunken houses in the Guernica, the dwellings of 1895 and 1937 (the Dream and Lie) represent a far cry from Picasso's own most conspicuous residence of the '30's, the chateau at Boisgeloup with its great terrace and processions of French doors.

93. This scene in the Dream and Lie of Franco, along with the companion scene of the man and his horse lying together apparently dead, is an example precisely of the pathos, elegy, and tender sympathy which is only a small part of the Guernica (for example in the figure of the dead baby). By contrast with such expressions of intimate sorrow, the dominant mood of iron determination in the Guernica is thrown sharply into relief. (Even the Dream and Lie scenes are not always seen clearly for what they are: one observer refers to these ineffable scenes as among "a few sarcastic etchings" (Sandberg, *52*, p. 246).

94. Scenery flanking the stage, somewhat in the manner of the Guernica wings, is to be seen in Picasso's scenery designs for the ballet "Le Tricorne," 1919. Here moreover the stage is flanked by houses which are forerunners of those in the Guernica—small tiled cubes whose only sign of occupancy in a single curtain in one window, the antecedent, evidently, of the lightbearer's curtain. And in these triptych-like designs the central portion is filled by the arching of a huge bridge or aqueduct, a formal aspiring which in the Guernica may be said to have been taken over by the figure of the horse. (See in Zervos, v. 3, Pl. 110, No. 308.).

The stage as a triptych with architectural wings, is foreshadowed also in the Guernica Studies (No. 37).

95. The inevitable inside-outside aspect of the Guernica is generally observed (see for example René Berger, 7, p. 350).

This unity and bringing together of space, with its complement in the bringing together of night and day (lamp and sun), might be likened to the compression of space and time in the classical drama. And as for the unity and rounded sequence of *action* in the classical drama, this is not merely reflected, but supremely intensified in the Guernica—an action unencumbered by any logical past or future whatever, a timeless and independent catastrophe.

These unities of space, time, and action in the Guernica might stand also as an additional, logical

link between the Guernica and the closed ritual of the bullfight. "A spectacular drama in four scenes, the bullfight preserves the unities of time, place, and action required by the classical theatre" (John Marks, *65*, p. 7). Not only does the Guernica bring together the dramatis personae of the bullfight, and its audience, but the Guernica stage itself might be seen as a parable on the bullring; the barrera of the lightbearer's house, and, in general, an arena walled in yet out of doors.

There is however no one literal definition or placing of the Guernica locale. "A bomb has fallen into the courtyard of a barn or farmhouse" (Canaday, *12*, p. 486); and Mr. Hilton demands, "why should we have to decide whether the light in this barn is electric or supernatural?" (*27*, p. 246). It is not explained what these barns are doing in the picture. Such a reading, stated thus flatly, ignores not only the bullring, but also the physical ambiguity as well as the essential symbolic character of the picture in general (it ignores the tiled pavement in particular; not "wooden planks," as in Elgar and Maillard, *20*, p. 198; the tiles in themselves bespeak a human habitation or a patio—neither a barn nor a bullring).

96. The indoor aspect of the scene, is reinforced by the inconspicuous table to the right of the bull: an indoor answer on the left, to the outdoor presence of houses on the right. Like the houses, the table is the simplest possible example of its type; "a package of tobacco, a bowl, a kitchen chair with a cane seat, a plain common table. . . . I don't go out of my way to find a rare object that nobody ever heard of, like one of Matisse's Venetian chairs in the form of an oyster. . . . I want to tell something by means of the most common object. . . . I will never paint a Louis XV chair, for example. It's a reserved object, an object for certain people but not for everybody. I make reference to objects that belong to everybody. . . . they're what I wrap up my thought in. They're my parables" (Picasso, quoted in Gilot and Lake, *25*, p. 74). (On this quotation see also Note 74).

97. Matthew 5:15.

98. The rooflessness of the Guernica enclosure is perhaps distantly prefigured in the oil painting of 1901, Landscape of Barcelona (Zervos, v. 1, No. 207, p. 92)—a vista of doors and standing walls entirely without visible roofs. (On this picture see also the author's discussion of Study 15).

99. Reflecting the absence of ruins in the Guernica, and the absence of blood, "the scanty flames in the picture are as small as the crest of a rooster" (Marrero, *34*, p. 75). The anomaly of reduced flames and uninjured houses in Picasso's picture is underlined by the vivid photographs of the ruins of Guernica which appeared in the Paris newspapers at the time of the bombing (see for example in Chipp, *15*, p. 101).

100. Quoted by Robert Payne (*38*, p. 198).

101. For the important reference to Numancia, its role during the Spanish Civil War, and the parallel between the Numancian pottery fragment and Picasso's corridas, I am indebted to José Maorta (in conversation). For a further discussion of the Iberian Celtic influence in Picasso's work, see the chapter on "Expressionismo Iberico" in José Camón Aznar, *4*. For this reference also I am indebted to Sr. Maorta.

102. The lower half of the burning woman, somewhat obscured in shadow, tends to disappear altogether in a very poor photograph of the mural. An interpretation based (as apparently one observer's is based) on such a reproduction, will have the burning woman as consisting of an upper half only, cut off abruptly below the arm-pits: "a woman who falls through the floor [sic] of a burning house" (Canaday, *12*, p. 486). Another observer has given us "the woman who is on fire, wildly extending her arms while the rest of her body seems to be sinking into a funnel-shaped form [evidently the triangle descending outside her body]." (Raphael, *43*, p. 153.) A somewhat more valid response has the burning woman a soul falling into hell, as in the medieval theatre (Vallentin, *61*, p. 37). The symbolism of such an idea, however, would seem to be at odds with the story of Guernica; unless one is willing to see in the burning woman something of the profound moral ambiguity of the Guernica bull.

103. Quoted by Robert Payne (*38*, p. 196).

104. In a painting compounded of contradictions and polarities, the contradiction between flatness and depth is only one. As in life, there is nothing in the Guernica which is one-sided; it certainly cannot be said that the Guernica figures exist mainly as solids located in deep space, but neither should it be asserted flatly that "The human figures and animals are given no volume at all (except for the shadow on the horse's neck), and consequently bring the eye back into the surface plane" (René Berger, *7*, p. 355).

105. I am indebted to Herbert Read for the idea of the lightbearer as a tragic mask: "The tragic mask in all its classical purity" (*44*, p. 319).

106. The classical quality of the lightbearer resides in her Greek profile, and in a certain balance of moods related to Greek vase painting or to Classical and Hellenistic personifications of anguish such as the Niobe in the Uffizi gallery or figures in the Pergamon frieze; adult grace united with a pure and somewhat childlike distress, innocent of bitterness or psychological complication.

Outside her face, the odd reduction of the remainder of the lightbearer's person has confounded certain observers. Herbert Read's "tragic mask in all its classical purity" becomes "a sort of ghastly ectoplasm which intrudes its head through a tiny window. . . ." (Juan Larrea, *30*, p. 14). Both observers have seen one aspect of the lightbearer only. An ectoplasmic or dwindled and immaterial sense is certainly there: and in its turn, this is counterposed against its own opposite, a rigidly tangible note in the inward-stabbing pointed nipples—"nails," as René Berger has it (*7*, p. 345). (The mechanical quality of these is presaged in early studies in which the nipples are designed as nuts and bolts: Zervos, v. 2, Pt. 2, No. 522, Pl. 239—oil, 1914; and No. 785, Pl. 342—charcoal, 1913–14). Like the Guernica as a whole, the lightbearer derives her breadth of significance from a dialectic of warring opposites—classical purity vs. gross deformity, immateriality vs. mechanical solidity.

The elegance of the lightbearer's profile is unrelated not only to the rest of her person: it has no direct counterpart anywhere else in the mural, "cast in a classical form, alien to the rest of the composition" (Brendel, *11*, p. 137). It stands alone, exotic, surrounded by images whose classicism is less evident, superficially almost anti-classical—like Picasso's Classic periods in the context of his painting generally. This isolation of the classic might be related to a foreignness of the classic in the Spanish tradition—the cool temper of Rome never so deeply assimilated in Spain as the hot spirit of the Moors (perhaps even the Visigoths). "After all the Spaniards and the Russians are the only Europeans who are really a little Oriental and this shows in the art of Picasso, not as anything exotic but as something quite profound. It is completely assimilated. . . . a Spaniard can assimilate the Orient without imitating it, he can know Arab things without being seduced. . . . The only things that really seduce the Spaniards are Latin things, French things, Italian things, for them the Latin is exotic and seductive, it is the things the Latins make which for the Spaniards are charming." (Gertrude Stein, *57*, p. 34).

107. The fragmentation of the lightbearer may be seen as the analogue to that of the swordbearer, forms suggesting simultaneously the artist's presence and his absence. (See also page 123 above.)

108. Rigidity and flatness of form in the Guernica, is counterbalanced by a small irregular wavering of outlines, as though the master's hand were occasionally out of control. There are no glib smooth contours, but everywhere an erratic seismographic unsteadiness, slight though it may be. At certain points the paint actually breaks free into a semblance of tears, i.e., it drips (as in the jaws of the horse).

Not only contours, but textures are broken and irregular—the brushwork suggesting a bristling or trembling, for example in the figure of the horse.

An examination based, as it must be presumed, on a poor photograph, will miss these very evident nuances: "There is so great an intensity of feeling that—not surprisingly—qualities of handling dissolve in it: there is no trace of brushwork in the Guernica. . . . It makes no difference if you bring your eye close to the surface; everything is smooth and sharp."(René Berger, *7*, p. 358).

109. The several incongruous devices for eyes, reflect the prevailing disruption and division—the free classical calligraphy of the eyes of the lightbearer, then the rudimentary wavering outlines of the kneeling woman's and the falling bird's, then the crazed tear-shapes of the falling woman's and bereaved mother's, then the rigid staring geometry shared by the eyes of the bull and of the warrior, and finally the unseeing circled pin-points of the eyes of the horse. In the same way that the mouths generally are shown in profile (see Note 12), the eyes in each case are given their own most characteristic aspect: both eyes seen as in full face. Further, the mutual dislocation and asymmetry of the two eyes, in context with other elements, has its own suggestiveness: a subtle quality of absence in the bull; an intense presence in the broken warrior; a straightforward derangement in the bereaved mother and the burning woman.

Such asymmetries can of course be referred more broadly to Picasso's general philosophy of shock-images. "I want to draw the mind in a direction it's not used to and wake it up. I want to help the viewer discover something he wouldn't have discovered without me. That's why I stress the dissimilarity, for example, between the left eye and the right eye. A painter shouldn't make them so similar. They're just not that way. So my purpose is to set things in movement, to provoke tension or opposition, to find the moment which seems most interesting to me" (in 1944; quoted in Gilot and Lake, *25*, p. 60).

At the same time, in several key Guernica personages it is precisely their symmetry which is suggestive in the two eyes: inert, in the sagging symmetrical arcs of the eyes of the dead baby; blindly mechanical in the horse's eyes; static, fixed, in the kneeling woman; classically clear-seeing in the lightbearer.

110. Ruth Kaufmann provides a summary of the publications of the picture of the corpse in the 11th century *Commentary on the Apocalypse of Saint Sever* in the Bibliothèque Nationale, and of the comparisons which, over the years, various observers have made between this image and the Guernica's swordbearer; further, its parallel—Miss Kaufmann's own suggestion—with the bodies of the two thieves in Picasso's Crucifixion panel of 1930; and finally, a reconstruction of the likelihood that the picture was known to Picasso, in its publication shortly before the 1930 Crucifixion (*29*, p. 558, text and note 20). According to Miss Kaufmann's apparently valid suggestion, the thieves of the Crucifixion and the swordbearer of the mural would stand as cousins in their common derivation from the Apocalypse MS—racking up yet another connection for the already much-loaded genealogy of the swordbearer; within the context of the crucifixion alone, the figure of the swordbearer would then relate to Christ, the centurion, and the thieves. (The idea of the thieves would seem to go, however, beyond any iconographic significance, and indeed although the swordbearer and the thieves each separately have a certain resemblance to the corpse in the MS, they have little such visual resemblance to one another.)

111. The Guernica studies of the heads of screaming women, with their hideous abandon, have yet a certain hard, bright angriness which bespeaks a core of moral optimism still unviolated. There is a significant change in the many comparable studies made in 1938, toward the imminent close of the Spanish war—themes of sluggish, futile insanity and pointless sadism (see the drawing of a woman stabbing a trussed goat, 1938—Zervos v. 9, No. 116, p. 56); the demoralization and disillusion follows into the paintings made in Paris during World War II (see Zervos, vols. 12, 13). The crucifixion itself flares up in 1938, to expire suicidally in a burst of scatology and pornography (Zervos v. 9, No. 193, p. 92).

112. Despite their overtones of allegory and generalization, the Guernica personages are not without a certain pungent suggestion of individual humanity. There are far more differences among these personages than among those in the usual conventionalized allegory, for example a ceiling by Tiepolo. Even the superficially similar profiles of the bereaved mother and the burning woman are subtly and importantly different—the one fine-drawn and full of nervous anger, the other swollen to a slightly bovine helplessness. Similarly, nothing could be more distinct than the innate elegance of the lightbearer, by contrast with the simple, homely gaping of her analogue, the kneeling woman (see also Note 109). It is possible to feel eventually that one knows and feels these almost as persons.

The sense of individual humanity pulses below the surface in innumerable Picasso figure-works of various periods, including even the most "abstract." It is only half true that "the [Guernica] forms are in revolt against visible reality. . . . no one would think of attaching names to the faces in *Guernica*, or trying to see them as belonging to recognizable categories of human beings. . . ." (René Berger, 7, p. 350).

113. The warrior's parts are clearly designed after plaster casts, trimmed, thick-walled, and hollow. These are usually misunderstood: ". . . a warrior whose decapitation reveals the hollow body of a mannequin. . ." (Vernon Clark, *16*, p. 72); or "a fragmentary statue. . . ." (Arnheim, *1*, p. 20, p. 128). Paralleling in part the present writer's observation, the connection between the warrior's parts and the casts in "The Studio," is made by Otto Brendal (*11*, p. 140).

114. Picasso's long-term fascination with fragmented hollow casts of arms holding a broken weapon, may seem to point toward some kind of malaise, perhaps of the sort touched on by one observer: "The architecture in the background of this still life [The Studio, 1925; Figure 180 above] is a cubist representation of a toy theatre belonging to Picasso's son. *The Studio is Father and Son*—to my mind. . . . The broken arm of the frightened, angry father and the cylindrical bludgeon in the father's detached hand indicate that the father [i.e., Picasso] cannot strike the son [Picasso's son, Paul], however much he might want to" (Schneider, *53*, p. 171). This, however, with the few unsupported and speculative comments which accompany it, does not seem susceptible of much weighing.

115. The element of cold classicism in the broken warrior, expressed in part in a specific bloodlessness, is perhaps related in turn to the entire absence of gore throughout the picture. "This painting is not cruel at all—imagine how Goya would have done it—and yet it represents war. It's good that pictures running with blood are no longer painted." (Edvard Munch in 1937, quoted by Boeck and Sabartés, *9*, p. 232.)

116. The stylization of the warrior's eyes in the mural, almond shapes with circles for irises, is a pre-Cubist (or African period) pattern seen in a number of early Picasso self-portraits: e.g. Zervos, v. 2, Pt. 1, No. 8, Pl 6.

117. Psalm 102:6.

118. In addition to all his other roles, the warrior is to be seen as a dead man. How much sense of death is to be felt, not only in this figure, but in the Guernica throughout? The answer to this, as to other questions, will depend in part on whether we think of the Guernica as a small photograph or as a mural. The two are indirectly related, but far from the same thing. George Weber, my sometime colleague at Rutgers, has pointed out that a print of a painting is in fact a separate and independent work, with its own characteristic emanations. The smaller emotions, the negative ones—fear, pain, resignation, confusion—emanate from prints of the Guernica more readily than from the mural itself; conversely in the presence of the mural with its twenty-six feet, one experiences a reflection of the larger and more positive states, those which consort with large scale.

The sense of death pervades the print and the mural both—but whereas in the print death comes across as a suggestion pertaining to the participants in the drama, in the presence of the mural it may be felt almost as a kind of imminent experience of the spectator's. In the photo it is an observation, bordering on the merely pathetic—in the mural, a catharsis, and tragic.

119. The figures in the Guernica may be taken as both alive and dead. "In this work which is dumb with the weight of horror—one seems no longer to hear the beating of one's own heart, but to hear the silence of death between two heartbeats." (Rene Berger, 7, p. 358.)

120. Quoted by Robert Payne (*38*, pp. 198–199).

121. The arrow suggests the Falangist symbol, but is not that necessarily—a somewhat similar, signpostlike arrow appears in an oil of 1926, The Open Window (Zervos, v. 6, No. 288, p. 117).

122. The static and rigid quality of the people in the Guernica, like that of the bull, is not always taken, as I think it must be, at its face value; to ignore or discount this quality is to miss part of the essence of the picture. According to one description "the women scream, push, run, and fall" (Arnheim, *1*, p. 20)—an imputation of helter-skelter and panic which is impossible to justify visually in the picture; allowing that the kneeling woman may recently have been running, where is one to find someone in the Guernica *pushing* (other than the pushing forward of the lightbearer's lamp, a gesture pre-eminently fixed). Similarly, Herbert Read's "writhing bodies of men and women" (*44*, p. 319) implies a fluidity of shape and of gesture, which is not a part either of the visual fact of the mural or of its emotional core and message. "Writhing" is the act of Laöcoon and his sons, helpless and pathetic in the toils of the serpent: there is helplessness in the Guernica, but little pathos, least of all in the rigid reaching which is almost the sole gesture of the participants (see also Notes 129, 133).

One observer has acknowledged the element of stasis in the Guernica, though only as a failure in the artist's revival of neo-classic style. "It is not suggested that David is there, in the picture, as a visible 'influence.' What is suggested is that Picasso's neo-classicism, long established in his own art, now becomes grandiosed into a stately display of conflict which has a strong undertow of David's tradition. For instance, an immediately recognizable link between *Guernica* and neo-classical painting would be in the combination of stasis and turmoil; controlled with such a clench in neo-classical paintings of the best sort, though falling apart in Picasso. The reason why the protagonists of neo-classical battle paintings can be so frozen in their attitudes and yet appear so powerful is that they are charged with precision. *Guernica* is a *vague* painting. Nobody knows what is going on in it, and it is the merest literary double-talk to maintain that this is what gives it universal application. The vagueness is iconographic: there is no possible reading for the bull, the dominant figure, because it is always possible that the bull might stand for something else. But it is also pictorial: why should we have to decide whether the light in this barn [sic] is electric or supernatural?" (Hilton, *27*, p. 246.) But Mr. Hilton's militancy on behalf of explicitness would, it is to be feared, invalidate most of the world's existing art with the exception of newspaper cartoons and Soviet paintings of Stalin meeting Gorky under an arbor. One would have to condemn as vague the smile on the Mona Lisa, also all nonobjective art, and ultimately all art which could always stand for something else; indeed the numbing effect of so much neo-classical art, even of "the best sort," it might well be argued, is due precisely to its simple two-dimensional moral clarity, compared for example with the forever-fascinating element of vagueness in the classic itself. "And there is yet a deeper artistic vagueness," proceeds Mr. Hilton, "betrayed by the making of the picture in its final stages, the sweeping up and harmonizing, the smoothing tinkerings, the personal turmoils given a public veneer. The comparison with the *Demoiselles d'Avignon* is irresistible. *Guernica* is the opposite of a breakthrough. It does not have a true concinnity of artistic intention. . . . " But it is unfortunate that Mr. Hilton could not resist the comparison with the *Demoiselles*, virtually a preview of the Guernica process with its numerous preliminary studies, obscurity of meaning, derivations in Ingres, and last-minute reversals on the canvas. As for David's *Battle of the Romans and Sabines*, one cannot say for certain that it was a breakthrough, but like most of the world's great art, it seems unlikely that it got through without the sweeping up and harmonizing of personal turmoil. (See also Note 69.)

123. Quoted by Robert Payne (*38*, p. 197).

124. The image of a stone slab expresses not only the funerary overtone, but also the rigid immobility of the bereaved mother, "planted on the ground like some classical stele" (René Berger, *7*, p. 356).

125. Classical antique style was of course dominant intermittently in Picasso's work prior to the Guernica, more openly and insistently admitted than any other historical influence in the artist's career. It is logical that this influence, converging with that of Cubism, should persist into the Guernica. Altogether the classic may be seen as one of the Guernica's most significant and deep-going elements. The classic pediment, its architecture and sculpture, is the subject of Chapter Five in the present work. Chapter ten contains a variety of references to classic sculpture, including a specific derivation in back of the figure of the swordbearer. Not the least pervasive throughout the mural is the influence of certain aspects of Greek vase painting, the evident pattern for so much of

Picasso's drawing in the '20's and '30's. Elements to be traced in the Guernica include the screenlike flatness of the figures and their pure unmodified line, together with their forthright, dancelike gestures. A certain broad affinity may be felt between vase painting and the Guernica monochrome, the figures in the picture relieved for the most part against a dark background as in red-figured style, and sometimes the reverse as in black-figured (the bull and the burning woman shift harshly from the one scheme to the other). Details of archaic vase painting in particular, are called to mind in the schematized parallels of the drapery (the mother and the burning woman), and in the specific mechanical eyes of the bull and the swordbearer; developed classic style, in the artist's lyrical sketching of the eyes of the lightbearer. Specific patterns derived from vase painting may well include the motif of the backflung heads of the Guernica women, traced to vase painting (and to Greek sculpture as well) by Anthony Blunt (8, p. 50); see also the black-figured youth with lyre illustrated above in chapter ten, closely suggesting not only the backflung heads, but also the distinctive classic profile of the lightbearer. In the light of these numerous and deep-going affinities it is almost (if not quite) possible to see the Guernica at large as a kind of monstrous rectangular vase painting. (On the classicism of the lightbearer see also Note 107).

126. As against the classic, medieval elements in the Guernica are to be sensed not only in the grotesque human proportions of the figures but in their display of moral urgency, and, underlying this, the specific religious iconographies and patterns which they share with medieval illustration, as discussed above in Chapter One. Generally a broken quality prevails, at odds with the bland surfaces of the classic. Fragments take the lead, as in the person of the swordbearer, suggesting the image of a martyrdom; or of the lightbearer, a self-sufficient arm entering from above like the hand of God in a medieval picture, again the antithesis of the essential wholeness in classic art. More broadly, pedimental structure in the Guernica is countered by that of the cathedral facade, with its sense of moral and structural agitation, as discussed above in Chapter Eight.

Specific outlines deriving from medieval art are perhaps not wanting. The Romanesque painting, to which one naturally turns for sources, offers a loose parallel to the figure of the swordbearer, as has several times been observed, in a figure of a corpse in the eleventh century Apocalypse of S. Sever (see illustration in Chapter Ten above, and Note 109). A suggestive detail in Catalan Romanesque fresco painting, a school which was coming into modern recognition in Barcelona in the '90's, is to be found in its several occurrences of fantastic beasts of the Apocalypse, designed with multiple eyes: these eyes may be related visually to the Guernica bull with its significant facial pentimenti (see the discussion of State VIII of the mural, above). A connection between the Guernica bull and animals in Catalan painting (though without the matter of the eyes) is made by Blunt (8, p. 53).

127. Undaunted by its seeming incongruity with the medieval, the Baroque, too, takes its place in the Guernica, as for example in the matter of gesturings. In particular the widespread demonstrative gestures of the mother and of the kneeling woman, are to be related to Spanish seventeenth-century sculptures of the Pietá and related scenes of extravagant emotion (see in Chapter One). Beyond this Spanish influence, there is in the Guernica, as Blunt brings out, the suggestion of some consciously classical attitudes and tragedy-mask faces as employed in scenes of massacre by Guido Reni and Poussin (8, pp. 44 ff.). The Guernica's physical breadth and something of its main architecture, too, can be related to the Baroque, the mural's rigid pyramidal tableau forecast in Poussin (The Triumph of Amphitrite, The Rape of the Sabines). And the Guernica's insistent and multiple uses of light with its symbolic overtones, can be seen as a characteristically Baroque emphasis, not without some antecedents in Renaissance and medieval art (discussed above in Chapter Nine).

128. In harmony with the Baroque, the Romantic strain in the Guernica is brought into the picture for its emotion and certain of its outlines, and indeed for a measure of its theatricality, while rigorously purged of its plastic appeal, its appeal to the senses generally, its erotic overtones and anything in the nature of diletto, the functioning as a source of delight. This curious and difficult discrimination among the resources of the Baroque and the Romantic, accounts for a good measure of the unique toughness in the Guernica and its special acrid pungency.

Connections between the Guernica and large works of Delacroix and Géricault, are discussed

above in Chapter Six. Key motifs which rhyme with silhouettes in Ingres (the backflung heads of the mother and burning woman, i.e., the continuity of the tragedy-mask tradition) are discussed as a likely historical connection by Blunt (*8*, pp. 46 ff.); a similar connection, between the forward-stretching bust of the lightbearer and a romantic sculpture by Antoine-Augustin Préault, has been suggested to me in conversation by Alexander Soper (see this work in Germain Bazin, *The History of World Sculpture,* Greenwich, Conn., 1968, Fig. 965).

It is difficult to point to a major phase of western art which cannot be said to be reflected in some way in the Guernica, surely the most eclectic of pictures. At the same time, to point to a particular visual parallel and claim a specific derivation, is generally risky (probably the safest single connection is Grünewald's Isenheim altarpiece, discussed in Chapter One). Cubism itself, perhaps the dominant style at first blush, proves to have more to do with the Guernica's surface than with its depths (discussed in Note 8). Western visual culture at large seems to be merged in that shadowy melting-pot under the surface of the mural, where the merging, the anonymity and total assimilation of its elements is the measure of their potency.

129. One of the most essential qualities of the Guernica is the ringing metallic determination in its human gestures and attitudes. Many observers, however, have read pathos and helplessness into the Guernica personages, and, it would seem, little else besides. Accordingly the human drama is disposed of in such few words as "there are only limbs and faces destroyed by fright and terror" (Marrero, *34*, p. 75), or "Terror, despair, cruelty, are made visible, almost tangible. . . ." (Elgar and Maillard, *20*, p. 171). Or fear and falling, death and pain ("l'effroi . . . chute dans la mort . . . l'élancement impossible. . . ." (Schwob, *54*, p. 161): but fear and falling are characteristics of the burning woman only, death is illustrated only in the child and, equivocally, in the warrior. Occasionally the mural is reduced to little beyond a vastly, an internationally magnified Ouch. "Every part of the kneeling woman," says one observer, rather as though commenting on someone who had just hit himself hugely on the thumb with a hammer, "contributes to the same end; her hands, her trailing leg, her twisted buttocks, her sharp nipples, her craning head—all bear witness to what at this moment is her single ability: the ability to suffer pain" (John Berger, *6*, p. 148). The same observer goes on in a passion of single-mindedness, "There is no heroism. . . . Just as Picasso [elsewhere] abstracts sex from society, . . . so here he abstracts pain and fear from history and returns them to a protesting nature. All the great protesting paintings of the past have appealed to a higher judge—either divine or human. Picasso appeals to nothing more elevated than our instinct for survival. "Yet this appeal," the critic's voice takes on a new resonance, "now confirms the most sophisticated assessment of the realities of the modern world, which the political leaders of both East and West have been obliged to accept" (*ibid.*, p. 169). Mr. Berger stands before the Guernica, but sees, laudably no doubt, a disarmament conference.

Pain is general in the picture, but so are such qualities as sympathy (the kneeling woman), determination (the lightbearer), anger (the bereaved mother), and, above all, exhortation, command (the horse, the swordbearer). These qualities, it seems to me, are dominant. Arnheim has touched on this: "the role of the antagonist . . . was assumed [in the evolution of the Guernica] by the victims themselves, by the aggressive elan of their complaint and appeal. . . ." (*1*, p. 134). This observation of Dr. Arnheim's is, however, more than a little undermined by his table of "Sentiments": the mother, for instance, is summed up as "lament, imploration"—so much for her blinding fury; the horse, "agony"—so much for his quality of command; and—most drastically unsatisfactory of all—the warrior is, simply, "collapse" (p. 29). In sequence to such negative conclusions, the Guernica becomes "a negative monument . . . to disillusion, to despair. . . ." (Herbert Read, *44*, p. 317); further, "Authentic tragedy is absent because there can be no question of pity and terror unless fate is *within* us as well as exterior to us, so that an individual's resistance to it is actually possible. Picasso, however, portrays passive submission. Accordingly, there is no catharsis here. . . ." (Raphael, *43*, p. 149); and "Guernica is not victory but defeat—a sprawling chaos. . . ." (Arnheim, *1*, p. 24). Dr. Arnheim goes on to qualify this by saying that the chaos is "shown as temporary by its dynamic appeal to the towering, timeless figure of the kingly beast. . . ."—i.e., there is no element of affirmation in the painting, outside of the detail of the figure of the bull, to which the other personages direct their appeal: "If the bull represented the enemy, the mural would

be an image of callousness, destruction, and distress only—a lament, rather than a call of hope, resistance, and survival." The same limited view is expressed by Zervos, *63*, pp. 106–107.

But one observer has pointed out that "We must not . . . overlook the motifs pointing to a higher world in this supposedly nihilistic picture. Destruction rains from the sky, but all the victims of the disaster raise their eyes toward heaven, even though they may do so in malediction rather than in hope" (Boeck and Sabartés, *9*, p. 231). And, subtly, on the subject of the most poignant tableau within the mural, that of the mother and child: "There is neither orphanhood nor discontinuity, but an unequivocal plastic unity which . . . identifies the body of the son with the maternal hand which sustains it; which submerges the cry of grief in the fierce affirmation of the essence of maltreated life" (Lopez-Rey, *33*, p. 6).

130. The ordinary inevitable flow of time and its peculiar cessation in art, have both appealed to Picasso as relevant to his work. "I paint the way some people write their autobiography. The paintings, finished or not, are the pages of my journal . . . I have the impression that time is speeding on past me more and more rapidly. I'm like a river that rolls on, dragging with it the trees that grow too close to its banks or dead calves one might have thrown into it or any kind of microbes that develop in it. I carry all that along with me and go on. It's the movement of painting that interests me, the dramatic movement from one effort to the next, even if those efforts are perhaps not pushed to their ultimate end. In some of my paintings I can say with certainty that the effort has been brought to its full weight and conclusion, because there I have been able to stop the flow of life around me. . . ." (Picasso, quoted in Gilot and Lake, *25*, pp. 123–124).

In the Guernica the flow of time is arrested iconographically by the dual light-source, lamp and sun—simultaneously night and day; and by the illogical and timeless character of the events in the mural (discussed above in Chapter Four); and, in a general way, by the mural's monumentality; and still more broadly, by the simultaneously forward- and backward-looking historical sense in Picasso's work generally, and in the crucifixion theme in particular (discussed in Chapter One). Passions, in this general stoppage of time, rise to an intensity which would be intolerable or incredible in a more naturalistic kind of picture, or perhaps even in everyday life with its sequences, its suppressions and reversals of emotion. "Men pity and love each other more deeply than they permit themselves to know. . . . Time rushes toward us with its hospital tray of infinitely varied narcotics, even while it is preparing us for its inevitably fatal operation. . . . It is this continual rush of time, so violent that it appears to be screaming, that deprives our lives of so much dignity and meaning, and it is, perhaps more than anything else, the *arrest of time* which has taken place in a completed work of art that gives to certain plays their feeling of depth and significance . . . the magnitude of events in the Greek drama and passions aroused by them did not seem ridiculously out of proportion to common experience. And I wonder if this was not because the Greek audiences knew, instinctively or by training, that the created world of a play is removed from the element that makes people little and their emotions fairly inconsequential." (Tennessee Williams, "The Timeless World of a Play," in *the Art of the theatre*, ed. Robert Corrigan and James Rosenberg, San Francisco, 1964, pp. 365–67).

131. The proximity of the bull and the mother have led some observers to conclude that the bull is not the mother's oppressor, but her protector (Boeck and Sabartés, *9*, p. 231). The view is carried to its logical extreme in Arnheim's "family group of the bull protecting the grieving mother and her dead baby" (*1*, p. 27).

To sum the bull up as protector and husband, seems no less unsatisfactory than to sum it up as mere callous indifference. Either view oversimplifies a complex and ambiguous relationship. What precisely, for example, is the mother's appeal—does she beseech the bull, does she rail against it? Does she utter an aimless curse—is she, in any ordinary sense, aware of the presence of the bull? Alas, the Guernica is a vision, and not the sort of drama which has a plot and ready-made dialogue.

Nonetheless the mother addresses herself in the direction of the bull: and the bull lies within the path, if not within the focus, of that address.

132. Quoted by Robert Payne (*38*, p. 197).

133. One observer speaks of "eyes askew in heads. . . . hands and feet with swollen fingers and toes, like hideous mutations . . . monstrous deformities . . . reminders that death by the violence of war is abominable and obscene" (Canaday, *12*, p. 487). Is monstrosity the most that should be read into the *Guernica* hands?

Or "Gestes aperçus [cursory], abreviatifs . . . générale . . . vite et fortement" (Schwob, *54*, p. 161). The *Guernica* speaks powerfully, but its gestures have seldom been accused of speaking fast—they require too much prolonged attention on the part of the communicant! As for "cursory," surely some of the more subtle elaborations of speech in the mural lie precisely in its language of hands. Consider for example the tangled fingers of the lightbearer clutching her lamp, an image which combines inflexible decision with confusion and poignant immediacy; or the rich genealogy, the moving combination of peasant simplicity and fiery command which inspires the distended hand of the broken warrior.

134. "Picasso's first sketch for *Guernica* contains much of the final basic form; the small drawing on a piece of blue paper certainly comes closer to the composition of the mural than anything else the painter put down before he started on the actual canvas." (Arnheim, *1*, p. 30.)

135. As Arnheim observes, the bird in Study 1 is transmitted, in its same position, into the mural (*1*, p. 30). A still deeper derivation of the bird of the mural, again similarly located within its composition, is observed by Ruth Kaufmann in her comparison of the Guernica and Picasso's 1930 Crucifixion panel: "The two works have open-beaked, earth-bound birds. . . ." (*29*, p. 558).

136. Arnheim refers to the spoutlike form rising from the mass of the horse's body in Study 1, not as its head and neck, but as its legs: "The horse's raised hindlegs are significant as the early establishment of a central rising vertical," etc. (*1*, p. 30). But it would seem from the long tradition of rising, agonized horses' *heads* in Picasso's works from the beginning onward and consistently through the Guernica series itself, picking up again with Study 2, that the rising vertical in Study 1 is indeed the head and neck (mentioned as such by Anthony Blunt, *8*, p. 28). The pose of the upraised neck and head and parted jaws of the wounded horse occurs in Picasso's work as early as a drawing of about 1890 (Fig. 84 above), a drawing which Herschel Chipp has astutely placed in relation to the occurrences of this motif in the Guernica series: "The horse . . . is almost identical both in its posture and in its realistic style to Study 5 of May 1, almost 50 years later. . . ." (*15*, p. 103). A comparison with corrida drawings of 1917 seems to bear out the reading of the form in Study 1 as a neck (Figures 75, 78, 85, 86 in the Bullfight chapter above); as in the Study, the horse's neck in each instance is seen to rise from between two large abrupt lumps, representing its shoulders; beneath these are the forelegs, suggested in the Study by a pair of long descending arcs. At the apex the jaws are always parted, as in the Study—a form difficult to read as a hoof, as a horse's hoof is not cleft.

For all this, it is perhaps possible to make out a case that Study 1 represents the horse's legs, or leg, elevated, as shown by Picasso in certain of the early bullfight studies (Zervos, v. 8, No. 217). Dr. Chipp has pointed to the raised leg of the horse in the 1936 drawing, "The Minotaur Moves his House" (*15*, p. 109; see fig. 116 above, in the chapter on the Minotaur), and proceeding from this, has echoed the view that the Guernica horse "lies dead with one leg extended grotesquely in the air" (*ibid.*, p. 100).

137. The writer's interpretation of the childlike element recurrent in the Guernica Studies, is based of course on the assumption that Picasso's drawings *are* childlike. The point is perhaps somewhat arguable. The writer bases his assumption on elements such as the stuffed fingers which figure prominently in these drawings, and their surface similarity with hands drawn by seven-year old children. Nevertheless it must be recognized that Picasso's drawings, howsoever childlike on the surface, were not done by a child but by a master craftsman in possession of his full wit; childlike they may be, yet child drawings they are not; the emergence of imagery and meaning for the mural through the medium of these drawings (as discussed under Studies 1, 4, 14, and 31–32) is the rich proof of this important ambiguity. A further ambiguity attaches to the matter of the biographical incident of Picasso's father and the brushes, with the large implications suggested in my discussion of

Study 1. These implications are offered as suggestions rather than assertion. Like all such romantic and distant reportage the incident of the brushes, retailed in all Picasso biographies, may or may not be entirely true, and, if true, may have had some factor rendering it innocuous (such as that Picasso's father, as indeed is sometimes suggested, was tired of painting, and wanted only an excuse for relieving himself of the tools of an unwanted craft.) Picasso seems never to have arrived at a mature feeling for his father or a clear vision of his father's unquestionable role in preparing the ground for Picasso's extraordinary achievement, and instead may be said to have whined pettishly in retrospect; "My first drawings could never be exhibited in an exposition of children's drawings. The awkwardness and naïveté of childhood were almost absent from them. . . . Their precision, their exactitude, frightens me. My father was a professor of drawing, and it was probably he who pushed me prematurely in that direction. . . ." (Brassai, 10, p. 86; quoted in Ashton, 2, p. 76). Certainly the artist has expressed here a malaise, a resentment against the absence of normality in his childhood, a feeling which one sees on another occasion expressed as a wistfulness, occasioned by an exhibition of children's drawings: "When I was their age I could draw like Raphael, but it took me a lifetime to learn to draw like them" (Penrose, 39, p. 275; quoted in Ashton, 2, p. 104)—and on yet another occasion inverted into a cocky defensiveness of his precocity and contempt for normality: "A boy who draws like Raphael would be punished today; they expect of him children's drawings" (Gasser, 24; quoted in Ashton, p. 104). The one fact which remains ineluctable is the persistence of the childlike element, whatever its origins and meaning, whatever the exact degree of its childlikeness, not only in the Guernica Studies but in the mural itself (see the discussions of Studies 1, 3, 4, 14, 31–32, 34, 37, 38–42).

With all its ambiguity the childlike element continues to challenge us not only by its frequency in the Studies but by its uniqueness. It seems to have little or no parallel in the works of other modern artists. Primitives such as the Douanier Rousseau, for instance, may be said to have moved away from, rather than toward, this tendency. Sophisticates such as Matisse may perhaps flirt from time to time through the bars of the crib, but never actually enter that enclosure. Picasso, it would seem, edged into it alone, the ultimate draughtsman come full circle to meet his beginnings.

Prior to the Guernica series the tendency had negligible occurrences. A rare instance would be the meticulously loutish cartoon-drawing of S. Junyer-Vidal, 1901; Picasso's friend is made to posture in a toga with lyre and wreath, a parody of the classic in which the child-manner, complete with colored crayon, is slipped through under cover of sarcasm (Zervos, v. 6, No. 346). Traces of such a tendency are scarcely to be seen among the serious evolutions of Cubism, classicism, and Surrealism which occupied the master up to 1937. The child-effusions of the Guernica series erupt like a force long pent up, and after that release their force may be said to continue above ground, visible perhaps in certain slack or slap-dash elements in pictures made during World War II and later. These post-Guernica pictures culminate in the bold works of the very late decades, with their raw color put down in fast easy ribbons and free spots; something of an infantile freedom from censorship, perhaps, inspiring a superb control.

It is possible no doubt to exaggerate the potency of the child experiments of the Guernica series, as it is possible to exaggerate their childlikeness. No doubt those experiments were only part of a broader release which took place within Picasso's work at that period. For whatever reasons there is an emotional ease inherent in the long decades of the artist's work since 1937, a resignation of the strictures of the classic no less than those of the inventing of ever new style revolutions. It is as though Picasso having found his means of release had been able at long last to resign the past and the future, the academy and the barricades, and settling into an acceptance of his own achievements, set about the business of simply existing, like the settled artists of other times.

138. Arnheim has observed that the turning away of the bull in Study 2 "was the basic thought, later refined when the bull was made to face the event but with his head averted." (1, p. 30.)

139. In Study 2 the bull carries the horse on his back. Arnheim has noticed that the bull "appears to be obligingly saddled and bridled for the purpose." (1, p. 32.)

140. Arnheim in discussing the winged horse of Study 6, refers provocatively to the Pegasus myth, in which the winged horse is born of the Medusa (1, p. 32); but a connection between the Guernica

horse and the Medusa is so impossible as to leave the relevance of the myth somewhat less than satisfying.

141. Anthony Blunt has noted the connection between Christ's wound and the horse's wound in one of the Studies, partly paralleling the present writer's observations. The Pegasus escaping from the horse's wound in Study 6 "probably symbolizes the soul of the horse, which leaves it at the moment of death. The idea of showing the soul leaving the body in material form is common enough in medieval art, but there it usually takes the form of a naked man or child, in which form it appears as late as the sixteenth century in El Greco's *Burial of Count Orgaz*, a painting which Picasso knew and admired. Since the horse stands for suffering humanity, it seems possible that there is a further allusion in this motive: the wound may well refer to that in the side of Christ, pierced by the spear of Longinus, which appears in several of Picasso's compositions of the Crucifixion, in one case actually in a closely similar form (Pl. 11b)." (*8*, p. 31.) (The Plate referred to, however, represents the 1930 Crucifixion painting, a work in which Longinus and his spear are in evidence, but the wound is not. . . .). Sir Anthony makes no reference to the wound of the Guernica horse in the mural itself.

142. "Any part of a whole must remain incomplete in its meaning and form," as Dr. Arnheim says of the horse's head which constitutes Study 9, with its air of decapitation. "It must be in need of the whole." (*1*, p. 44.)

143. The air of resoluteness which characterizes the horse's head of Study 9, may be said to culminate in the spikelike triangular tongue, first established in Study 6; of this detail, Arnheim says (speaking of its appearance in Study 8) that it "has truly become the top theme of the whole pattern, whose upward thrust it repeats in miniature. The geometrically simple, piercing wedge of the tongue breaking through the confining cavity of darkness is an abstract summary of the total dynamics embodied in the horse and indeed in the central theme of the entire composition." (*1*, p. 42). This resolute note characterizes the whole series despite its theme of disaster, contrasting with the dejected and hopeless note which is struck in the related drawings made posterior to the mural, called by Arnheim the Guernica Postscripts. The theme of the horse, with its invariably angry or otherwise positive expression, does not occur among the Postscripts. (It is to be wondered at that one observer has referred, unaccountably, to Study 9, dated a week earlier than State I of the canvas, as typical of the Guernica Postscripts; Elson, *21*, p. 389.)

144. So often we are given the circumstances in back of a picture rather than the picture itself, like a legal proceeding which concentrates on circumstantial evidence and tends to ignore the defendant. In the issue of Life devoted to Picasso (Dec. 27, 1968) a team of specialists presents a mountain of detail about Picasso's life, not omitting speculations concerning the frequency of the artist's sexual activity, the identities of mistresses and of subordinate mistresses maintained during the incumbencies of regular mistresses, etc. This is pushed aside from time to time for a glance at the pictures, yet even then the background has a way of getting in front of the foreground. On the question of the Guernica bull, we are given speculations concerning the role of bulls in ancient Crete, the character of the Minotaur in ancient Crete, the adventures of Zeus as a bull, the bull in Mithraism, etc. This background research on bulls is not irrelevant in itself, but by the time we get to an actual Picasso bull of the Studies, it is too late; the impulse toward observation has been exhausted. On the artist's actual work (Study 11), "It is nothing like the final bull in the mural but merely a pretty calligraphic ornament. Once put down, it was quickly discarded." (Tom Kern, *32*, p. 94B).

(Earlier, on Study 11: "the pencil is playing with the shapes, making them into calligraphic flourishes, transforming the bull into an Oriental ornament. To the extent that there is serious purpose in this elegant drawing, it can be said to explore further the theme of upward-directed appeal and the outcry of despair [the horse]." Arnheim, *1*, p. 48.)

145. In Study 12, the one group Study in which the lightbearer is absent, "the tail of the bull," Dr. Arnheim suggests, "ends by adopting the role of the lightbearing arm." (*1*, p. 50.).

146. In the mural, unlike their appearances in the Studies (Nos. 12, 13, 14, 15, 16, and 21), the mother and child are not literally united in a rhyming of the overall forms of the child's head and that of the

mother's breast. Nonetheless in the mural "There is neither orphanhood nor discontinuity, but an unequivocal plastic unity which . . . identifies the body of the son with the maternal hand which sustains it; which submerges the cry of grief in the fierce affirmation of the essence of maltreated life" (Lopez-Rey, *33*, p. 6; on this quotation see also Note 109).

147. Arnheim has observed that the two pairs in Study 12, that of the horse and spearholder and that of the mother and child, are "almost mirror-images of each other. The same leaning triangles of over-all shapes, the same support through front legs and arm. The comparison even tempts us to think of the head of the dead soldier as the opposite number of the dead child." (*1*, p. 50.)

148. In Study 14 there is a counterpoint of physical rhyming. The mother's breast, while it is made to repeat the child's throat, is made to repeat also the child's head; the same size and shape, the nipple balanced exactly against the child's descending nose. The same scheme is to be found in Study 21 (a descent on the ladder).

149. Of the triangular shadows in Study 15, Arnheim has observed that "These shadows are sharply outlined, as though the scene took place on a planet without atmosphere, and tend to detach themselves from the objects and to populate the picture plane with independent, aggressive pointers." (*1*, p. 56.)

150. As Arnheim has observed, the wheel in Study 15 occupies the center of the composition, and may represent "an attempt to create order by means of a central pivot." (*1*, p. 56.)

151. Arnheim has suggested plausibly that the bull, the mother, and the dead child may be seen as a sort of "family group" (*1*, p. 27), as supported by the intimate juxtaposition of the group, and in particular, as Arnheim observes, the close juxtaposition of the bull's testicles and the mother's breasts.

152. Of the bull's intense glance in Study 15, Arnheim says "The eyes look threatening" (*1*, p. 56). But it would seem indeed that nowhere in the series whether in the Studies or in the States, does the bull's glance or any part of its presence suggest an overt threateningness; where the animal's glance is intense it is intensely grasping, grasping in the sense of realizing, like that of the artist whom it reflects.

153. The isolated arm and fist emerging from a tiny window on the right in Study 15, is seen by Anthony Blunt as *two* arms: "all that is visible of the figure is the arms, stretching out from a window, with the hands joined in prayer. . . ." (*8*, p. 34). The idea would be supported by the two raised arms with clasped hands in Picasso's various Magdalenes, and at the left in Study 15 itself; but in the motif under discussion, the muscular arm on the right in that drawing, there is nothing I can see which departs from a paralleling of the single arm and clenched fist across the scene in that same drawing on the left. The answering symmetry of the two one-armed apparitions seems essential to their power, an aspect of the developing triptych plan with its answering wings.

154. The raised arms and clasped hands at the right in the 1930 Crucifixion panel, like most of the elements in that picture, are ambiguous as to their rightful iconographic reading. A certain ambiguity, as in so much of Picasso's work in the '20's and later, seems to be the point—a clear-cut reading seems uncalled for and quite likely beside the artist's intention. The motif in question has been read by William Rubin as pertaining to the Virgin (*48*, p. 292), and, alternately, by Ruth Kaufmann as pertaining to the Magdalene ("The so-called Magdalene now appears, it would seem, on the far right of the painting"; *29*, p. 557). The Magdalene reading has been suggested by Barr (see Note 29) and also by Anthony Blunt (or so it would seem; Sir Anthony's interpretation is difficult to follow verbally or to square with the picture; *8*, p. 26). My own feeling is that the figure suggests mainly a Magdalene, echoing the upraised arms and clasped hands in the Crucifixion Studies of 1929, as cited by Sir Anthony. These Studies seem, like the drawings made at Boisgeloup in 1932, to be derivations from Grünewald—in this case, the raised and clasped hands of the Grünewald Magdalene.

155. In study 12, the woman with the dead baby at right occupies "the place which the woman patterned after her will finally occupy in the role of the fugitive," as Arnheim points out (*1*, p. 47).

156. Discussing the sluggishness of the mother descending the ladder in Study 16, Arnheim points out that in the mural itself the "extreme descent of the falling woman will finally supply the needed intensity" (*1*, p. 58).

157. Of the horse in Study 17, Arnheim observed that the "meeting of head and hoof is a meeting of the extremes—of the crown of the animal and its lowest base—the visual definition of total collapse. . . . This coincidence of head and hoof will be represented in the final mural by that of the warrior's head and the horse's hoof. The formal motif, here invented, will survive but will be portrayed by a different member of the cast, and the contrast between the hero's head and the animal's foot will make the fall even more complete." (*1*, p. 60.) The transference from the horse's head to that of the swordbearer is astutely observed. However, this somewhat limited or one-sided view of "total collapse" should be countered by a recognition of the factors suggesting a sense of struggle and indeed of triumph in the two personages, especially in the developed mural, but incipient also in the Study; see the discussion of Studies 43 and 44 above, and the discussions of the horse and of the swordbearer in Chapter Two and elsewhere above.

158. Of the horses' heads in Study 18, Arnheim observes that the sculptural contradictions force on us "the squeezing effect that results from the perceiver's efforts to reconcile the several aspects in one image.")*1*, p. 82.)

159. Anthony Blunt contrasts a bull or Minotaur, in the Guernica series (Study 19, the youthful head with the advancing irises) with "the ferocious beast which it had been in early drawings, and which it was to become again in the two drawings made on 20 May" (*8*, p. 38) (i.e., the last two heads of the bull, Studies 26 and 27). The "early drawings" referred to are presumably Guernica Studies; if so, the ferocity is much exaggerated, for surely throughout the Studies ferocity is a mythical quantity only, a hold-over in the mind, derived from earlier corridas prior to the series.

160. The anomaly of the bull's female face in Study 22 has gone generally unnoticed, one observer referring to the Study as "the body of a bull with the clearly defined and realistic head of a man" (Chipp, *15*, p. 111). The female identity is all the more striking in that Picasso's Minotaurs are generally of course highly masculine in visage. The appearance of Dora Maar, in particular in the midst of a Minotaur fantasy, is not without precedent, occurring in a most richly and poetically developed drawing of 1936 in which the unmistakable image of Mlle. Maar, as a full-length, reclining nude, is shown in an erotic embrace with the Minotaur (Zervos, v. 8, Fig. 296; in sequence with a series of portraits of Mlle. Maar). In this curious drawing the countenance of the woman, flung upside down in the midst of a heroic copulation with the godlike and mythic lover, is entirely grave, composed, and thoughtful, the lips closed, the eyes normally open, as though she were considering some doubtful though interesting philosophical point—the antithesis of the swooning images of Marie Thérèse-Walter in similar circumstances. This was the cool Mlle. Maar who gave us those excellent photos of the giant canvas of the Guernica at the stages of its development, and whose presence may logically be felt in the dark beauty of the lightbearer of the finished mural—the capable wielder of the lamp and projector of intelligence and still-contained passion.

The blond and always passive Marie-Thérèse Walter, as Herschel Chipp has pointed out, was a frequent female presence in Picasso's corrida-fantasies of the early '30's, sometimes with candle, and certainly a precursor and analogue of the lightbearer of the mural—"The Marie-Thérèse profile had often appeared throughout these troubled years as a sympathetic observer—usually of scenes of crisis—but always as a serene and gentle onlooker" (*15*, p. 103). Dr. Chipp perceives her likeness, or guesses her identity, in the somewhat ambiguous features of the recumbent female matador of the Minotauromachy, whose pose and set lips are however perhaps more reminiscent of those of the Dora Maar fantasy of 1936. In the Guernica series itself, Dr. Chipp holds that the sketchy lightbearer of Study 3 "closely resembles Marie-Thérèse Walter whose face and body had dominated his art since 1931" (p. 103; with a 1939 portrait of Marie-Thérèse).

It might be mentioned as a damper to the prurient, that Picasso kept his mistresses out of the Guernica Studies almost entirely, outside of Study 22, and, if Dr. Chipp is right, Study 3. Dr. Chipp has observed a similarity of grouping between the mural and a corrida of 1934 which features a female matador of the Marie-Thérèse strain: "the personnel of this murderous drama of 1934—like a tragedy of Lorca—make up the characters, and even the composition, for Study 6 of May 1, 1937, Picasso's first version of the central figure group of *Guernica*. The wounded bull [but no, hardly—the Guernica bull is never wounded] towers over the dying horse, who writhes on the ground with neck upstretched. This group persists to become the central group in the final conception of the painting" (*ibid*, p. 108). However, the recumbent Marie-Thérèse of the corrida bears no resemblance of pose or face to the heavy-featured lightbearer of the Study, and little relationship with the lively intelligence (and wavy dark hair) of the final lightbearer of the mural.

It is true that the intelligences of the final lightbearer is perhaps less a matter of intellect, than of clarity and vividness of emotion. Her physical likeness to Mlle. Maar, moreover, while suggestive, is not more than that; she contains also a certain likeness to Picasso himself, or anyway a clear projection of his own emotion (as discussed above in the chapter "On Stage"), and perhaps includes something of both the women in question—the clarity and capability of Mlle. Maar, and something of the softness of the other; a paragon, that is, of the artist's imagining.

161. Of the bull's head in Study 26, Arnheim observes that "the horns are in conflict with each other, and so are the nostrils; the upper lip is displaced against the lower lip." (*1*, p. 78.)

162. Arnheim suggests that the horse's head "plays a dominant part within a vertical and horizontal axis of the composition, and the relative strength of these two directions needs to be determined. The vertical, which prevails in sketch 28, establishes the horse's head as the top of the backbone sustaining the triangle, whereas the horizontal, dominant in sketch 29, sets up the lateral motion of the three profile heads, from the lightbearer over the horse to the bull." (*1*, p. 82.)

163. The woman's head in Study 30, as Arnheim observes, is "turned so fully upward that it assumes the static position of the horizontal. . . . the mother's is a permanent cry. . . ." (*1*, p. 84.)

164. The scattered features in the faces of the screaming women of the Studies, have led some observers to see these faces as chaotic merely, or a result of "automatic drawing," the Surrealist-related approach innovated in 1924 by André Masson, and of course known to Picasso: these impressions of crazed faces "utilisent diverses variantes de l'automatisme pour mettre à nu la panique, la révolte. Non seulement, ils cessent d'épouser les contours du visible, mais leur graphisme abrupt fait voler en éclats de symbolisme lui-même, trop superficiel et trop littéraire pour se trouver en mesure de percer le chaos des sentiments" (Vallentin, *61*, p. 33). These drawings, however, contain too much organization, consistent in pattern from one to the other, to be referred in any final sense to automatism or perceived as chaos. As Dr. Arnheim has observed, on the subtle organization of these drawings, the asymmetry of the eyes "endows vision with the expression of centrifugal expansion, reminiscent of light rays spreading from a center in all directions, and leaves the mouth limited to, and concentrated on, the theme of linear [one-directional] attack." (*1*, p. 90.) The mouths are organized in a steady anatomical architecture. The tear-flails, as discussed above in the chapter on the Crucifixion, may be seen as the traced and jeweled tears of baroque Spanish Madonnas, and as such, a note from long tradition rather than from random instinct.

(Another traditional source has been suggested by one observer: "Grünewald's *Isenheim Altarpiece* is a source for this drawing [Study 32]." Elson, *21*, p. 388. However, as this statement constitutes the whole of Dr. Elson's observation on the subject, its substance remains invisible. The drawing is further discussed by Dr. Elson, but without apparent reference to Grunewald's polyptych; see Note 168.)

165. In the figure in Study 35, Arnheim has observed that "the central axis of the neck is reinforced within the head by the vertical eye, a strong supporter of the over-all symmetry. . . ." (*1*, p. 92.)

166. For this drawing, see Arnheim, No. 58.

167. Of Study 37 Arnheim observes further that "the child is pierced by the centrally located vertical arrow, and this replacement of the horse by the child suggests that the open mouth of the child, not to be found in other representations of the child, reflects that of the horse." (*1*, p. 96.)

168. Like Goya, Picasso could and did stare from time to time at death and at physical torture. Still it is questionable whether his temperament leaned that way. He stared also at everything else. And of course it is to be taken into account that he grew up in the Spanish atmosphere of bullfights and martyrdoms; as for digressions such as his birds eviscerated by cats, insisted on twenty times over in Studies of 1953 (Zervos, v. 16, Nos. 36 and ff.), these have at least the excuse of being dramas enacted regularly near his house (described by Francoise Gilot). The man had not grown up in an American dream-suburb where violence is zoned out of existence, or even, like painters of most contemporary nationalities, where violence is deprecated.

One observer, speaking of the 1930 Crucifixion panel, speaks of "the detached sadism of the centurion," and goes on to generalize: "Picasso's interest in using the crucifixion as a focus for investigating sadism and brutality . . . continues to be emphasized by these figures [the centurion and the naildriver], in spite of their reduced sizes." (Ruth Kaufmann, *29*, p. 554, p. 557.) This of course is to misread the centurion's act, the coup de grâce, administered traditionally by Longinus in Christian iconography since as early as the Rabula Gospels of the sixth century and persisting as late as Rubens. Picasso's repeated illustration of it (discussed above in chapter one) shows it generally as a dry and somewhat dim-witted affair; in itself it implies an aspect of the crucifixion's completion and relegation to the past, rather than the revival of its present horror. The coup de grâce to one side, in the broad arc of Picasso's Crucifixions over the years between 1902 and 1959 we are shown little in the way of physical empathy with torture except in the 1930 panel (on this see Rubin, *39*, p. 292) and perhaps in some few of the more orchestral among the Grünewald adaptations of 1932. Of gore there is none from first to last (unlike the bullfights; some of these are couched in an imaginative serenity, but some, it must be admitted, plunge into a seemingly gratuitous excess of gore, the bull drawing out and devouring the horse's guts like a demonic tiger—or like the cats with birds).

In the Guernica series, given its theme, immediate physical experience is notable for its relative infrequency, confined chiefly to the limited sequence of screaming women and to the occurrences of the struggling horse. More generally in the series the theme is sublimated in a variety of ritual pantomimes and visions. Certainly a one-sided view of the series is conveyed by the reproducing of two of the Studies only, a screaming horse and a screaming woman, the latter accompanied by a most spine-chilling crescendo of descriptive phrases; still more inconclusive is it to observe further of this Study, "The drawing betrays the fierce pressure with which the crayon was dug into the paper, particularly in the brow and hair. Picasso's sadism, extended to his means as well as to his subject, is frankly manifest." (Elsen, *21*, p. 388.)

In the mural itself, physical immediacy is withdrawn entirely. On the mural, "Each form of pain, each form of fury, disfigures the body, of which it takes possession, dehumanizes and mutilates it," etc., etc. (Roger Garoudy, quoted by Jacques Senecal, *56*, p. 12). This is the kind of reading (discussed at length in Note 129) which carries to the mural the reader's after-image of atrocity-photographs, and ignores the prevailing emphasis in the picture; not so much horror, as resistance and resurrection.

This kind of horror-reading of the Guernica ignores unaccountably, too, the nature of Picasso's visual language, which we see adapted with no less "mutilation" to the patently affectionate rendering of girls skipping rope or sketching. To call the Guernica a picture of mutilation because of its swollen fingers is not altogether different from calling a Cufic inscription the same because its letters are not Roman.

169. Arnheim observes of the recumbent warrior's head in Study 43, "The meeting of head and hoof indicated that the collapse had gone full circle. The top had reached the bottom." (*1*, p. 102.) However on this limited view of "collapse" see Note 157.

170. Of the stripped and recumbent head in Study 44, Arnheim observes that "The nose, the upper lip, and the chin have been made to fit something like a geometrically regular sine curve. So are the two negative spaces formed by the mouth and the cavity between nose and lip." (*1*, p. 104.)

171. George Weber has pointed out the peasant character of the Guernica warrior's hand, "a hand which cannot be imagined holding a pencil." (In conversation.)

172. It is Dr. Arnheim who has pointed out that in the extended hand in Study 45, the thumb is on the wrong side. (*1*, p. 45.)

173. The montage of horse's wound and swordbearer's upraised arm in State I, is noticed, though with some confusion, by Anthony Blunt (*8*, pp. 42–43). (On this see Note 176.)

174. The somewhat Baroque theatricality of the sunburst in State II of the mural is forecast in a number of early Picasso drawings, for example a pencil sketch of 1920: La Renommée, perhaps adapted from a traditional work—a Tiepoloesque nude female figure, seen from below, recumbent on clouds, blowing a trumpet!—and in back of her head, like a halo, the sun-device of the Guernica State II, a circle with long soft petals (Zervos, v. 4, No. 2). The artificiality of the emblem was presaged in a very literal way in a circus drawing of 1917 (Zervos, v. 2, Part 2, No. 950, Pl. 398), in which a large cardboard sun dominates the scene from the top center. The picture contains also the motif of the ladder. (On this drawing see also Note 26).

175. Various observers have commented on Picasso's rejection of the excessive symbolism of the fist and the sun in the early States of the mural. "Il est . . . vraisemblable . . . que Picasso ait jugé son poing tendu trop symbolique, comme il a jugé trop symbolique le soleil rayonnant qui apparait egalement dans ce deuxième état. . . ." (Vallentin, *61*, pp. 35–6). Similarly, "Perhaps such a symbol of regeneration [the Pegasus in Study 6] was thought too obvious. And so it is, for the justice of emblematic motifs in modern art does not lie in their translatability (or their obscurity, for that matter). Picasso may also have felt this about the clenched fist upraised in salute, the immediately recognizable anti-Fascist and proCommunist gesture [in State I]. . . . That salute, however, with its blazoned militancy, must not be ignored, even if the purpose of mentioning it is to point out that it was rejected. It is merely perverse to deny a social aspect to the painting, though we need to correct the way that it has long been over-interpreted as a major political statement. *Guernica* had political intentions, but nothing other than artistic means" (Hilton, *27*, pp. 241–2). (It is puzzling that Mr. Hilton could have made such a clear and adequate answer to his own mechanical objections to the mural's obscurity. On these, see Note 122).

It may be noted that although the swordbearer's clenched fist is seemingly relevant to the Communist salute, as Mr. Hilton points out, the straight extension of the arm is not. Similarly in Study 15, the fists are raised but the arms avoid the obvious flex of the Communist gesture. There is a difference, however, between the ultimate destiny of the fist and that of the sun, in the finished mural; whereas the swordbearer's gesture retains ultimately its moral force, albeit lowered and unclenched, the image of the sun achieves a moral two-sidedness no less challenging than that of the bull (see above in the chapter "On Stage"). It is George Weber (in conversation) who has pointed out this important ambiguity.

176. The bird-relic of the bull's original position, persisting in the mural from State IV, has been noticed by Anthony Blunt, paralleling in part the present writer's observations; and similarly the permanent relic of the warrior's upraised arm. "In changing the position of the bull's hind quarters, Picasso leaves in its original position a small light patch, which in the third state had formed part of the animal's back. For the moment [State IV] it appears to have no function, but later it was to be given meaning by being incorporated with the bird which originally appeared on the ground but in the final state was to fill the gap left beside the horse's head. A precisely similar problem had arisen with the removal of the upraised arm. Picasso preserved a narrow diamond-shaped area which had originally defined the elbow. In the third stage it has no clear meaning, but later we are invited to read it as a section of the spear which has pierced the horse, and in this form it survives to the finished picture." (*8*, pp. 42–43.) But the diamond-shape never "defined," rather it enclosed, the elbow. It is, further, entirely separate from "the spear which has pierced the horse," for it exists alongside and quite irrelevant to this explicit object. Its identity as a wound is evident from parallels in the bullfights, Crucifixions, and Guernica Studies (discussed above also in chapters one and four).

177. Of the arrangement in State V, Arnheim has observed that "The disappearance of the second head [the one between the horse's forelegs] has made some space, which is being filled by a turn of the hand with the sword. This diagonal recession into the third dimension relieves the flat arrangement of verticals and horizontals which prevails along the lower border." (*1*, p. 126.)

178. One observer has connected the seeming sacrificial nature of the Guernica bird, with the presence of the table: "We might also ask: Is the table an altar of sacrifice?" (Raphael, *43*, p. 156).

On Picasso's own notion of his representations of simple furniture-articles as "parables," see Note 96.

179. No Guernica image is more complex than the mural's ceiling fixture, with its surface readings of sun, lamp, and eye, and its further suggestion of Grünewald's crown of thorns. And it has been suggested by one observer that the Guernica sun is "an allegory of the Nazi bomb. . . ." (Max Raphael, *43*, p. 154). Still further, an esoteric link with Mithraism is suggested.

Ruth Kaufmann holds, with some ingenious reasoning, that one of the floating heads within the 1930 Crucifixion panel, is a combined sun and moon, a face with a light and a dark triangle superimposed over it—the two triangles deriving, by a rather loose hypothesis, from the sun and moon which are present at the Crucifixion in Christian iconography (Dr. Kaufmann makes no mention of the overt sun and moon in Picasso's Crucifixion drawing of 1930, which she reproduces), while the light triangle in particular is put forward as deriving at the same time from the peaked hat of the sun-god Mithras. This pattern, it would seem, is derived from Picasso's likely contact with adumbrations of Mithraic lore current and published among his circle of Surrealist friends in 1930. The suggestion advanced is that the sun in Mithraism is "degraded or rotten" (i.e., blinding), thereby making a link between the Crucifixion panel and the Guernica: "The two works have . . . degraded images of the sun—the sun with the electric light bulb of the *Guernica* and the sun of Mithraism of the Crucifixion." Further it would have been known to Picasso, it seems, that the sun was "identified with Mithras who slaughters a bull"—thereby lending the theme some further appropriateness to the two scenes of sacrifice. (*29*, pp. 554 ff.) Visually if not iconographically this link between the two pictures remains tenuous, yet there is no clear reason to discount it, taking into consideration the tenuous skein of Picasso's cross-influences generally. Indeed it could be suggested that the light and the dark triangle superimposed over the face in the Crucifixion painting (taking these, with Dr. Kaufmann, as the sun and moon) are multiplied as the ranks of light and dark triangles which surround the sun in the Guernica, giving that motif its own identity as a sun and moon combined—a resolution of the sun and moon seen separately in the mural State III, and an explanation of the anomaly of dark triangles surrounding the sun. The argument still remains somewhat literary; light and dark triangles do not necessarily need to depend on Mithraism or Early Christian iconography; still it is to be allowed that there is in any case a strong literary current in Picasso's Crucifixions, some of the more elaborate of them indeed containing no smallest line which does not hew to some scriptural detail. When it came to his themes of sacrifice—the corrida, Calvary, and, it may be, Mithraism—Picasso of course was often nothing less than avid in his holding up of symbols and iconographic paraphernalia, sometimes straight-forwardly, sometimes scrambled and cross-bred as in the Guernica; grasping, with the freedom allowed by his stature, for a broader meaning outside his own visceral strengths as a painter.

INDEX

Index

Layout of the text and illustrations was designed by Frank D. Russell.

The book was set in *Bembo* by Allanheld, Osmun & Co., Publishers, and printed and bound by Universal Lithographers, Baltimore, Maryland.